THE DIVINE TRINITY

THE DIVINE TRINITY

David Brown

OPEN COURT PUBLISHING COMPANY
LA SALLE, ILLINOIS 61301

✹

OPEN COURT and the above logo are registered with
the U.S. Patent and Trademark Office

Published by arrangement with Gerald Duckworth & Co., Ltd., London

OC 854 10 9 8 7 6 5 4 3 2 1

ISBN 0-87548-439-5

Brown, David, 1948-
 The Divine Trinity.

 Includes bibliographical references.
 1. Trinity. 2. Philosophical theology. I. Title.
BT111.2.B73 1985 231′.044 85-18941
ISBN 0-87548-439-5

Printed and bound in Great Britain

Contents

Preface

This is a book which would never have been written without the help and encouragement of friends. A number of my colleagues have read various parts of the work, among whom I owe a special debt of gratitude to David Charles, F.W. Dillistone, Andrew Louth, Anthony Meredith, Robert Morgan and Howard Robinson. I also owe a wider debt to colleagues who have been subjected to previous versions of sections at various seminars, including the Oxford Society of Historical Theology, the pre-termly Doctrine Tutors Meeting and the Metaphysicals. Several graduate members of Oriel have also lent their aid, among whom special mention should be made of Gregor Duncan, Steve Holtzer, Michael Ipgrave and Paul Keyte. Gregor and Michael commented on almost the whole of the first draft of the manuscript, which was no small task.

There is one further debt to two dead members of Oriel which cannot be passed over in silence. It was through reading John Henry Newman (Fellow 1822-45) on development of doctrine within the Church that I gradually came to appreciate that the same approach must also be rigorously applied to the Bible. This debt to Newman is nowhere acknowledged in the text, unlike that to Bishop Joseph Butler (undergraduate of the College 1715-18). As will be obvious from the first chapter, his earlier refutation of deism has helped to inspire my own.

Oriel College, Oxford D.W.B.

Introduction

A Task for the Philosophical Theologian

Before explaining the rationale behind the ordering of the chapters which follow, what I would like to do first in this brief introduction is draw attention to what may be regarded as the most interesting and distinctive features of my treatment of the topic. Three in particular may be singled out.

(i) The first is indicated by the sub-title of this Introduction, 'A Task for the Philosophical Theologian'. In British universities there is no doubt that philosophy of religion is a firmly entrenched discipline with its own clearly defined curriculum – arguments for and against the existence of God, the nature of religious language, philosophical problems connected with life after death, etc. Given such an agenda it is hardly surprising that it is treated very much as a prolegomenon to theology as such, that is, as more concerned with justifying theology as a legitimate academic discipline than as having anything itself directly to say on how theologians argue. Even where the two subjects of philosophy and theology can be studied together in a joint course, such as in the School of Philosophy and Theology at Oxford, the tendency has remained to keep the degree of penetration of theology by philosophy to a minimum. I used to believe that this was the correct approach, but the relation has not always been like this. One need only think of St. Thomas Aquinas' *Summa Theologiae* to see the high degree of interpenetration which might be possible.

My own change of mind can best be explained by referring to the genesis of this book. Roughly speaking, the three parts were written in reverse order, previous parts being made necessary as I became progressively more aware of the extent to which philosophical considerations could not be separated from the whole range of issues relevant to the debate about the tenability or otherwise of the doctrine of the Trinity. Thus, initially a version of Part III, 'The Coherence of the Doctrine', was written under the impetus of irritation at the way in which so many radical theologians were prepared to dismiss the doctrine in a single throw-away remark as 'self-contradictory' or 'incoherent', while conservatives, in defending the doctrine, seemed to think that an appeal to 'mystery' was sufficient response. But then, when one turned from

such reflections to look at the way in which theologians examined the Biblical evidence for the doctrine, one observed that their lack of care in analysing what would constitute an Incarnation or substantiate a trinitarian view of God also contaminated and obfuscated their discussion of the evidence. The result is that very often one found theologians making incarnational claims on the basis of logically inadequate evidence, or, at the other extreme, suggesting more to be required than is in fact the case. Hence the necessity dawned upon me of looking at the evidence from a more explicitly philosophical point of view, which is the burden of Part II, 'The Justification of the Doctrine'. Finally, I realised that what one made of the evidence had little to do with agreed criteria that could be applied independently of some wider framework. Rather, unless one is prepared to endorse an interventionist view of God (that over and above his general ordering of the world there are certain specific actions which he performs within our historical, temporal framework), then the very idea of an Incarnation will inevitably seem such a startling exception to the uniform pattern of God's relation to the world as to be, quite literally, incredible. That being so, Part I, 'Divine Action and Theological Truth', finally emerged as equally integral to the discussion. Not only that, but also it became clear that once again philosophy and theology could not be kept apart. For, whether one adopts an interventionist or a non-interventionist view of God (in Chapter 1 respectively labelled deism and theism) can only be determined by philosophical and not theological considerations, given the degree of generality involved in the question. This is certainly true of Chapter 1, 'Deism v. Theism', where the argument is pursued without any direct reference to Christianity. But, even in Chapter 2, 'Revelation – the divine dialogue', where the question of the Bible as revelation is discussed, it will be my contention that theism has lost ground largely for conceptual reasons, notwithstanding the common contention of Biblical scholars that it is historical criticism that has made them deists. This is because of the failure of theism to provide a model of revelation which takes adequate account of the extent of the fallibility of the authors, cultural conditioning and so forth.

Such then in brief is the motivation behind this book. It stems from the perception that philosophy and theology cannot be kept artificially apart, as they are at present within the Anglo-Saxon tradition. It is a refrain that will be taken up many times in the course of our discussion. The implication, I take it, is for nothing less than the founding of a new discipline of philosophical theology (or the widening of the horizons of the philosophy of religion) to apply more widely the type of penetration of theology by philosophy that is illustrated in what follows by my treatment of the doctrine of the Trinity.

At the same time one is aware that, given the nature of the topic, the great majority of readers of this book are likely to be theologians, many of

whom will have little or no philosophical knowledge. It is appropriate, therefore, at this point to reassure them that no knowledge is assumed and that technical discussions are avoided, so far as possible. If the non-philosophical reader prefers to substitute 'conceptual' for 'philosophical', this might well make him less alarmed about the prospect of what follows, while at the same time it would not substantially alter my meaning. However that may be, in deference to such readers, I have postponed the most abstract part of my discussion to Part III, although there is something to be said for having included it at an earlier stage. Briefly, the argument for inclusion at an earlier stage is that the models for Incarnation and Trinity which are assumed in Part II are only defended at length in Part III. On the other hand, one is only likely to be interested in the coherence or otherwise of such models if one thinks that there are grounds for believing that a trinitarian view of the Godhead has in fact been revealed, which is the substance of Part II. So, on balance, I decided to leave the most technical part of the discussion to the end of the book, with only a brief account of the models being given in the relevant sections of Part II.

(ii) The second feature of the discussion that I think is of particular interest is the large role assigned to religious experience. Originally my interest in religious experience and in the doctrine of the Trinity were two entirely separate interests. But a process of mutual fertilisation occurred with the result that I came to see that not only does the doctrine of the Trinity depend for its justification on certain key experiences but the tenability of religious belief in general. That is a large claim. But it is, I think, amply justified by Part I. Thus in Chapter 1 the argument between deism and theism is presented primarily in terms of alternative accounts of religious experience, and the conclusion reached that it is only on a theistic analysis that both what experients claim to happen in such experiences can be sustained and adequate grounds be offered for seeing religious belief as a more reasonable alternative than atheism.

But it is perhaps later chapters that will occasion the reader greater surprise. Even with the growth of Biblical criticism, with the application of ordinary historical techniques to the Bible, there is still a temptation to treat 'revelation' as a totally unique category without parallel elsewhere. But, as I came to the realisation that the doctrine of the Incarnation and of the divinity of the Holy Spirit must stand or fall by the analysis one is prepared to give of the disciples' experiences of Resurrection and of the gift of the Holy Spirit, so I also noticed that this carried with it two implications of much wider import for the future of theology.

First, each of these experiences belong to categories of religious experience (distinguished in the first chapter) that are to be found not only elsewhere in the Bible but also extensively outside the canon of Scripture. This is not to say that the two types of experience relevant to

the doctrine of the Trinity have no distinctive features that set them apart from others within their classification group. Obviously they must have, if they, and they alone, point to something as remarkable as the doctrine of the Trinity. But it is a difference of content rather than of form, and so anyone accepting such experiences as veridical cannot just automatically dismiss other experiences of similar form as of no account. For casting a universal blanket of doubt over experiences of similar form must inevitably undermine the credibility of the Biblical experiences in question. To put the point as briefly and as controversially as possible, since the Resurrection must be analysed as basically a visionary experience, anyone who accepts it as veridical must also be prepared at least to take seriously other visionary experience e.g. visions of the Virgin Mary, even if in the end he rejects them. Likewise in respect of 'Pentecost', if this is taken as veridical, one cannot avoid giving serious attention to other alleged experiences of divine indwelling, even within other religions e.g. Islam and Hinduism. That is to say, there will be a strong obligation to provide a justification for treating one experience as veridical and not another, that is not arbitrary, that is, that avoids any simple appeal merely to content. This first implication is not one which is pursued to any great extent in what follows, though I do think that the consequences for theology are profound. Only at one point is an extended illustration given, namely in our discussion of the separate personhood of the Holy Spirit in Chapter 4. There I argue that, even if justification for the doctrine could not be found in the relevant Biblical experiences, that would not be the end of the argument, as one can appeal to the content of certain other non-Biblical experiences, both within Christianity and in other religions.

By contrast, the second major implication is accorded a much more extensive treatment. This is a matter of how we treat the question of revelation, which is the theme of Chapter 2. At present, as the chapter notes, there is considerable conceptual confusion with regard to how the matter may be most appropriately treated. On the one hand, those of a more conservative disposition try to retain the old model of inspiration, and locate the authority of the Bible in the authors' experience of writing its constituent books under some direct divine impulse, while, on the other, more radical thinkers, if they retain the notion of revelation at all, tend to move the locus of authority to divine acts in history, in terms of which the books are then seen as secondary reflections. But both models are unsatisfactory: the radical because it ignores the fact that what God does is only of significance if it is perceived correctly; the conservative because it fails to concede that the important perceptions are not so much those of the authors themselves as of those whose religious experiences are described within their books. Hence my argument in Part II is not that the doctrine of the Trinity can be defended by appeal to the inspired nature of certain writings, but rather that certain experiences,

as described within them, legitimate the endorsement of such a view of God. In addition, Chapter 2 makes it clear that this applies just as much to other revealed doctrines.

However, to say this much is still only to scratch the surface with respect to the extent to which it seems to me that the concept of revelation needs revision in the light of the nature of religious experience. One common objection made to taking the content of religious experience seriously is the extent to which it bears obvious features of cultural conditioning (only Christians see visions of Christ; God 'talks' in the theology of the time; etc.). Certainly, it is an objection that needs to be answered. For, though all forms of experience are culturally conditioned, this will not do as a reply, as God presumably has the power to override such conditioning. What one needs, therefore, is some reason why God does not do so. This I attempt to provide in Chapter 2 in terms of a model of revelation as a divine dialogue. What exactly is meant by that, it is not necessary to elucidate here. The important point that does need underlining is one particular consequence of the model. This is that religious experiences cannot be treated as isolatable units to be assessed totally independently of the religious tradition to which they belong. In other words, the extent of the divine communication is dependent on what already exists in the tradition, and not just on the receptivity of the recipient to new ideas. But, if this is so, then there will be important implications both for a particular tradition and with regard to cross-tradition comparisons. Thus, in respect of the former, it will mean not only a presumption in favour of some progress in understanding (though not the inevitability of such progress), but also the likely redundancy of much of what has occurred at an earlier stage of the dialogue, as simply 'primitive' by comparison. Clearly, this cannot but affect how one views much of the Bible. But, equally, it will make possible a more positive assessment of alternative traditions. For a straight comparison between experiences in different religions will, on this view, simply not make sense. There will be a need to record the stage which the divine dialogue within each particular tradition has reached, and in those terms, because the experiences have occurred in the context of different stages, it may be possible to pronounce them both veridical experiences, despite profound surface differences. The assessment of how plausible such claims are must obviously await a reading of Chapter 2, especially given the difficulty of expounding briefly the proposed model. But at least its considerable ramifications, if accepted, should not be in doubt.

(iii) The third and final distinctive feature to which I want to draw attention is the way in which, though a conservative conclusion is reached, in the sense that this book is intended as a defence of the doctrine of the Trinity, it is a conclusion that is reached by anything but a conservative or traditional form of argumentation. One hopes,

therefore, that it may act as an encouragement to those worried by the impact of Biblical criticism, so that, instead of seeing it merely as a threat, they may regard it as a legitimate tool to be used, but not as necessarily carrying with it the radical implications that are often claimed for it. Indeed, if my argument is correct, then the doctrinal conservative is entitled to regard the Biblical fundamentalist and the radical Biblical critic as in some ways tarred with the same brush. For both share a conviction that fundamental truth is to be sought in the original intentions of the Evangelists, or indeed the Biblical writers in general, whereas it is my contention, especially in Part II, that a sharp cleavage should be made between historical original and theological truth because of the developmental character of the model of revelation which is advocated in Chapter 2. Thus, for example, in Chapter 3 it is conceded that Jesus in no sense conceived of himself as divine, as also that no such ascription was intended by the Synoptic Gospels; yet it is claimed that this is by no means the end of the argument. Likewise, in Chapter 4 it is acknowledged that Paul does not draw a sharp distinction between Christ and the Spirit, and indeed that nowhere in the New Testament is there to be found anything like a full endorsement of later Trinitarian doctrine; yet, again, this is held to be far from the end of the argument.

From what has been said so far it might be thought that the argument amounted to no more than an appeal to the inevitable rightness of development. But this is far from being so, and in Chapter 2 examples are given of where things went badly wrong. So it is not just that the doctrinal conservative need not accept the original interpretation of events as authoritative for him; in some cases he can reject them as not authoritative at all. This cannot but have implications for the canon of Scripture, and indeed it seems to me that the doctrinal conservative should not be afraid of declaring many aspects of the Biblical view as no longer authoritative for the Church, including whole books. At the same time, he should not hesitate to assert the Church's right to read, for example, the Gospel accounts or even the Epistles to the Romans and Hebrews in a way very different from that intended by the original authors. Of course, there is an obvious danger of arbitrariness in all of this, but criteria of appropriateness can, I think, be found.

One point at which this feature overlaps with the first, the need for a philosophical theology, is the way in which a more philosophical approach helps the conservative to realise that what he may once have regarded as an important issue for the defence of orthodoxy is in fact of relatively small significance. So, for example, not only is no claim on Jesus' part to divinity necessary for him to have been divine, he need not even have had a very 'high consciousness' of his mission; moreover, it is even arguable that no clear sense could attach to a human being ever having had such a consciousness. Again, much ink has been wasted in

defending the bodily resurrection of Jesus, whereas in terms of guaranteeing his continued existence after death, at most what is required is a defence of the objectivity of the disciples' visions, that is to say, that they were caused by God and not by 'natural' processes. As a final example one might mention the Virgin Birth. In this case philosophical analysis reveals that the doctrine is only essential to one model of the Incarnation (the Kenotic), and even here, supposing that the Infancy narratives must be pronounced insufficiently reliable to form the basis for such a belief, the doctrine could still be defended, if one could provide independent grounds for believing that Jesus was divine and that the Kenotic model is the most defensible model of how this might be so; in other words, even in the total absence of historical evidence for the Virgin Birth, a backward inference could still be made, provided it was supported by other appropriate historical evidence and the necessary conceptual framework.

Having drawn attention to what seem to me to be the three most novel and interesting features of the book, it remains now in this introduction to explain its general plan as an aid to the reader in understanding what follows.

Part I, Divine Action and Theological Truth, with its two chapters on 'Deism v. Theism' and 'Revelation – the Divine Dialogue', is concerned with the wider context that helps to make plausible the justification of the doctrine. That the doctrine cannot be maintained without interventionist premises is made abundantly clear in Part II. But to suppose such intervention to be confined to the New Testament period would undermine the credibility of the whole notion, just as any departure from a norm strains belief and requires greater evidence before we are prepared to concede the truth of the claim. That being so, the more such intervention can be shown to be part of the normal patern of divine activity, the more prepared we will be to see the relevant experiences in the New Testament as straining belief only in respect of their content and not also with regard to their cause. Given such an aim in Part I, 'intervention' sounds in some ways like a misnomer, since it does tend to suggest an exception and a major exception at that. This is unfortunate, but there is no other word which immediately conjures up the appropriate sense of special divine action over and above the general ordering and sustaining of the world that is subject to ordinary natural laws. Part of the problem is that when the word 'intervention' is mentioned, people tend to think of stupendous events like miracles rather than the everyday events of grace, many of which seem to demand just as much an interventionist interpretation. However, provided these caveats are observed, the term may continue to be used. At all events, it is against this background that the argument of Part I should be read, with Chapter 1 seeking to establish the advantages in general of an interventionist view of God and Chapter 2 the advantages when it is a

question of the Scriptures as revelation. Inevitably however, there are a number of recurring subsidiary themes, as, for instance, the significance and correct analysis of religious experience.

Part II, The Justification of the Doctrine, with its two chapters on 'Incarnation' and 'Holy Spirit' then looks at the complex question of the New Testament evidence. Setting the two issues side by side enables one to perceive more clearly the different nature of the problem in each case. For, in the case of the second Person of the Trinity, his separate personhood from the Father has never been in doubt, that is as the man Jesus; what has been questioned is his divinity. By contrast, in the case of the Holy Spirit, the divinity has never been in doubt; what has been challenged is his separate identity, particularly from the Son. The conclusion reached is that, if one has accepted the arguments in Part I, then there are sufficient grounds for claiming that there are three persons in the Godhead.

One word of caution about terminology in Part II is perhaps also necessary. By the word 'Incarnation' I should be taken simply as referring to the divinity of Christ, not specifically to his birth, as the expression is sometimes used. The intention is thus to refer to the whole of his earthly life. Also, by 'divinity' I should be read as indicating a full-blooded, unequivocal designation, not what could in any way be described as a metaphorical usage. The aim is thus a defence of the doctrine in something very much like its original patristic sense.

In the previous sentence an element of vagueness was introduced with the expression, 'something very much like'. This was deliberate, because, no matter how loyal one attempts to be to the formulae of the Church in their original sense, the tremendous revolution that has occurred in our understanding of the Scriptures cannot but make some change inevitable. This is one of the questions to which Part III, The Coherence of the Doctrine, addresses itself. First of all, Chapter 5 looks at the whole range of alternative models for Incarnation and Trinity that have been proposed both in the past and today. It argues that both historically (in terms of what Nicaea and Chalcedon were attempting to safeguard) and philosophically (in terms of criteria of identity) only a strictly limited range can properly, even *prima facie*, count as really maintaining the divinity of Christ and the permanently trinitarian character of the Godhead. The following two chapters on 'The Coherence of the Incarnation' and 'The Coherence of the Trinity' then examine this limited range to see both whether the two doctrines can in fact be defended as logically coherent and how they might adapt themselves to changes in our historical knowledge and in our conceptual understanding. One obvious difficulty, for example, with which Chapter 6 deals, is the fact of Jesus' limited consciousness and the fallibility of his knowledge. The conclusion reached is that, of the two models for Incarnation, the Kenotic and the Chalcedonian, both can be defended as

coherent, provided suitable revisions are made, while, of the two Trinitarian models, doubts are expressed about the Unity model, as found, for instance, in Augustine, whereas the Plurality model, as exemplified in the Cappadocian Fathers, is held to be relatively trouble-free. It is these models which are assumed as the objects of justification in Part II, where their character is briefly described, but no knowledge of the logical problems they involve is necessary until Part III.

There is then one brief concluding chapter which is significantly entitled, 'Conclusion and Prelude'; 'Prelude' because there is at least one major omission from the book, which would have to be rectified in any complete examination of the doctrine, namely some consideration of why the Incarnation happened and of the soteriological implications which might be drawn from it, as from the doctrine of the Trinity as a whole. However, there are other omissions, two of which might in conclusion be mentioned here. First, because of the range of topics being covered, it has not always been possible to pursue arguments in detail and sometimes only sketches have been given. Perhaps too sometimes I have made the wrong decision about which arguments to pursue in detail. However, I hope that at least the sketch is always clear, since detail is normally easier to envisage than the form of an argument. Secondly, in writing this book, I have been very conscious of venturing into terrain that is far from being my main area of competence, namely Biblical scholarship. Though I have tried to read as extensively as possible, no doubt I have still sometimes made wild errors of judgment. But, if as a result a serious dialogue has begun between the philosophical theologian and the Biblical scholar, then all the effort, and possible opprobrium which the effort may arouse, will have been worthwhile.

PART I

DIVINE ACTION
& THEOLOGICAL TRUTH

Chapter One

Deism *v*. Theism

The debate in context

Probably the most important factor in determining the success or otherwise of a counter-argument to an alternative perspective to one's own is the choice of the argument's starting point. For, so often without such prior consideration all that emerges is an exchange of mutual bombast. For example, this seems in large part to explain the mutual incomprehension that still in the main holds sway between the two types of philosophy practised in the Western World, the divide between Anglo-Saxon philosophy and continental.[1] However, more relevant to our purposes here is what happened with the emergence of *The Myth of God Incarnate*[2] in 1977. The subsequent popular reply, *The Truth of God Incarnate*,[3] fell like a damp squib simply because the presuppositions of the contributors were so different from those held by contributors to the other volume, and yet no serious attempt was made to challenge that alternative perspective at its most fundamental roots; instead, familiar arguments were once again rehearsed, arguments that had already been rejected by their opponents because of these unexamined fundamental roots. Nor does it seem to me that the situation was much improved by later more academic contributions to the debate, such as *Incarnation and Myth* or Moule's *The Origin of Christology*.[4] For, while there was undoubtedly some widening of the discussion, it was a process that was not carried nearly far enough. At all events, it is in this belief that Part I of this book is seen as integral to the subsequent discussion.

Thus, if one wants to start the argument at a point of shared assumptions, one has to go a very long way back indeed. Of course, for some this would even involve raising the question of God's existence, but fortunately this much at least is not at the moment a serious issue within

[1] The failure to take the different starting point into account is well illustrated by A.J. Ayer's article in the dialogue volume edited by E. Pivcevic, *Phenomenology and Philosophical Understanding* (Cambridge University Press, 1975), as contrasted with A.M. Quinton's contribution to the same volume.

[2] J. Hick (ed.), *The Myth of God Incarnate* (S.C.M., London, 1977).

[3] M. Green (ed.), *The Truth of God Incarnate* (Hodder & Stoughton, London, 1977).

[4] M. Goulder (ed.), *Incarnation and Myth* (S.C.M., London, 1979); C.F.D. Moule, *The Origin of Christology* (Cambridge University Press, 1977).

Christianity.[5] However, almost everything else is; hence the necessity for beginning with the subject of this chapter, the type of God one is committed to believing in, interventionist or not, though even here, as we shall see, this is not an issue that can be entirely divorced from the prior question of what grounds one has for believing in God at all.

That serious philosophical discussion of the doctrine of the Trinity must begin this far back is, I think, a fact that no sustained reflection on the issues involved could possibly gainsay. The reason for this is that, as Chapter 5 argues in detail, any incarnational claim in the strict sense of the term must involve an interventionist God, and, if that is so, given the obvious connexion between Incarnation and Trinity, the doctrine of the Trinity will also collapse without adequate justification for postulating an interventionist God. Briefly, the point is that, if there is to be a proper incarnation, God the Son cannot stand aloof from the created order but must become interrelated with it, in a reciprocal exchange with a particular aspect of it, namely the human nature, if the Chalcedonian model is adopted, or, something which is clearly even more interventionist, himself become part of that created reality, which is what I take to be implied by a strict application of the original versions of the Kenotic model. Likewise, as Chapter 4 argues, evidence for the separate personality of the Holy Spirit is only likely to be forthcoming if God vouchsaves very specific experiences of a type that preclude identification with either the Father or the Son.

By now the importance of this chapter for our subsequent discussions should, I hope, be clear. What, however, may not be clear is why I have chosen to express the nature of the debate in the way indicated by the title of the chapter. I therefore proceed to an explanation.

In fact, one of the most interesting features of the contemporary attack on doctrines of Incarnation and Trinity is the way in which its advocates can be seen as standing within a tradition that was previously best exemplified in the seventeenth and eighteenth centuries, though as a matter of fact they do not refer themselves back to this period beyond at most a passing reference; not only that, but also the definitive intellectual respose to the non-interventionist movement then, Butler's *Analogy of Religion*, seems to me to employ a strategy which, though irrelevant in detail to the contemporary debate, nonetheless bears marked similarities to the arguments employed later in the chapter for defusing contemporary non-interventionism, or, as I shall henceforth call the position, deism.

The earliest known occurrence of this word is in Pierre Viret, a disciple of Calvin, who in his *Instruction crétienne* of 1564 described a deist as

[5] Neither the earlier views of T. Altizer in *The Gospel of Christian Atheism* (Collins, London, 1967) nor the more recent proposals of D. Cupitt in *Taking Leave of God* (S.C.M., London, 1980) have won any wide acceptance.

someone who, while committed to belief in God, rejects Jesus Christ and his doctrines or, by implication, any other revealed theology. Thereafter, the term migrated to England, where it was used in various senses but the sense which prevailed was the definition given in Johnson's dictionary of 1755: 'a man who follows no particular religion, but only acknowledges the existence of God, without any other article of faith.' For it captures well the negative, condemnatory significance with which the term was largely used by opponents. Samuel Clarke,[6] more fairly, distinguished four types of deists, those who acknowledge a Creator God but believe that he takes no further interest in the world, those who accept the existence of Providence but confine it to the natural order, those who extend it to include the moral order, and finally those who also accept a future life but on non-revelatory grounds. Given such a variety of options, Johnson's definition is obviously inadequate. Probably, we need do little more than characterise it as 'belief in a non-interventionist God', since implied therein are the two key features shared by past and present variants. First, there is the claim that all that we can know about God is derivable from 'natural religion', from investigation of the ordinary world. This, of course, immediately explains Clarke's four categories, since presumably what distinguishes them is simply a differing estimate about how much can be ascertained by such a process. Secondly, and allied to the first, there is the denial that any means of knowing beyond this exist through the intervention of God in history. This latter point is best expressed as a denial of what is sometimes known as 'special revelation', rather than a denial of revelation in general. This is because some deists insist on continuing to speak of revelation, either meaning thereby what can be learnt by natural religion in general, sometimes known as 'general revelation', or intending to refer to particular features of the world which are regarded as having special 'revelatory' significance, though nonetheless just as much part of the ordered, natural universe as any other event. The latter option, as we shall see, is particularly prominent in contemporary deism.

An interesting shared feature between present and past variants is the nationality of its leading exponents. Thus, at the present day, in striking contrast to German theological thought which with the decline of Bultmann's influence and the rising star of Moltmann and Pannenberg has very much moved in a more conservative direction, it is not difficult to find prominent exponents of deism within contemporary English theology. Nineham's *The Use and Abuse of the Bible* and Wiles' *The Remaking of Christian Doctrine*[7] might be taken as representative

[6] In his 1705 Boyle Lectures, 'A Discourse Concerning the Unchangeable Obligations of Natural Religion', in *The Works of Samuel Clarke* (London, 1738), vol. 2, pp. 600-6.

[7] D. Nineham, *The Use and Abuse of the Bible* (S.P.C.K. edition, 1978); M. Wiles, *The Remaking of Christian Doctrine* (S.C.M., London, 1974).

examples. Indeed, Wiles explicitly acknowledges his position to be deistic: 'Such a view is not deistic in the most strongly pejorative sense, in that it allows for a continuing relationship of God to the world as source of existence and giver of purpose to the whole.'[8] Similarly, although the centre of the movement eventually moved to the continent, the earliest advocates were also English. Thus, the first of note was Lord Herbert of Cherbury, who, though he never uses the term 'deist' of himself nor indeed anywhere openly repudiates revelation, nevertheless is such since the five universal truths of religion which he sets forth in his *De Veritate* of 1624 are clearly all that he regards as necessary for the practice of religion, his five being (i) the existence of one supreme God, (ii) the obligation to worship him, (iii) the identification of virtue and piety as the chief constituents of this worship, (iv) the necessity of repentence for wrong-doing, and (v) the attachment of rewards and punishments by God to the corresponding conduct both in this life and the next.[9] However, the most famous English deist of the past is undoubtedly Matthew Tindal, whose *Christianity as Old as the Creation* of 1739 became known as 'the Deists' Bible'; in it Tindal argues not only that revelation is unnecessary but that it is positively confusing to a rational mind; it was also the work to which Bishop Butler saw himself as most directly responding. Numerous exponents of this type of approach can be mentioned from the late seventeenth and early eighteenth century, such as Anthony Collins, John Toland, Thomas Morgan, William Wollaston and Viscount Bolingbroke, all of whom were British (Toland was a former Roman Catholic Irishman and Morgan came from a poor Welsh family). But thereafter the centre very much moves to the continent, and finds expression in the works of people like Voltaire who during his exile in London (1726-9) had come into contact with deism, and thereafter popularised it on the continent in such works as '*Traité de métaphysique* (though in fact he called his position 'théisme'!) Subsequently we find the position in Rousseau's *Emile*,[10] the Encyclopaedists, and Kant's *Die Religion innerhalb der Grenzen der blossen Vernunft* of 1793.

As for the question of how we can best explain the phenomenon of deism's past rise and decline, the issue is a complex one, but the following explanation suggests itself. Its rise corresponds to a period of highly successful advances in the growth of modern science, and it is tempting therefore to see the principal impetus as stemming from respect for the empirical inquiring spirit displayed in science, coupled with the belief that a similar attitude to religion would likewise produce more assured results. Thus the argument from design is the one most

[8] Op. cit., p. 38.
[9] Expressed most clearly in the expanded London edition of 1645.
[10] The relevant section is part of Book IV, 'Profession of Faith of a Savoyard Vicar'.

favoured by deists, though there are exceptions, including Matthew
Tindal. Another factor must have been the less authoritarian attitude
that was beginning to prevail in politics; certainly this influenced
Voltaire, as can be seen in his *Lettres philosophiques sur les Anglais*. As
for its decline, there is no doubt that at the intellectual level Butler can
take almost all the credit, since other replies such as Berkeley's
Alciphron and *Analyst* were deservedly much less influential. Little
wonder then that *The Analogy of Religion* became a set textbook in the
Universities, and indeed Newman described Butler as 'the greatest name
in the Anglican Church'. However, one suspects that in setting a general
climate of hostility to such views probably more influential was the
changed nature of the Church in England during this period with the
move away from latitudinarian rationalism towards enthusiasm within
Methodism and the Evangelical Revival, with such persons as Fletcher,
Venn and Newton and then later Charles Simeon, Henry Martyn and the
Clapham Sect. Likewise, on the continent, although intellectually the
chief reply was given by Schleiermacher with his appeal to *Anschauung
und Gefühl* (intuition and feeling) instead of reason, there is no doubt
that he was greatly helped by the whole Romantic reaction to the
Enlightenment, of which indeed he was part.

So far as the first factor in deism's first rise is concerned, respect for the
scientific attitude, an intriguing aspect to this feature is the fact that, so
far as the practitioners of science themselves were concerned, deism
seems to have had very little influence; indeed, very much the reverse.
Thus Newton continued to believe in the infallibility of scripture, while
Robert Boyle actually endowed a lectureship with the intention of
defending orthodoxy from attack, the first of which by Richard Bentley
was specifically aimed at deism, 'The Folly of Atheism and what is now
called Deism' (1692). Of course, one must not infer from this that deism
was therefore based on a misunderstanding of the implications of science.
One is all too familiar with the compartmentalised mind, with
inconsistencies of approach between different aspects of one's life
unresolved, for one to give this any automatic credence. Yet, it does
suggest the possibility of an over-reaction to alleged conclusions in
another discipline.

At any rate, I shall argue later in this chapter that modern deism is
likewise constituted by an over-reaction to the apparent implications of
other disciplines, in this case particularly history but science, philosophy
and the sociology of knowledge also play their part. This is particularly
well illustrated by attitudes to miracle. Thus, it is commonly assumed
that because it plays no explanatory role for the secular historian, the
same must be true for the theologian. It is an attitude that even affects
one of the contributors to *The Truth of God Incarnate*. Thus MacQuarrie
in his *Principles of Christian Theology*, having declared that 'the
traditional conception of miracle is irreconcilable with our modern

understanding of science and history',[11] proceeds to offer a
non-interventionist account in terms of events which are particularly
'experienced as a focus of divine action'.[12] But not only, as I shall argue
later in this chapter, is such a retreat before other disciples unnecessary,
but also, as Chapter 5 will attempt to demonstrate, it is incompatible
with any incarnationalist claim in the strict sense of the term, a point to
which I have already referred. Some might, of course, be tempted to
argue at this stage that the incarnation is a unique exception to the
normal pattern of divine activity. This is a possibility to which we shall
return later, but it cannot really be regarded as a live option for a number
of reasons, principal among which is the fact that Christ's experience
would have no analogy to our own and thus be of no clear relevance to us.

However, before we pursue particular arguments for and against
modern deism, I would first like to summarise the nature of the argument
used in that earlier refutation of English deism which proved decisive in
its time, Bishop Butler's *Analogy of Religion*. In the process the strategy
of my own counter-argument to contemporary deism will become clearer.
The work is divided into two parts, 'Of Natural Religion' and 'Of
Revealed Religion'. In essence, his argument is that the difficulties that
the deists allege to be found in revelation can be paralleled in nature and,
since the deists accept the God of nature, they are therefore bound in
consistency to accept the God of revelation, or, as he himself puts it in
the Introduction: 'The design then of the following Treatise will be to
show that ... the particular parts principally objected against in this
whole dispensation are analogous to what is experienced in the
constitution and course of Nature, or Providence; that the chief
objections themselves which are alleged against the former are no other
than what may be alleged with like justice against the latter, where they
are found in fact to be inconclusive.'[13]

Such tactics are then followed out in detail in the course of the book by
means of arguments, some of which remain as powerful as they ever were,
while others fall flat in the changed circumstances of our contemporary
knowledge. Illustrations of the former would be the way in which the first
chapter tries to lend plausibility to the notion of human immortality by
drawing attention to dramatic transformations within the natural order,
as with 'worms' into flies,[14] or the way in which he argues against the lack
of universalism in appealing to a particular revelation at a specific point
in time by noting the equal lack of universalism in nature: 'Then those
who think the objection against revelation, from its light not being
universal, to be of weight, should observe, that the Author of Nature, in

[11] J. MacQuarrie, *Principles of Christian Theology* (S.C.M., London, 1966), p. 226.
[12] Ibid., p. 231 (See sec. 38 passim, pp. 225-32).
[13] J. Butler, *The Analogy of Religion* (Ungar, New York, 1961) p. 8.
[14] Ibid., p. 11.

numberless instances, bestows that upon some which he does not upon others, who seem equally to stand in need of it. Indeed, he appears to bestow all his gifts with the most promiscuous variety among creatures of the same species: health and strength, capacities of prudence and knowledge, means of improvement, riches and all external advantages.'[15]

By contrast, other arguments have definitely failed to stand the test of time. A striking instance of this is the way in which he attempts to justify belief in miracles by pointing to the 'very strong presumption ... against the most ordinary facts' as, for instance, the 'presumption of millions to one against the story of Caesar'[16] or 'the presupposition against such uncommon appearances, suppose, as comets, and against there being any such powers as magnetism and electricity, so contrary to the properties of other bodies not endued with these powers'.[17] This will not do as an argument because only an initial presumption against exists, not a continuing presumption as is the case in the absence of any law-like pattern of activity that would make expectations of such activity reasonable – a point that Butler himself indirectly concedes, when he contemplates the possibility that miracles may have their own laws corresponding to natural laws.[18] Still more tenuous is the way he uses the traditional arguments of his day to justify the Christian revelation in particular (through appeal to miracles, prophecy and the preservation of the Jews)[19] or analogy to support the theology of his day, e.g. a penal theory of the atonement.[20] But, even with these qualifications it remains an impressive work, and contains the seeds for a possible contemporary reply to modern versions of deism.

Indeed, in what follows I shall attempt to offer a strengthened version of Butler's claim. For, I shall argue not merely that whatever difficulties are to be found in 'the God of Revelation' have a parallel in 'the God of Nature', the deists' God, but that the difficulties are in fact greater if one has only such a God. This more powerful strategy is possible for us in a way that was not so for Butler, largely because, as we shall see, religious experience plays a far more crucial role both evidentially and conceptually than either theists or deists of Butler's time had even begun to appreciate. At all events, the three most common type of arguments for contemporary deism are isolated below, and the key role, in determining one's response, of religious experience indicated in each case. The three are what I call (i) the redundancy argument, (ii) the conceptual argument, and (iii) the evidential argument. Of the three the last is the one which probably deists and theists would agree is the most

[15] Ibid., p. 191.
[16] Ibid., p. 147 [17] Ibid., p. 149.
[18] Ibid., II, iv, iii, pp. 167ff.
[19] Ibid., II, vii passim.
[20] Ibid.; cf. esp. p. 186.

important. Certainly, it is the one to which I assign the most detailed discussion.

The redundancy argument

Here the argument is, as with the earlier version of deism, that all that is most important in Christianity can be preserved without resort to the hypothesis of an interventionist God. With such a claim, everything depends on what one regards as 'most important', and on this the deist and theist clearly have very different perspectives, as attitudes to the doctrine of the Incarnation clearly illustrate. Rather than enter into that dispute, however, what I want to suggest is that even what is most important on the deist's own terms cannot be satisfactorily defended within a deist framework. As a second stage in the argument I will then go on to argue that a similar type of redundancy argument as the deist employs against the theist can be utilised by the atheist to argue against the deist: that is to say, he can maintain that what is legitimately regarded as most important within deism is best preserved by atheism, not deism.

The redundancy type of argument is one that is commonly employed by Wiles in *The Remaking of Christian Doctrine*, and so we may usefully give some illustrations from this book. The examples he takes are symptomatic of the whole deist approach, and so in discussing them we will be in a position to assess the strengths and weaknesses of this type of argument in general. At all events, Wiles accepts belief in the identification of God with human suffering, creation *ex nihilo* and human survival of death, all without any specific appeal to revelation.

(i) On the first issue he tries to demonstrate that appeal to the sufferings of a God Incarnate are unnecessary by recalling how Hosea reached a similar belief without any such resort: 'It seems to me most reasonable to see the early chapters of Hosea as more than mere allegory, as reflecting experiences in the life of the prophet himself. The writing is allusive and the exegetical problems are well known, but it does not seem too fanciful to claim that it was the pain of Hosea's continuing love for his unfaithful wife which gave rise to the distinctive emphasis in his oracles on the compassionate love of Yahweh for his erring and suffering people. Such a conviction about God remains on any assumption an unproven judgment of faith. But it does not seem impossible that it could have arisen from essentially human experiences of suffering, and could be as reasonably grounded on them as any other aspect of our belief about God.'[21] He then goes on to argue that, even if one does hold to belief in a suffering incarnate God, it still does not solve the key issue of the 'continuing self-identification of God with the sufferings of men and

[21] Op. cit., pp. 71-2.

women': 'The truth or otherwise of that conviction is not determined by the truth or otherwise of a different order of divine self-identification with suffering in the person of Jesus. There does not seem to be any ground for claiming that the former is either causally dependent on or qualitatively transformed by the latter.'

Two observations may be made on this argument. First, Wiles seems to have drawn altogether too much out of the experiences of Hosea. At most, Hosea's reflections would have been justified, had he argued thus: if I can continue to love Gomer, despite all her whoring, how much more so can the all-good God continue to love his rebellious people? Even in this form the argument is not devoid of possible criticisms, as, for instance that such human love is not necessarily good; it may be sentimental, carried to irrational lengths or based on a proud unwillingness to give up what one believes to be one's own possession. However, leaving aside such criticisms, which can I think be successfully dealt with, there is still the overwhelming objection to Wiles' account that from such reflections it in no way follows that God in any sense suffers, still less that one may legitimately speak of his 'self-identification with the sufferings of men and women'. For the latter would surely most naturally be taken to imply that more than mere metaphorical empathy is involved, while the former fails as an inference because to care is by no means to suffer, since arguably all the factors that make Hosea's caring suffering are absent in the case of God, e.g. the uncertainty about whether Gomer will continue in, or return to her whoring.

Secondly, it would seem that the present sufferings of an individual could be qualitatively transformed if he had grounds for believing that God himself had once experienced the sufferings of man. This is because there is a major difference of meaning between the claim that God knows that someone suffers and cares and the claim that God knows that someone suffers and he himself once suffered likewise. The difference lies in the fact that in the latter case suffering is part of the memory of God (and divine memories presumably do not fade!) and, if that is so, then self-identification means exactly what it says, that God has direct experiential knowledge of the situation and not just an abstract factual knowledge.

(ii) In the case of the doctrine of *creatio ex nihilo* my complaint against Wiles is rather different. It is not that he claims to derive a belief without benefit of revelation that cannot be so derived. In this instance such a claim would seem eminently reasonable. For, though to be found in revelation,[22] it is easily established by appeal to natural theology as in the cosmological argument, and so could be used successfully as an

[22] Though not in Genesis 1, it is undoubtedly the assumption of the New Testament, e.g. John 1:3.

illustration of the redundancy argument. Rather, I mention this successful instance, partly simply to indicate the possibility of such success, but more importantly to highlight the narrowing of natural theology's horizons that is to be found in contemporary deists. For there is a marked tendency to reduce natural theology to reflection on experience and one's personal experience at that. Thus Wiles writes: 'The 'absoluteness' of Schleiermacher's feeling of absolute dependence and the 'ultimacy' of Tillich's 'ultimate concern' must be taken with full seriousness. However much it might seem to ease the intransigent problem of evil, there is no possibility of going back on the Christian conviction of creation *ex nihilo*. Implicit in awareness of God is awareness of that which is the source and the ground of everything else.'[23] This surely just will not do. For, however much we may feel at times totally dependent on God, much of our experience is very different, and indeed is occasionally best characterised by the exact opposite, the feeling of being possessed by an evil power. Also, even if we always experienced absolute dependence, this would provide no justification for extending the claim to the non-human creation. That being so, though a viable postulate of natural theology, it cannot be a postulate of experience. Its viability for the redundancy claim comes from elsewhere, from the cosmological argument. For that argument would seem to establish this much: if there is an explanation for the existence of the world as a whole, it will lie in a single transcendent cause.[24]

(iii) With our final illustration, we return once again to a situation where Wiles claims altogether too much for natural theology, a situation where revelation is seen in fact to be indispensable. In this case, however, there is an additional feature that will provide an appropriate transition to the second half of our counter-argument. Wiles' justification of belief in life after death runs as follows: 'The whole tenor of the gospel as a revelation of God in Jesus Christ points to a God whose love knows no limits to which it will not go in eliciting and establishing such a response of love. There does seem to be a fundamental inconsistency in a conception of a God whose purpose in creation includes as so prominent a feature the emergence of personal life capable of response to him, but whose purpose also allows for the utter extinction of those relationships of love, developed so gradually, so profoundly and yet with such tantalizing incompleteness.'[25]

Again I have two observations to make. First, take the initial sentence with its claim that 'the revelation of God in Jesus Christ points to a God whose love knows no limits'. With revelation understood in its traditional

[23] Op. cit., p. 33.

[24] A good treatment of the cosmological argument is given by R. Swinburne in *The Existence of God* (Oxford University Press, 1979). He contends that 'this supposition' (i.e. of God's existence) 'postulates a simpler beginning of explanation than does the supposition of an uncaused universe' (p. 132).

[25] Op. cit., p. 137.

significance and something like the orthodox notion of Incarnation accepted, there would be no problem. But Wiles' denial of an interventionist God extends to the doctrine of the Incarnation, and so he cannot in consistency claim that it is the extent of God's accommodation to the human condition in the Incarnation that shows that his love knows no limits, since there was no extensive accommodation on his view. The penultimate sentence before the passage quoted suggests an alternative answer: 'In the answer of Jesus to the Sadducees' question, it is not merely justice but the inviolability of a loving covenant relationship which ensures that Abraham, Isaac and Jacob must still live in God.' One way of interpreting this would be to say that it constitutes a plea to some special insight given by God to Jesus, but this again will not do, so far as the deist is concerned, since it implies some sort of divine intervention. At most what the deist might claim is that Jesus was a specifically gifted sort of individual who perceived easily what it has always been open for any of us to perceive, but the perception of which has now been considerably eased by his making explicit the possibility of the perception. That this is the most the deist may claim is argued in detail when the second main type of argument, the conceptual, is discussed. For the moment, the important point to note is that on such a model the perception has at least in theory to be available to any one of us, and, if that is so, I quite fail to see how we could ever know that God's love has no limits.

It should be noted that I am not denying the possibility of knowing through natural theology the perfect goodness of God. But I take it that, even if this were established, it would not be possible immediately to infer the limitless love of God. This is because the moral goodness established by this means is a formal notion rather than one with completely determined content. That is to say, we infer from the fact of God being the source of our moral knowledge through creation the fact that whatever we discover to be good must therefore be predicated of God, but from such an argument nothing follows about us thereby knowing by natural means all the content that there is to the concept 'good'. Revelation is necessary to complete the picture, as it were. Now, this is something the deist must deny, except in the limited sense already referred to, and what I fail to see is how the demand on God's moral perfection that his love should be limitless could possibly be ascertained except on explicitly interventionist principles. Thus no doubt we can know by natural means that God is under various moral obligations in relation to his creatures, the sort of obligations, for instance that are assumed in formulations of the so-called 'problem of evil' in the philosophy of religion,[26] but this is still a long way off from what Wiles is claiming. Indeed, the whole notion is surely almost counter-intuitive to

[26] For example, if he is perfectly good, he cannot directly intend his creatures harm. At most evil may be allowed, if it is the only logically possible way of securing some good end.

our normal moral assumptions; after all the difference between the
Creator of the Universe and 'small-fry' human beings seems so vast that
all one's natural reason would tend to pull one in the direction of denying
any special relationship of love, far less admitting that such love is
limitless. In a word, the position seems to give supererogation on the part
of God the force of an obligation, so clearly is it alleged that we must see
God as acting thus in virtue of his goodness.

But, secondly, even if one were to concede that the extent of God's love
could be established without appeal to interventionist principles, it is
still not clear why belief in an after-life should follow from belief in love
of this kind. Wiles mentions the incompleteness of our present
relationship, but why, it may be asked, should this not be seen as a
function of us rather than of the world *per se*? After all, we do read
accounts of some holy persons who claim already to be living in intimate
relationship with God; so, perhaps, if we as individuals spent more time
in prayer and contemplation, we could achieve the maximum degree of
intimacy that is possible for human beings in this life. Again, even if
survival is a logical possibility, it by no means follows that limitless love
is required to actualise the possibility. Thus, such love may realise that
the survival of those whom it loves may be counter-productive to their
own happiness, tied as human happiness seems to be in this life to the
realisation of finite objectives. This is not to deny the inference that, if
God raises those whom he loves, they must be happy; it is merely to point
out that the converse does not automatically hold, that human happiness
must be increased by survival. For reasons then such as the two just
given, we do therefore, it seems to me, require confirmation from
revelation that such an inference does in fact hold.

In the redundancy argument which we have just been examining much
emphasis is placed on God's desire to elicit 'a response of love' from
human beings. Reflection on what this might mean will, I suggest, lead
us to see that a redundancy argument of the type employed by deism
against theism, can also be utilised by the atheist against deism. I would
not wish to claim that the parallel is a complete one, but one could argue
that in some ways the argument is stronger in the latter case, especially if
my recent attempt to pinpoint flaws in the former case is accepted.
However that may be, the precise nature of the parallel can best be made
explicit by setting out the two arguments side by side. Deism argues
against theism as follows: theism believes that Christianity's claims
depend on a key metaphysical thesis, the doctrine of the Incarnation, but
not only is this doctrine indefensible, both in terms of logical coherence
and justification, but also what is in fact the core of Christianity, the
implications for the individual, can be defended without any such
metaphysical resort. Following this pattern, the atheist might then argue
against the deist thus: deism believes that Christianity's claims depend
on a key metaphysical thesis, the doctrine of God, but not only is that

indefensible, both in terms of logical coherence and justification, but also what is in fact that core of Christianity, its implications for the individual, can be defended without any such metaphysical resort.

So far as the first half of the two arguments is concerned, that against theism is refuted in subsequent chapters (Chapters 3 for justification, Chapter 6 for logical coherence). By contrast, later in this chapter, when considering deism's evidential argument, we shall endorse the atheist's complaint against deism, at least so far as the question of justification is concerned. That being so, we shall confine our attention here to the second half of the argument, as indeed we have just done when considering the redundancy argument against theism. Obviously, whatever strengths such an argument may have are going to depend on how we identify the core of Christianity, and so arbitrariness in the identification must be avoided. This is a problem that equally affects deism's dispute with theism, and so it would seem most fair to use the same sort of criteria against deism as it uses itself against theism. This would seem tantamount to consideration of the effects on the individual believer, in particular the way he views his experience. Note, for instance, in the arguments of Wiles which we have just considered the way in which appeal is made, in the first to the problem of the self-identification of God with the present suffering of the individual in the world, in the second to his present experience of total dependence on God, and in the final to the fact of both the possibility of loving response and the experience of its essential incompleteness. From such comments it would, I think, be fair to deduce that for him the core of Christianity is seen in certain experientially based attitudes, and, of course, as a definition of the essence of Christianity it is not altogether too far from the mark, given the common emphasis on the acquiring of a particular attitude, namely the attitude of faith.

At all events, applying this now to the atheist's argument against the deist, he could presumably argue that the kind of attitudes which the deist wishes to see present in the individual could be produced without any resort being had to the premiss of belief in God. On first hearing this no doubt sounds like a highly implausible claim, especially given talk of 'a response of love', 'relationships of love', etc., but the point can, I think, be sustained. To do so it is necessary to venture a little into consideration of an issue which we shall discuss in much more detail when looking at the second of the main types of deist argument, the conceptual argument. Suffice it to note that it would seem impossible to attach clear sense to such phrases within a deist framework unless they are understood as essentially metaphorical. This is because the reciprocity that is so characteristic of personal relationships cannot be preserved in respect of God outside of theism. That is to say, what is precluded by a non-interventionist account of God is the interaction that seems so constitutive of personal relationships, with one individual acting, the

other responding, the first reacting in turn and so on. All the deist can claim is that the human being responds to specific features of his environment which God from all eternity has always had placed there in the hope of eliciting such a response. But there can be no dialogue, no interaction. Apart from the general signs left by God, the movement is all from the human side, as he attempts to read more clearly these signs. God makes no specific response to that particular individual, and so it would seem misleading to characterise what is taking place as a personal relationship at all.

If that is so, then something further follows. For it will mean that the essence of Christianity as deism identifies it, when shorn of its misleading metaphorical (or mythological) forms of expression, is not appropriately described as a personal relationship at all but rather as a specific type of attitude, the attitude that these kinds of signs evince. Once this is conceded as the correct perspective on deism, the atheist's critique will then, I think, go through. For what he can argue is that the appropriate attitude does not require the metaphysical assumption that the deist believes to be necessary to it, the doctrine of God. Thus, so far as the content of the attitude is concerned, there would seem no doubt that the atheist can exhibit the same kind of attitude. Schubert Ogden once wrote: 'The primary use or function of the word "God" is to refer to the objective ground in reality itself of our ineradicable confidence in the final worth of our existence.'[27] Thus defined, an atheist might well be willing to endorse the conviction, at least in the sense that he believes his existence and that of every human being to have a certain worth and that such a belief is more than just a subjective conviction.

But, it may be said, while the content of the attitude could be the same, its justification would be very different, and this is what precludes a redundancy argument against deism; there is total disagreement about what 'grounds' the attitude in 'objective reality itself'. Certainly, there is a major divergence in the name given – in the one case, 'God', in the other, not. But, if we look at the justifications offered, we will find both parties appealing to the same signposts as the basis of their 'ineradicable confidence'. Thus, the atheist who had this kind of confidence will appeal to certain experiences, particularly moral, and the deist will do likewise. Indeed, it is surely no accident that those deists who come nearest to a position of explicit atheism are normally those who find the core of Christianity in its moral emphasis. Certainly, this was true of Braithwaite in his well-known 1955 lecture, 'An Empiricist's View of the Nature of Religious Belief';[28] true also of the so-called 'Death of God theology' with Hamilton, Van Buren and Altizer.[29] A more recent

[27] S. Ogden, *The Reality of God* (S.C.M., London, 1967), p. 37.
[28] Reprinted in, for example, B. Mitchell (ed.) *The Philosophy of Religion* (Oxford University Press, 1971), pp. 72-91.
[29] W. Hamilton, *The New Essence of Christianity* (Darton, Longman & Todd, London, 1961); P. Van Buren, *The Secular Meaning of the Gospel* (Pelican, 1968); T. Altizer, op. cit.

example would be the fact that of all the contributors to *The Myth of God Incarnate* it is the one who seems closest to a position of explicit atheism who most emphasises the absolute character of the moral element in the Christian faith. Thus, what above all pervades Cupitt's contribution is a sense of moral outrage at what he sees as the morally corrupting effect of the traditional doctrine with its alleged endorsement of the status quo,[30] and it is a sense of outrage which is carried a stage further in his book *Taking Leave of God.* For there the gist of the argument would seem to be that any attempt at objectification, e.g. speaking of God as an independently existing being, inevitably entails a relaxing of the moral challenge, and, although he denies that he is simply equating the religious demand with the moral in the manner of Kant, [31] it is significant that he expounds the religious demand in what sounds like exclusively moral terms: 'No external object can bring about my inner spiritual liberation. I must will it for myself and attain it within myself. Only I can free myself. So the religious imperative that commands me to become spirit must be regarded as an autonomous-authoritative principle that I impose upon myself.'[32]

Given this appeal within deism to moral experience, it is not difficult to comprehend why atheists are so often totally puzzled by the deist's reluctance to take the final step of abandoning what seems to them to be the redundant metaphysical postulate of God's existence. For they (or at least the type of atheist delineated above) would claim fully to understand the transcendent aspect of the type of experiences to which the deist points, but see the personalising aspect of them as a completely unjustified blunder. What the transcendent element points to is the demand to go beyond self, not the demand *from* something beyond self. Thus, in moral experience, we experience the demand to take account of others besides oneself, but this does not mean that there is some transcendent person who is confronting us with this demand. Similarly, in what might be regarded as more obviously 'religious' experience like awe before the world, one experiences onself as of no significance compared to the majesty of that which is other than oneself, but it does not follow from this that what is assigned the higher worth should be regarded as an individual transcendent person. Again, mystical experience should be seen as simply being taken out of oneself and seeing the value of a larger whole, rather than the taking out of oneself into something else.[33]

One thing that should be emphasised about such an argument is that it applies only to the deist, not the theist. For the theist will claim that there are specifically interventionist aspects to the experience that

[30] Op. cit.; e.g. pp. 133, 140, 144.
[31] Op. cit., p. 148.
[32] Ibid., p. 164.
[33] A well-argued non-religious but positive interpretation of mystical experience is that given by M. Laski in her book *Ecstasy* (Cresset Press, London, 1961).

justify the postulation of God, and which indeed mean that the atheist and theist do not normally have the same experience, however similar on the surface descriptions appear. But such an escape route is not available to the deist, since for him God is necessarily totally transcendent and the signposts to his existence that are already present within the world are necessarily available indifferently to all. That being so, I fail to see how the deist could ever successfully deal with the atheist's acceptance of the element of transcendence in his experience, combined as it is with a belief that it points merely out beyond himself, but emphatically not out to an individual beyond himself. Indeed, the atheist would seem to have the stronger case. After all, it is the simpler hypothesis which he is advocating.[34] Not only that; he can also argue that the deist by individuating an object of transcendence in effect precludes further experiences of transcendence by denying the individual's moral autonomy and thus his openness to fresh moral demands. This latter fact certainly explains Cupitt's reluctance to objectify God, and it is not all that far removed from the atheist James Rachels' 'moral disproof' of the existence of God.[35]

The conclusion of our examination of the redundancy argument against deism, then, is that not only can it not be sustained, but a far more effective redundancy argument can be brought against deism itself by the atheist.

The conceptual argument

This objection might be pitched at a number of different levels. At its strongest, the deist might argue that the theist account of divine activity is logically incoherent. More normally, however, something weaker is claimed, that the deistic picture makes more sense. It is this variant which we shall consider here, once again using Wiles as our illustration. My argument will be that it is theism which in fact makes more sense, and that the greater conceptual difficulties lie with deism.

Wiles comments as follows: 'I have argued that the idea of some special relationship of God to particular events is not to be excluded in advance as logically absurd. But logical possibility is not by itself sufficient to justify positive affirmation. Nor do I think that such a positive affirmation can in fact be justified. The experience of divine guidance or divine providence is so frequent and so fundamental to Christian

[34] Certainly even a deist like Wiles acknowledges the need to show that postulating God offers an improved explanation of the way the world is. 'But when the principal of economy beckons me to dispense with the concept of God, I resist. To do so would be to leave a whole dimension of human experience even more opaque and inexplicable than it already is' (*The Remaking of Christian Doctrine*, p. 108).

[35] J. Rachels, 'God and human attitudes,' pp. 34-48 in P. Helm (ed.), *Divine Commands and Morality* (Oxford University Press, 1981).

experience that if it were to be understood as always implying special divine causation (however possible theoretically that may be), the occurrences of such special divine activity would have to be so numerous as to make nonsense of our normal understanding of the relative independence of causation within the world. On the other hand, there does not seem to be any insuperable difficulty in choosing rather to interpret such language on the analogy of God's clothing of the lilies. Certain events happen in the world; the possibility of their happening derives (as with all other events) from the absolute dependence of the world as a whole on God. But particular events by virtue of their intrinsic character or the results to which they give rise (like the beauty of the lilies) give particular expression to some aspect of God's creative purpose for the world as a whole. They are occasions which arouse in us, either at the time or in retrospect, a sense of divine purpose. But that sense does not necessarily entail any special divine activity in those particular events.'[36] Cupitt takes a similar line. For, while drawing attention to the possibility that the traditional understanding of petitionary and intercessory prayer 'may well turn out to be absurd, illogical or superstitious',[37] he is more concerned to argue for the alternative deistic model, that 'prayer is a way of opening ourselves to the requirement that we have laid upon ourselves and meditating upon the ideals and values to which we have committed ourselves',[38] or, as he puts it elsewhere, 'God acts only in the sense that he produces effects in us'.[39]

Figuring out what exactly the nature of the deist's complaint against theism is on this issue is not altogether a straightforward task. In fact, a number of competing strands seem to be involved. In Cupitt's case the motivation seems to be a desire that theologians should come clean, as it were; he detects a common conviction that prayer is essentially a matter of gearing ourselves up to action, and thinks that this should be made explicit;[40] presumably, it is also coupled with a belief that it is hard to see how else it can have an effect. Wiles speaks of 'the relative independence of causation within the world', and his desire to make his account of divine activity compatible with this. Elsewhere one gains the impression that a relatively tight causal system is being assumed, and that this is what motivates resistance to interventionism. Certainly, it is notable that he displays a similar reluctance to see the human will as an additional causal factor to the physical, but instead regards its introduction as important because it enables certain types of question to be raised. The following passage would seem highly significant: 'A parallel can be drawn with the incompleteness that attaches to a purely

[36] Op. cit., pp. 37-8.
[37] *Taking Leave of God*, p. 130.
[38] Ibid., p. 131.
[39] Ibid., p. 94.
[40] Ibid., p. 130.

physical account of the human body. At one level of treatment that account might attain relative completeness. But however far it progressed at that level, it would always remain radically incomplete in its ability to deal at all with the whole area of psycho-physical interaction and its implications for understanding man's bodily functioning. In a similar way, what is required to fill out a non-theistic account of human life is not some further explanatory agent to account for a number of unexplained phenomena; it is, rather, another explanatory framework from within which to discuss all experience in order to be able to deal with the full range of questions that that experience raises for us.'[41] If I have understood the analogy correctly,[42] then it is that, as mind is to 'the whole area' of physical actions, so God is to the world as a whole. This would seem confirmed by the following paragraph, where the human will, like God, seems to be denied a role within the same causal nexus as ordinary physical causation: 'what is needed is not the simple inclusion of the human will as an additional factor in an otherwise identical account.'

On such an interpretation, Wiles is seen to be offering a stronger challenge than Cupitt. It is not just that he fails to see what a plausible account of divine activity might sound like on a theistic view, but he suspects that scientific causal explanation makes the theistic option unnecessary, as indeed also the human mind as a separate causal agent. The accusation of 'a God of the gaps' has thus very definitely been excluded well in advance of any such scientific claim. The question, however, remains as to the price paid. Certainly, in our present state of knowledge it would seem an unnecessary price. For able defenders of the view that the human mind stands outwith the physical causal system with a contra-causal freedom are not lacking. Examples would be C.A. Campbell and John Lucas.[43] And, if man has such a freedom, it would be rather surprising if God did not possess the same kind of freedom to act without causal restraint within the world. This is, incidentally, not to deny a relationship between mental activity and the firing of neurons in the brain, only to deny that a complete causal account of the world could ever be offered exclusively in terms of the latter; this is because such firings will not be wholly explicable through causal laws in terms of previous firings, but resort will have to be had to the intervention of

[41] Op. cit., pp. 87-8.

[42] The analogy seems to pull in rather a different direction from what he says elsewhere, where the logical and practical possibility of a complete scientific explanation is excluded. 'The claim that a full and complete account of these regularities has been or ever could be given us is one that cannot be sustained' (p. 36). Perhaps the two passages can be reconciled by supposing that Wiles means that, though not actually excluded, scientific advances point strongly towards the conclusions that mental or divine causes never operate independently of more basic physical laws.

[43] C.A. Campbell, *In Defence of Free Will* (Allen & Unwin, London, 1967); J.R. Lucas, *The Freedom of the Will* (Oxford University Press, 1970).

mental decision processes. In short, my point is that, if 'interventionism' is still thought of as a viable option in the Free Will debate in moral philosophy, it seems premature to exclude God from a similar pattern of activity. However, even if this debate were conclusively lost, it would not necessarily follow that divine intervention must therefore be totally excluded. For, given the statistical character of so many modern causal laws, at least at the micro level, presumably God could tamper occasionally at the micro level without the effect produced at the macro level being necessarily thereby perceived as a violation of the natural order. However, such a defence does sound rather like a last ditch stand, and so will not be investigated further here.

What we do need to investigate are the less extensive claims of Cupitt (probably also the more normal position adopted by Wiles),[44] namely that it is hard to tell a theistic story of divine activity and that theologians have been covertly admitting this for years in their views on prayer. In reply what I want to sugest is that not only must theists take most of the blame for this deist attack because of their failure to get to grips with the necessary conceptual spadework but also, in consequence of this, the heart of the debate has been wrongly identified. For it would seem to me quite unnecessary for the theist to maintain that all divine activity in the world should be conceived of in distinctively theistic terms. Rather, what is important is that a certain area should be, in particular the area of personal relationship. With this area in mind, the theist can then issue a counter-challenge to the deist, that deism makes no sense when set against the experiences in question to which reference will shortly be made.

But, first, something must be said on the considerable area of divine action within the world, where it seems to me the theist could quite happily accept a non-interventionist account. With the general sustaining of the world by its Creator, etc., I am not concerned. Nor need we devote time to consideration of what is often the stuff of deism, moral experiences, aesthetic experiences, etc. I take it that the average theist would be content that a non-interventionist account be offered in such cases. The interesting cases are rather those to which Cupitt refers, where an individual believes that a change has been effected in himself or another through either petitionary or intercessionary prayer. Theists commonly suppose that here at last we are confronted with the necessity of speaking of divine intervention, but I would argue that this is not in general so, and that such a thesis can be maintained without in the least retreating in a reductionist direction in the manner practised by Cupitt.

So far as effects on the individual himself are concerned, it is very far from being the case that, once intervention is rejected, the only

[44] Certainly, if his preference for talk of the immortality of the soul (pp. 142ff.) is to be defended, our minds must be capable of an existence that is independent of the physical causal nexus.

alternative is Cupitt's view that it is then all up to us. Bringing out the parallel with moral experience will help make the point clearer. Our moral experience is in a sense all up to us, but in another sense it clearly is not. We have to make up our minds whether to tune in or not, as it were – tune in to what exists as a reality independent of ourselves. That is to say, although whether we perceive or not is ultimately dependent on ourselves, this gives us no reason for thinking that what we perceive is purely subjective. Not only that; it is also possible to identify various conditions that have to be fulfilled if the requisite perception is to be possible. To characterise the full range of these conditions would be very difficult, but their existence surely could not be challenged. For example, Piaget has attempted to identify some of them in his influential book *The Moral Judgment of the Child*.[45] Other psychologists have noted the way in which the psychopath is precluded from moral perceptions by his lack of a capacity for sympathy; yet others the way in which egoistic beliefs about human motivation can be self-fulfilling.[46] There would seem no doubt that such things as rationality, sympathy and sensitivity are required before the relevant moral perceptions can be had. Now, in the case of morality we do not think any reduction has been effected if we concede that some perceptions may be had, only provided that certain conditions are first met. That being so, it is hard to see what objection could be made to a parallel account being offered in the case of a wide range of spiritual perceptions, especially as they often overlap with the moral. We would then be committed to the belief that provided certain spiritual conditions are met, the corresponding spiritual perceptions may be had by the individual.

One suspects that most common religious experiences could be appropriately fitted into this mould, as, for instance, the conviction of God's protecting care or the so-called experience of the numinous as with, say, awe before the created order. Some fellow theists may still suspect some denigration of such experiences, but, if so, they are probably falling foul of the genetic fallacy, the supposition that the source of a belief throws doubt on its validity. In response, I would draw attention to the fact that I am only suggesting that God may have so ordained that necesarily certain spiritual perceptions and experiences may be had, provided the requisite spiritual conditions have been met; I am not suggesting that the validity of such perceptions cannot be checked by other means, just as indeed is the case with moral

[45] J. Piaget, *The Moral Judgment of the Child* (Routledge & Kegan Paul, London, 1932).

[46] A typical example would be the case of someone who feels unsure of himself and thus is aggressive towards others. He finds it difficult to believe that others do not have similar aggressive feelings towards him. To begin with, there may be little evidence to justify his suspicions, but, if his insecurity leads him to give indications of hostility, others will soon begin to shy away. On the next encounter they will be more wary, and this in turn will confirm his suspicions of their intentions, and increase his hostility. And so the process will continue.

perceptions; indeed, I would think that we are under an obligation to do so in both cases, that is to say, check that the surface interpretation is the one most compatible with a rational interpretation of the world. As for what these spiritual conditions might be, again characterisation is difficult, but their identification would not seem an impossible task. Indeed, there are numerous prayer manuals in existence which could be interpreted as being engaged in precisely such a task. The emphasis on the purgation of desire, calmness and openness of mind are obvious cases in point. In attempting to explicate these conditions, one would then be in pursuit of those 'general laws of wisdom',[47] which that undoubted theist Butler I think wrongly believed to exist for all divine action in the world.

Turning now to intercessory prayer, once again it would seem possible to offer a satisfactory account without resorting to a postulation of intervention. Thus, in what is surely an unjustly neglected essay, H.H. Price once suggested that we think of intercessory prayer having an effect through the power of telepathy with thought suggestions unconsciously transmitted between individuals. Indeed, the article ends with a law-like formulation of the relationship: 'When and if we sincerely place ourselves in this "I-Thou" relationship with God, and make our requests to him, the very fact that we do so "releases" paranormal forces of some kind, and these in turn bring about the result which we asked for.'[48] The heavy reliance placed on such a contentious form of alleged communication may be thought unsatisfactory, but the body of evidence in favour of its existence is in fact substantial.[49] However, whether we resort to telepathy, 'the corporate unconscious' of Jung or whatever is not immediately important. What is important is the fact that the communication of general concern between individuals or even specific desires need not necessarily be seen as requiring divine intervention for them to be communicated. It may well be that one day we shall see that there are divinely established rules according to which this takes place automatically, if the requisite conditions are fulfilled. Under such conditions nothing would be lost from the theist's account of God, and so the issue of answers to prayer in neither the petitionary nor the intercessory sense can constitute the real kernel of the conceptual debate between the deist and theist.[50]

[47] Op. cit., p. 168.

[48] H.H. Price, 'Petitionary prayer and telepathy', pp. 37-55 in *Essays in the Philosophy of Religion* (Oxford University Press, 1972).

[49] I.G. Barbour in *Issues in Science and Religion* (S.C.M., London, 1966) points out the extent to which non-evidential factors contributed to the rejection of Rhine's data on Extra-Sensory Perception (cf. p. 180).

[50] Price's account is not the one which I would adopt. My preference would be for a theistic account of intercessory prayer as the aligning of our wills with what God already intends to do, should the requisite human cooperation be forthcoming. This avoids any accusation of unfairness on God's part, with his action appearing to depend on one's luck in having someone to intercede for one.

Rather, it would seem to me that it must lie in the experience of God as personal. To see why, I suggest that we look at two types of experience in particular, the experience of God in personal relationship and the experience of God as personal presence. In each of these cases the model that has so far been used of the fulfilment of certain conditions leading to 'impersonal' spiritual perceptions will be found to prove totally inadequate.

(i) In the case of the former, when considering the redundancy argument we noted the way in which a deist like Wiles seemed unjustified in talking of a personal relationship in view of the absence of reciprocity that is such an essential feature of relations between persons. That is to say, at most he could claim that the human person developed in his relation to the divine as he perceived more clearly the signs that the latter had left there of himself from all eternity. But there could be no specific response to that particular individual and his needs as a person without violating the canons of non-intervention. That being so, to describe the relation as 'personal' would seem a complete misuse of language. The nearest human analogue to the relation is that of a research student investigating a dead historical figure or an immigrant gradually deducing from what the locals say and do the status and nature of the Head of State. Notice that in both cases they would be compelled to deny that they knew the individual in question personally.

Admittedly, the claim to such a relationship is made frequently in religion, and is by no means confined to situations where the degree of interaction is of a kind that would demand intervention as an explanation. But all this surely shows is that the term is widely misused in the religious context, so natural is the temptation in religion to exaggerate one's own position vis-à-vis God. Yet, undoubtedly, there have been individuals whose life stories are such that, if true, they can only be characterised as personal relationships of the type desiderated. That being so, deism can only explain them away, not explain them. Pre-eminent among such would be those that are most naturally described as 'revelatory'. For there comes a point at which spiritual perceptions become so specific that our earlier suggestion of them being guaranteed by the appropriate spiritual conditions no longer remains plausible. The specificity I have in mind is of two kinds: first where the individual experiences a relationship of detailed guidance and direction, and secondly where his insights into the nature and will of God, though of general application, are none the less too specific to be plausibly attributable to the fulfilment of spiritual conditions. By the latter I should be taken to be referring to such alleged insights as human survival of death or the demand for limitless forgiveness. As the following chapter will reveal, I do not think that such privileged access is by any means as common or straightforward a phenomenon as theists often suppose. But without it the deist is able to explain neither the special status of such

'insights', particularly those of Christ, nor the conviction that they stemmed from the closeness of his relationship to God. The same applies to individuals' experiences of specific guidance. Often this amounts to no more than the occasional conviction arising that this is what I must do, and in such cases it would be hazardous to suggest that the conviction must have arisen from the intimacy of a personal relationship. Indeed, the individual himself will normally be prepared to admit that he is offering an interpretation of his experience, rather than the only possible way in which it can be seen because the only way in which it presented itself to him. However, this latter type of case does undoubtedly exist, where the guidance is detailed and the conviction of its source so certain that the possibility of its being an interpretative overlay would be rejected out of hand by the individual as not being a viable option. Examples might be taken from the prophets or the lives of some of the saints, for example, the Curé D'Ars.[51] It does not, of course, follow from the fact that some individuals have seen their experience in this way that it must be so interpreted. All I am pointing out at this stage is that deism cannot offer an account that preserves the integrity of such experiences. It can only explain them away, in the sense of reducing them to a level of contact with God that the individual concerned could not possibly accept.

(ii) Much the same applies to the other type of experience mentioned, the experience of personal presence. Here I do not have in mind experiences such as the general conviction of God's upholding care or the experience of the numinous, sparked off, say, by awe at God's creation; for experiences such as these can be accommodated within the notion of spiritual conditions. Rather, attention is being drawn to mystical experiences of union. The point is that the individual experiences himself as being caught up into direct relation with God, and this is a claim that can only be sustained within a theistic framework. For, if non-interventionism is accepted, then presumably at most what is happening is that God has so ordained that the effects as of his presence are experienced, not He himself, since that would involve him being available, however temporally, within the natural order. The only alternative description which would preserve the directness and intimacy of the experience would be to think of the individual concerned being pulled out of the natural order into God's timelessness, but, whichever is adopted, the one is just as much interventionist as the other. Deism once again thus cannot preserve the way in which the individual would naturally describe his experience, and accounts like those of St. John of the Cross or Meister Eckhart must be completely reinterpreted into

[51] The life of St. John Vianney is well told by L.C. Sheppard in *The Curé D'Ars* (Burns & Oates, 1958). The official biography (F. Trochu, *The Curé D'Ars*, Tan Books, Rockford, Illinois, 1977), though more useful for documents, is too credulous.

something more indirect, something in complete conflict with the way in which the experience presented itself to them.

My conclusion then, so far as the conceptual argument is concerned, is that not only is it not necessary for theism to be committed to endless interventions within the natural order, as deism claims, but also it alone of the two is able satisfactorily to account for those experiences of relation or presence that are pre-eminently characterisable as 'personal'. In its earlier version, deism took particular exception to intervention on the grounds that it was derogatory to God's dignity; theism suggested, the deists claimed, the need for corrections to his ordering of the universe, and also impugned his majesty by requiring his pre-occupation with what seem trivial matters; Voltaire, for instance, makes such points in his *Traité de métaphysique*. One suspects that such sentiments are also not far distant from the thoughts of modern deists, but, however that may be, the irony is that, if my argument is correct, there is no doubt that God's dignity is better preserved on theism than on deism. For, what greater dignity can an individual have than to be acknowledged as personal, and, as we have seen, such interventions as are necessary within the theistic framework are motivated by a heightening of this sense of God as personal.

The evidential argument

This is in many ways the most important of the three arguments which we have undertaken to consider. For many deists claim not merely that there is no evidence for an interventionist God, but that on a priori grounds we know that there could be no such evidence. If this stronger claim were substantiated, obviously the role of the argument would become absolutely decisive. Similarly, for the theist it must play the decisive role since the fact that, as our examination of the two previous arguments has shown, certain claims would have to be abandoned if deism is true, does nothing to show that grounds are likely to be forthcoming for continuing to persevere in such claims, unless evidence for an interventionist God can be provided.

Given such a situation, then, what I propose doing is first to take the stronger version of the deist claim, that no evidence *could* be forthcoming, and argue against this. Thereafter, I shall examine the possibility of such evidence existing, and endeavour in the process to show that the existence of such evidence is not only crucial for an adequate defence of theism, but crucial also to the claim whether God exists at all. Thus, once again it will be my contention that not only is the deist argument not true but a counter-argument of a kind similar to that used in the deist attack can itself be brought against deism to show that it is in fact the weaker position of the two.

I begin then by looking at the stronger version of the deist claim. This

standardly takes the form of an appeal to the alleged facts of cultural relativism. It is claimed that in order to justify belief in an interventionist God it would be necessary to appeal to evidence drawn from cultures very different from our own, and such 'evidence' can have no secure place in our culture, since our cultural assumptions just are so different and in any case no perspective that transcends particular cultures is possible. It is an argument that is well represented by Nineham in *The Use and Abuse of the Bible*. Following Troeltsch, 'who, though until recently so grievously neglected, yet perhaps more than any other single man has made this subject his own, at any rate in its bearing on religion',[52] he speaks of cultural 'totalities', and draws attention to the radical difference between our cultural assumptions and those of the first century, in particular drawing attention to the fact that, as C.G. Darwin has put it, 'London in 1750 was far more like Rome in A.D. 100 than like either London or Rome in 1950'.[53] He notes our very different attitude to history, with accuracy replacing edification of the sort desired by Bolingbroke in the eighteenth century with his description of history as 'philosophy teaching by examples', or as evinced in Troeltsch's accusation that Schleiermacher viewed 'history as a picture book of ethics'. Again, on the subject of miracles he points out that the Biblical understanding of miracles was in fact quite different from ours in that they were seen as 'signs' and 'wonders' rather than violations of natural law. It was a world where uniformity of nature was not expected, and so miracles were much easier to believe in then than now. Indeed, because of the different cultural assumptions they made a very different kind of demand from what belief in them would do today.

From reflections such as these Nineham then goes on to draw various conclusions about one place in particular from which the theist might draw his evidence, namely the Bible. On the Old Testament he remarks that it 'belonged to, and was conditioned by a particular cultural totality. It cannot *be* the truth of God or the will of God for any other totality, however much it may help other totalities to see the will of God for them. We may be enlightened by it; we cannot be bound by it.'[54] The New Testament receives similar treatment. Nineham quotes with approval Schweitzer's comment that 'the historical Jesus will be to our time a stranger and an enigma' and then continues: 'The point is clear: both the Jesuses of the New Testament and all the Jesuses of subsequent ecclesiastical totalities are equally, though in very different ways, strangers or enigmas to our time. And the Jesus of history, you notice, is – surely rightly – not excluded from the judgment.'[55]

[52] Op. cit., p. 60.
[53] Ibid.; quoted on p. 55.
[54] Ibid., pp. 137-8.
[55] Ibid., p. 110.

The first observation that must be made about this argument is the undoubted element of truth which it contains. Nineham's comment on the socialising process seems basically correct: 'When we speak of people "interiorising" the society in which they are born, the word carries very profound connotations. It is not just that they take note of the institutions which make up their society, or even that they take them for granted and gradually discover how they work. They define their own identity and significance in terms of their relation to these institutions.'[56] It is a phenomenon of which the theist must on my view take much more cognizance than he does in general at present, especially as it is something which affects our analysis of a number of different areas. I shall briefly mention three. First, in the next chapter we shall find ourselves forced to admit that the Bible is very heavily a social product, large tracts of which are without religious significance to us today. A relatively trivial example of this would be the necessity of endorsing Nineham's own rejection of the Biblical causal explanation of the Babylonian Captivity, it being seen as a divine punishment for the idolatry of previous centuries. Secondly, there is undoubtedly a strong degree of social conditioning in the various forms religious experience takes. An example, to an examination of which I return later in the chapter, is the remarkable contrast between the experience of the saints in Western and Eastern Christendom; in the West the summit of their experience is commonly seen as the receiving of the Stigmata, whereas in the East it is conceived of in terms of being bathed in light, the difference being due to the different doctrinal traditions, with the West emphasising the Crucifixion and the East the Transfiguration. Finally, with respect to the attitudes and experiences of ordinary Christians, it is exceedingly difficult to read the Bible free from one's presuppositions, or even to persuade one's fellow Christians to read it with the possibility in mind that another religious tradition may have as much justification for its positions in the Bible as they have. Indeed, one is even tempted to speak of ghettoes of the Chistian consciousness in the sense that so often Christians seem trapped in their own particular tradition's framework of thought (cf. Ghettoes as ethnic areas) that they are unable to see their experience except by reference to that framework of thought. But, even with all this conceded, this is still a long way from Nineham's position. The difference can be expressed by saying that what I have conceded is social conditioning rather than social determination. That is to say, it has to be conceded that one's culture plays a decisive part, but its role is not dictatorial. Contrary to Nineham's view, one is not a prisoner of one's own culture. To justify this contention, I offer five considerations.

(1) First, Nineham's position only seems plausible for so long as one confuses different senses of 'verstehen' or 'understand', a term

<hr>

[56] Ibid., p. 11.

introduced at an early stage of his argument. On the following page, he comments: 'The present writer ... can remember being expected when he was an undergraduate studying philosophy at Oxford to discuss and evaluate the ideas of such thinkers as Descartes and Hobbes with only the most tenuous guidance as to their relation to the thought and conditions of the time.'[57] This remark is entirely apposite, if it is intended as a criticism that no guidance was offered in explaining why certain arguments and issues interested Descartes and Hobbes rather than others, but it will not do if it is supposed that those arguments, *qua* their logical standing, can only be evaluated in relation to the thought and conditions of their time, except, of course, in the limited sense that one must know how the various terms of the argument were being used then. That it is the latter, less reputable sense that is in question seems to be suggested by the fact that he seems willing to lend some support to Troeltsch's comment that 'even the validity of science and logic seems to exhibit, under different skies and upon different soil, strong individual differences present even in their deepest and innermost rudiments'.[58] I doubt whether any philosopher, Anglo-Saxon or continental, would agree here, except in the former of the two senses distinguished earlier.

(ii) Secondly, his use of the phrase, borrowed from Troeltsch, cultural 'totalities', inevitably tends to lend verbal support to his argument by suggesting discrete, monolithic structures. But even the most closed societies have had some variety of alternative interpretations inherent within them. Thus, for example, Nineham mentions how a diabetic or epileptic fit might have been treated at different periods of history, but does not record how alternative accounts may have been available at the same time. So, with respect to first century Palestine, he only mentions possession by a devil as a possibility, but other ideas were surely also current, e.g. punishment for sin or for the sin of one's ancestors or natural causes, as in Greek medicine. Similarly, with respect to the Resurrection, this was not the only way of interpreting the continuing influence of a dead person on one's life. Such relative openness is an important fact to note, because it shows that societies have inherent in themselves their own critique, and it is not the case that one culture has thus to replace entirely the thought-forms of a previous culture. It is a pity that Nineham has not taken more seriously his own passing recognition of the fact that 'Troeltsch would have been the first to admit that from one point of view totalities are abstractions from a continuous connexion of becoming which is the very stuff of life in history'.[59] Had he borne this in mind, he might have avoided committing himself to a comment like the following on the quest for the historical

[57] Ibid., p. 17.
[58] Ibid.; quoted on p. 112.
[59] Ibid., p. 100.

Jesus: 'The whole attempt has been to portray a Jesus intelligible and attractive to us, and any Jesus who would be likely to appear immediately attractive to most people in the modern West would have been unlikely to attract first century peasants and fishermen in Galilee, and vice versa.'[60] But this seems plainly false. There are of course differences – that I have already conceded – but surely there are at least some clear continuing common elements of attraction, e.g. the interest in, and concern for, others, the sense of leadership or the ability to heighten one's moral perceptions.

(iii) Thirdly, not only can factual points be made about the openness of totalities, like those above, but also it is possible to raise a purely logical objection to the way Nineham expresses himself. This is what John Barton does, when he argues that 'Nineham's argument appears to contain an unresolved paradox. No one can escape from his cultural background; yet, if this is so, cultural change cannot occur, which is obviously false.'[61] In other words, it is a logical necessity that totalities be open to some degree, if change is to be explicable at all.[62] Thus, whether one looks at the matter from the point of view of logic or any actual historical situation, the same conclusion emerges, that isolated self-contained 'cultural totalities' neither do nor can exist.

(iv) Fourthly, Nineham never once raises the question whether some of the cultural assumptions of our own particular totality might not be wrong. Yet this would seem a particularly important question in view of twentieth-century scepticism about religion. The explanation might be, of course, as Nineham suggests, that religion, as traditionally understood, belongs to a no longer tenable totality. But there is an alternative explanation. This is that twentieth-century man does not avail himself in general of the opportunity of exposing himself to the types of experience which produced the traditional faith, that, in short, twentieth-century man's experience of the distance of God has nothing to do with difference in cultural totalities, but in difference of prayer life and openness to God. The bustle of modern life might thus constitute a more adequate explanation than any difference in thought-forms, great though these be. It is against such a background that one must see his endorsement of Leslie Dewart's comment that 'the Christian theism of the future might so conceive God as to find it possible to look back with amusement on the day when it was thought particularly appropriate that the believer should bend his knee in order to worship God'.[63] For, may it

[60] Ibid., p. 189.

[61] J. Barton, 'Reflections on cultural relativism: II', p. 196 in *Theology*, 1979.

[62] As an argument it is not in fact entirely conclusive. For it is possible to claim that cultural change could occur other than through an individual's escaping his totality, as a consequence of purely external conditions such as rapid technological advances or wars. But whether this could produce a different cultural totality is unclear. Would not the same attitudes simply be adapted to the new circumstances, unless the capacity of the individual to step outside his culture is assumed?

[63] Op. cit.; quoted on p. 203.

not be possible that such reticence over worship is again nothing to do with cultural differences *per se* but rather the exclusion of much of modern society by its own choice from exposure to precisely those experiences that demand this type of worship?

Perhaps the point can be made more clearly by contrasting the positions of Bonhoeffer and the 'death of God' school of theology. The latter firmly believe that our culture is such that certain perspectives are now firmly foreclosed to us, and so only a radical demythologising, including removal of the concept of God, can salvage anything of Christianity for our times. Thus, Altizer declares: 'God has died in *our* time, in *our* history, in *our* existence',[64] while Hamilton expresses it less dramatically by saying that for the modern Christian there is not 'the absence of the experience of God, but the experience of the absence of God'.[65] On first reflection it might be thought that Bonhoeffer's position was identical to this, especially with his famous phrase about 'the world come of age'. But there is an important difference. Undoubtedly, Bonhoeffer says such things as: 'Men as they are simply cannot be religious anymore', or again: 'The truth is, we've given up worshipping everything, even idols. In fact we're absolute nihilists.'[66] Undoubtedly, too, this appears to suggest a pessimistic acceptance of the thought-forms of the present cultural totality in which we find ourselves. But there is another side to Bonhoeffer, his emphasis on the secret discipline, the 'Arkandisziplin' or 'disciplina arcani', the need to preserve the essence of Christianity until the possibility of a reasonable translation becomes a reality, 'reasonable' in the sense of the essence being preserved. The result is that, though on the one hand he is very radical indeed in suggesting that everything will require reinterpretation, including the concept of God, on the other hand even the miraculous element in the Gospel, particularly the Resurrection, is to be preserved until an appropriate translation can be found, so inextricably bound up is the notion with the Christian conception of God. In other words, Bonhoeffer, while acknowledging the enormous force of cultural conditioning, does not endorse the cultural determinism of Nineham and the death of God school, but rather envisages the Church preserving its deposit of faith until a more favourable cultural setting presents itself. This surely represents a more realistic, because more open-minded, perspective on one's own culture; there ought to be no automatic endorsement of any particular cultural totality.

(v) Finally, there is the point made by several Biblical scholars that in several respects the Bible is in fact closer culturally to us now than it

[64] Quoted without page reference in W. Nicholls, *Systematic and Philosophical Theology* (Pelican Guide to Modern Theology, Penguin, Harmondsworth, 1969) p. 336.

[65] W. Hamilton, 'The Death of God theologies', in T. Altizer & W. Hamilton (ed.), *Radical Theology and the Death of God* (Penguin, Harmondsworth, 1968).

[66] D. Bonhoeffer, *Letters and Papers from Prison* (English ed., S.C.M., London, 1953). The quotations are from the letters of the 30 April 1944 (p. 122) and 27 June 1944 (p. 153).

has been for several centuries. A.E. Harvey[67] in particular has drawn attention to four ways in which this is so. First, there is a renewed interest in apocalyptic, since there is now a very real sense in which our world may soon end, i.e. through some nuclear catastrophe. Secondly, the Biblical emphasis on man being a bodily entity rather than being constituted by his soul has found a new appreciation in modern understandings of the relation between mind and body. Thirdly, at present there is widespread interest in the notion of charismatic leadership, with everyone from J.F. Kennedy to Charles Manson being considered as potential candidates, and, of course, the Old Testament has much to say on the notion of charismatic leadership, e.g. the Book of Judges. Finally, whereas the medieval mind was primarily interested in the general or universal i.e. in establishing universal truths about man, about history, etc., the modern and Biblical mind share a far greater common interest in the particular, in what is unique to each individual.

Sufficient has now been said to justify rejection of the strong deist claim that no evidence could be forthcoming for an interventionist God because of the closed nature of cultural totalities. We are neither committed to the dominant world view in our own particular culture nor prohibited from exploring alternative perspectives presented by previous cultures. The question of evidence remains a completely open question. What, therefore, I intend to do now is examine the nature of this evidence. In the course of our examination we shall find ourselves forced to admit some limited truth in the thesis of cultural determinism, a weaker version already labelled as cultural conditioning. However, despite this concession, it is my contention that what follows is a type of argument which may legitimately be used to justify belief in an interventionist God; not only that, but without such an argument no rationally justified belief in God is possible. In other words, it will be my claim that one has either to accept an interventionist God or abandon rational justification of belief in God, a fact which, if true, would tell seriously to the comparative disadvantage of deism.

It should be noted that I am adopting a distinction that is sometimes drawn between the 'rational' and the 'reasonable'. By the former is meant a belief that is justified by the balance of reasons pointing in one direction rather than another; by the latter a belief for which there are reasons that can be validly endorsed as offering some grounds but which never amount to more (at most) equality with the degree of evidence pointing the other way. That said, the deist may breathe a sigh of relief, seeing in 'reasonable belief' all he desires. But such relief would be premature. For, first, even with reasons approaching equality, while it might then be reasonable to believe in God, it would still not be reasonable to risk all on the basis of that belief, and so anything like the

[67] In comments made orally in my presence.

traditional notion of faith as absolute commitment would be ruled out as irrational. Rather, what would be indicated would be playing one's cards carefully, an approach surely far removed from that of traditional religion. But, secondly and more important, it is far from clear that a position of equality is reached in the absence of the argument we are about to discuss, the argument from religious experience. This is because it is not the case that the other arguments merely point to evidence that can be interpreted equally well in either direction, as, for instance, in the argument from design. There is also a strong argument against belief in God, the existence of evil, in response to which the absence of any necessary incompatibility can be demonstrated. But positively to counteract its force, something rather more is surely required, some reason for believing that God cares what happens to particular individuals, and such evidence is only likely to be forthcoming from religious experience.

With my last statement some deists might well agree. Where they would differ would be in insisting that religious experience does not necessitate an interventionist framework. Indeed, they might draw attention to the fact that I have already conceded earlier in the chapter that this is not always so. But at the same time the previous section stressed that for certain types of religious experience such a famework is essential, and what I shall argue here is in fact that the argument from religious experience is only effective when appeal is made to the type of experiences for which such a framework is essential. Why this is so will emerge in due course. However, we shall examine the argument in rather more detail than is necessary to make this point because various distinctions can usefully be made here that will be crucially relevant in the next two chapters.

But first the wider setting of the argument must be made clear. Before Hume and Kant the general position was that it was thought that conclusive, deductive proofs of God's existence could be provided, e.g. Aquinas' Five Ways. The three most popular were the cosmological, the teleological and the ontological, though this last was rejected by Aquinas. But all these arguments were decisively undermined by Hume and Kant in the eighteenth century, who are important not only for their objections but also because they established a general framework that seemed inimical to the possibililty of knowledge of a transcendent being, Hume through his extreme empiricism and Kant, despite his rationalism, through his casting doubt on whether we could ever have knowledge beyond our phenomenological experience, of things-in-themselves. However, among philosophers of religion sympathetic to the role of reason in religion, the attempt has been made recently to present the arguments in a more empirical way. This has been characterised by a move away from a deductive understanding of the arguments to an inductive, producing a claim that this is where the

balance of evidence points. The approach can be seen in Basil Mitchell's *The Justification of Religious Belief* with his view that a 'cumulative' case for theism can be offered, using all available arguments, similar to what goes on in critical exegesis of literature or the arguments of historians. Thus he endorses Newman's talk in *The Grammar of Assent* of 'the cumulation of probabilities', as also W.H. Walsh's view that 'if the reasons to which metaphysicians appeal do not, as they themselves suppose, necessitate, they nevertheless incline'.[68]

Mitchell was concerned simply to demonstrate the feasibility of such an approach by drawing parallels with other areas. Richard Swinburne has carried the process a stage further by actually producing such a cumulative argument in *The Existence of God* (1979). He uses much technical apparatus from confirmation theory, but from our point of view the important element in his presentation is the fact that, though the cosmological and teleological arguments are presented in a new rigorous way, his case relies heavily on the argument from religious experience. Indeed, his view is that it is only with this argument that one moves from 'quite likely' to 'probable': 'On our total evidence theism is more probable than not ... The experience of so many men in their moments of religious vision corroborates what nature and history show to be quite likely – that there is a God who made and sustains man and the universe.'[69] His presentation suggests that he would not regard the question of whether intervention is presupposed or not as of much significance. Indeed, at one point he writes: 'If there is a God, he is omnipresent and all causal processes only operate because he sustains them. Hence any causal processes at all which bring about my experience will have God among their causes ... And so if there is a God, any experience which seems to be of God, will be genuine – will be of God.'[70] This is a very odd argument. There is, of course, a sense in which this is true, just as there is a sense in which it is true that God is the cause of all evil. But, just as the latter is a matter of permission rather than will, so may the same be true of some 'religious' experiences. This is not to argue against all natural causation, but it is to suggest that not all forms are compatible with the claim that religious experience is veridical. For instance, one way of defeating the claim would be to show that the psychological laws are of such a kind that they indicate a sub-conscious escapist motivation at work.

In order then to demonstrate the key role that interventionist assumptions must play, I now proceed to a presentation and examination of the argument. However, a rather different version is given to that offered by Swinburne. There are two reasons for this. First, while I agree

[68] B. Mitchell, *The Justification of Religious Belief* (Macmillan, 1973). Walsh is quoted on p. 87.
[69] R. Swinburne, *The Existence of God* (Oxford University Press, 1979), p. 291.
[70] Ibid., p. 270.

that the argument is of considerable force, Swinburne exaggerates this force. He does so on the basis of his Principle of Credulity according to which with perceptual claims 'initial credulity is the only attitude a rational man can take'.[71] The result, as he sees it in its application to religious experience, is that 'the onus of proof is on the atheist; if he cannot make his case the claim of religious experience stands'.[72] For my part I fail to see why the Principle should apply to perceptual claims as complex as those of religious experience, especially as such experiences are not readily available to be 'had' by everyone, as with other perceptual claims. The onus of proof, therefore, seems to me to lie with the theist. But that does not mean that the argument necessarily therefore becomes weak. My second reason for pursuing a different presentation of the argument is that, though Swinburne's fivefold classification of religious experience is 'both exclusive and exhaustive',[73] it does not draw attention to the significantly different types of problems raised by different types of experience. This is perhaps indicated by the fact that Swinburne opens his discussion of his classification by saying that 'in due course I shall make similar points about all of them'.[74]

The form of argument which I propose is the following:

(1) Religious experience is a distinct type of experience.
(2) Whenever a type of experience occurs with which one is not personally acquainted, then the only rational course is to accept claims made on the basis of this experience, unless sufficient grounds can be adduced for doubting the coherence or intelligibility of such claims.
(3) Therefore, if cognitive claims are made on the basis of religious experience, the only rational course is to accept these claims – with the same proviso.
(4) But all those who have these experiences sincerely claim that they give knowledge of the existence of the divine.
(5) Therefore, the only rational course is to accept the existence of the divine – again, with the above proviso.
(6) But the proviso in (2) is met – there are no such sufficient grounds.
(7) Therefore, the divine exists.

A number of explanatory comments on the argument are necessary. (1) is important because an obvious means of preventing the argument from even getting off the ground would be to maintain that exactly the same experience is had by others who do not feel it necessary to give that same experience a religious interpretation. Success in establishing this will vary, as we shall see, depending on the sub-division of religious

[71] Ibid., p. 276.
[72] Ibid., p. 265.
[73] Ibid., pp. 249-53, esp. p. 252.
[74] Ibid., p. 249.

experience being appealed to. (2) and (3), while requiring believer and non-believer alike to check for alternative explanations, none the less insists that the only rational course for the non-believer who has not had such experiences is to accept their veridical character, unless the plausibility of an alternative explanation can be demonstrated. (2) insists that such a demand is by no means confined to the phenomenon of religious experience. A very different instance would be the acceptance by a blind man of the fact that the rest of us have a faculty of sight that gives us access to certain types of knowledge not available to him, e.g. the existence of colours. Certainly there is a difference in that the blind man might resort to predictive tests, but this does not destroy the analogy. For a reason can be given why predictive tests could not be used in this instance, and so why exclusive reliance must be placed on tests of coherence and the absence of alternative explanations. This is because religious experience claims to involve encounter with a personal reality and so falls foul of the unpredictability of personal action. In (4), (5) and (7) the rather vague term 'the divine' is used instead of God. This is to avoid prejudging the form of spiritual reality which religious experience claims as its object. Thus 'God' would normally be taken to refer to a distinct reality and so would prejudge the issue against, for example, monistic forms of experience.

Under (1) we have already noted one major difficulty. Is it really a distinct type of experience, or merely the same experience that can be had by a non-believer differently viewed? Under (6) account must be taken of two other major objections. These are: (a) the possibility that, though religious experience constitutes a distinct type of experience, it admits of a complete explanation in terms of psychological conditions that need make no reference to the divine, and (b) the degree of conflict that seems so noticeable between different people's accounts of their religious experience, especially when one compares descriptive claims across religious frontiers. However, as already mentioned, it seems to me that these objections are of varying power depending on the type of religious experience under consideration. That being so, I now proceed to identify four types of religious experience, and then consider the strength of the argument in each case, in particular noting how far its force will depend on an interventionist framework.

The four we may call thematic, numinous, sensory and mystical.[75] I do not wish to suggest that all religious experience fits neatly into one or other of these four categories. But most, I think, does. More important, they exhibit significant differences one from another. For thematic experiences it is difficult to find a satisfactory descriptive word. What I mean is the type of experience where the theme or interpretative

[75] The relationship between my classification and Swinburne's (p. 249ff.) is roughly as follows: thematic corresponds to his type (1), sensory to types (2) and (3), and mystical and numinous to his types (4) and (5), though differently divided.

framework is believed to have been set by the divine, but apart from that there are no unusual features. The theme could take a wide range of different forms, e.g. a conviction that a particular event is God's will, an assurance of peace, a call to a particular vocation, etc. By sensory experience I understand those which involve unusual sensory perceptions, irrespective of whether or not the object of such perceptions is conceived of as existing in the external world. The obvious marks of such experience will therefore be visions, dreams, auditions, stigmata, levitation, etc. With the mystical I have in mind instances where the primary import of the experience is a feeling of intimacy with the divine, whether this is taken to involve a union with the divine where distinctness is retained or total absorption. Finally, the numinous is intended to mark off those experiences where awe of the divine is the central feature and so which most naturally provide an incentive to worship.

(i) We begin our examination of the argument then with thematic experience. Here establishing a distinct group of experiences rather than the same experience as can be had by the non-believer differently viewed, is likely to prove an impossible task, at least so far as the whole range is concerned. This will be especially true of those experiences where the believer is prepared to admit that the same event would probably have happened even if God had not existed, e.g. a personal tragedy which is none the less seen as religiously significant. An extreme case would be someone who experiences the whole of life as religiously significant. With these types of experience John Hick's analysis of 'Religious Faith as Experiencing-as'[76] becomes highly plausible. This is not to say that the individual is wrong to interpret his experience in this way. It may be that God has so ordered the world that, given certain triggers, such an interpreted experience becomes possible. But the important point to note is that, precisely because one is compelled to acknowledge the legitimacy of a non-interventionist framework, the evidential value of such experiences reduces to nill. There is no way of choosing which interpretation is the legitimate one from within the experiences themselves.

However, this is not to say that all thematic experiences fall under this pattern. This is a mistake that might easily be made for so long as one thinks of this category as equivalent to 'ordinary' religious experience. But ordinary experience can be found within the other categories, except perhaps sensory experience, just as thematic experience will include rather unusual experiences. Thus, a feeling of awe before the divine or intimacy with it are by no means confined to the spectacular instances; on the latter one need only think of the intimacy, claimed by some believers, in the Eucharist or claims to experience Jesus as a friend.

[76] J. Hick, 'Religious faith as experiencing-as', pp. 20-35 in G.N.A. Vessey (ed.), *Talk of God* (Royal Institute of Philosophy Lectures, vol. 2, 1967-8, Macmillan, 1969).

Similarly, with thematic experience, it would be wrong to suppose that it never involves any major claims. The fact that any claim to inspiration must often come under this heading should give one pause for thought. It is thematic when perfectly normal writing or speaking (i.e. without a voice having been heard) is given the interpretative framework of it being done at divine instigation. One suspects that most scriptures come under this category. If this is so, then this sub-category might provide a basis from which the argument could proceed, using thematic experience. For one could certainly successfully isolate all such experiential claims, and plausibly argue that they involve a distinct type of experience. rather than the same experience differently viewed. For, while there are obviously related experiences of inspiration, e.g. in the writing of music, it would seem odd to describe it as essentially the same type of experience in the same way as, for example, an experience of peace might be when had by believer and non-believer. Nor does it seem plausible that a complete psychological explanation could be offered. Rather, the difficulty with such an argument is likely to come with the third type of objection I mentioned, the lack of consistency between the different reports made on the basis of such experience. This of course in effect amounts to a demand that one explain why one revelation be preferred as against another. It is a question to which we shall refer again later in this chapter and also in the next. For the moment suffice it to note that as an argument it will only succeed if an interventionist God is assumed. The explanation for this is quite simple. It is that no non-interventionist account is likely to be at all plausible except one which refuses to endorse the great amount that is standardly claimed to have been communicated. But then the problem will be that the amount salvaged is so small that it will then fall into the same pattern as other thematic experience, i.e. as being most naturally viewed as simply an alternative way of viewing the same experience. This is in effect conceded by Hick when he offers his analysis as an analysis of all religious experience.[77]

(ii) With sensory experience there is likely to be little difficulty in maintaining that it is a distinct type of experience. Admittedly, with things like levitation and telepathy there are plenty of instances of people allegedly having the experiences and not giving them a religious interpretation, but with the central cases of visions, auditions, etc., one does not find people claiming to have seen, e.g., the Virgin Mary, while at the same time denying the experience any objective reality. The appropriate place to look for relevant objections is thus with the other two difficulties, the question of psychological conditioning and apparent conflict between the claims made.

The problem of psychological conditioning is at its most acute here. Indeed, commonly it is thought to constitute a decisive objection. For

[77] So the Old and New Testaments are treated in this way, as is also the 'miraculous' (p. 31ff.).

example, Bertrand Russell remarks in *Religion and Science*, as though
the objection were fatal: 'Catholics but not Protestants may have visions
in which the Virgin appears; Christians and Mohammadens, but not
Buddhists, may have great truths revealed to them by the Archangel
Gabriel.'[78] MacIntyre takes a similar view in his article on visions.[79]
Swinburne notes a similar objection from Flew. He replies by pointing
out quite correctly that some experiences may be better authenticated
than others, and that even in the less authenticated case the subject need
not withdraw his claim entirely: 'He need only describe it in a less
committed way. e.g. claim to have been aware of some supernatural
being, not necessarily Dionysius (as originally claimed).'[80] However,
while he thus establishes the logical possibility of such a reconciliation,
he does nothing to show that it is in the least plausible. For that
considerably more investigation is required. Some preliminary remarks
towards such an empirical inquiry may be made here.

To begin with, it should be admitted that a much more powerful form
to the objection can be given than such critics realise because of their
unawareness of the lives of the saints in any detail. For, not only can one
contrast the apparently incompatible experiences of Krishna by Hindus
and of the Virgin Mary by Roman Catholics, as MacIntyre does, one can
also point to the following additional facts. Those who have sensory
religious experience often tend to be rather odd psychologically. For
example, St. Margaret Mary Alacoque (seventeenth century) scratched
the name of Jesus on her breast or, again, St. Terese of Lisieux
(nineteenth century) described the blood she brought up as 'a precious
gift from Jesus'. Secondly, their visions tend to take the shape and
appearance of previous normal experiences. For example, St. Bernadette
of Lourdes' vision closely resembled the statue of Our Lady in the local
church, as she herself admitted. Finally, what form the sensory
experience takes depends on the already existing pattern of experience
within a particular community not only for what is perceived but how it
is perceived. Thus on the whole Protestants, Jews and Mohammadans
hear voices while Catholics and Hindus see visions. There is also an
interesting contrast between Catholics and Eastern Orthodoxy to which
we have already alluded. Catholics like St. Francis and Padre Pio are
granted the stigmata, while Eastern Orthodox saints, such as St.
Seraphim of Sarov and Staretz Silouan are transfigured by light. The
obvious reason for the difference is that, whereas the crucifixion is at the
heart of Catholic spirituality, in the case of Orthodoxy it is the
Transfiguration because of its emphasis on the divinisation of man.

A natural temptation on the part of the believer at this point would be

[78] B. Russell, *Religion and Science* (Home University Library, n.d.), p. 180.
[79] A. MacIntyre, 'Visions', in A. Flew & A. MacIntyre (ed.), *New Essays in Philosophical Theology* (S.C.M., London, 1955), p. 260.
[80] Op. cit., pp. 265-6.

for him to dismiss such experiences as therefore without significance. But this would be an unwise move for two reasons. First, such conditioning may be more conspicuous with this type of experience, but any thorough investigation of the other types of religious experience would reveal exactly the same type of problem emerging there as well. We shall see this clearly when we examine thematic revelatory experience in the next chapter. There is thus no way out of facing the issue. But, secondly, the believer should recall that sensory religious experience lies right at the heart of the traditional presentation of the Christian faith. For the Resurrection, Pentecost and Paul's conversion experience are all naturally classifiable as sensory experiences. If someone objects that with the first two at least one is dealing with something in the external world rather than mere visions, etc., my reply would be that, even if this is so, there is still just as much a problem of cultural conditioning to be faced. Thus for a Jew being a person was so closely bound up with having a body (Sheol, the absence of the body, entailing the absence of personhood) that survival could have been envisaged in no other way than by resurrection of the body. Again, one has to reckon with the possibility of the prophecy of Joel (2:28) having at the very least conditioned an expectation of such an experience as Pentecost.

But in any case the conclusion that such experiences could not possibly be veridical does not follow from such facts as those we have mentioned. Here two points need to be underlined, an experiential one and a theological.

The experiential point is that such conditioning is in fact part of a much more general phenomenon. For it can easily be shown that all experience is a function of previous experience in the sense that it is interpreted in the light of it. This is true even of our personal relationships. That is to say, we explain our experience of people to ourselves in the light of what we have already experienced of human behaviour, and what form our experience of them takes is largely conditioned by the type of psychological make-up we have. Thus, to give a simple example, a warm-hearted person more often experiences similar reactions in others, whereas the cold evoke cold reactions. There are numerous psychological studies confirming this fact. So, to argue that, because psychology determines who has visions and what form they take, these visions cannot possibly be veridical, would be as silly as arguing that, because only warm-hearted people tend to experience warmth, the existence of the warm-hearted is only a figment of their imagination.

The psychological aspect of the objection, that is to say as distinct from the point about difference in content, is in fact only a substantial one if it could be shown that those who have sensory religious experiences are somehow all psychologiclly maladjusted, that their experiences are a symptom of mental illness parallel to the hallucinations to which the mentally ill are subject. Such an argument will not work. No doubt, some

who have been canonised have been mentally ill, but most of those whose sensory experience has been widely accepted within Christianity or one of the other major religions can easily be shown to pass tests of mental health as, for example, the obvious ones of internal peace and happiness. The saints themselves have normally realised the need for such tests. St. Teresa of Avila in *The Interior Castle*[81] distinguishes true voices from false voices by the sense of certitude, peace and interior joy which they produce. One must also acknowledge that there is a distinction between strange behaviour and madness. The words and actions of the two saints mentioned earlier, St. Margaret Mary Alocoque and St. Teresa of Lisieux, were certainly strange, but this is far from justifying us writing off their actions as indicative of madness.

But such points as these cannot of themselves establish an argument from sensory experience on a sound basis. What is also required is some kind of plausible theological explanation of the fact of such diversity of content as between the various sensory experiences. As this also affects revelatory thematic experience, it is worth preparing the ground here a little in anticipation of the next chapter.

At present three types of theological explanation are to be found among Christian theologians. At one extreme there is John Hick who argues in *God and the Universe of Faiths*[82] that all religions are equally valid approaches to God, while at the other there is Hendrik Kraemer who in *The Christian Message in a Non-Christian World*[83] takes a Barthian position and maintains that only one religious tradition has veridical experience, the rest being merely vain searchings. Finally, there is J.N. Farquhar's *The Crown of Hinduism* on the Protestant side and R. Panikkar's *The Unknown Christ of Hinduism*[84] on the Roman Catholic side, which maintain that genuine religious experience does exist in other religions but that their crown is to be found in Christianity.

The problem with the conservative position of Kraemer is that it is impossible to conceive of a plausible criterion which rules out altogether the sensory religious experience to be found in other religions. The difficulty with the liberal position of Hick is twofold: first, it fails to explain why the subjects of the experience should have supposed so much to have been communicated when Hick's position of equality allows so little, i.e. little more than the presence of God; secondly, it fails to explain why, when there is so much variation in quality of experience within a religion, there should not also be differences of quality as

[81] St. Theresa of Jesus (or Avila), *The Interior Castle* (English ed., Catholic Publishing Co., South Ascot, Berks., 1944): Sixth Mansion, p. 66ff.

[82] J. Hick, *God and the Universe of Faiths* (Fount Paperback, London, 1977).

[83] H. Kraemer, *The Christian Message in a Non-Christian World* (Edinburgh House Press and Harper, New York, 1938).

[84] J.N. Farquhar, *The Crown of Hinduism* (Oxford University Press, 1913; reprinted, New Delhi, 1971); R. Panikkar, *The Unknown Christ of Hinduism*[2] (Darton, Longman & Todd, London, 1981).

between the surviving world religions. However, the middle position of Farquhar and Pannikar is also not very plausible, since the palm seems too rapidly conceded to Christianity. The position I shall argue for in the next chapter is rather that the quality of religious experience in other religious traditions often exceeds that within Christianity, including the Bible, but that yet certain sensory experiences within Christianity must be seen as fundamental.

A proper assessment of such a position must await the next chapter. But some indication should perhaps be given here of the sort of account of divine action which is being assumed. I am assuming that God would not wish to leave himself without witnesses, but because he realises that the recipient's willingness to accept his sensory experience is a function of his past experience, he is willing to accommodate himself to descriptions in terms of those past experiences. To this it may be objected that such adaptation could only mislead and not instruct and so could not possibly be an activity of the Christian God. But the reply may be given that all religious experience, like all other experience, is fallible and so, while it might mislead in certain directions, e.g. in suggesting that God is but one god among many, in other directions it could well achieve more than if the sensory experience had not occurred.

Another objection that might be raised is that, if we adopt such a position, we are forced to conclude that we could never be justified in believing in the actual existence of the god, angel or other person whose form is presented to the visionary. They would all have to be treated as ways of God appearing to men. But this would only follow if all tests for the veridical character of the experience were to place all sensory experience on the same level. But, as the following chapter will try to demonstrate, tests are available not only for testing for the presence of a veridical experience but also for its relative priority vis-à-vis other such experiences. By such tests it might well turn out that one was justified in saying that it was Jesus or the Virgin Mary themselves who were present in certain experiences that involved visions of them.

Once again, it seems to me that deism would rob the argument of any possible credence it might gain as a result of further empirical investigation. The problem is simply that in order to offer a deist account so much of the experience has to be jettisoned that the gloom in which most of it is then put inevitably casts its dark shadow of doubt over what little remains according to the deist. With the next type of experience to which we turn, the numinous, there is no such great content, and it is here in fact that the deist has most hope of constructing a viable argument on the basis of religious experience.

(iii) It seems to me a great pity that experiences of awe and intimacy are seldom distinguished in the literature, but instead commonly lumped together under the one heading of 'mystical'. This is true even of Otto who in my view provides the best analysis of the experience of awe in his

The Idea of the Holy. For at one point he declares that 'what we have been analysing is a feature that recurs in all forms of mysticism everywhere, and is nothing but the "creature-consciousness" carried to the utmost.'[85] The problem may well stem from the use of his famous formula to describe the object of the experience.: *mysterium tremendum et fascinans*: For *mysterium* suggests mystery and so mysticism, but the term seems best reserved for experiences of intimacy where the claim is that the mystery is in some sense entered into rather than merely being confronted.

The central feature in the numinous experience of awe we have already noted. But this by itself will hardly establish the existence of a distinct type of experience, especially given the fact that most such experiences will have triggers of various kinds that will admit of alternative explanation in moral or aesthetic terms, e.g. Bach's Christmas Oratorio, Ulm Cathedral, a landscape, the 1662 Prayer Book, etc. One could add the presence of a heightened sense of objectivity, or what Otto calls 'the element of overpoweringness' and ineffability, acute difficulty in description – something that is only to be expected if the alleged experience is of something transcendent, whereas the uses of our language are learnt from recognisably empirical contexts. But even then one would not have sufficient criteria for marking off the experience as not simply an alternative way of viewing what others would regard as a moral or aesthetic experience. A comparison with Longinus' description of the sublime,[86] for example, would immediately reveal this to be so in respect of accounts of aesthetic experience.

Otto mentions other features such as feeling of fascination, a sense of guilt combined with an overwhelming feeling of release and purification from guilt, and a sense of one's own nothingness. A feeling of fascination cannot be a necessary condition because there is no reason in principle why a religious experience should not be demonic, thus exercising a strong feeling of repulsion on the person concerned. Again, there seems no reason why a sense of guilt should always be present. But it is hard to see whence the sense of awe was derived unless either there was such a feeling of guilt or a sense of one's own nothingness or contingency. So one might add to the features already mentioned that there should be a feeling of fascination or repulsion, and either or both of the two aspects just mentioned.

Anything approximating to the satisfaction of all five criteria in what is regarded as simply a moral or aesthetic experience is likely to be exceedingly rare. Indeed, an occasional exception might be taken as casting doubt on the moral or aesthetic interpretation rather than on

[85] R. Otto, *The Idea of the Holy*² (Oxford University Press, 1950), p. 22.

[86] Longinus, *On the Sublime*, esp. chs. 8 & 9 (ed. D.A. Russell, Oxford University Press, 1964).

other religious interpretations. But perhaps rather than casting doubt on either type of interpretation what such convergence may show is that at their extremes one type of experience merges into another, rather than that they are fundamentally the same. In any case one can certainly point to cases where no moral or aesthetic element seems involved. An example would be an individual in an ugly church who is none the less overcome by a feeling of the presence of prayer and so of his own contingency before God. His response could easily be one of worship but a worship that involves no sense of sin, simply a feeling of absolute dependence.

A case for regarding numinous experience as a distinct body of experience can thus be made out. Not only that, but the two other standard objections are easily dealt with. Thus, any attempt at a psychological reduction is unlikely to make much headway. There are no obviously contestable features of the kind we noted with respect to sensory experience. Likewise, there is no serious problem with apparent conflicts between the type of claims made on the basis of such experience. For by definition all numinous experience is non-sensory; so there will be no way of telling gods apart. Indeed, all that will be able to be said on that score is whether the experience was divine or demonic. This is not to say that this is all there will be to the experience. Other claims will also be made such as that one felt forgiven, or utterly dependent or an overwhelming presence of evil etc. But there seems no reason to suppose that it would be difficult to reconcile them. Thus, for example, the existence of both supernatural good and supernatural evil could be admitted, but the quantity of experiences of the former as against the latter be used to justify asserting the superiority of the good.

That such experiences will readily admit of a deist interpretation must be conceded. Nothing substantial in the content of the experience nor in its quality would be lost by such a concession. For the content is so much less than with other types of religious experience and its quality does not seem to be necessarily personal in the sense of relational in the way we identified when discussing the conceptual argument. It is thus possible without significant loss to conceive of God having so ordered causal laws that, just as aesthetic and moral experiences come after certain forms of training, so the possibility of such numinous experiences is guaranteed after the development of analogous innate spiritual faculties. However, while the possibility of an argument along deist lines must be conceded in this case (and in this case alone), it is doubtful whether one has in fact conceded very much. This is precisely because the content of such experiences is so small. For on the basis of an empirical investigation of such experiences the most one could claim is the mere existence of the divine. There would be no clear ground for asserting its unity in a single cause (we make no such inference in the analogous cases of moral and aesthetic experience); nor for asserting its essential goodness except in

the limited sense already noted, i.e. quantitatively. Not only that. The fact that the deist is compelled to describe other types of religious experience as consisting mainly in an overlay of unjustified belief must inevitably call into question whether there is not here too a similar overlay. The critic can easily contend that it is only the vagueness of the experience that enables it to escape such a critique. If so, the alleged content would be reduced still further. So, my conclusion is that, while a deist argument can be constructed on the basis of numinous experience, its yield would be so small as to make it doubtful whether the argument could meaningfully be described as an argument for the existence of God.

(iv) We are left now with mystical experience. That religious mysticism is a distinct type of experience has been challenged by Marghanita Laski in her book *Ecstasy*. She attempts to assimilate religious mysticism to ecstasy in general, and on those grounds argues that religious mysticism is simply an ecstatic experience given a religious interpretation as a result of what she calls 'overbelief'. But there are a number of reasons for challenging her account.

First, she is equating experiences which we all have with those very few of us have and then only after a long process of askesis. Of course, both types might be sufficiently alike to have the same explanation, but, if so, one wants one's attention drawn to more than superficial resemblances and also some explanation provided of why the preparation which is thought so important in religious mysticism in fact makes no difference. That there is some similarity of language certainly cannot be denied, but then the language employed by the mystics to describe their experience had to come from somewhere. Her emphasis on a shared momentary character only holds for so long as she denies that what she calls religious ecstasy is characteristic and at the heart of all religious mystical experience.[87] For religious mystical experience is often prolonged, and not at all transitory, as is the case with ecstasy.[88]

Laski's view is accepted by Horne who in *Beyond Mysticism* argues that religious mysticism is not always preceded by practices of self-discipline. He refers to such experiences as 'spontaneous introvertive mystical experiences'.[89] Further support might be thought to come from my earlier reference to the ordinary believer's experience of intimacy. But it is doubtful whether such experiences, though analogous, should be treated as of fundamentally the same kind as those experienced by the mystics. For there would seem to be a major difference between claiming

[87] M. Laski, *Ecstasy: A Study of Some Secular and Religious Experiences* (Cresset Press, London, 1961); cf. p. 6.

[88] For instance, St. Catherine of Siena had one which lasted for four hours, her so-called 'mystical death' in August, 1370. The story is told in A. Curtayne, *Saint Catherine of Siena* (Augustine Publishing Co., Devon, England, 1981), pp. 44-5.

[89] J. Horne, *Beyond Mysticism* (Canadian Corporation for Studies in Religion, 1978, S.R. Supplements 6), pp. 24-5.

closeness of relationship and union, the latter of which seems only to come after askesis. As for nature mysticism, while it can certainly be, and indeed usually is, instantaneous, again there is an important difference. For this time while there is no doubt that a union is involved, a feeling of being at one with nature, it is an identity with everything else on the same plane of existence, not a feeling that one has been caught up into a higher plane (as with monistic and theistic experience) from which everything else is then viewed as subordinate to the perspective now gained. In short, my view would be that, while some mystical experiences that have been given a religious interpretation can be assimilated to ordinary experiences of ecstasy, this is not true of the experiences that have been claimed by those who have been standardly identified as 'mystics'. There is just too major a shift in the perception of reality involved and too much difference in the conditions that make such perceptions possible for it to be defensible to deny that a distinct type of experience is in question.

Nor is Laski's attempt at a psychological reduction plausible. She argues that the content of such experiences is entirely explicable in terms of a co-ordinating of previous patterns of thought without fresh input. This may be true, but her way of trying to establish this is a complete failure. For she argues for this not by consideration of mystical experience but on the basis of non-mystical conversion experiences, namely those of Augustine and Wesley.[90] But from the fact that some conversions may have a wish-fulfilment element about them, it by no means follows that all religious experience is of the wish-fulfilment type. The argument is as bad as arguing from the fact that the Cure d'Ars and Catherine of Siena fought with unpleasant devils to the view that all religious experience is the exact opposite of a wish-fulfilment, namely a Freudian death-wish.

Staal's means of attempting a psychological explanation is also a failure. In *Exploring Mysticism* he tries to make something of the fact that mystical experiences can be induced by drugs.[91] But, first, drugs might well open up the unconscious and enable a person to have a genuine experience which he might not otherwise have had. Secondly, it is in any case impossible to distinguish on that basis what would count as genuine and what not, since it is possible to induce any experience whatsoever under drugs.

On the question of apparently conflicting content, Staal draws our attention to the fact that two great religions of the world, Theravada Buddhism and Jainism, have already accepted an atheistic interpretation, despite being themselves replete with mysticism. Indeed, he suggests that 'the prevalent belief that mystical experiences (or at

90 Op. cit., pp. 319ff.
91 F. Staal, *Exploring Mysticism* (Penguin, Harmondsworth, 1975); cf. p. 158.

least the "real" ones) are divinely inspired, is very similar to the age-old belief, that dreams are divinely inspired ... With regard to mysticism, there are precisely two prevalent views, the scientific view and the religious view. But since we have successfully abandoned "the religious hypothesis" with regard to dreams, it stands to reason that we have to do the same with regard to mystical experiences.'[92]

A defence of overall coherence in the content of mystical experiences might seem an impossible task, given such different descriptions ranging from those in terms of a Buddhist nirvana and negation of the external world to pantheistic descriptions, and from theistic accounts to monistic. Such a task has, however, been attempted by Zaehner in *Mysticism, Sacred and Profane*. Thus, pantheistic experiences are assigned to what he describes as a restoration of Adamic consciousness,[93] Buddhist nirvana type experiences to a mere stage on the way to true mysticism, the necessary preliminary stage of purgation of the soul,[94] while the conflict between theistic and monistic interpretations is adjudicated in terms of moral criteria with the victory going to the theistic account.[95]

For this type of approach he has been severely criticised. Staal remarks: 'Zaehner's approach has nothing to contribute to the serious study of mysticism. It does not establish a position from which one can do more than scratch the surface of Hindu and Muslim forms of mysticism.'[96] However, Laski agrees with Zaehner at least to the extent of assigning her equivalent of the Theravada Buddhist experiences, what she calls 'withdrawal' experiences, to a lower rung.[97] In fact, the contention does seem a plausible one that they are merely a necessary preliminary to other mystical experiences, especially as they contrast with them, as again Laski admits, in respect of the fact that withdrawal ecstasy can be voluntarily induced but this is not so with the other types of experience.

Where she differs from Zaehner is in arguing that pantheistic, monistic, theistic and non-religious mystical experiences (such as those of Proust in *Swann's Way*) are all essentially the same type of experience, what she calls an 'intensity' experience, merely differently interpreted. But we have already given reasons for challenging the placing of pantheistic experience in the same category as monistic and theistic experiences. For the former unlike the latter can easily be had by us all and require no prior preparation. Also, they do not involve the feeling of being caught up into a higher perspective from which everything else is

[92] Ibid., pp. 183-4.
[93] R.C. Zaehner, *Mysticism Sacred and Profane* (Oxford University Press, 1957), pp. 200-1.
[94] Ibid.; cf. p. 168.
[95] Ibid.; cf. p. 193.
[96] Op. cit., p. 75.
[97] Op. cit.; cf. p. 369.

viewed. Proust's account of his experience shares these features with pantheism, and in fact non-religious mysticism would seem best classified as either closely analogous to, or even perhaps identical with, pantheistic experiences. Indeed, both could easily be explained in evolutionary terms, that there is a natural affinity with one's environment which at times can become particularly intense, leading to a feeling of identification with it.

However, Zaehner's understanding of monistic experience in terms of a regression to withdrawal mysticism will not do.[98] For an examination of the relevant texts clearly shows it to be affirmative of a relationship that has gone far beyond mere purgation of the self. Henle in an interesting article[99] points out how, given a primitive language, one might easily find oneself with no alternative but to express oneself in contradictory terms as the only means available of expressing what one wants to say. It would seem a legitimate development of his point to suggest that this offers a not implausible explanation of why we have such apparently conflicting claims with monistic and theistic interpretations of the highest forms of mysticism.

For in describing an intimate relation between the soul and God it is not clear that one is necessarily saying different things by using the rather different metaphors of the soul living in God and God living in the soul and the suggestion that God is the soul and the soul God ('tat tvam asi'). Staal uses the fact that monistic and theistic accounts cross religious frontiers to argue against Zaehner.[100] But the fact that the accounts seem thus to defy the obvious restraints of cultural conditioning surely suggests not just that Zaehner is wrong, but that it is the same experience that these mystics are trying to describe, however haltingly. Thus, it seems to me that, despite the difference in description, one is not necessarily committed to the view that one form of experience, *qua* experience as distinct from description, is necessarily more genuine or higher than the other. So, the presence of monistic mystics like Meister Eckhart and Al Hallaj in theistic religions like Christianity and Islam, and the presence of monism with Sankara and theism with Ramanuja in Hinduism, cannot be used to undermine the veridical character of such experiences, but rather points to the alternative explanation which I have suggested.

Both Masignon and Maréchal have attempted to defend one Sufi mystic who has traditionally been labelled a monist, namely Al Hallaj. Thus, Maréchal defends his famous monistic claim, 'I am the Truth', in the following terms: 'Was it the sacriligious boldness of the impious, who stretches out his hand to the holy Ark to steal the hidden treasures, or the

[98] Op. cit.; cf. p. 193.
[99] 'Mysticism and semantics', in *Philosophy & Phenomenological Research*, 1948-9, pp. 416-22.
[100] Op. cit.; cf. p. 73.

heroic sincerity of the seer who bears testimony to the indwelling of the divine Spirit, knowing the while that his confession is his death-warrant?'[101] Maréchal's preference for the latter alternative is obvious from the context, and my own view would be that in this he is right. But he fails to note one major problem that will arise with any such endorsement of monistically described experience. This is that in terms of the experiences themselves there can then be no criterion for adjudicating which of the two interpretations is correct. In the absence of any further considerations beyond those so far adduced the monistic account is just as likely to be the correct one as the theistic.

This is not to say that mystical experience cannot be used as an argument for the existence of the divine. If my analysis is accepted (and, of course, much more detailed empirical work would be required to substantiate it in full), then it would provide grounds for believing in the existence of a transcendent reality who may be described as personal or suprapersonal. It might be thought that monistic accounts disagree on the last point, but I do not think that this is so. Note, for example, Al Hallaj's use of the personal pronoun, 'I am the Truth'. Even Hindu monism is no exception. In the famous formula, 'Tat tvam asi' (That art thou) in the Chandogya Upanishad, 'tat' is neuter, as indeed is 'Brahman', but the intention is clearly to describe a more than personal reality, not less than personl, and indeed desires etc. are attributed to Brahman. Where the argument will fail, therefore, seems to me not on this point, but on the question of whether identity with this reality is possible, or rather only a union in which distinct personality is retained.

As for whether deism could use this argument, I think that only a negative answer can be given. For the situation is quite different from that which pertains with respect to thematic and numinous experience. For there nothing significant is lost if the experience is interpreted entirely in terms of its effects, e.g. a feeling of peace or an overwhelming sense of awe. That is to say, it is not normally integral to such experiences that the divine is felt to be present in a particular kind of way. Rather what matters is that his action is felt upon the believer, or that the believer sees on this occasion clearly what is always the case about God's activity. For example, peace is experienced and the cause is believed to be God, but there is no specific commitment to a particular method of causation. Or again, a sense of awe and wonder may be felt before the divine creation, but it does not follow from this that there is any commitment to the view that God is somehow more present. There are of course exceptions. Someone may experience awe before the presence of what he believes to be God in the Eucharist. In such a case someone of Catholic persuasion is unlikely to accept a model of divine

[101] J. Maréchal, *Studies in the Psychology of the Mystics* (trans. A. Thorold, London, 1927), p. 259.

activity which suggests that the mode of his presence differs in no way here but only in his ability to perceive it. But in general with thematic and numinous experience there is no such commitment.

With mystical experience, however, the situation is quite different. The mystic does not think that he is, as it were, simply plugging into an experience that can be had by anyone, provided they have gone through the requisite training. For it is not believed that it is just effects that are then produced but a transformed relationship. He conceives of himself as either engaged upon a mutual personal exchange with the divine (union) or having been totally caught up into and having gained completely the divine perspective (identity). It is thus integral to the human viewpoint that a change has occurred in the divine-human relationship, not merely in the psychology of the mystic. God is now personally interacting with the mystic. In other words, there is action on the part of the divine tied to a specific individual, not just a general availability to be perceived.

There are two ways in which an attempt might be made to counteract this claim. The deist might appeal to God's timelessness or he might appeal to some of the descriptions of such mystical experiences that are to be found in Hindu thought. Thus, on the first point, it might be alleged that since God is outside time no such distinction can be drawn. But in reply not only may one note that many contemporary philosophers are now challenging such a conception of God as incoherent,[102] but also in any case, even if one accepts the view, there would still be a difference. It would be seen as an action of special, not general, providence, with God responding from outside time to a particular individual. One also suspects that, if any sense is to be made of the level of intimacy claimed, it would also involve envisaging God taking the individual concerned into his own timelessness. Perhaps this is why mystics' experiences can often last a very long time, but the mystic be totally unaware of this, e.g. St. Catherine of Siena's four hour 'mystical death' in 1370 when her body seemed totally lifeless to the observers present.

The other type of objection involves drawing attention to the way in which Indian thought often takes the view that in such an experience true reality is perceived for the first time, and the 'unreal' character of one's previous experiences discovered. On the basis of this it might be argued that mystical experience for them would indeed be a plugging in to a hitherto unperceived reality. One discovers that one's personality is simply an aspect of Brahman, and in so far as this is not reflected in one's experiences, they are illusory. But one should distinguish this from the true mystical experience of identity. In that it is not a case of just seeing oneself as an aspect of Brahman. One becomes for the duration of the

[102] E.g. N. Pike, *God and Timelessness* (Routledge & Kegan Paul, London, 1970); R. Swinburne, *The Coherence of Theism* (Oxford University Press, 1977); A. Kenny, *The God of the Philosophers* (Oxford University Press, 1979).

experience Brahman and sees the world as a whole with his eyes. For that it is impossible to conceive of a deist account that preserves the nature of the claim. For how could a finite aspect, of itself, gain an infinite perspective by its own powers? The only coherent possibility would be to think of the transpersonal core of Brahman making such a transformed consciousness possible.[103]

My conclusion then is that it is only with numinous experience that there is any hope of the deist being able to use the argument from religious experience in order to justify the rationality of belief in God, and even there it was, as we saw, only a very limited possibility. In possibilities for continued argument theism thus has a tremendous advantage. In the course of the next two chapters we shall note various ways in which the argument might be pursued further. But my primary intentions will lie elsewhere, just as they have done so in this present chapter. For the conclusion of the chapter as a whole is not just that in respect of the argument from religious experience theism has the advantage, but that in each of the three areas where contemporary deism has attacked theism, what I labelled the redundancy, the conceptual and the evidential arguments, it is theism which is intellectually the more promising position, if belief in God is to be defended. Butler's verdict thus remains just as valid today as in the eighteenth century.

[103] A recent impressive attempt to produce an argument from mystical experience is W.J. Wainwright's *Mysticism* (Harvester Press, Brighton, 1981). However, he makes the task easier than I think it is by his acceptance of Zaehner's treatment of monistic experience as necessarily inferior to 'theistic'. More worrying is the cavalier way in which he dismisses the challenge of a naturalist explanation by drawing a parallel with divine causation of physical events (pp. 74-6). Not only would such a natural explanation reduce justification for postulating a divine cause, it would also call into question the personal character of the experience. For free personal action is most obviously contrasted with natural events precisely by its unpredictable quality, where 'unpredictable' means, of course, not 'arbitrary' but subject to personal considerations rather than scientific laws.

Revelation: the Divine Dialogue

In the previous chapter I argued that the acceptance of deism would involve paying a price that is unacceptable in terms of any defensible conception of God. Not only that, but in the manner of Butler the contention was made that any arguments brought against the interventionist position of the theist could be countered by pointing out that, so far from such arguments being of any effect, parallel arguments of a more devastating kind could be brought against the deist's own position. Attention was also drawn to the way in which the theist's view of divine activity might be substantiated by a detailed investigation of accounts of various types of religious experience.

What I propose to do in this chapter is to examine in detail the one area where the theist is most concerned to see such divine intervention at work, namely in the area of revelation, or 'special revelation', as it is sometimes known in order to distinguish it from such natural knowledge of God as one might be able to obtain by ordinary processes of inference ('general revelation'). Here, it seems to me that the major obstacle in the way of taking the interventionist view seriously is the failure of theism to develop an adequate model of divine activity that takes sufficient account of our transformed understanding of the nature of the material in the light of historical criticism, our awareness of cultural conditioning and so forth. For this reason, therefore, the chapter is devoted to the search for such a suitable model, first negatively by noting the inadequacies in popular presently canvassed options, and then more positively with the presentation of an alternative account.

However, in order to aid the reader's comprehension of what follows, perhaps a brief anticipation of the argument would be appropriate here. Basically, the point I shall be concerned to make is that the theist has already lost the argument with the deist for so long as he confines himself to arguing only particular cases. Rather, he needs to follow the strategy of Plato's *Republic* and see the issue 'writ large' before he will be able to deal satisfactorily with the particular.[1] Thus, just as the previous chapter argued that the debate with deism must take account of the whole range

[1] Plato, *Republic*, 368d.

of religious experience and its interpretation, so it is my view that theism must provide an interpretative framework that takes into account the whole range of what has been claimed as 'revelation' before it can even begin to make a satisfactory counter-case to deism's view of the material. If this is so, there are four important consequences.

The first is that the question of evidence for intervention and the nature of the theistic model cannot be disentangled, as though the evidence could be looked at entirely separately from one's assumptions about what form divine intervention might take. For, the more the theistic model leads one to expect the precise nature of the material with which one is confronted, the more plausible will be the postulation of divine intervention in the particular case. That is why the following comment from Wiles' debate with Mitchell about revelation seems to me to be a mistake. 'I want here to draw a distinction between the ontological possibility of there being divine intervention in the world, and the epistemological possibility of our being in the position to have good reasons for affirming divine intervention in particular cases ... The evidence available to us seems to me too ambiguous for us to be able to do that with ... confidence.'[2] This seems to me wrong, not only because it suggests that we look at specific cases rather than a whole range of data, but, more important, because in any case what we regard as evidence will be dependent on *how* God is conceived of as possibly acting, and, if this is so, it will make a vital difference what sort of theistic model it is with which we are operating. In other words, there is a slide between ontological possibility, conceptual plausibility and epistemological certainty that makes any sharp differentiation impossible, and therefore doubly important the correct choice of one's theistic model for revelation.

The second consequence is that, for the model to be as plausible as possible, the philosophical theologian will need to engage very closely with the material in question. This is a point which emerges clearly from Barr's review of Abraham's book, *Divine Revelation and the Limits of Historical Criticism*. Barr observes that all the efforts of philosophers to establish the coherence of divine intervention in this and similar books essentially miss their target. 'The philosophical reassertion of classical theism, with its traditional intellectual parameters and definitions, seems simply to bypass the question of the meaning of the biblical data.'[3] For it is not that Biblical scholars reject the possibility but that they do not find interventionism the most natural reading of the Biblical evidence. This seems to me largely right. But it has the consequence that, if a plausible theistic model is to be provided, the

[2] M. Wiles, 'Does Christianity need a revelation?' (*Theology*, 1980, p. 111).

[3] J. Barr, 'Allowing for God's intervention', in *Times Literary Supplement*, 24 December 1982, p. 1422. W. Abraham, *Divine Revelation and the Limits of Historical Criticism* (Oxford University Press, 1982).

philosopher cannot escape some detailed acquaintance with Biblical
criticism.

Not only that, but the traditional procedures of the philosopher will
need to be reversed. For, if a satisfactory model can only be produced by
a detailed investigation of the material, we will have to assume in
advance that the material under investigation is that most likely to fall
under the rubric of 'revelation', without the application of any proposed
tests for revelation being made in advance. This is because what will
constitute appropriate tests can only be decided once we have resolved
the question of a satisfactory model for revelation. Thus, we will have to
assume in advance that the Bible is the correct place to look for such
revelation, and only subsequently decide appropriate tests for its
occurrence, as is in fact done later in the chapter. This may seem a
viciously circular approach, but it does not in fact turn out to be so
because any other likely candidates (e.g. the alleged revelations of the
other major religions) would have produced the same model and the
same set of tests.

Finally, there is the consequence that no precise signification can be
attached to the term 'revelation' until the investigation is complete. As
will become apparent, for example, any simple identification with the
Bible must be ruled out, as also must the suggestion that it is the
communication of truths that could not be known by natural means.[4] For
present purposes, the following will suffice as a working definition: the
unveiling of truth by God through his intervention in some aspect of the
world.

Rejected models: speech, acts and person

(i) Of the antiquity of the model of revelation as divine speech there
can scarcely be any doubt. Thus as early as the second-century apologist
Athenagoras, we find a Christian theologian following a suggestion of
Philo that we should conceive of the Holy Spirit breathing through the
prophets, as a musician does through a pipe. In something very similar to
this extreme form, it is a position that continues to be enormously
influential even today in Biblical fundamentalism, particularly through
B.B. Warfield's book, *The Inspiration and Authority of the Bible*.[5] But
the simplest one-sentence exposition of the view is undoubtedly to be
found in a papal encyclical, Leo XIII's *Providentissimus Deus* of 1893:
'All the books and the whole of each book which the Church receives as

[4] This is to reject the common definition of revelation as 'God ... communicating to his
creatures fundamental truths about his nature and purposes which they otherwise could
not discover'. So B. Mitchell, 'Does Christianity need a revelation?' in *Theology*, 1980, p.
103.

[5] B.B. Warfield, *The Inspiration and Authority of the Bible* (Presbyterian and Reformed
Publishing Company, Philadelphia, 1970).

sacred and canonical were written at the dictation of the Holy Spirit.'
Were it just a matter of historical errors such as the conflict in the dating
of Baasha and Asa between Kings and Chronicles (with Baasha still alive
ten years later in Chronicles than what Kings records) or the conflict
between John placing the cleansing of the Temple at the beginning of
Jesus' ministry and the Synoptics at the end,[6] no doubt *ad hoc* solutions
could be offered. But, since it will be my contention in what follows that
the Bible is also permeated with moral and doctrinal error (certainly
even if only judged by the standards of later Biblical orthodoxy), the pursuit
of any simple model of divine speech must inevitably seem a hopeless
will-of-the-wisp. If the reader doubts this, he is asked to suspend
judgment until he has reflected on the examples given later in the
chapter.

In the meantime what must engage our attention are recent attempts to
produce a more complex model of revelation as divine speech that try to
take full account of the fallibility of the Scriptures. This is something
W.J. Abraham in particular has attempted to do in his two books, *The
Divine Inspiration of Holy Scripture* and *Divine Revelation and the
Limits of Historical Criticism*. In the first he is concerned to argue
against fundamentalism by insisting that a clear distinction should be
drawn between divine speaking and divine inspiration. 'The two are
related, of course. It is partly through speaking to various significant
individuals that God inspires them and others to write, edit, collate and
preserve the various traditions that go to make up the Bible. But the
relation between speaking and inspiration is contingent; there is no
necessity for divine inspiration to be accomplished through divine
speaking. Thus the relation cannot be one of identity, as so much writing
on inspiration either states or presumes.'[7] For a correct understanding of
inspiration he suggests that 'we must concentrate on the meaning of
"inspire" as used in everyday contexts before we turn to what it means
as applied to God. By so doing we shall be attending to the root meaning
of the concept.'[8] Then on the same page he adds: 'A familiar case that I
find helpful is furnished by a good teacher inspiring his students.'
Leaving aside his strange reference to 'the root meaning' after he had
already acknowledged that it is derived from the Latin verb, *spirare*,[9] the
main point he is making with the analogy does seem a helpful one,
namely that students are not always up to their teachers and so we can
see why the Biblical authors might not always reflect the standards we

[6] For the former, cf. II Chronicles 16:1 and I Kings 16:6 and 8; for the latter, cf. John
2:13ff. and Mark 11:15ff.

[7] W. Abraham, *The Divine Inspiration of Holy Scripture* (Oxford University Press, 1981),
p. 69.

[8] Ibid., p. 63.

[9] 'To breathe into' suggests a different model for understanding than the modern English
meaning of 'inspire', where the force of the original Latin and Greek has largely been lost.

might reasonably expect of God. But, rather disappointingly, Abraham nowhere systematically pursues the more fundamental question of why God might allow this to happen, a subject to which I shall return. Nor does he note one major source of disanalogy with the secular case, namely our inability in the religious case to identify independently the source of the inspiration. That is, in contrast to the normal situation in the teacher/pupil case, there is no independent access to God's speech and acts. Yet the way he treats divine speech in the second book gives the impression that he thinks that such a process of disentanglement is possible. To see why this will not do, and why because of the nature of the Bible even his modified model of divine speech has therefore to be abandoned, I turn to his defence of the notion of divine speech.

Abraham strongly endorses Mitchell's argument that, without speech, behaviour remains essentially ambiguous: 'Although I do not know you, I can learn a certain amount about you by observing and responding to your behaviour, but unless I am *very* familiar with the work you do and the way you live I am likely to find this somewhat ambiguous. And even if I have this kind of background knowledge and you behave always as someone of your sort might be expected to do, I can have no warrant for supposing that *this* bit of behaviour rather than *that* represents your distinctive behaviour and intentions.'[10] Abraham suggests that we remain agnostic about the method of speaking employed, but he is very insistent on the necessity of retaining the concept: 'Were the concept of divine speaking to be abandoned, the Christian religion would be undergoing drastic reformulation.'[11] One of his arguments is that 'a theology without the concept of divine speaking has of necessity a God who cannot forgive, command or make promises. The reason for this is that forgiving, commanding and promising are performative utterances. To forgive someone their sins is to say sincerely to them, "I forgive you your sins".'[12] But his main point is the same as Mitchell's.

My reaction to this proposal is that it misleads more than it clarifies, even given an interventionist God. Indeed, on the question of forgiving, commanding and promising we can go further and say that he is quite wrong. Thus, in the case of forgiveness, even in the human case words are often unnecessary to indicate this. I see that I am forgiven in virtue of the kinds of acts that are done towards me. So, similarly, in God's case; a particularly loving action would seem to suffice, for example, the continued experience of divine aid even after some dreadful deed of which one has repented. Again, with commands. The Old Testament itself contains examples of inferred commands, e.g. that the Exile was a punishment due to the omission of certain acts.

But these are really minor points compared with my main anxiety.

[10] B. Mitchell, op. cit., pp. 108-9.
[11] *Divine Revelation*, p. 23.
[12] Ibid., p. 21.

This is that to use a model of divine speech is inevitably to suggest that in principle at least the process of disentanglement could be performed and so certain parts of the Bible could be isolated and definitively labelled 'divine speech'. Fundamentalism thus returns with a new inner canon. Abraham's whole discussion seems to me flawed by a failure to engage with the Biblical material in detail, and this is one juncture at which this becomes particularly evident. For on the actual evidence even his modified version of the divine speech model seems to me highly implausible. To see why this is so, I shall take the two most appealing candidates, prophecy and the words of Jesus, and indicate thereby where the difficulties lie.

These are the two most appealing candidates because, in the case of the prophets, they often report their experience in terms of the reception of a divine word, 'Thus saith the Lord', while, if Jesus was God Incarnate, it might well seem natural to describe his words as the very words of God. Presumably Abraham and Mitchell would concede that such speech would be expressed in the thought-forms of the age; otherwise it would not have been intelligible to the hearer. That in itself makes a major difference from the human case. For when a human being speaks, the thought-forms he uses are essentially bound up with his being the person he is, that is, as having been shaped by one particular culture rather than another. Reading human speech thus reveals far more about the essential person than could ever be the case about God. This in itself is not an insuperable objection to the model. After all, translations between different cultures, though often difficult, are certainly possible. But this initial difficulty in locating *ipsissima verba* of God hints at far more acute problems to come.

For, as soon as one acknowledges the necessity of divine accommodation to the thought framework of the hearer, we are led on to ponder whether the extent of the accommodation is such that, though the cause of the words heard may be attributed to God, to identify them as his speech would be to give a false clue as to where revelation of the divine nature is properly to be sought. That is to say, the intentions and character of God would be an inference, not something directly declared in what could appropriately be called divine speech. Of course, such inferences are also sometimes necessary in the human case as well. But in the case of God I want to suggest that such inference is the norm, and that his intentions and purposes are not best identified by calling what is heard by the hearer, even when caused by God, 'divine speech'.

The point I am getting at can be made most clearly by underlining the extent to which the original words heard were directed to the immediate situation, and only secondarily, if at all, can they be given eternal significance. Yet it is only the latter that would give them continuing significance as revelation. Take the prophets. Again and again they stress the immediate relevance of what they have to say, particularly the need

for repentance in the face of impending divine judgment. This applies
equally to their promises of a happy future. Any detailed historical study
of their writings indicates the implausibility of attributing to them any
predictive powers in respect of the coming of Christ. Even with the most
famous of such passages, the four Suffering Servant Songs in
Deutero-Isaiah, it is clear that for the prophet their power lay in their
ability to offer immediate reassurance to his fellow-suffering exiles.
Whether he simply had Israel in mind as one gloss in the text suggests,[13]
or was recalling the sufferings of a particular historical individual,
perhaps Jehoiachin (as Ackroyd proposes)[14] who was imprisoned for 36
years before his release, is a matter we need not go into here. It may even
be that the hope he entertained was a vague one. What is important is
that the primary thrust should be seen as immediate relevance, and this is
certainly confirmed by some other 'prophecies'. An obvious example is
Haggai's identification of the Messiah with his contemporary
Zerubbabel[15], as indeed is also the case with the original text of
Zechariah, which now refers to the priest Joshua.[16] In recalling such facts
I am not attempting to undermine the permanent relevance of the
prophets. All I am drawing attention to is that the permanent relevance
cannot be the same as what was 'heard' at the time. Now to this it may
be objected that I am confusing the interpretation of what was heard
with what was actually heard, and that once we remove the
interpretative overlay, as, for example, in Haggai and Zechariah making
the identification with Zerubbabel, permanent significance, revelation
and divine speech can all be equated. But I doubt if this will do. For
without the presumed immediate significance it is doubtful whether
what was heard would have been heard at all (i.e. been listened to, or at
any rate listened to as something of particular significance). My point is
that where the thought of the prophets was leading to could only really be
appreciated after the life and death of Christ. Not only that; what was
heard at the time when falsehood is removed would be less indicative of
the divine will, not more, because the ability of a human listener to
respond is heavily conditional upon seeing some immediate relevance to
his own situation. This is not to attribute false utterances to God, but it
is to suggest that he may have foreseen such false perceptions, but yet
felt it necessary to allow them as part of his divine plan. Otherwise, the
relevant framework in terms of which Jesus' life and death could be
interpreted might never have arisen, and maintained its force.

But, it may be said, surely in the case of Jesus' own words there can be

[13] Isaiah 49:3 'You are my servant, Israel' must be a gloss because the servant is said later
(v. 6) 'to restore the tribes of Jacob and bring back the survivors of Israel' (Jerusalem
Bible).

[14] P. Ackroyd, *Exile and Restoration* (S.C.M., London, 1968), pp. 125-6.

[15] Haggai 2:2-23, esp. *v.* 23 (signet ring = special royal representative).

[16] Zechariah 6:9ff.

no such problem? Certainly, if a claim to his perfection is to be maintained, there must be less of a problem. But it does not follow from this that there will be no difficulties at all. This is because, as Chapter 3 will argue, there is no need to see his perfection as extending beyond perfection in moral and spiritual qualities, and that excludes any guarantee of purely factual accuracy. Moreover, as that same chapter also argues, his own self-perception of his status cannot be taken as normative for that status. This need not be regarded as a particularly controversial point. For not even the most liberal Christian scholar would deny that Jesus is appropriately regarded as the Messiah, irrespective of whether or not the common contention is true that he did not in fact regard himself as such. The argument here would be that he was none the less the legitimate fulfilment of such expectations. At all events, the net result is that his own words on his status are not necessarily finally revelatory of that status. It is an argument which can be applied more extensively than the title of Messiah. But in the meantime what I want to draw attention to here are other types of case where the same lack of definitive revelation applies, and so where to speak of Jesus' words as divine speech, even conceding an Incarnation, would be to mislead rather than help understanding of the nature of revelation.

Basically, the point is the same as has been made with respect to the prophets. It is that Jesus speaks to a specific historical context. But true 'divine speech' will be of eternal unchanging significance unconditioned by the needs of a particular audience. This is partly because, as we have seen, speech will be most in accord with the divine character when it is not subject to such conditions, and partly because in any case the use of the word 'revelation' with respect to the Scriptures is normally also taken to suggest a relevance beyond the immediate temporal context. This is not to deny eternal significance to Jesus' words, but it is to suggest that such significance is to be found by inference and only very seldom, if ever, in the words themselves. Two examples will make the issue clearer.

First, a relatively trivial example. Jesus sums up his teaching on the sabbath with the remark that 'the Sabbath was made for man, not man for the Sabbath'. As it stands, its contemporary relevance would be confined to orthodox Jews or supporters of the Lord's Day Observance Society. For only they might be in danger of placing sabbath observance above human compassion. But clearly the implication is intended to be much wider, and say something about the order of priorities between rules and compassion for human need. So the eternal word is more appropriately identified with the implication than with the words actually said.

The other type of example I have in mind is the extent to which the sort of issues discussed by Christ was conditioned by the environment in which he lived. Thus, I find it impossible to believe that they constitute a total list of the most important spiritual issues as they are seen by God.

There are just too many questions omitted, which in an eternal perspective seem of vital importance but the reason for whose omission from consideration in first-century Palestine admits of ready explanation. Two instances would be abortion and war. The first was not practised among the Jews and so was not a 'live' issue, while to say anything at all in acknowledgement of the legitimacy of war would inevitably have been mistaken as an endorsement of the Zealot party. Indeed, one of the great tragedies of subsequent Christian reflection is the extent to which Christ's words have been allowed to determine whether something is a legitimate area of concern for a Christian or not. The obvious instance here is political issues. The reason for an absence of any allusion on the part of Christ has nothing to do with his seeing the question as unimportant. Rather, the obvious explanation is that he was addressing those who were powerless to effect any change in the social structures and therefore concentrated on what was within their power, their own personal transformation through God's grace. Strictly speaking, of course, none of this demonstrates that what Christ does say should not be regarded as the divine speech of revelation. But it does, I think, indicate the need for extreme caution. For, were we to call it such, it would tend to suggest that its status as divine truth would be higher than what can only be deduced from general principles enunciated by Christ or perhaps as an implication of what is said elsewhere in the Bible. But that would be an unjustified point of view, since what Christ chose to discuss was as much a function of the period in which he lived as any other part of the Bible.

To sum up, then, my main objection to an analysis of revelation simply or largely in terms of divine speech is that it encourages us to look for a will-o'-the-wisp, parts of the Bible which can be identified as the *ipsissima verba* of God, whereas the extent of the divine accommodation to the specific human situation seems to be such that what is of eternal significance and so most appropriately regarded as divine speech can only be deduced by inference. It cannot be ascertained by ostensive definition, by simply pointing to certain expressions and statements in the Bible.

However, I also have a second reason for wishing to reject this model. This is the way in which the simple model of divine speech has enticed so many people in the past into a false equation between Bible and revelation, an error that is found frequently even today. The meaning of the word 'revelation', I take it, gains its primary currency by contrast with 'reason'; that is, it represents an alternative way of gaining theological knowledge in which truth is unveiled by God rather than resort being had to the normal processes of inference. But, if this is so, then there is much in the Bible that is more naturally classified as reason rather than revelation. The arguments of St. Paul are a case in point, and need therefore to be assessed by normal criteria of rationality. But the

clearest instance is undoubtedly the Wisdom literature.

Thus, much of it reads as early, not very successful attempts at natural theology. Indeed, in one case we know that a direct borrowing from Egyptian Wisdom literature has occurred, with a section of Proverbs deriving directly from the *Instruction of Amenemopet*.[17] Again, Crenshaw declares that Job 'bears a striking resemblance to discussion literature in Mesopotamian literature',[18] and later refers us to *The Babylonian Theodicy*. Again, Von Rad places Israel's Wisdom in the context of a universal search: 'Like all nations, Israel was on the search for the "rational rule" ... "Rational" means that this rule is supported by general evidence which can be controlled and confirmed by the mind.'[19] If Israel's Wisdom tradition was thus constituted by a search for a naturally deduced moral order and theology, it is hardly surprising that parallels with the literature of the surrounding nations are clearer here than elsewhere. But, precisely because of this, it makes it implausible to postulate any process of special revelation as part of the Wisdom books' origination.

That being so, it would seem highly advantageous to differentiate sharply between the question of revelation and the question of the canon of Scripture. In declaring something to be part of a canon of literature, what one is doing is not commenting on the source of any epistemological claims made therein, but rather assigning the literature a certain authority, as constituting part of the material that is meant to form and shape the community's perspective. The canon is a matter to which I shall return, when presenting an alternative model for revelation, but for the moment let me just note how this applies to the Wisdom literature.

What one would wish to say of the Wisdom literature is that it guarantees a continuing role for natural theology within the community and insists on the compatibility of revelation with the natural order. This is a compatibility which is clearly accepted by Jesus. Not only does he teach by parables or 'proverbs' (the Hebrew word is the same), he frequently appeals to the natural order as the basis of his teaching. Perhaps the most startling instance is his revoking of the Deuteronomic bill of divorce and direct appeal to the original created order.[20] But many more examples could be quoted: for example, God's providential care for the sparrows and the lilies in the field.[21] Paul too, though perhaps more reluctantly, accepts an appeal to the created order.[22]

But it was an insight that the Wisdom literature only slowly won. For

[17] Proverbs 22:17 to 23:11.

[18] J.L. Crenshaw, *Old Testament Wisdom* (S.C.M., London, 1981), p. 16, and pp. 230-1 for *The Babylonian Theodicy*.

[19] G. von Rad, *Wisdom in Israel* (S.C.M., London, 1972), p. 289.

[20] Mark 10:2-12, esp. *vv.* 6-8.

[21] Matthew 6:25-30.

[22] Romans 1:18ff.

the tradition of Law developed quite separately and was seen as made up of commands based directly on the divine will, not to be ascertained mediately from God's creation. Indeed, the two traditions of Law and Wisdom seem to have developed quite separately. It is only with the Book of Ecclesiasticus that the two methods of discovery are acknowledged as necessarily pointing in the same direction. In the magnificent Chapter 24, where Torah and Wisdom are identified, as Von Rad says, 'it is not that wisdom is overshadowed by the superior power of the Torah, but vice versa, that we see Sirach endeavouring to legitimise and to interpret Torah from the realm of understanding characteristic of wisdom ... This is not simply a legitimisation of Torah. The question is not "Where does Torah come from?", but "To what extent is Torah a source of Wisdom?". The answer is, "Because Torah is a self-presentation of primeval order, it is able to help men towards wisdom".'[23]

In other words, I would see the Wisdom literature as the best illustration of the need to separate canon and revelation, given the fact that it culminates in an insistence that even commands of God must find their rationality and support from within the natural order.

(ii) Presumably mainly because of the difficulty of satisfactorily identifying anything which might be labelled 'divine speech' in the Scriptures, one popularly canvassed alternative model has been that of revelation as divine acts in history. It is a model to which Abraham is willing to lend some support, as one of the ways, along with divine speech, in which God has inspired the various authors of the Bible. But better known examples would be G.E. Wright and R. Fuller's 1950s best-seller, *The Book of the Acts of God*,[24] in which our attention is drawn to the extent to which the Bible consists in reflection on two groups of events, those centring round the Exodus and those round Jesus, or, to give a more academic example, Pannenberg's 1969 symposium, *Revelation as History*.[25]

So far as Abraham is concerned, I would wish to make a similar complaint as before, when considering divine speech acts. For his lack of attention to the empirical data leads him into supposing that the act that inspires and the interpretation of it can be disentangled from each other, whereas in fact it seems to me that, if revelation occurs at all, it can only properly be said to begin to occur at the point of interpretation of the event. Thus there just is no neutral description of an act which inspires that is susceptible of separate analysis. In other words, in the theological case action and response are too inextricably intertwined for it to make sense to say that such-and-such is what the person had as a distinct

[23] Op. cit., pp. 245-6.
[24] G.E. Wright & R. Fuller, *The Book of the Acts of God* (Penguin, Harmondsworth, 1957), esp. pp. 16-22.
[25] W. Pannenberg (ed.), *Revelation as History* (Sheed & Ward, London, 1979).

source of inspiration. For example, ignoring miracles for the moment, it is not the case that, say, the Exile was an act of divine judgment that then inspired the exilic prophets. The decision to see the Exile as a divine act at all was the important 'revelatory' contribution (if revelatory it indeed was), but this was hardly the only possible interpretation of the situation.

Even with miracles there is a similar kind of difficulty. Suppose we take the Resurrection. Two facts need to be taken into account. The first is that for the Biblical authors a violation of a law of nature would not have had the same significance as for us. For all events were seen as equally directly in the hands of God, and so what violates a law of nature was not seen as automatically bearing a divine significance that could not be had by a naturally caused event. Indeed, what we would identify as a naturally caused event, for example, the Exile, was often seen as the more divinely significant 'action' than what would have been an absolutely astounding miracle if it occurred, e.g. the standing still of the sun to enable a victory to be won.[26] In other words, since all events were seen as divine actions, to say that a particular event was a miracle was not necessarily to identify it as an especially inspiring divine action. Secondly, not only was the significance of an event not given by its mode of causation, but also the precise nature of its significance is likewise a function of something other than the event itself. Resurrection from the dead could not of itself make the life of Jesus the most significant event in the history of the world. After all, Enoch and Elijah were reported to have met equally remarkable ends, and yet no ultimate significance had been accorded them.

Pannenberg, for one, would refuse to concede this, at least so far as the Resurrection is concerned, since for him 'the special aspect is the event itself, not the attitude with which one confronts the event'.[27] But other advocates of the model are willing to admit the absence of any 'naked' confrontation with the historical situation. C.H. Dodd, for example, writes: 'The pattern of history in which God's covenant with men is established has two elements, (a) a direction of events and (b) an interpretation of these events. These two elements interact ... The decisive significance of the interaction is accounted for upon the Biblical postulate that God is both the Lord of history and the Interpreter of his own action to the mind of man ... This total structure of event and interpretation is God's word to man.'[28]

Even so, on my view Dodd does not get it quite right. For, while it is certainly true that the really important element, rather than the event

[26] The latter is only mentioned briefly in Joshua 10:12-14, whereas the Exile, both when impending and actual, dominates the thinking of contemporary prophets.

[27] Op. cit., p. 137.

[28] C.H. Dodd in A. Richardson & W. Schweitzer (ed.), *Biblical Authority for Today* (S.C.M., 1951), p. 159.

itself, is the experience which determines how the event is to be read, this is not to say that the experience in question should simply be identified with revelation – 'God's word to man'. This is because, as we noted when considering divine speech acts, any interpretation is likely to have a specific temporal setting that can only be given permanent significance, if at all, by a complex process of inference (comparing it with other revelatory experiences, noting its place in the tradition of such experiences, etc.).

How this process of inference works by setting such experiences in the wider context of a revelatory tradition rather than by considering them merely as isolated events is a question to which I shall turn in the second half of the chapter. But the need for such a wider context in order to render plausible a theistic view can be as much illustrated by our present more narrow subject of divine action as by the topic of revelation. For, so far as miracles are concerned, it would be absurd to suggest that the issue could be determined in a particular case simply by looking at the 'evidence'. For much also depends on how one conceives of God acting elsewhere, even granted interventionist assumptions.

Perhaps the point can be made most clear by alluding to Abraham's critique of Van Harvey's book, *The Historian and the Believer*. Harvey does not deny the possibility of miracles. Rather, he fails to see how one could ever have warrants for belief. His position is perhaps best illustrated by a passage to which Abraham does not refer, in which Harvey attacks Barth for accepting the historicity of the Resurrection. 'The issue is, by what right does Barth in this particular case suspend those warrants he normally uses and which he applies when, say, dealing with the story of Jonah or Joshua? ... The issue is, as F.H. Bradley saw, one of consistency. For if Barth's own argument presupposes these warrants, how can one enter into debate with him if he suspends them when his inferences are questioned?'[29] Abraham's answer is that there is the test of whether such events 'are related to a wider conceptual scheme that gives point and intelligibility to their occurrence'.[30] It is this he suggests which might lead one to accept the historicity of the Resurrection but reject the story of a saint walking to his cathedral with his head under his arm, after having been beheaded.[31] It is a pity that he gives us as examples of 'miracles' to be discounted such uncontroversial cases (his only other illustration is of birds singing a *Te Deum*). For his point is a good one, and admits of wide application, as indeed would have become clear had he taken for consideration Harvey's comments about Barth on Joshua and Jonah. For example, the account of God making the sun stand still so that Joshua could defeat the Amorites obviously fails on such criteria.

[29] V.A. Harvey, *The Historian and the Believer* (S.C.M., London 1967), p. 159.
[30] *Divine Revelation*, p. 111.
[31] Ibid., pp. 132-4. The example of the birds singing is given on p. 149.

That God should make such a major alteration in the laws of the universe for what was a relatively insignificant incident in the history of Israel defies belief precisely because it is incompatible with the type of concern shown elsewhere in the Biblical narrative, e.g. the lack of intervention to prevent Israel's sufferings in the Exile and thereafter. This criterion of appropriateness is equally one that can be applied to the New Testament. For example, one is led to doubt whether Jesus ever turned water into wine not because of the impossibility of such action, but partly because of historical doubts about whether the historical record is the real motivation of John's gosepl and also because, while symbolically, as foreshadowing the new life that the Gospel brings, it is entirely appropriate, literally it flies in the face of the type of God revealed elsewhere, where miracles exhibit some deep pastoral concern.

Whether I am right or not in the instances quoted is not a matter of any great importance. What is important is that the theist is not in an all-or-nothing situation, as Harvey seems to assume. He can use the same sorts of analogical tests as are applied to secular history, by testing for consistency with what has been revealed elsewhere of God's character. Nor are such tests of appropriateness new to theology. Anselm, for example, distinguished between what is *'necessarium'* (strictly required by the case) and *'conveniens'* (fitting or appropriate in the situation).[32]

However, it would be rash to claim on this basis that the historian who accepts some miraculous events is thereby simply doing history. It takes Abraham rather a long time to admit this, but he eventually does so after three chapters of discussion, towards the end of which he remarks that 'because of the disputed character of theological or atheological claims, it is awkward to call arguments about the resurrection of Jesus simply historical'.[33] This is surely right. In saying this, one is not of course denying that God intervenes in history. What one is denying is that this could ever be decided except when the historian also takes for granted a certain theological framework. By that I do not mean theist as distinct from deist assumptions. I simply mean belief in God. What the theist and deist are arguing about is not the presence of a divine purpose, but whether this can be most satisfactorily explicated in deist or in theist terms. Indeed, some scholars may be tempted to agnosticism as between the two. Certainly, Robert Morgan in his monograph comparing the work of Wrede and Schlatter, finds himself commenting: 'Schlatter's conviction that his theism was bound to affect his view of the world must surely be taken seriously. The test case for this matter in recent years has been discussion of the resurrection of Jesus, where it can be argued that

[32] The distinction is discussed in J. Hopkins, *A Companion to the Study of St. Anselm* (University of Minnesota Press, 1972), pp. 48-51.
[33] Op. cit., p. 161.

faith leaves a door open, even in the physical world, for the possibility of something which is scientifically and historically inexplicable actually to have happened. To say this is at least as persuasive as most liberal Protestant speculations about what happened to give rise to the Easter faith of the disciples.'[34]

In that same monograph Morgan, while criticising some of the attempts to combine the two perspectives in one person, none the less gives the impression that he is sympathetic to the attempt on the part of New Testament scholars to produce something called 'New Testament Theology' that might be of relevance to today. But one suspects that clarity in theological discussion is only likely to be produced if a sharp distinction is drawn between the work of the pure historian investigating the Bible and the believing theologian's assessment of that evidence. With such a sharp distinction one would then be able to recognise clearly what is ruled out by the historian and what is truly open to a number of different interpretations. For example, it would seem to me that the correct attitude of the historian is to leave the explanation of the Resurrection open. That will depend on wider presuppositions, whether theist, deist or atheist. But that the disciples were convinced that they had seen Jesus after his death does seem a reasonable hypothesis on the basis of the available evidence. The fact that non-Christian historians sometimes reject this possibility out of hand shows that overestimation of the role of the historian is to be found in both camps. By contrast, historical investigation can rule out a miraculous crossing of the Red Sea. For it reveals to us that the earliest account made no such assumption. Thus source criticism attributes to a different hand the miraculous record, while the two earliest sources both assume a naturalistic explanation.[35]

Historical investigation of the Bible, then, cannot decide whether a deist or theist framework is the one to be adopted, although in some cases it may be able to exclude a theist option. The resolution of the issue is likely to depend partly on the examination of particular cases where history leaves the question open (and so on the issue of whether deism can preserve anything other than a minimal content that reflects adversely on the experient's credulity and God's lack of serious involvement with the world), and partly on the ability of theism to offer an alternative account which takes seriously the extent of fallibility in revelation.

(iii) The third and final model for revelation which I said I would

[34] R. Morgan, *The Nature of New Testament Theology* (S.C.M., London, 1973), p. 31.

[35] The two earliest sources are Exodus 14:21b and its poetic equivalent, Exodus 15:8, while the miraculous account, perhaps formed by taking the poetry literally, is to be found in Exodus14:21a and 21c-22. Such, at any rate, is G.B. Caird's account of the development in *The Language and Imagery of the Bible* (Duckworth, London, 1980), pp. 209-10, using established pentateuchal source criticism.

consider but reject is that of revelation as a Person. For example, William Temple claims in *Nature, Man and God* that 'what is offered to man's apprehension in any specific revelation is not truth concerning God but the living God himself'.[36] A more recent instance would be Gabriel Moran's *Theology of Revelation*, in which he rejects the notion of revelation's being 'communicable through propositions from one generation to another' and substitutes in its place the personal presence of Christ 'that remains among men to continue that revelation'.[37] His emphasis on revelation as the experience of a Person is one of the reasons why he is prepared to identify the liturgy as the 'summit of continuing revelation'.[38] In addition, integral to his view is that one can have pre-predicative experience and knowledge,[39] and so it is always possible to know far more of a person than one is able adequately to conceptualise. The result is that Christ, and indeed the apostles, 'knew more than he could say',[40] and in general 'the Bible communicates more than it states'.[41]

There are three problems which I detect in any such approach. First, it just seems to introduce an unnecessary lack of clarity in one's thinking to identify revelation with the Person. Of course, God is the author, and, of course, one is liable to make mistakes in identifying his will and purposes. But that does not compel one to retreat from ever claiming, however tentatively, that such-and-such is what one believes to have been revealed. Uncertain information is better than no information at all. Secondly, it will not do to talk of us having the same direct access to the central feature of revelation, the Person, as the early Church had. For it is only in virtue of their experiences, not ours, that we know how to appropriately describe our own experiences, e.g. at the Liturgy. Ours are thus inevitably subordinate and secondary. Finally, while he is surely right about the possibility of pre-predicative knowledge (the problem of knowing more than one can say is something we all experience as children), the use to which he puts it is questionable. For to use it as a means of explaining the fallibility of the Scriptures is to put the emphasis in the wrong place. For so often what one wants to say is not that the author has got hold of an inadequate conceptualisation, but that he has got hold of the wrong concept altogether. Examples of the sort of thing I have in mind are given later in this chapter.

However, my main complaint would be the same as that made in respect of Abraham, namely Moran's failure to relate the model to the specific details of the Scriptures as they are now exposed to us by Biblical

[36] W. Temple, *Nature, Man and God* (Macmillan, London, 1934), p.322.

[37] G. Moran, *Theology of Revelation* (Search Press, London, 1973), p. 56.

[38] Ibid., p. 121ff.

[39] Ibid.; cf. esp. p. 86.

[40] Ibid., p. 72; for apostles, cf. p. 87.

[41] Ibid., p. 107.

criticism. This is an objection that could hardly be raised against
Schillebeeckx in his major work, *Christer.*[42] Yet in the introductory chapters
he produces a model not too dissimilar from that of Moran, though with
this difference that it is firmly deist in its presuppositions. Thus he
asserts that his model 'in no way implies the assertion that alongside
such truths which are accessible to human reason there are also
supra-rational truths which then become the object of religious faith'.[43]
Actually, his position is rather more complicated than this. For on the
following page he attempts to distinguish his position from the deism of
the Enlightenment, but that the net effect is deistic is seen not only from
the quotation, but from his endorsement of revelation as simply an
alternative 'seeing as', as paralleled in various phenomena of gestalt
psychology.[44]

Certainly, there are features in Schillebeeckx's account that will recur
in my own model, particularly his emphasis on the key role played by
experience in revelation, as also his view that all such experience occurs
in the context of tradition and so inevitably is interpreted experience.
'Even new experiences are possible only within the sphere of a tradition.
Our thought and experience are subject to historical and social influence.
Reflection means thinking with presuppositions. This bond to a
particular cultural tradition of experience is on the one hand positive: it
makes understanding possible. On the other hand it is negative: it limits
our understanding, is selective, and already guides new experiences in a
particular direction. In its direction, this understanding is limited by the
distinctiveness of one's own tradition'.[45]

Yet, the more one reads of the book, the more, despite its wealth of
learning, one is depressed by it. For the revelatory content he accepts
turns out to be very minimal, and this cannot but reflect adversely on
what he claims to be the basic (and it seems the only) input in the
experience, an input which is shared by the early Church and ourselves,
namely the experience of grace, or life as a gift. For it does seem a strange
notion that a God, of whom according to Schillebeeckx our basic
experience is that he is interested in us, should then proceed to provide
no further specific guidance for us. But that is certainly what he sees as
happening. Thus, for example, in striking contrast to his earlier book on
marriage, he refuses even to consider that the New Testament teaching
on divorce might be normative.[46] Or, to give a more substantial example,
it is significant that, despite his claim in his earlier book *Jesus*[47] to have

[42] E. Schillebeeckx, *Christ: The Christian Experience in the Modern World* (S.C.M.,
London, 1980).

[43] Ibid., p. 43.

[44] Ibid.; cf. esp. pp. 49-55.

[45] Ibid., p. 38.

[46] Ibid., p. 593; cf. p. 590. Contrast *Marriage: Human Reality and Saving Mystery* (Sheed
and Ward, London, 1965).

[47] E. Schillebeeckx, *Jesus: An Experiment in Christology* (Collins, London, 1979; Fount
Paperback, 1983).

defended the doctrine of the Incarnation, in this one his preferred usage is a non-Incarnational phrase, 'salvation in Jesus from God'.[48] But all this is perhaps hardly surprising, since he seems uncertain even about the personal element in the definitive experience of grace. 'It is by no means immediately clear that the character of this gift is *personal*, i.e. that it comes to us from the hand of a living and creative God who establishes the basis of all meaning and in so doing at the same time opens the future to mankind. However, this talk of God is primarily not something that we invent ourselves; we always find it already present historically in our human tradition as a possibility of human experience ...'[49] Then on the same page he gives a second reason for using personal language in addition to this appeal to tradition: 'This appearance and disappearance of meaning shows that we cannot grasp it, and that meaning comes to us from reality. We are addressed, called and summoned by it. All this has a structure which seems to compel us – however tentatively – to adopt a personal model in order to explain as fully as possible this experience of meaning.'

But, even if one concedes him the personal character of God, which he assumes elsewhere, there is still this startling paradox in his thought, a paradox which recurs in many other contemporary deists. On the one hand, he confidently affirms life beyond the grave,[50] a belief which surely implies a strong desire on God's part for greater intimacy with us. But, on the other, he denies any such intimacy of specific guidance or reassurance for the individual in this life, despite the logical possibility of God being able to provide it, if he so wanted. There is thus an inherent tension in modern deism, which it is hard to see how to reconcile.

As for what has misled Schillebeckx, one possible explanation is that his detailed study of the Scriptures has led him to the conviction that one has no alternative but to see man as simply trapped within a particular tradition of experience, which cannot therefore be seen in itself as definitive. At all events, it is significant that in the passage quoted earlier he speaks of 'a particular cultural tradition of experience' 'limiting our understanding' and 'guiding new experiences in a particular direction'.[51] The alternative would have been to make God the subject – in charge of the directional process, but at the same time respecting limits set by the cultural tradition. It is to just such an alternative model of revelation that I therefore now turn.

Revelation as the divine dialogue

The three models so far considered have been rejected for a number of

[48] Op. cit.; e.g. p. 838.
[49] Ibid., p. 47.
[50] Ibid.; cf. e.g. p. 800.
[51] Ibid. p. 38.

different reasons, but one recurring theme has been the need to set revelatory experience in some wider context. Thus, in the case of divine speech, I observed that it would be highly misleading to identify any particular words of the Bible as the Word of God; revelation must be, if anything, much more a matter of a general inference from the tradition as a whole. Again, with divine acts, I noted that the important issue revolves not around isolated events, but rather is a matter of the wider interpretative framework that enables them to be understood in a certain light. Finally, with the model of revelation as a Person, I criticised Moran at the one extreme for his failure to come to terms with empirical detail, and at the other Schillebeeckx for his failure to take account of the possibility that a strong sense of divine initiative might none the less be compatible with full recognition of the controlling element exercised by prior tradition, the recognition that comes with study of that empirical detail.

A setting of revelation in a wider context that I believe preserves a strong sense of divine initiative is a model which may be characterised as that of divine dialogue. This may be briefly summarised as follows: revelation is a process whereby God progressively unveils the truth about himself and his purposes to a community of believers, but always in such a manner that their freedom of response is respected. As will become apparent during the course of the discussion, each element in the definition is important. But for the moment what most calls for explanation is why it is thought that the term 'dialogue' most effectively sums up this process. The answer is that it suggests, on the one hand, accommodation to one's interlocutor – expressing oneself at a level at which he can understand and, on the other hand, some contribution from that interlocutor, some explication of the point which he believes the dialogue to have reached, which will then in turn elicit a further response and so on. Or, putting it another way, the notion of dialogue fully acknowledges that God's communication with man takes place in very specific contexts with certain things already assumed at each stage, an already existing canon of assumptions, as it were, – a canon that has shaped the community's conception of God, and thus inevitably shapes both the present experient's response to a particular experience and also what it is possible for God to put into that particular experience by way of content.

However, before considering the advantages of this model in detail, the most likely objection to be raised against it must be faced, namely that all this talk of divine accommodation to the interlocutor's present state of knowledge is a mere subterfuge without justification, designed in the face of the frequently inconsistent or morally unacceptable character of the Scriptures to resist admitting the obvious, that they are the all too purely human reflections of man upon God. An advantage of tackling the objection at the start is that it will enable one to examine the character of

the interventionist God being assumed. This is important because the plausibility of the model will depend in large part on whether the sort of God being assumed strikes the reader as more than just an *ad hoc* hypothesis to deal with embarrassing features of the Scriptures.

As a matter of fact, it is possible readily to identify two reasons why God might have preferred revelation to proceed in this manner rather than in the apparently more simple method of an infallible communication. One is logical; the other moral.

(i) The logical is a question of whether even if God had wanted to give an infallible communication, it was completely in his power to do so. Two examples that illustrate the difficulty would be any reference to the theory of evolution or the future Incarnation of the Son. Either would simply have confused the minds of Old Testament recipients of revelation, and indeed have led them to doubt whether the rest of what they had received was not simply a delusion. For both constituted too basic a challenge to their existing thought framework. The Incarnation is a particularly interesting example to take since it is a doctrinal and not a scientific issue. For with the scientific issue it could always be maintained that such information was not in any case of relevance to God's purposes of salvation. But the same can hardly be said of knowledge of the Incarnation, if indeed it is a true doctrine. The reason for doubting whether such information could have been communicated in advance of the event is that Israel's religious history largely consists of the attempt to extricate itself from 'incarnational' type mythologies among the surrounding peoples. What I mean by this is that the worship of Baal and similar deities offered very human sorts of gods, and, if Yahweh had also revealed his capacity to take human form, this would surely have simply delayed the process of extrication from anthropomorphic conceptions of God. Even 'the angel of Yahweh' theophanies, in which Yahweh is described as taking human form, should not properly be regarded as an exception, since these only occur in early popular stories that have all the marks of the primitive legends of the surrounding peoples (e.g. Jacob's wrestling with God, or Moses seeing the back of God).[52] At all events, it is surely significant that there are no late references to such phenomena. In other words, in terms of the process of conceptual understanding, distancing from anthropomorphism had to take place before it could be reintroduced at a time when it might be correctly understood and not simply assimilated to fundamentally antipathetic misconceptions.

In calling this first reason logical I should not, of course, be taken as implying that a logical impossibility would have been involved. I am using 'logical' rather more loosely than that. What I am drawing attention to is the extreme difficulty of God communicating certain sorts

[52] Genesis 32:24ff., Exodus 33:19ff.

of information such that he would both be believed and understood. In respect of belief the challenge to existing thought patterns would have been so fundamental as to make the recipient doubt the veridical character of the revelation rather than his basic beliefs. In respect of being understood the problem would be that what was revealed was so out of keeping with what else they knew about God and his world that there would have to be endless qualifications and corrections of misconceptions such that in effect we would be back with the model of dialogue which I proposed.

But this can hardly constitute the entire explanation of the considerable amount of moral and doctrinal falsehood that would now be widely retrospectively acknowledged to exist in the Bible. For example, many of the morally outrageous statements would not have required any such major readjustment. Often they read more like the person just having a 'blind spot', and indeed often it is a blind spot that is not even shared by all his contemporaries. One might therefore have felt that no more was required than some powerfully felt stern rebuke from God. Yet clearly this did not always happen. The Old Testament contains many repulsive expressions of nationalistic prejudice, e.g. Nahum, Obadiah, Esther, and even in the New the Gospel of John helped lay the foundations of later anti-semitism.

(ii) It is at this point, rather paradoxically, that it becomes appropriate to invoke what we called the moral reason. For it might be that God deliberately refrains from ever imposing a particular viewpoint on a recipient, but always wishes that it should become, as it were, internalised or, putting it another way, experienced as the recipient's own insight. This is one of the features I was trying to highlight in suggesting the model of dialogue. For dialogue surely conjures up an image of two persons responding to each other, with each trying to ensure that the other freely adopts the interlocutor's position as his own. In other words, persuasion towards self-acceptance is the order of the day, not compulsion. Now, of course, there is this difference in the divine case that it is a rather unequal dialogue, and the recipient is hardly trying to persuade God also to his view. But there is this similarity that, as in any dialogue, God will adapt his mode of discourse to the manner best calculated to persuade the recipient freely, and at the same time base any further response in the light of the recipient's previous reaction.

Two objections to this second reason suggest themselves. First, it may be objected that such an emphasis on divine respect for a free human response sounds much too like a special *ad hoc* invention to deal with some embarrassing empirical facts. Secondly, doubts may be expressed about the intelligibility of the idea of God being misunderstood again and again. It may be suggested that, even if God does not wish to force a point on an individual, God must surely be able eventually to get a point across over the course of an individual's life. All it requires is persistence,

and so this cannot be used as an explanation of why serious flaws occur in the expression of a particular Biblical writer's thoughts.

On the first objection my response would be to point out how central is an emphasis on divine respect for human freedom in a totally different area, namely the problem of evil with its most commonly accepted solution, the so-called free-will defence.[53] So it would be very unfair to characterise this attribute of God as simply specially postulated to deal with the problem. In general, God desires a free response, not just with respect to revelation. It is, of course, in striking contrast to the traditional position in which revelation is seen as an alien (but welcomed) imposition from without. But then it has taken man a very long time to work out all the implications of the unique worth God seems to place on each and every individual. It is well-known how the Old Testament moves from corporate responsibility to individual.[54] The New Testament places still more emphasis on the value of the individual. If I am right about the proposed model, then this would merely be one small further development in that process, as the implications of Biblical scholarship's discovery of the extent of the fallibility of the scriptures are taken fully into account.

So far as the other objection is concerned, it should be remembered that of the four categories of religious experience which we distinguished in the previous chapter the Biblical record suggests that most of its contents must be fitted into what I called thematic experience, i.e. experience in which what others might see as ordinary events are given a religious theme or interpretation. In such experience without voices or visions it by no means follows that we must assume a deist explanation. For it might well be that God intervenes to suggest thoughts to the individual that he would not otherwise have had. But even if an individual were regularly to 'hear' such thoughts, it does not follow that he would 'hear' them as significant. Either the depth of the individual's prejudices or fear of stepping too far outside the religious susceptibilities of his age or doubt about whether he alone can be right about God and everyone else wrong – these and many other motives might well prevent an individual from ever accepting the validity of such thoughts, no matter how often they were presented to him by God.

There is in fact a clear secular parallel. An individual may often have revolutionary thoughts about what is true, but dismiss them out of hand as absurd because, if pronounced, no one in his society would take him seriously. It is one mark of genius to pursue such thoughts to see where they may lead. But it can also be a sign of madness. Hence, even the

[53] Seen, for instance, in the debate between J.L. Mackie and A. Plantinga in B. Mitchell (ed.), *The Philosophy of Religion* (Oxford University Press, 1971). It was an issue to which Mackie continued to attach considerable importance in his last contribution to the debate in *The Miracle of Theism* (Oxford University Press, 1982), pp. 150-76.

[54] Some illustrations are given in footnote 56.

genius may only be prepared to take some risks, and dismiss some of his thoughts, of which a later generation might have approved, as a mere temptation to folly. So, similarly with the recipient of revelation. Another undoubted parallel is the way in which blind spots can affect our perception of our fellow human beings, never mind God. Racial prejudice is one obvious widespread instance, where it can take an enormous amount of contact with instances to the contrary, e.g. intelligent blacks, generous Jews, etc., before any weakening of the prejudice occurs.

But, it may be said, if there is this problem with thematic religious experience why was not sensory experience employed more often, with the use of auditions, visions, etc.? In part the answer must be that, unless it were the central feature of the audition or vision, there is no guarantee that the corrective to the prejudice would be picked out as significant. As with racial prejudice, it would remain obfuscated, despite its obvious character had an impartial observer been present. But this cannot be the entire answer, since if it were the main feature of a direct audition or vision it could hardly be denied. Under such circumstances such a fundamental challenge to his presuppositions might well lead him to doubt the validity of the rest of his religious experience, but the main point seems to me to turn once again on this question of a free response. As with it seems to me all religious experience it is a matter of God carrying the individual further along a path which he has already indicated some willingness to pursue. In other words, revelation must be treated like the question of grace in general, as demanding synergism, the full cooperation of both parties. In a word, without a free response, God wishes no revelation.

Turning now to the explication of the model, I want to pursue its advantages under three headings: first, its emphasis on a past deposit conditioning present experience; secondly, the nature of this fallible but revelatory experience and the tests that may be employed to determine the extent of its veridical content; finally, the whole forward directional character of the analysis and the implications this has not only for our understanding of the Bible but also other religions and the history of the Church.

(i) Under the first heading two advantages of the model may briefly be mentioned.

The first is one to which I have already alluded, namely the ability it gives us to differentiate sharply between canon and revelation. The canon will be the deposit that indicates where the community believes itself to have got to in its process of understanding, but not all of it needs to be regarded as having been itself a product of revelation at some stage in the past. Inevitably, there will have been some mistakes and also, as noted earlier in the chapter, it will include material that is more appropriately regarded as the work of reason. Interestingly too, on this definition of 'canon' it becomes highly misleading simply to describe the

Bible, *tout court*, as the canon of the Church, the deposit that conditions the experience of believers. For, clearly, in medieval times it was rather the Bible as interpreted by the Church, with the Creeds placed on a par with the Bible, just as for the twentieth-century Christian it is equally clearly not the Bible but a highly selective version of it.

The second advantage of this emphasis on a canonical deposit as the backdrop to all revelatory experience is the way in which it acknowledges the extent to which our present possibilities for perception depend on how our community has shaped us, and so helps to explain why from the point of view of the later community the Bible contains much moral and doctrinal material that it would wish to reject totally. Advance in understanding has occurred. Thus, it is undoubtedly the case that some of the Psalms assume the existence of other gods,[55] a proposition that is denied elsewhere in the Bible. Again, the story of Achan in the book of Joshua assumes a theory of corporate punishment without reference to individual guilt that is explicitly denied in the prophets Jeremiah and Ezekiel.[56] A related illustration would be the way in which several Old Testament passages assume a connection between material prosperity and divine favour,[57] a thesis that is challenged from within the Bible itself by the book of Job, as also by Jesus himself. Another case would be the way in which the shadowy existence in Sheol is replaced by a very positive hope in the resurrection of the body. And so the list might go on.

Or, to give some moral examples, one might mention the concluding verse of Psalm 137, which one can only describe as morally outrageous. Yet there is no reason for doubting that the author believed such blood-curdling sentiments against the children of Babylon to be in accordance with the divine will. Indeed, we are sometimes explicitly told that some dreadful piece of conduct is the divine will, as, for example, the injunction to kill all the native inhabitants of the land of Israel, including women and children.[58]

Both in the light of later revelation and on the basis of our natural moral sensibilities, we must say that such never could have been the divine will. Yet, at the same time, given the extent of the divine accommodation within the dialogue, to acknowledge this is not also to force oneself into the admission that the individuals who expressed such sentiments had no direct personal experience of God. Rather, all we need say is that, though God advanced their moral perceptions, he brought them nowhere near what would eventually be seen to be the divine will.

Such an approach will, I believe, commit one to regarding large tracts of the Bible as of purely historical, as distinct from religious, interest –

[55] Psalms 82, 86, 97; contrast I Corinthians 8:4.
[56] Joshua 7; contrast Jeremiah 31:29 and Ezekiel 18:2.
[57] E.g. Psalm 2; contrast Job 2:3 and the subsequent story, and John 9:3.
[58] Deuteronomy 20:16-18.

mere past stages in the history of the dialogue. A critic might object that such an account merely reflects modern squeamishness. This seems to me quite wrong. Even in the early Church there was a similar embarrassment, that was one of the main motivating factors towards the use of allegory.

For example, Gregory of Nyssa in his *Life of Moses* makes it clear that certain events as recorded are incompatible with the goodness of God. His view is that they are therefore unlikely to have taken place, and their presence in Scripture is due to their allegorical significance, not their literal truth. For instance, on the putting to death of the Egyptian first-born he remarks: 'How would a concept worthy of God be preserved in the description of what happened if one looked only to the history? The Egyptian acts unjustly and in his place is punished his new born child, who in his infancy cannot discern what is good and what is not ... If such a one now pays the penalty of his father's wickedness, where is justice? Where is piety? Where is holiness? ... How can the history so contradict reason?'[59] Nor is this the only point at which Gregory challenges the moral worth of the historical account. Other examples would be his rejection of the view that God hardened Pharaoh's heart ('if this were to be willed by the divine nature, then certainly any human choice would fall into line in every case, so that no distinction between virtue and vice in life could be observed'); and his rejection of the implied divine sanctioning of the 'borrowing' by the Israelites of things from the Egyptians which they had no intention of returning.[60] Nor is such a critique confined in the patristic period to those who in any case favoured an allegorical interpretation of much of Scripture. Even Augustine, whose natural sympathies are with the literal interpretation, sometimes finds himself so embarrassed by the moral implications of the literal sense that he looks for an appropriate meaning elsewhere. For example, he finds it impossible to believe that the divine approval which is accorded to Jacob's act of setting up rods whereby his father-in-law Laban is deceived into conceding most of the flocks to himself[61] indicates divine approval of such deception. His suggestion is that the real divine intention was that Jacob should perform an acted prophecy of the coming of Christ.[62]

Nor were such challenges to the Scriptures always motivated by an appeal to conscience or natural reason. Sometimes later revelation is used as the measure, as, for instance, when Gregory of Nyssa in the passage already quoted follows the question 'Where is holiness?' with the further question: 'Where is Ezekiel, who cries: The man who has sinned

[59] St. Gregory of Nyssa, *The Life of Moses* (trans. A.J. Malherbe & E. Ferguson in *The Classics of Western Spirituality*, Paulist Press, New York, 1978), p. 75.

[60] Ibid., p. 71 and p. 80

[61] Genesis 30:25ff. Divine approval is indicated in Genesis 31:11-12.

[62] *Quaestiones in Heptateuchum* 1.93.

is the man who must die, and the son is not to suffer for the sins of the father?' Yet, even so, the notion of a progressive dialogue which I am proposing as the model for understanding revelation is not something which entered into his horizons.

(ii) I turn now to the second element which I said I wanted to discuss, the revelatory experiences themselves and the manner in which truth might be deduced from them.

So far as the Biblical writings themselves are concerned, in general they offer us reflections on religious experience rather than claim themselves to be such experiences, or, if they do make the claim, at most they then offer what I earlier called thematic experience: that is to say, the experience is constituted by giving a religious theme to events which others might equally interpret non-religiously. Whether such reflections and thematic experiences should be interpreted as directly divinely caused, I do not propose to discuss here. On the whole, I would regard such a postulation as unnecessary, and it is not here that I would wish in any case to locate what might be called the core revelatory experiences. For it seems to me that these are of a rather different sort, involving numinous experience or sensory phenomena (auditions, visions, etc.) or mystical experiences of union. At this point, the typical liberal Protestant theologian will, no doubt, hold up his hands in horror at the sorts of experiences being appealed to, but it seems to me that there just is no escaping how central a role religious experience of a non-thematic kind does actually play in the Bible.

Thus there is a growing conviction among Old Testament scholars that the Sinai tradition is the oldest Yahwistic tradition for which we have clear evidence. Nicholson in *Exodus and Sinai in History and Tradition* certainly is prepared to declare that 'it seems clear that there was from ancient times a special relationship between Yahweh and mount Sinai, a relationship which was already in existence before the Exodus from Egypt and the emergence of Israel.'[63] If this is so, then it is possible to conceive of the process of the Christian revelation beginning with some definitive religious experience at Sinai, perhaps of a numinous kind of the sort recorded in Exodus 19: 16. However, that may be, certainly by the time of the prophets, direct religious experience plays a crucial role, particularly sensory experience. This is perhaps the most valuable corrective that Linblom is able to offer to traditional accounts of the prophets in his book *Prophecy in Ancient Israel*. Although he does not insist on a theist explanation, he devotes over two hundred pages[64] to the

[63] E.W. Nicholson, *Exodus and Sinai in History and Tradition* (Blackwell, Oxford, 1973), p. 63. Pannenberg's insistence in *Revelation as History* (p. 134) on excluding Israel's early history from the supernatural activity of God and confining it to the period of Christ is not only unnecessarily dogmatic; it also makes any such claim less credible because so different from the normal pattern of divine activity.

[64] J. Lindblom, *Prophecy in Ancient Israel* (Blackwell, Oxford, 1962), pp. 1-219; his brief comment on interventionism is on p. 219.

religious experience of the prophets, particularly to its abnormal character. No one reading Linblom can fail to be persuaded that sensory experience is crucial to the attitude of the prophets. He does not deny that some are literary creations, even as early as Jeremiah, but his view seems to be that these are a minority in the prophets, though expansion of ecstatic visions, e.g. Ezekiel's concluding vision, undoubtedly occurs.[65] However that may be, with Apocalyptic sensory experience continues to play a crucial role. Russell in *The Method and Message of Jewish Apocalyptic* devotes a chapter to consideration of the experience of apocalyptic writers. His conclusion is as follows: 'A balanced judgment may be that in apocalyptic inspiration we have a link between the original inspiration of the prophets and the more modern inspiration of a literary kind. Again and again the apocalyptist showed that he believed himself to be writing under the direct influence of the spirit of God in a manner akin to that of the prophets and even when he accepted the conventional literary framework, as he often did, he still believed himself to be divinely inspired.'[66] At the same time earlier in the same chapter Russell had remarked that 'the reader is conscious of a certain artificiality about the literature as a whole whose description of visionary experiences, for example, give the impression of pseudo-ecstasy and assumed inspiration'.[67] What is perceived to be direct divine intervention thus does not play as prominent a role as with the prophets, but none the less it still plays a key role. Perhaps the Apocalypse of John is the best example in the Bible for seeing the way in which literary creation has come to dominate but in which an original vision none the less plays its part. As Linblom says, it is 'a combination of genuine vision and literary visions, in which the reflection of the visionary plays a more marked part'.[68]

But the key role of non-thematic experience can hardly be said to end with the Old Testament. For, as later chapters suggest, the two key experiences of the New Testament are also of this type, namely the Resurrection and Pentecost, one of which is best seen as a sensory experience, the other as mystical. Nor can it be seriously maintained that such types of experience are unique to these two cases in the New Testament. St. Paul's conversion was clearly a sensory experience, while much of his writing is unintelligible unless we assume that he was regularly subject to mystical experiences. 2 Corinthians 12 describes what certainly sounds like a mystical experience. Moreover, it is introduced by a reference to 'visions and revelations' (in the plural) which Paul apparently has had. But in addition there are constant

[65] Jeremiah 4:13; 6:22-6; 31:15; 46 (so pp. 141-2); Ezekiel 40-8 (so p.147).

[66] D.S. Russell, *The Method and Message of Jewish Apocalyptic* (S.C.M., London, 1964), pp. 172-3.

[67] Ibid., p. 158.

[68] Op. cit., p. 145.

allusions throughout his writings that are most naturally interpreted as accounts of experiences of union, whether with Christ or the Holy Spirit. Again, whether we take the speeches in St. John's Gospel as the words of Christ or as the invention of St. John, they certainly read like an account of experiences of mystical union.

Thus, so far as concerns the form revelatory experience takes, there seems to be no insuperable difficulty in identifying the variety that such core experiences take. Nor is one troubled by the implausibility of having to postulate a type of experience – 'revelatory experience' – that is unique to the Bible. Far from it. In fact, the core experiences take the same shape as are to be found in standard non-Biblical experiences. This also has clear implications for how their content should be treated. For it means that we must subject such experiencees to exactly the same kind of tests as we would apply to non-Biblical experiences. That is to say, there would be the same two-stage process, the first stage being concerned to establish the veridical character or otherwise of the experience (that God was its cause), the second the degree to which its alleged content must be accepted (for there will also be a human contribution).

Nowhere can the contrast between the complexity of our present situation and its past presumed simplicity be seen more clearly than in the way Aquinas defends the veridical character of the Christian revelation in an early chapter of the *Summa Contra Gentiles*. The argument is very compressed, and it is possible to read it as an appeal to miracles and nothing more. But this would be a mistake. Certainly, an appeal to miracles is part of the argument – 'wonderful cures of illnesses ... the raising of the dead'. But mention is also made of 'the inspiration given to human minds, so that simple and untutored persons ... come to possess instantaneously the highest wisdom and the readiest eloquence'. That it is the highest wisdom he takes to be indicated by its unexpected character. 'In this faith there are truths preached that surpass every human intellect; the pleasures of the flesh are curbed; it is taught that the things of the world should be spurned.' Again, appeal is made to prophecy: 'Now, that this has happened neither without preparation nor by chance, but as a result of the dispensation of God, is clear from the fact that through many pronouncements of the ancient prophets God had foretold that he would do this.' Finally, he declares that 'this wonderful conversion of the world to the Christian faith is the clearest witness of the signs given in the past'.[69] Nor is he unaware of the necessity of testing the alternatives. Indeed, he argues that Islam decisively fails on such criteria. For instance, 'Mohammed seduced the people by promises of carnal pleasure to which the concupiscence of the flesh goads us'. Also,

[69] St. Thomas Aquinas, *Summa Contra Gentiles* I.6 (trans. A.C. Pegis, University of Notre Dame Press, Notre Dame 1975 ed). All the quotations are from p. 72.

'he did not bring forth any signs produced in a supernatural way, which alone fittingly gives witness to divine inspiration; for a visible action that can be only divine reveals an invisibly inspired teacher of truth. On the contrary, Mohammed said that he was sent in the power of his arms – which are signs not lacking even to robbers and tyrants.'[70]

Unfortunately, as has already been implied in the course of our discussion, none of these criteria are adequate. In the case of prophecy we have already noted the way in which the messianic prophecies were understood very differently. Indeed it is possible to provide an instance of the prophets themselves acknowledging that their prophecies had a provisional or conditional character. Thus Jeremiah is saved from death despite prophesing the destruction of the city because the people recalled an apparently unconditional prophecy of the earlier prophet Micah which in retrospect had been seen to be conditional.[71] Again, the astonishing growth of Christianity cannot be used as an argument in view of our heavy emphasis on human freedom. Given divine respect for it, there could have been no guarantee for such growth, and it is always possible that the growth represents a perversion of the divine purposes. Likewise with miracles we cannot have Aquinas' certainties. As a theist I do not wish to deny the occurrence of miracles. The problem rather lies in the evidence for those associated with the Biblical revelation. In the case of the Exodus we have already noted that the miraculous element is probably a later legendary accretion. With the Resurrection, as Chapter 3 notes, the evidence for the Empty Tomb is late. Despite this, Chapter 3 argues for an interventionist explanation. But, irrespective of whether this is correct or not, the key point is that not only is the only evidence for Biblical miracles internal but even such evidence as there is can only, as we saw earlier, be accepted against the background of an already acknowledged theistic framework.

That leaves us with Aquinas' test of the unexpected character of the contents of the revelation. This is the only test which I think continues to hold up. Of course, *in extremis* the most unexpected utterances are those of the madman. But, while it may be difficult to formulate the difference, presumably what is required is both a degree of congruence with one's present perspective and some challenge to it of a sort which one feels that one would not have naturally discovered for oneself. This is still desperately vague, but not, I think, unintelligible. For example, love might have a very subordinate role in one's moral perspective, but what is claimed to be a revelation challenge one to give its demands a central role, but in a way which one believes one could never have perceived for oneself. This criterion is thus a matter of both continuity and difference.

What counts as an unexpected challenge to one's existing perspectives

[70] Ibid., p. 73.
[71] Jeremiah 26: 15-19; cf. Micah 3:12

will obviously be context-dependent, i.e. dependent on what stage these perspectives have reached. For once the insights of a former revelation are embedded in a particular culture, clearly they may not appear to have the same novelty and so not appear to necessitate in the same way an appeal to an external source of inspiration as an explanation. For example, neither Israel's early opposition to images nor its later insistence on absolute monotheism seems to us today a particularly startling insight. But in the context of the time both seem to have been very much against the grain of the surrounding cultures. On the question of monotheism, Lindblom notes that there were gods in neighbouring cultures that were treated as universal gods, i.e. rulers of heaven and earth, but argues that they do not provide a proper parallel since 'we have a universalism which never breaks the bounds of polytheism'.[72] Again, we should note that explicit monotheism only arrived in Israel at the time of Deutero-Isaiah during the Exile. As Ackroyd observes, given that it was a period at which Israel's fortunes had reached an all time low, 'the probability is that we should recognise that the degree of the disaster would lead to a more definite supposition that the gods of Babylon had superior power'.[73] But yet exactly the opposite happens with Deutero-Isaiah's insistence on the sole existence of Yahweh as God.

Now, of course, whatever instance one takes it will still be possible to put forward a deist or atheist explanation of the development. My point is simply that, when the cultural context is examined, the case for special revelation under this test of content is by no means a weak one – provided, that is, we apply the test in direct relation to the context, not with reference to our knowledge today. For example, today we might reach a position of absolute monotheism through abstract philosophical reflection. But there is nothing to suggest that this is how Deutero-Isaiah's mind worked. Rather, it was something he discovered on the basis of his experience of God. This is an important point to bear in mind. For it means that we should not think of revelation and reason as necessarily two mutually exclusive vehicles towards reaching the truth about God. Thus it may well often be the case that all the revelatory process does is enable a particular individual to grasp a truth that could also have been independently ascertained and confirmed by reason. Monotheism is the example we have just mentioned. But, equally, this might have been said about the central moral insights of the Bible. For it may well be that these can be independently defended, but that any such defence would compare unfavourably in complexity with the simplicity of the insight afforded by a particular revelatory experience.

An opponent of theism might object to what I have said so far by suggesting that he is not required to give a detailed alternative

[72] Op. cit., p. 333.
[73] Op. cit., p. 42.

explanation of the development. All he need say is that it is like the inspired insight of any other genius, for example, scientific or artistic, where we do not think it necessary to postulate a cause over and above the workings of that individual mind. But there is, of course, this difference. The 'inspiration' of the religious genius is no mere metaphor. For he claims to be able to identify the source of his inspiration as another Person. This introduces a second test for veridical character, in addition to the innovatory quality already mentioned, namely the form of the experience and the extent to which interpreting it in anything other than revelatory terms would be to denigrate it.

Here I have in mind the extent to which the revelation is understood in directly personalist terms. For, as I argued in the previous chapter, only theism can offer a non-reductionist account of mystical and sensory experience, i.e. an account which takes seriously the way in which the recipient perceives his experience, viz. as personal communion and interchange or direct confrontation with some spiritual reality. To search for causes purely in the psychology and environment of the recipient would totally transform and diminish the type and extent of the relationship with God that is claimed. This might of course be all that can be claimed. But this is what the theist is concerned to deny. He sees the psychological input into mystical and numinous experience as no greater than in any other type of experience, and also reasons why God should voluntarily limit his operations within those conditions. Since this argument has already been pursued in detail in the previous chapter, no more need be said here.

A third test is that of the character of the recipient. Here two aspects seem relevant. First, there are the usual sorts of questions that test the reliability of the witness. In the case of the Biblical revelation we have no way of testing their general reliability in contexts other than the record of the revelation. For the record is all we have to go on. But this does not mean that there is no way of assessing the recipient's integrity in speaking the truth. For the record itself sometimes gives clear indication of the recipient's loyalty to the revelation he believes himself to have received. An obvious example is the book of Jeremiah which is full of autobiographical details and indicates clearly the price Jeremiah paid to witness to what he believed to be God's word. There is, for instance, the moving passage in Chapter 20 in which he describes some of the price he has had to pay for his witness, in the course of which he remarks: 'I used to say, "I will not think about him, I will not speak in his name any more." Then there seemed to be a fire burning in my heart, imprisoned in my bones. The effort to restrain it wearied me, I could not bear it.'[74] Again, we know that for the sake of loyalty to the revelation given to him he faced imprisonment and indeed only narrowly escaped death.[75] Of

[74] Jeremiah 20:19 (Jerusalem Bible).
[75] Jeremiah 37:11-38:13.

course, such conduct does not provide an absolute guarantee of the truth of what someone claims, but it does at least make one much more confident that he believes in the truth of what he is saying. As an example of such a test working in the opposite direction, we might take an incident from the life of Mohammed. For, despite Mohammed's emphasis on monotheism, we find him admitting at one point in the Koran[76] the value of prayers to three virgin goddesses, his object being to win over the Meccans. Such a subordination of the revelation that he claims to have received to purely expedient political motives must count against its veridical character. Whether it must do so decisively is of course another matter. It might simply represent a temporary weakness on Mohammed's part.

A rather different sort of character test that might be employed is the test of whether such close communion with God has had any effect on the person's character. For, given the perfect goodness of God, we might reasonably expect some degree of transformation in the recipient's moral attitudes and general state of mind. Indeed, such tests have been recommended by those who claim to have had sensory experiences themselves. For example, St. Teresa of Avila in *El Castillo Interior* suggests that true voices can be distinguished from false by the sense of certitude, peace and interior joy which they bring.[77] Unfortunately, this is not a test that can be applied to the Biblical revelation. For we know virtually nothing about the previous life-styles of the alleged recipients of revelation. But with non-Biblical claims to revelation, where we are much better informed, it can certainly play a useful role.

The fourth and final test which I want to mention is what may be called the test of congruity, the extent to which the putative revelatory experience can be seen to fit into a particular tradition of such experiences. It might be objected that there is an inherent conflict in this suggestion with the first test of innovatory character. But I do not think so. For, if the proposed model is correct, what we expect to happen is that the religious tradition will not stand still, but exhibit developments that both indicate continuity with the past and also the ability to transcend that past into new and richer forms of understanding. Put at its simplest, an experience will gain an additional cachet if it can be shown to be congruous with other experiences that are already believed to be veridical and thus part of a particular tradition of dialogue.

This is an important observation, so far as the Bible is concerned. For, to begin with, there is the problem that there is often insufficient information available for us to apply the other three tests. In addition, as already mentioned, so much of the Bible is best seen as reflection on such experiences rather than as the naked record itself. That being so, the only way of defending their status will sometimes be the way they exhibit

[76] Sura 53:19.
[77] Reference given in footnote 81 to Chapter 1.

congruity with the tradition. Nor need this test always be a forward-looking process. Thus, even if the Christian regards the revelatory experiences surrounding the life, death and resurrection of Jesus as the most firmly secure as revelation, and all else in doubt, he can still argue backwards towards a special status for earlier experiences, for example those of the prophets, on the grounds that these can appropriately be seen as anticipatory of the later definitive experiences.

However, a word of caution with regard to this argument is perhaps necessary – a caution which can also be related to some comments about what I earlier described as the second stage in the process of assessment, the decision about how much of the content is to be accepted, as distinct from the decision about whether to regard the experience as veridical or not. So far as the Bible is concerned, at least three layers should be distinguished.

First, we should be firmly on our guard against simply identifying the various books of the Bible with a revelatory deposit. In the first part of this chapter I mentioned the Wisdom literature, which is best characterised as a work of pure reason, though still having authority as part of the canon that helped to determine the subsequent direction of the community's experience. But this is by no means the only example. Another would be Chronicles, which reads more like a primitive attempt at a theology of providence than as reflections on particular profound experiences. At all events, it is a theology that penetrates to no deep level, the history of the kings of Judah being seen as no more than a series of rewards and punishments according to their attitude to religion.

Secondly, there are books that are reflections on religious experience. This is certainly the dominant category, though the extent to which reflection has taken over varies enormously. But the reflective element needs to be emphasised, since it frees us from always feeling bound by the content of the books concerned, whereas whatever authority a book has comes only from the religious experience from which it is derived. An example will make the point clearer. Paul was undoubtedly the subject of some profound religious experiences. But this does not mean that we should feel under any obligation as a result to treat with respect the uses to which reason is often put in his Epistles, when he is expanding upon those basic experiences. Thus the experience on which the Epistle to the Romans is based is that of justification by faith, but it is immersed in arguments that cannot carry conviction with us today. Central to the argument of Chapters 1-8 is his appeal to the fact that Abraham was justified before the coming of the Law,[78] but the net effect of the appeal is to call into question the divine purpose in ever having introduced the Law, and indeed his comments on its function give it a wholly negative role.[79] Again, in the second half (chapters 9-11) there emerges his strange

[78] Cf. Romans 4.
[79] Romans 7, esp. v. 7ff.

conviction that his mission to the Gentiles is intended by God as a means of converting the Jews,[80] the full ramifications of which are effectively brought out in Munck's book, *Paul and the Salvation of Mankind.*[81] Likewise, it is hard to resist Schillebeeckx's assessment of the argument of the author of the Epistle to the Hebrews,[82] in which he attempts to demonstrate that Christ's priesthood is higher than the Levitical by placing Christ in the priesthood of Melchizedek: 'All this seems to us to be a fantastic exegesis of the Tanach, but this was not the case for the Jews of the time. Of course, the author of Hebrews retained his experience of Christ before embarking on an argument of this kind. His experience is that decisive and definitive salvation is given by God in Jesus ... compared with it, everything else pales into insignificance. Hebrews really does not need this argument from scripture ... Genuine Christian experience has an authority of its own, and does not need to be grounded in ancient texts, however sacred they may be.'[83]

Finally, even at the layer of the experience itself, it is not the case that it comes 'neat', as it were. In fact, as the investigations of the next two chapters will reveal, analysis of the definitive experiences for the doctrine of the Trinity is hardly a straightforward matter. Nor is this surprising. It is not just that such experiences are seldom described 'just as they happened', but also that, even where it is possible to get back to the experience as it was viewed by the original recipient, this is still not the final point of adjudication. For it may be that its content, when ascertained, is such that an impartial observer can detect a significance (whether greater or less) unbeknown to the recipient. At all events, this phenomenon is illustrated in both the subsequent chapters.

But, it may be objected, given this degree of complexity, how can the second stage ever be accomplished? I do not pretend that the task is an easy one. But the next two chapters give two very different examples of how the process might operate in detail. At the same time it must be conceded that at least in these two illustrations (Resurrection and Pentecost) there is a degree of access to the relevant experiences that is not always present elsewhere. For example, with Jesus we have his claim to intimacy with the Father but no description of the sort of experiences upon which such a claim might be based. That being so, what authority we assign to his insights into the divine will must be dependent upon a prior decision about his status in general. In other words, the authority of his teaching will be derived from an independent verdict about his status, not simply or primarily from an assessment of his religious experience.

Finally, it should perhaps be emphasised that I am not claiming that

[80] Cf. esp. 11:13-14.
[81] J. Munck, *Paul and the Salvation of Mankind* (S.C.M., London, 1959), esp. ch. 2.
[82] Hebrews 7.
[83] E. Schillebeeckx, *Christ*, pp. 250-1.

such core religious experiences are the only place where direct divine intervention operates within the revelatory tradition. In fact, it seems to me that the reflective stage could equally well be interpreted as part of the continuing divine dialogue. Even what seem to us bad arguments, such as those in Paul and Hebrews, might have been the most appropriate at that stage of the community's development. Rather, my point is that it is the core experiences that most compel the interventionist dialogue model because to interpret them in any other way would be to denigrate the fundamental character of the way in which they have been experienced, whereas in the case of reflective writing we are mostly ignorant of the conditions under which it was written.

(iii) It remains now to say something about the whole directional character of the process. This I examine under three headings: first, the way in which the original significance of a revelatory text may become superseded; secondly, the application and relevance of the model to other religions; and, lastly, the relation between revelation and the continuing history of the Church.

First, then, something needs to be said about past revelatory texts which in the light of the later experiential history of the community might be thought likely to become redundant. Certainly, if we take the directional character of the model of divine dialogue seriously, this is what we might have expected to happen. But in large measure this is not so. Two reasons may be given, the first of which is purely secular and appeals to Gadamer's work, *Truth and Method*, while the second posits a divine motivation that would lead to the refurbishing of the past.

Gadamer remarks that 'the artist who creates something is not the ideal interpreter of it. As an interpreter he has no automatic priority as an authority over the man who is simply receiving his work. He is, insofar as he reflects on his own work, his own reader ... The only criterion of interpretation is the significance of his creation, what it "means". Thus the idea of production by genius performs an important theoretical task, in that it does away with the distinction between interpreter and author.'[84] Such a claim could, of course, be carried to absurd extremes in which the historical context including the intention of the author is regarded as a complete irrelevance. But it does contain the profound truth that the life of any literary text, including the Bible, is greater than simply its original setting. Gadamer is particularly enlightening in his comments on the role of tradition. He notes that even the Reformers, despite their claim to rely on scripture alone, used the tradition of Protestant credal formulae as a guide towards understanding the text.[85] Likewise, he insists on the inevitability of our approaching a text with certain 'prejudices' (*Vorurteil*) given to us by the tradition. 'In fact

[84] H.-G. Gadamar, *Truth and Method* (Sheed and Ward, London, 1979), p. 170.
[85] Ibid., p. 155.

history does not belong to us, but we belong to it. Long before we understand ourselves through the process of self-examination, we understand ourselves in a self-evident way in the family, society and state in which we live ... The self-awareness of the individual is only a flickering in the closed circuits of historical life. That is why the prejudices of the individual, far more than his judgments, constitute the historical reality of his being.'[86] But this does not mean that he thinks we are trapped in our present prejudices. Rather he sees a present confrontation with a past text as itself contributing to the shaping of the tradition, so that tradition is not something static but is itself always on the move, if it is truly in dialogue with its past. He describes the process in the dramatic image of the fusion of horizons (*Horizontverschmelzung*). As he puts it: 'Horizons change for a person who is moving. Thus the horizon of the past, out of which all human life lives and which exists in the form of tradition, is always in motion ... Our own past, and that other past towards which our historical consciousness is directed, help to shape this moving horizon out of which human life always lives, and which determines it as tradition.[87]

David Tracy, in *The Analogical Imagination*, makes a similar point. He draws our attention to the process which he calls a 'hermeneutics of retrieval',[88] whereby a 'religious classic' takes on a life of its own and acquires an ability to speak to another age. Indeed, he insists that 'a necessary condition for the preservation of that meaning ... is a distancing from the author, from the original situation and from the original audience.'[89] Thereby hermeneutics becomes not just re-statement but a highly creative process, as the original classic perhaps inspires the production of a new classic that is itself genuinely innovatory. Unfortunately for our purposes, the examples he has in mind are non-Biblical, e.g. Barth's retrieval of Calvin and Lonergan's and Rahner's retrieval of Aquinas.[90] Likewise, Gadamer gives no illustrations of specific applications of his insights to the Bible. That there are such I shall shortly suggest. But, first, in order to give them their proper context, let me mention the second reason for expecting a continuing relevance of the past, the religious dimension in the divine motivation that might bring this about.

This divine motivation can most easily be explained in terms of the following question: If God is really engaged in a continuing divine dialogue of the sort described, but finds human beings ascribing permanent significance to what he regarded as only a transitory and provisional aspect of the dialogue, what could be more natural than that

[86] Ibid., p. 245.
[87] Ibid., p. 271.
[88] D. Tracy, *The Analogical Imagination* (S.C.M., London, 1981); cf. esp, p. 199.
[89] Ibid., p. 128.
[90] Ibid., p. 104.

he should inspire re-interpretation of the material in question such that it then gains a more appropriate and lasting significance? At all events, this is one possible (and to me the most plausible) way to interpret how the revelatory documents have been frequently subject to revision.

Brevard Childs' *Introduction to the Old Testament as Scripture* is particularly interesting as highlighting the extent to which editorial alterations to various books have transformed the content of the original revelation. For example, Childs admits that Amos' original message was one of unrelieved gloom, but comments on the redaction of Chapter 9: 'The effect of the canonical shaping of ch. 9 is to place Amos' words of judgment within a larger theological framework, which, on the one hand, confirms the truth of Amos' prophecy of doom, and, on the other hand, encompasses it within the promise of God's will for hope and final redemption. In its canonically interpreted form the historically conditioned ministry of the eighth century prophet of judgment serves as a truthful witness of scripture for the successive generations of Israel.'[91] Again, of the composite book of Isaiah he remarks that the editorial aim was to emphasise that 'sinful Israel would always be the object of divine terror; repentant Israel would receive his promises of forgiveness. To assure this theological understanding, the redaction of the book as a whole also assigned promise to First Isaiah and judgment to Second (and Third) Isaiah.'[92]

But Childs carries his approach beyond the bounds of probability when the whole Hebrew canon is found to achieve some kind of rationale by these means. After all, one could scarcely get lower than Nahum and Obadiah with their nasty unrelieved vindictiveness on Nineveh and Edom.[93] Again, it is hard to see why Ecclesiastes secured a place in the canon. As G.W. Anderson comments: 'Ecclesiastes was suspect because it appeared to contradict itself (e.g. 4,2; 9,2) and because it was alleged to contain heretical material (e.g. 1,3). How these difficulties were overcome is not clear. Perhaps the attribution of the book to Solomon, together with the presence in it, and at its close, of expressions of traditional orthodoxy and piety, secured its place in the Canon.'[94] Childs suggests that its place in the Canon is deserved because of its corrective role: 'Koheleth's sayings do not have an independent status, but function as a critical corective, much as the book of James serves in the New Testament as an essential corrective to misunderstanding the Pauline letters.'[95] But this seems very unfair to James. The pessimism and

[91] B. Childs, *Introduction to the Old Testament as Scripture* (S.C.M., London, 1979), pp. 407-8.

[92] Ibid., p. 327.

[93] Nahum 3 is particularly repulsive.

[94] G.W. Anderson, 'Canonical and non-canonical', in *The Cambridge History of the Bible* (Cambridge University Press, 1970), vol. 1, p. 134.

[95] Op. cit., p. 588.

negativity of Ecclesiastes do not seem revelatory at all, and do not give the impression of being based on any religious experience, except its absence! One's suspicion is, therefore, that it only got in because of the false ascription of authorship to Solomon.

Nor need there be any difficulty about providing other examples. For instance, the fact that Ezra-Nehemiah achieved admission to the canon despite its apparent endorsement of national exclusiveness even to the extent of requiring compulsory divorce of non-Jews need not have been a source of worry, provided that its status was controlled by the more tolerant attitudes of some of the prophets, e.g. Amos and Deutero-Isaiah and the Deuteronomic legislation. But in fact what happened instead was an increasing endorsement of such attitudes to the point where a totally jingoistic and unreligious book like Esther gained admission to the canon, despite the protests of books like Ruth and Jonah. The baneful influence of such exclusiveness is felt to this day in some of the more extreme Evangelical sects. Yet it is an influence that could so easily have been avoided if it had been acknowledged as an aspect of the past that needed to be unequivocally rejected.

Thus, in emphasising the directional character of the model, I should not be taken as implying an automatic endorsement of every book contained within the canon of the Scriptures. Far from it. At most, what I am suggesting is a presumption in favour of some divine corrective, should things go badly wrong. This may be illustrated further by what happened to the book of Esther.

Of the additions proposed by the Apocrypha to the Hebrew Canon, Esther seems to me to be incomparably improved. As is well known, the original version nowhere mentions God, and it is very difficult to read it except as a narrow piece of Jewish nationalism. Luther certainly pronounced a negative verdict on its worth. One cannot help thinking that Childs is trying just a little too hard when he offers the following justification: 'On the one hand the book of Esther provides the strongest canonical warrant in the whole Old Testament for the religious significance of the Jewish people in an ethnic sense. The inclusion of Esther within the Christian canon serves as a check against all attempts to spiritualise the concept of Israel – usually by misinterpreting Paul – and thus removing the ultimate scandal of biblical particularity. On the other hand, the canonical shape of Esther has built into the fabric of the book a theological criticism of all forms of nationalism which occurs whenever 'Jewishness' is divorced from the sacred traditions which constitute the grounds of Israel's existence under God.'[96] But, on the first point, it seems doubtful whether the reminder is required. We have after all the whole of the Old Testament! His other point is the interpretation he gives to the institution of the Feast of Purim as recorded at the end of

[96] Ibid., pp. 606-7.

the Hebrew version.[97] But we should note that it also makes no reference to God and it reads as purely a nationalistic celebration. The Greek additions, in fact, transform the book, as any unbiased reading of the two versions immediately suggests. For example, Mordecai's refusal to bow is changed from nationalistic pride to a religious motive of obedience to God.[98] Metzger objects[99] that inconsistencies in the narrative are introduced. This is true, but they are only disclosed by a careful reading of what is in any case not an historical narrative.

Indeed, is it not possible that we should detect direct divine inspiration in the creation of these additions by the Greek editor? For it cannot have been consonant with the divine will that a book so inconsistent with the general drift of his divine dialogue with Israel should have achieved the status of revelation. And so it is perhaps not too fanciful to suppose that he inspired someone to make suitable correctives to what was now incapable of being displaced from its special status as part of the process of divine dialogue.

Another example we might take is the Song of Songs. In its original meaning we cannot possibly interpret it as anything other than a series of secular love songs, and even then any attempt to justify its inclusion in the canon on the grounds that 'the love that is declared here would have meaning only in a lifelong monogamous partnership'[100] rings utterly hollow. So too does the suggestion that it provided a useful corrective to any possible undervaluing of sexual love. For in fact, of course, the corrective to errors in the Christian tradition, when it came, came not from this book but from the secular conscience. Rather, what must be said is that it had originally no justification for being in the canon apart from a pious but false belief about its authorship, but that it was given a far more profound interpretation by its later history, particularly in the sermons of St. Bernard, with his allegorisation in terms of Christ's love for his Church. It is also interesting to observe that St. Bernard believed his interpretation to be the result of a revelation.[101]

However that may be, lest the reader think that the point I am making is confined to relatively minor Old Testament books, let me give as one final illustration the Gospels themselves. For, if the argument of the following chapter is correct, only St. John's Gospel offers an Incarnational view of Christ's life, and yet there was an Incarnation. In

[97] Esther 9:20-32.

[98] 3:2 (Hebrew). Contrast with Greek 4:17d-e (Jerusalem Bible enumeration) and 13:12-14 (New English Bible).

[99] B.M. Metzger, *An Introduction to the Apocrypha* (Oxford University Press, 1977), pp. 62-3.

[100] A.S. Herbert in his introduction to the book in *Peake's Commentary on the Bible* Nelson, 1962), p. 469; margin number 406m.

[101] Canticle 74; quoted in E. Underhill, *Mystics of the Church* (James Clarke, Cambridge, 1925), pp. 86-7.

such circumstances it seems to me that the best course for the Church to pursue is neither to discount the other gospels nor to read them in the sense which their authors originally intended, but to read them as the Church has always read them, that is, with the hindsight of the credal formulae which St. John's Gospel largely helped to shape. Whether this is a plausible claim or not will have to await the detailed arguments of the following chapter.

In the meantime the next aspect of the directional quality of the model which I wish to underline is the possibility which it affords of some degree of reconciliation between the conflicting claims of the world's major religions. Certainly, neither of the two extremes in the understanding of their relationship has much plausibility. Thus, on the other hand, if we say they are all on a par,[102] this immediately reduces the truth content of religion to a minimum, while, on the other hand, if we claim that God operates exclusively through one tradition,[103] we are confronted with the implausibility of a God of love abandoning the great mass of mankind without any direct awareness of himself and his purposes for them. But there is a third alternative.

For, if revelation operates in a dialogue, we cannot simply establish incompatibility by comparing religious experiences in different religious traditions directly with one another. Rather, we have also to try to assess what stage the divine dialogue has reached within the different traditions. For since the dialogue depends on human free will, there is every reason to suspect that different religious traditions may be at different stages, and that Christianity may in some respects be in advance of other religions and in others much behind. For example, there seems no reason in principle why Christianity must reject the Koran as a veridical revelation. Of course, there is much surface incompatibility. But to say that it is historically unreliable, as it is, is not decisively to reject it, since the Bible itself is not always historically accurate. The Koran contains many profound religious insights. One way of acknowledging this would be to see the divine dialogue as occurring with Mohammed at a stage roughly comparable with the great prophets of Israel, though historically Mohammed's experiences took place over a thousand years later. Nor is this as implausible as it may sound. For these experiences occurred in the context of a highly primitive society in which Mohammed had the greatest difficulty in persuading the tribes towards monotheism, never mind anything further. Indeed even today that part of the world maintains Old Testament ideas that the Christian Church has long since abandoned. As King Faisal of Saudi Arabia once asked, 'Who do you think gave us all the oil and money?' In other words,

[102] As in J. Hick, *God and the Universe of Faiths* (Fount Paperback, London, 1977).
[103] As in H. Kraemer's classic, *The Christian Message in a Non-Christian World* (Edinburgh House Press and Harper, New York, 1938).

a belief in a direct connexion between divine justice and national prosperity or adversity continues to this day. 'Totally oblivious of the vast mineral wealth that lay beneath the land they were conquering, the house of Saud performed brave and reckless deeds for the sake of their religion; and then, having pulled together both the eastern and western coasts of the peninsula, the family received the divine seal of approval on their adventure: out of the ground came oil.'[104] It is, I believe, by exploring this model of divine dialogue further that a true understanding of the relation between the different world religions will become possible – an understanding which demands neither exclusivity nor equality but sees each as engaged in a divine dialogue, though at different stages and in some respects more advanced, and in others more retrograde, than other religions.

Obviously, whether this is a plausible contention or not will depend on some detailed comparative work on the way in which revelation has developed within the different world religions. But one aspect that may greatly aid plausibility and thus acceptance should not be overlooked. This is the fact that the divine dialogue need not be seen as proceeding uniformly in one kind of way, and so insights can be gained at different stages within the different traditions. An example will make the point clearer. Mystical experiences of union seem only to occur first properly in the Christian tradition in the New Testament; in the Old Testament it is numinous and sensory experience that is particularly prominent. By contrast, in the early history of Hinduism it is mystical experience that very quickly comes to the fore, as is reflected in some of the Vedic hymns[105] but more particularly in the *Upanishads*, whereas it is only with the *Bhagavad Gita* that numinous experience begins to be given due weight,[106] culminating in the Bhakti cults. Again, it is not impossible to argue, as Parrinder does in *Avatar and Incarnation*,[107] that more personal but legendary theophanies such as those of Krishna in the *Bhagavad Gita* helped to make comprehensible to the Hindu mind a notion of Incarnation that would have been inconceivable to the writers of the Upanishads. With Islam the situation is different again. The Koran is dominated by numinous experience,[108] but even so the necessary corrective to understanding of the character and activity of God that

[104] Robert Lacey in *The Times*, 30 June 1982: special supplement on Saudi Arabia, p. ii.

[105] Cf. R.C. Zaehner's remarks in *Hinduism*[2] (Oxford University Press, 1966), p. 40. The hymns from the tenth book of the Rig-Veda which he mentions are nos. 90, 121 and 129.

[106] Note especially the climax in Chapter 11: 'When Arjuna heard the words of Krishna he folded his hands trembling; and with faltering voice, and bowing in adoration he spoke ... How could they not bow down in love and adoration, before thee, God of gods, Spirit Supreme?' (11:35 & 37; pp. 92-3 in *The Bhagavad Gita*, trans. J. Mascaro, Penguin, London, 1962).

[107] G. Parrinder, *Avatar and Incarnation* (Faber, London, 1970); cf. esp. p. 277.

[108] Though there are exceptions that were to provide the germ for later mysticism, e.g: 'We (i.e. Allah) created man. We know the promptings of his soul, and are closer to him than the vein of his neck' (50:15; p. 120 in *The Koran*, trans. N.J. Dawood, Penguin, London, 1956).

mystical experience provides eventually came in the Sufi Movement of the ninth century onwards.

This reference to the way in which Sufism contributed to the divine dialogue in Islam provides a natural transition to the final aspect of the directional character of the model which I would like to comment upon. For, as with Islam, it seems to me impossible to maintain a sharp distinction between Bible and Church, so far as the continuing history of the dialogue is concerned. That there are far more profound uses of reason to be found in the history of the Church compared with the early attempts in the Bible should, of course, go without saying. But it might be thought that, since Part II defends a revelation of the doctrine of the Trinity as an implication of certain Biblical experiences, there is unlikely to be much further contributed by revelatory experiences at a later stage. But this would be a mistake. In fact, there would seem to me to be two ways in which later revelatory experience might make a significant contribution. The first is through what I call non-innovatory revelatory experience. What I have in mind here is the possibility of God intervening through a particular person's experience to produce something highly apposite for the direction of the Church at that time, but not of a kind that is innovatory in terms of what we may claim to know of God. I shall shortly give some examples. The other category is 'innovatory', but here I deliberately confine myself to not over-controversial examples, as I wish the readers' consideration of my point to be unclouded by possible prejudices introduced from elsewhere.

First, then, non-innovatory revelation. Earlier mention was made of some tests for the veridical character of religious experience, and the intriguing thing about such tests (and any others that may legitimately be brought forward) is that, whatever success they have in legitimising the experience of the prophets, they also succeed in legitimising much experience within the Church. In the days of Biblical infallibility there was, of course, thought to be a clear difference, but now that we know the prophets also to have had a limited understanding of the divine initiative any sharp differentiation must disappear, especially when we see some individuals in the life of the Church having been subject like them to profound religious experiences and also like them impelled to challenge and upbraid the society of their day.

An obvious case in point would seem to me to be St. Catherine of Siena. In her brief span of thirty-three years (1347-1380) not only did she lead a life of extraordinary sanctity but parallels from within it exist for all the main features of Biblical prophetic experience. Like them she felt compelled to utter and we know that her masterpiece, *Dialogue*, though probably later expanded, was dictated over a period of time in states of ecstasy.[109] Not only that, it contains records of visionary experiences of

[109] St. Catherine of Siena, *The Dialogue* (in The Classics of Western Spirituality, S.P.C.K., London, 1980), pp. 12-14.

the same sort of kind as the prophets, e.g. her vision of the Trinity at the Eucharist.[110] Likewise, there are emphatic denunciations of abuses within the contemporary Church. Admittedly there are differences. For example, the *Dialogue* does not mention individuals by name, but Catherine amply makes up for this in her letters, in which she is not afraid to take on anyone. The dyer's daughter from Siena did not hesitate to instruct and upbraid Gregory XI and Urban VI,[111] nor to reprimand the notorious Queen Joanna of Naples ('What account can you give?' A very bad one'),[112] and, most savagely of all, to indict the Cardinals who by their abstentions created the Great Schism: 'You have turned your backs, like mean knights afraid of your own shadows ... What made you do it? The poison of self-love.'[113] Like the prophets too of ancient Israel, those in power felt compelled to consult her and invite her to their palaces, despite the severity of what she might have to say to them. Nor is she an isolated example. Lindblom singles out another fourteenth-century saint for comparison with the prophets of ancient Israel, from his own native Sweden St. Bridget.[114] In the course of his discussion he mentions the same features to which we have pointed in respect of Catherine, though Bridget did have an advantage in being of noble birth.

Since both the examples so far mentioned are from medieval Catholicism, lest the reader be misled into thinking that it is my contention that only 'Catholic' religious experience can be defended as non-innovatory revelation, let me add one example which led at least indirectly to divisions within the Church, namely Martin Luther. It is amazing how often biographers of Luther make no specific reference to the *Turmerlebnis*, his own version of his discovery of justification by faith as a result of a very specific experience. This is true of both Bainton and Atkinson.[115] Part of the explanation may lie in embarrassment in the implied location of the experience – a privy. But there is no reason in principle why such an important experience should not have happened in such a context, and in any case, as Erikson points out,[116] given Luther's psychology it may have been particularly appropriate. At all events, the

[110] Ibid., section 3, p. 210.

[111] E.g. Letter 23 and Letter 56 in *I, Catherine; Selected writings of Catherine of Siena* (ed. and trans. K. Foster & M.J. Ronayne, Collins, London, 1980).

[112] Ibid., Letter 58, p. 257.

[113] Ibid., Letter 47, p. 209.

[114] Op. cit., pp. 19-26.

[115] J. Atkinson, *Martin Luther and the Birth of Protestantism* (Marshall, Morgan & Scott, New York, rev. ed., 1982), pp. 76-7; R. Bainton, *Here I Stand: A Life of Martin Luther* (Mentor Books, New York, 1950), pp. 45-51. Both use the word 'experience' but so describe it as to suggest that it was no more than the typical insight that a scholar might have. As Bainton puts it (p. 47): 'The solution to Luther's problems came in the midst of the performance of the daily task' – the daily task being, according to Bainton, not the privy, but preparation of Lectures on the Psalms.

[116] E.H. Erikson, *Young Man Luther* (Faber, London, 1958), pp. 198-200.

most recent detailed study of the experience by Cargill-Thompson[117] fully acknowledges its psychological significance. Admittedly, the experience is such that it may not seem to require a theist interpretation; it might just be the sort of insight that comes to an individual in his study. But I think we have to take into account the very direct way in which it was addressed to Luther's psychological difficulties, his so-called *Anfechtungen*, as also the very personal and direct way in which he describes the experience: 'Thereupon I felt myself to be reborn and to have gone through open doors into paradise.'[118] So, appearances notwithstanding, to read it in non-interventionist terms would be to reduce its significance. However that may be, the point I wish to underline is that the more we incline to a high view of the divine role in the Reformation and in particular to a view of this experience as not a human solution to an intellectual difficulty but a divine response to an individual in anguish, the more will we feel impelled to admit that non-innovatory revelation is a continuing phenomenon in the Church.

It may seem strange to call Luther's insight non-innovatory, and in fact I am uncertain how far it is appropriate to do so. For in some ways Luther's experience might be regarded as intermediate between non-innovatory and innovatory experience. Thus, while the experience was certainly also had by St. Paul, and while some subsequent theologians, e.g. St. Augustine, do make much of it, it is only really with Luther that the fundamental importance of the insight is fully acknowledged. In addition, we need to take account of the contention of Biblical critics such as Stendahl and Sanders[119] that the real thrust of the argument of the Epistle to the Romans lies elsewhere. For, if so, Paul, unlike Luther, may not have realised the full implications of his experience.

The second type of case I said we would consider is innovatory revelatory experience, but of a relatively non-controversial kind. As examples we shall take the Stigmata of St. Francis and the experience known as the Dark Night of the Soul, as recorded, for instance, in the writings of St. John of the Cross. Both admit of non-interventionist explanations, but for both it seems to me that the most satisfactory account is a theistic one of a specific divine action; not only that, but the experiences are best seen as revealing to us something more about the divine purposes than can be gauged from the New Testament revelation alone.

[117] W.D.J. Cargill-Thompson, *Studies in the Reformation* (Athlone Press, London, 1980) pp. 60-80. His challenge to its intellectual significance is misplaced, since there is no reason why it should not have been the spur to what was only slowly formulated.

[118] The general character of the experience, though without any reference to the privy, is described in Luther's own words in E.G. Rupp & B. Drewery, *Martin Luther: Documents of Modern History* (Arnold, London, 1970), Document 5, p. 5.

[119] K. Stendahl, *Paul among Jews and Gentiles* (S.C.M., London, 1977); cf. esp. pp. 2-4 and 28-9; E.P. Sanders, *Paul and Palestinian Judaism* (S.C.M., 1977), pp. 442-7 and 474ff.

If we take St. Francis first, a naturalist explanation is, of course, readily available – that it was simply the product of Francis' intense desire for total identification with Christ. But as an attempt at a complete explanation it fails to satisfy. To begin with, it is an explanation which for consistency would have to be extended to other 'abnormal' features of Francis' life, e.g. to what Moorman in his biography calls 'a series of divine strokes or visitations'[120] that led to his conversion. But to say that the voice which spoke to him from the Cross in the ruined church of St. Damian at Assisi[121] was in fact only a product of his internal psychology would be not only to undermine the personal and intimate nature of the communication, but also to cast doubt on its very validity as reflecting the will of God. So the interpretation of the Stigmata stand or fall with the interpretation of his life as a whole. But in any case, unlike later saints, who always had his example available as evidence of the possibility, St. Francis, being the first, cannot have known that such total identification with Christ was a real option. Moreover, though his prayers certainly exhibited a willingness to share in Christ's sufferings, our earliest records give no indication that he ever expected it to take this form.

But, it may be said, even if the experience was theistic, why speak of innovatory revelation? The answer I think, is, given by St. Bonaventure who in his *Life of St. Francis* comments on the reception of the Stigmata that 'the true love of Christ had transformed his lover into his image'.[122] He is probably alluding to Paul, but the point is that whereas with Paul we were given conceptual knowledge that salvation involved being 'changed into the same image',[123] with the life of Francis we are given experiential evidence, evidence that culminates in this experience of total identification. This is no doubt why St. Francis has always been the most popular of the saints, giving confirmation, as he does, of the nature of salvation and the possibility of its full realisation even in this life. He was in fact in his life the 'alter Christus' that St. Paul aspired to but, because of obvious character defects, such as pride,[124] never quite realised in this life.

My other example, however, does involve a conceptual advance. Nowhere does the New Testament speak of what later accounts of religious experience call 'the dark night of the soul' of which St. John of the Cross's work, *The Dark Night*, is but one, rather late instance.[125] Yet

[120] J.R.H. Moorman, *Saint Francis of Assisi* (S.P.C.K., London, 1976), p. 1.

[121] St. Bonaventure, *The Life of St. Francis* (in *The Classics of Western Spirituality*, S.P.C.K., London, 1978). The story is told in Chapter 2, pp. 191ff.

[122] Ibid. 13:5; p. 307.

[123] II Corinthians 3:18.

[124] Cf. e.g. Romans 15:17-21, with its admission of unwillingness 'to build on other men's foundations'.

[125] St. John of the Cross, *The Dark Night*, pp. 295-389 in *The Collected Works of St. John of the Cross* (ICS Publications, Institute of Carmelite Studies, Washington D.C., 1979).

there seems no doubt that it is a very widespread experience as part of the soul's progress which, without some official endorsement that it marks merely a stage on life's path, might well lead to total despair and to the abandonment of hope that one's previous relationship with God could ever be restored, far less that a richer and deeper one be given in its place. Thus what I am in effect saying, in calling the recording of such experiences 'innovatory revelation', is that, whether or not they occurred before the post-Biblical period, it is only then that they were recorded with sufficient clarity to be made public as part of the corporate witness of the Church – that is to say, as a witness to others that, should they also have such experiences, it by no means marks the end of their relationship with God, but rather can open up a still deeper relationship.

There is in fact a long tradition of seeing such a dark night as the all but necessary transitional phase between what has become known as the illuminative and the unitive ways, that is, between a profound sense of the presence and hand of God and an experience of union with him. Evelyn Underhill attempts a psychological explanation: 'Each great step forward will entail a period of lassitude and exhaustion in that mental machinery which he has pressed into service and probably overworked. When the higher centres have become exhausted under the great strain of a developed illuminated life, with its accompanying periods of intense lucidity, of deep contemplation, perhaps of visionary and auditory phenomena, the swing-back into the negative state occurs almost of necessity.'[126] This is surely an example of deism at its most poverty-stricken (a position adopted by Underhill throughout with her idea of man breaking through to levels of consciousness where the Absolute is already available to be experienced). For there is no evidence to suggest that the dark night is particularly associated with psychological or physical exhaustion, and the fact seems to have been specially hypothesised in order to provide a natural explanation. A much more plausible explanation is in fact available from the mystics themselves. It is a divinely ordained means of ensuring that the individual does not rest content with the rather earthly based joys he has so far been vouchsafed, but is led on to expect true contentment in exclusive dependence on God alone. Thus St. John mentions as the first of his tests for such a night that 'as these souls do not get satisfaction or consolation from the things of God, they do not get anything out of creatures either. Since God puts a soul in this dark night in order to dry up and purge its sensory appetite, He does not allow it to find sweetness or delight in anything.'[127] A couple of chapters later he continues: 'God so weans and recollects the appetites that they cannot find satisfaction in any of their objects. God proceeds thus so that by withdrawing the

[126] E. Underhill, *Mysticism* (Methuen, London, 1977 ed.), p. 456.
[127] Op. cit., p. 313; I,9,2.

appetites from other objects and recollecting them in Himself, He strengthens the soul and gives it the capacity for this strong union of love ... In this union the soul will love God intensely with all its strength and all its sensory and spiritual appetites.'[128] I suppose that it might be said that there is something odd in describing a withdrawal of divine activity as revelatory, but it does seem a legitimate use of the term, since its public endorsement provides reassurance to countless others that it is merely a transitional phase in the process of their personal relationship with God.

Part I has been concerned to provide a wider conceptual framework against which Part II will be seen to be more readily defensible. Thus Chapter 1 argued for the superiority of theism over deism, and Chapter 2 for the claim that, despite the extensive fallibility of the Scriptures, an interventionist model for revelation is none the less the most appropriate, both in terms of an understanding of the divine purpose and with regard to the model's ability to handle the available evidence. Part II will focus our attention much more narrowly. But many of the points already made will reappear and find further confirmation, e.g. the importance of certain core revelatory experiences.

[128] P. 353; II, 11,3. Underhill notes that this is the general view of the mystics (op. cit., pp. 472-3), but does not retract her earlier naturalist explanation.

PART II

THE JUSTIFICATION
OF THE DOCTRINE

Chapter Three

Incarnation: the Argument from History

It is important, here at the beginning of Part II, to emphasise the extent to which the persuasiveness of the conclusions reached in the course of the next two chapters is dependent on arguments already employed in Part I. In particular, two aspects of our previous discussion need to be underlined.

The first is the argument of Chapter 1 in defence of an interventionist account of divine activity. For, clearly, if we already believe that we have good reason to accept such an interpretation in many other cases, we will be far more willing to endorse the interventionist view of what happened in the case of Jesus (a view which, as we shall see, is indispensable to any strictly incarnational account of his life). This is not to say that the events surrounding his life, death and resurrection cannot be analysed independently of such presuppositions; nor is it to say that the only evidence for a theistic view of his life is based on arguments drawn from elsewhere. In what follows the evidence is in fact examined without resort to Part I, and in any case, as Chapter 1 has already conceded, even for the theist some experiences are best interpreted deistically. My point is thus not that, given the argument of Part I, the events of Jesus' life must be interpreted theistically, but that it will be so much easier to endorse such a view if the Incarnation is not being treated as some strange unique exception to a general deistic pattern of divine 'action'. Equally, we may add that, if we discover independent grounds for an interventionist model here, this will give more weight to such an interpretation when offered elsewhere.

The other aspect concerns the argument of Chapter 2, where a particular model of revelation was proposed. A similar strategy to that mentioned in the previous paragraph has in fact been employed. For, just as an interventionist account of Jesus' life becomes so much more plausible if it is not a unique exception, so the implausibility of postulating an incarnational account of Jesus' life as late but legitimate becomes dramatically lessened if such gradualism is seen to be the normal pattern of divine revelation. But that was precisely the argument of Chapter 2. For there I proposed a model in terms of a divine dialogue in which truth was only gradually perceived because of the way in which

God always respects the recipient's free will. Equally, however, here too the qualification needs to be made that Part I does not render Part II redundant. For, as I illustrated in Chapter 2, precisely because of the nature of the model with its emphasis on human freedom, such progress in understanding is not inevitable. Human beings can fail to comprehend because of deeply seated prejudices. There is thus only a presumption, not a certainty, in favour of progress, the presumption stemming from a conviction (based on its past history) that the theists' God wishes the dialogue with the community to continue and eventually be perfected. That being so, an independent examination of the doctrines discussed in Part II will likewise be able to strengthen or weaken this independently based conviction.

But, before we go any further, we must deal with an obvious objection. For, it may well be said, a philosophical theologian has no place delving in what is essentially an historical matter; the question of historical evidence for the doctrine should be left in the capable hands of New Testament scholars who, after all, see themselves as essentially historians; the philosophical theologian should content himself with building on the evidence they present, especially as previous attempts of philosophers to examine the evidence have shown little awareness of the historical problems.[1] Obviously, there are difficulties in setting out upon what are for me relatively uncharted seas, but this seems to me a risk that must be taken. For it can plausibly be argued that the lack of dialogue between philosophy and theology is in danger of sinking both ships (on the theology side, Biblical studies and doctrine; on the philosophy side, the philosophy of religion), through their failure to stock their ships with the appropriate ballast from the other discipline. Here, I will mention three specific ways in which the Biblical historian might be helped by reflections drawn from the philosopher, in respect of his examination of the historical evidence for the doctrine of the Incarnation.

First, there is what one might call general conceptual considerations. The most important of these is the question of what can properly be called an Incarnation. For reasons given in the Introduction detailed discussion of this is reserved for Part III. There in Chapter 5 the claim of theologians such as Donald Baillie and J.A.T. Robinson to be offering an incarnational account of Jesus' life is rejected, on the grounds that they fail to deliver the appropriate identity claim, that Jesus was in some literal sense God. That being so, the only two models for the Incarnation to which I refer in this Chapter are those which meet this criterion, and whose logical coherence is defended at length in Chapter 6, namely the Chalcedonian model and the Kenotic model. By the former, I understand, roughly, the view that Jesus was simultaneously God and

[1] The problem probably stems from the fact that many, if not most, philosophers of religion have never studied theology as an academic discipline.

man; by the latter, the view that God became man and then subsequently became God again. Reference to the two models is kept to a minimum in this chapter; for the details the reader should refer to Chapter 6.

However, even so, such general conceptual questions cannot be entirely relegated to Part III. So, for instance, in this chapter we shall have to discuss the conditions under which the Resurrection might legitimately be regarded as an objective event or, again, the question of when a person's words or deeds might implicitly commit him to a belief that explicitly he may even wish to deny. The consideration of such questions is more familiar to the philosopher than to the New Testament scholar and so, unless there is dialogue, the latter may simply misunderstand what conclusions he may legitimately draw from his material.

Secondly, there is the problem of setting minimum conditions for the next stage, as it were, if an adequate defence of the doctrine is to be sustained. In some ways this is simply a specific application of my first point. New Testament scholars are all agreed that various stages in the growth of the doctrine can be distinguished, but they differ in the amount of development they see, in particular on whether Jesus himself made any significant pronouncements on the subject. In this situation the philosopher can clarify what would actually count as a decisive undermining of the historical credibility of the doctrine. So, for example, I shall claim that evidence for Christ's fallibility is not necessarily of any adverse weight, but, on the other hand, this does not mean that total reliance can safely be placed on later stages of the development, such as the Resurrection experiences or reflections upon them; a claim to Christ's perfection (more narrowly defined) must still be maintained. Similarly with the Resurrection: historical evidence that a conviction of Christ's divinity grew immediately out of the Resurrection experiences is not necessary, but it is a minimum requirement that the objectivity of the experiences be maintained. Such questions are clearly not purely historical. So, unless the Biblical historian's examination of the historical material is reinforced by the reflections of the philosopher, he may make quite the wrong inferences about the effect of his researches upon the credibility of the doctrine.

The third and final way in which the philosophical theologian can help the Biblical historian is in avoiding the false equation of historical original with theological truth. For major mistakes seem inevitable unless the insights of a very different discipline, where truth is very differently perceived, are used to protect the New Testament scholar from this false assumption to which he is ineluctably drawn by the presuppositions of his discipline. All historians try to get back, so far as possible, to what one might call the historical original, what actually happened or was said. This carries with it the danger of inferring that

that is all that can or need be said on the matter; in short, that the historical original is none other than what is ultimately or theologically true.

In the case of the Old Testament the tendency to assign exclusive importance to the original words of the prophets, etc., has only recently begun to be reversed by the pioneering work of Brevard Childs on the canonical form of the books in *Introduction to the Old Testament as Scripture*. However, New Testament scholars might claim that this is a danger of which they have for long been aware, and at first sight their claim looks fair enough. With the advent of Form and Redaction Criticism New Testament scholars now clearly distinguish between 'what took place' (the historical facts) and 'what was going on' (their theological significance).[2] But I doubt whether as much can be inferred from this as is being proposed. For, although these forms of criticism have brought full recognition that all the evangelists engage in a theological structuring and handling of the historical events, their theological treatment is still approached in an essentially historical way. Thought is given to the historical conditions under which each evangelist's particular theological perspective rose rather than to what might make it true, what might make it a justified belief.

The absence of this latter kind of reflection plagues the work of New Testament scholars when they attempt to move into the field of doctrine, just as the reflection of philosophers of religion is similarly plagued by a failure to treat seriously the complexity of the available historical evidence. The former type of failing comes out most clearly in Biblical historians' treatment of the self-consciousness of Jesus. For, it is noticeable that, with very few exceptions,[3] either this is seen as very limited and linked with a reduced view of Christ's divinity, as, for instance, in the writings of John Robinson,[4] or his full divinity is maintained but with it a claim to a considerably heightened consciousness as, for instance, in the writings of Charlie Moule.[5] What I shall suggest later in the chapter is that philosophical reflection can aid here by indicating and justifying a third way that combines the limited consciousness of Robinson with the full divinity postulated by Moule.

Apart from the natural temptation of the historian to equate the historical Jesus with the true Christ, one other factor may possibly be at work, and that is the desire for a revelatory 'core' that can then be assigned something like the status once accorded to the Bible as a whole. At all events, it is puzzling why so many deists assign so much weight to

[2] So J. Marsh, *Saint John* (Pelican Gospel Commentaries, Penguin, Harmondsworth, 1968), p. 49.

[3] An obvious exception is J.A. Baker, *The Foolishness of God* (Fontana Books, Collins, London, 1975).

[4] J.A.T. Robinson, *The Human Face of God*, (S.C.M., London, 1973).

[5] C.F.D. Moule, *The Origin of Christology* (Cambridge University Press, 1977).

Jesus, when on their own admission his experiences differ only in degree, not in kind, from other non-scriptural accounts of such experience to which one has more ready access. By contrast, on the model of revelation canvassed in the previous chapter there could be no such temptation. God always respects our freedom, and never simply overrides our prejudices and misconceptions. So mistakes in perception will be seen as inevitable, and dramatic divorces between historical original and theological truth become conceivable.

In what follows this is precisely what I shall suggest happened with the doctrine of the Incarnation, the latest Gospel, St. John's Gospel, being at once the most unhistorical of the gospels, but also the most true theologically. To see whether such a claim can be substantiated, the evidence is examined in three stages: (i) the life of Jesus, (ii) the Resurrection events, and (iii) Post-Resurrection reflection. At each stage I shall comment on the relevance of philosophical considerations, as also on how much may reasonably be adduced as historically credible. The result will be, I hope, the beginning of serious dialogue between the philosopher and Biblical historian.

The life of Jesus

As an illustration of the sort of conceptual difficulties encountered at this stage I shall take C.F.D. Moule's highly praised book, *The Origin of Christology*. Moule argues that Jesus' consciousness of his own status, evidenced in his claim to be 'Son of God' and 'Son of Man', is such that we may legitimately make such claims explicit by ascribing divinity to him. Indeed, he argues from the alleged existence of such claims to the view that we should see what took place in the Church as developmental, as distinct from what he calls evolutionary, christology. That is to say, the early Church should be seen as merely drawing out what was already implicit in Jesus' own claims, rather than there being dramatic discontinuities in the process, as with the genesis of a new species in evolution. 'If, in my analogy, "evolution" means the genesis of successive new species by mutations and natural selection along the way, "development", by contrast, will mean something more like the growth, from immaturity to maturity, of a single specimen within itself.'[6] In short, what is being rejected is any suggestion that belief in Christ's divinity is a new species created by a new environment, that of Hellenistic rather than native Palestinian thought.

So far as the details of the argument are concerned, Moule maintains both that the use of the term 'Son of Man' must be taken to attribute an exalted status to the person to whom the designation is made to refer and that the New Testament usage in this exalted sense must go back to

[6] Ibid., p. 2.

Jesus himself. Thus, on the first point he notes that the Gospel tradition almost invariably has the phrase with the definite article, which he suggests probably indicates an Aramaic original, 'that Son of Man', thus clearly indicating a reference to the relevant passage in Daniel with its exalted conception of the Son of Man.[7] On the latter point, his argument is that 'evidence for "the Son of Man" becoming a popular title for Christ in the early Church seems to me virtually non-existent',[8] and, that being so, the most natural explanation of its presence in the material is that as a title it dates back to Jesus himself. As for the meaning of the title, he suggests that Jesus took up its original corporatist significance (referring to God's exalted loyal people) to apply it to himself as inaugurator and mediator of God's Kingdom, a corporatist notion that was then expressed in rather different Pauline language such as 'in Christ', 'the Body of Christ', etc., but with essentially the same significance. The corporatist sense of Daniel is thus maintained, but now Jesus claims (and St. Paul takes up the claim) that it is only through incorporation in him that the exaltation and victorious vindication of those who are called to be the people of God can take place.

This is by no means the only argument that Moule would offer for Christ's divinity, and indeed he points out that even the appeal to the corporate nature of Christ can be made independent of any reference to Jesus's use of the title 'Son of Man' by resort to the early disciples' 'experience of Christ as corporate': 'In some measure, this bypasses the use of titles in Christology and affords an independent criterion for the nature of Jesus Christ.'[9] But, it remains one of the linchpins of his argument, as indeed it does for all those who, while accepting modern Biblical criticism, still wish to claim a very high consciousness of his status for Jesus. That being so, it will clearly be worth our while to reflect on how important and relevant this or a similar claim about Jesus's consciousness might actually be in establishing the divinity or otherwise of Jesus.

Certainly, in support of his position a galaxy of eminent New Testament scholars can be drawn upon: to name but a few, Dodd, Manson, Culmann, Jeremias, Caird and Hooker.[10] But the position is far from securely established, since equally persuasive arguments can be brought forward for alternative interpretations. Thus Hahn and R.H. Fuller argue that Jesus was thinking of a distinct person who would come at the end,[11] or there is the possibility that the expression might simply

[7] Ibid., pp. 13ff.; cf. Daniel 7:13-14.

[8] Ibid., p. 19.

[9] Ibid., p. 47.

[10] Moule mentions some of these scholars on p. 20. As a representative example, cf. T.W. Manson, *The Teaching of Jesus* (Cambridge University Press, 1935), pp. 211-36.

[11] F. Hahn, *The Titles of Jesus in Christology* (Lutterworth, London, 1969), p. 15ff., esp. pp. 36-7; R.H. Fuller, *The Foundations of New Testament Christology* (Fontana, London, 1969), pp. 119-25.

be a periphrasis for 'man' or 'I', as seems to be the case in the prophet Ezekiel, which is the view of Eduard Schweizer and Vermes,[12] among others. Moule[13] himself notes that not all Aramaists would endorse his suggestion about the significance of the use of the article. Indeed, perhaps the most interesting feature of scholarly discussion about Jesus' use of titles to apply to himself is that it is not just the use and significance of some of them that is in dispute, but that this is true of all of them, including the most familiar. Thus, Wrede's contention[14] that the Marcan notion of a Messianic secret is pure invention, the result of a Messianic belief of the early Church which was not held by Jesus himself, is a thesis accepted in one form or another by the majority of New Testament scholars.[15]

Such, then, seems to be the state of play among the experts. Given such a situation, it does, of course, remain important for specialists to continue their efforts to establish once and for all what the historical situation really was, but the philosophical theologian cannot help but suspect that apologetic reasons lie behind much of the energy devoted to the question, and, if that is so, the pity is that these reasons are falsely based on assumptions born of a failure to consider seriously what would constitute a correct analysis of divinity.

One such false assumption is that, unless Jesus believed himself to be more than a man, he could not have been more than a man. This is but one particular instance of the general false equation between historical original and theological truth mentioned at the beginning of the chapter. The sense in which it is false will become clear when we discuss shortly the minimum conditions that must be met at this stage for a subsequent legitimate ascription of divinity. But, first, two other errors produced by this failure to analyse the notion of divinity must be noted. For, on the one hand, there is no appreciation of how strong Jesus' claims would have had to be before they would amount to even an implicit claim to divinity, while, on the other hand, there is still less any realisation that it may not even make sense to suppose his being conscious of his divinity at all.

Thus, on the first point, even if Jesus did conceive of himself as Son of Man in the sense outlined, this is still very far from admitting that he conceived of himself as divine, or even that implicit in his self-perception was a claim to divinity. For, although on this account he would have been claiming a more important role for himself than any other man in that he would have seen himself as the unique mediator and instrument of

[12] E. Schweizer, *Jesus* (S.C.M., London, 1971), pp. 19-22; G. Vermes, *Jesus the Jew* (Fontana, London, 1976), pp. 160-91.

[13] Op. cit., p. 14ff.

[14] W. Wrede, *The Messianic Secret* (trans. J. Greig, James Clarke, 1971).

[15] For instance, support is given to this view by R. Bultmann, *Theology of the New Testament* (S.C.M., London, 1965) vol. 1, p. 32. For a different view, cf. the arguments of A.E. Harvey, *Jesus and the Constraints of History* (Duckworth, London, 1982), pp. 136-40.

salvation for others, this is still at an enormous distance from traditional divine attributes such as omniscience or what is normally regarded as being at the heart of the concept, namely the right to worship. In fact, as is well known, there is much evidence against Jesus ever having been, or ever having thought himself to be omniscient,[16] just as there is good evidence to suggest that he never saw himself as a suitable object of worship.[17] Now, of course, *kenôsis* in the sense of God's deliberate self-limiting is brought in to explain the absence of such features. But one cannot have it both ways; their absence must count against any claim that Jesus had even an implicit awareness of his own divinity.

None of this is to say that the question of the nature of Jesus' consciousness is irrelevant to the issue of his divinity. It is merely to point out that the question is a considerably more complicated one, conceptually, than might initially appear. Evidence of a high consciousness is not necessarily evidence towards his divinity, just as, I shall shortly argue, the absence of such evidence is not necessarily evidence against his divinity. The complicated nature of the question can perhaps best be illustrated for the moment by referring the reader to the undoubted fact that, historically (assuming the unhistoricity of St. John's Gospel), it is certain that other individuals have from their experience been led to make far higher claims for their consciousness than was the case with Jesus. A case in point is Al Hallaj, the tenth-century Sufi mystic who was crucified for claiming, 'I am God'.[18] This, it should be emphasised, does not show that Al Hallaj, or any of the other mystics who have made the same kind of claim, have in virtue of such language more right to be considered as candidates for divinity than Jesus who seems to have made no analogous claim. What it does show is that individual religious experience and the claims made thereupon are complex matters which require careful examination.

It is therefore impossible to base any claim for Christ's divinity on his consciousness once one abandons the traditional portrait, as reflected in a literal understanding of St. John's Gospel. There is just not enough in the notion, 'Son of Man', to deliver the goods, as it were. The fact that Michael Goulder in one of his contributions to *The Myth of God Incarnate* can accept an analysis of Christ's consciousness similar to that of Moule's and yet deny any implication of divinity[19] ought in any case to

[16] Most obviously, when Jesus says of the Parousia: 'But as for that day or hour, nobody knows it, neither the angels of heaven, nor the Son; no one but the Father' (Mark 13:32: *Jerusalem Bible*).

[17] Jesus' words to the Rich Young Ruler: 'Why callest thou me good? There is none good but one, that is, God' (Matthew 19:17 A.V.).

[18] R.C. Zaehner, *Mysticism: Sacred and Profane* (Oxford University Press, 1957), pp. 157-8. Absolute identity was also on occasion claimed by Christian mystics, e.g. Meister Eckhart, Nicolas of Cusa and Angelus Silesius. The speeches of *John* cannot be used as evidence because of their startling lack of support in the earlier Synoptic material.

[19] M. Goulder, 'Jesus, the man of universal destiny', in J. Hick (ed.), *The Myth of God Incarnate* (S.C.M., London, 1977), pp. 52-5.

give the incarnationalist pause for thought. The reason he gives is not very impressive: 'We are not obliged to accept the first Christians' supernaturalist account of what happened: indeed, as historians, we shall be bound to prefer a naturalist account if one can be offered.'[20] I have already argued against such a position in Chapter 2, but his intuitions are none the less correct that a high consciousness in Jesus cannot of itself guarantee Christ's divinity.

But, that said, it does not mean that the defender of the doctrine should become downcast. For – and this leads me on to the final error I mentioned – in any case it seems doubtful whether a human mind *could* be conscious of its own divinity, except on the model of infused knowledge as it is found in Aquinas, where doubts are silenced by the invasion of certainties guaranteed by the divine nature. Such a model is incompatible with Christ having a truly human nature, since in our case the normal way of acquiring knowledge is experientially. That is to say, once we have a model in which the freedom of the human mind is respected and thus only naturally acquired knowledge admitted, it is just incoherent to suppose that such a mind could have any means of suspecting its own implicit divinity, any means of distinguishing the possibility from the intimacy that can be created by other means, as, for example, through the experience of mystical union. For a more detailed defence of the view that it is incoherent to suppose that a human mind could be conscious of its own divinity, the reader is referred to Chapter 6. But perhaps any remaining doubts can be allayed more simply by asking him to try constructing an appropriate validating experience. For it will immediately become obvious that it depends either explicitly or covertly on aid from some sort of notion of especially infused, self-guaranteeing knowledge.

All of which brings us back to the need to explicate the minimum necessary conditions which must be fulfilled at this stage to justify a subsequent postulation of divinity. Here it becomes important to distinguish the demands of the two very different disciplines of philosophy and history, since it is by no means true that what is required historically is also required conceptually. The historian is presumably concerned to given an historically plausible account of the development such that aspects of Christ's person and life can be pointed to that make it in some sense natural for the disciples to assign a higher status to him after his death and resurrection. By 'natural', of course, I do not mean 'inevitable' or 'appropriate' or 'justified', but rather that, given the normal pattern of human behaviour in the relevant cultural setting, the transition is historically explicable, intuitively plausible. In short, the historian is concerned to produce a story of development that can sound credible as a story, whereas the philosopher sees it as a purely conceptual question. Both demands must, of course, be met, but it is still important

[20] Ibid., p. 55.

to remember that they are there as demands for different reasons.

Thus, so far as the historical demand is concerned, in attempting to produce their plausible story of development New Testament scholars have traditionally concentrated on the titles, whereas one suspects that this is in fact a confusion of the historical problem with the conceptual. For by no means as much is required if the story is to be a plausible one. Eduard Schweizer's emphasis on Jesus' unparalleled authority, for example, would be quite sufficient, with no reference to title claims being required. That is to say, if Jesus did exhibit such authority, that would seem enough, given human nature, to make it natural for the disciples to assign him an exalted status after his death, especially if this were coupled with certain mysterious experiences of his presence. Less will not do because then there would be a puzzle about why after his death he should be regarded as so enormously different. More is not required because the historian has only to make the development explicable in terms of the normal canons of human nature, not inevitable as the only way events might proceed.

Of course, it is true that attempts have been made to set Jesus fully within the framework of other typical religious leaders of the time. One of the most impressive recently has been Geza Vermes' *Jesus the Jew* which argues that Jesus can best be seen against the background of contemporary charismatic Judaism; in particular he draws interesting parallels with the lives of Honi the Circle-Drawer (first-century B.C.) and Hanina ben Dosa (first century A.D.). However, if he were able to make Jesus exactly on a par with such figures, problems of historical explanation would arise since it would then become puzzling why Jesus alone was subsequently given such an exalted status after his death. It might be argued that the explanation would have to be found entirely within the Resurrection experiences of the disciples, but that is unsatisfactory since it places too great a weight on these experiences alone. After all, without the conviction that there was already something unique about Jesus, it would surely be more natural for them to doubt, or at least underplay, their significance.

But Vermes can do nothing to undermine the unparalleled nature of Jesus' authority, and indeed this is one of the most firmly established features of his life. At all events, Schweizer is prepared to talk of certainties: 'There can be no doubt that Jesus ... offered forgiveness as though he stood in the place of God. It is also certain that he promised men the kingdom of God as though he had the authority to grant it. It is certain that he did not begin, like the prophets of the Old Testament, by saying, "Thus says the Lord", or like the rabbis, by saying, "Thus it is written". In short, he did not refer his own words to any other authority. Quite the contrary: among the sayings of Jesus that are most likely to be genuine are such unprecedented statements as the "But now I tell you" passage (Matt. 5,21-48), in which laws of the Old Testament are

abrogated and the "I" of Jesus speaks in the place of God.'[21]

That said, the historical demand for this stage is fulfilled. Yet in the writings of some New Testament scholars there is a reluctance to accept this assured minimum as guaranteeing historical plausibility, a reluctance which one suspects stems from the continued confusion of the demands of historical and conceptual plausibility. It is somehow thought that conceptual plausibility is not thereby guaranteed, that the development is not thereby validated as a legitimate one. In fact, so far is this from being so, that in some ways less rather than more is required for conceptual plausibility.

But before discussing what this 'less' is, it will be helpful to consider an interesting alternative approach to the question of historical plausibility which is to be found in A.E. Harvey's Bampton Lectures, *Jesus and the Constraints of History*. For by so doing an illustration will be provided of the way in which a divorce can occur between historical and conceptual plausibility. For it is arguable that in the process of making historically plausible a high consciousness in Jesus, Harvey undermines its conceptual plausibility, that is to say, its correctness.

Harvey believes that by examining the evidence in the context of the historical constraints, i.e. the assumptions of the time, he can defend the view that Jesus had a very high understanding of his mission, though subsequent reflection on this still stopped well short of Incarnation even in the late Biblical period since one of the firmest historical constraints of the time was the strong Jewish commitment to monotheism.[22] The result is that even St. John is interpreted in non-incarnational terms.[23] But, by contrast he holds, for instance, that Jesus riding into Jerusalem in violation of convention provides clear indication of his high claims for himself and his mission.[24] However, as we have already seen, whether or not Jesus conceived of himself as Messiah, Son of Man and so forth, though obviously interesting issues, are not crucial in determining his status. Where Harvey's book is important in this respect is the way in which, while making it entirely 'natural' that the disciples should subsequently assign Jesus an exalted status, he makes it more questionable whether we should follow suit.

For, not only does he argue for a high consciousness for Jesus, he maintains that historical constraints indicate what cannot but seem to us highly questionable features of his practice and teaching, though Harvey does not concede this. So, for instance, his reason for performing the sort of miracles he did was not compassion,[25] but because that was

[21] Op. cit., p. 14.

[22] A.E. Harvey, *Jesus and the Constraints of History* (Duckworth, London, 1982); cf. pp. 154-7.

[23] Ibid., p. 172.

[24] Ibib., pp. 120ff.

[25] Ibid., p. 111.

the only option for someone who wished to create a particular impression of himself as the eschatological prophet.[26] Again, he believes Jesus preached the end of the world, but defends him on the grounds that such a time scale was 'the only option available to one who has a prophetic message'[27] because only thus would his message be taken with sufficient seriousness. A parallel is drawn with the nature of the Marxist hope,[28] as also with prophets of nuclear catastrophe.[29] As a final example there is the way in which Jesus' teaching is seen as severely subject to 'the constraint of law'. So, that he should have declared all foods clean is 'highly improbable', since 'there is nothing else in the records about him which comes anywhere near such a forthright repudiation of a central feature of the culture in which he lived'.[30] Other possible repudiations such as 'the dead burying their dead' or breaches of the Sabbath are then treated as isolated prophetic actions, without further implications. 'This does not mean that the sabbath regulations should not continue to obtain in the normal way.'[31] Even an intention to repeal the clause in Deuteronomy relating to divorce is rejected on the strange grounds that 'it would have been illogical to eliminate divorce without also eliminating polygamy, which, though seldom practised, was still permissible under the Law of Moses'.[32]

I would not dispute that the issues are far from simple, and in some cases Harvey may well be right. My point rather is that, the further this process is carried and the more Jesus is made purely a creature of his time, the less reason is there for us to be interested in him and see him as having anything approaching a unique relationship with God. But, fortunately for the argument of this chapter, the constraints of which Harvey speaks are not nearly so self-evident as he supposes. Thus, history is not short of illustrations of situations in which the followers of a movement have proved less radical than its instigator, which help to make intelligible why Jesus' attitude to the food laws or the sabbath might not have been immediately followed by his disciples. The radicalism of Luther and the later conservatism of the Lutheran church is a case in point. Again, the obvious explanation for his failure to refer to polygamy was its admitted infrequency. One might add that even cases of astonishing discontinuity with the existing culture are not unknown. An illustration would be the so-called 'stupor mundi' Frederick II, whose atheism is in striking contrast to the medieval Catholicism of the thirteenth century, and who was even rumoured to have written a book

[26] Ibid., p. 101.
[27] Ibid., p. 96.
[28] Ibid., p. 96.
[29] Ibid., pp. 94-5.
[30] Ibid., p. 39; cf. Mark 7:18ff.
[31] Ibid., p. 62.
[32] Ibid., p. 53.

entitled *De Tribus Impostoribus*, in which Moses, Christ and Muhammad were branded as imposters.

Historical plausibility and conceptual plausibility are thus by no means the same thing. Even if Harvey had shown that the development was historically plausible, he has, if anything undermined evidence for the more important issue of conceptual plausibility. This lack of parallelism between the two demands is further illustrated by the fact that rather less seems required for conceptual plausibility than for historical. According to the position defended at length in Chapters 5 and 6, there are only two ways in which one might coherently suppose Christ to have been God without knowing it; either on the nineteenth-century Kenotic model of God literally becoming man, in which case one would have to argue for a very strong continuity of character and post-Ascension memory as justifying belief in the identity of God and man in the Christ-event, with the philosophical problems raised being paralleled by the types of problems raised by a belief in reincarnation; or, less startlingly, one would have to adapt the original Chalcedonian claim that there were two natures in one person to take account of the demand I noted earlier in the chapter, that only naturally acquired knowledge should be admitted, if it is indeed to be claimed that a truly fully human nature is present. On the latter model the requirement would be sufficient evidence of interchange between the two natures for talk of one person rather than two to be justified. A human analogy, though a very inadequate one, is the existence in ourselves of two centres of consciousness, in our conscious and unconscious or sub-conscious selves; in virtue of there being sufficient interchange between the two it remains legitimate to talk of one person. If there is not sufficient interchange, we talk instead of schizophrenia.

That being so, the necessary conceptual conditions which must be met at this stage to justify a subsequent postulation of divinity are either, on the Kenotic model, identity of character (moral perfection or holiness) or, in the case of the revised Chalcedonian model, evidence of a total openness to the divine grace that presumably will once again produce moral perfection but also intimacy of a kind at least as close as that claimed by any of the mystics. These are, of course, only minimum necessary conditions. There would only be sufficient grounds for belief if some further conditions were met. In the case of the Kenotic model this would be some further event validating Jesus as God. In the Chalcedonian case, not only would this be required, but also some historical or conceptual grounds for believing that the human nature remains in the new exalted status; otherwise, on grounds of economy (the requirement that in the absence of other considerations one should always opt for the simpler hypothesis), the Kenotic model would presumably have to be preferred. If it be asked why the subsequent ground could not of itself be a sufficient ground, why, for instance, the

Resurrection could not in itself provide sufficient grounds for believing in Jesus' divinity, the answer is that, as a matter of the logic of identity, unless these minimum necessary conditions are met, we would not be entitled to speak of the *same* person being involved both in Christ's earthly life and post-Resurrection glorification. There would be just too great a discontinuity.

With minimum conceptual conditions like these, it becomes clear why in some ways less is required for conceptual plausibility than for historical plausibility. For moral perfection and openness to divine grace are not features associated automatically only with divinity; rather all the saints of the Church are expected to exhibit them to a very high degree. Unparalleled authority is much more an abnormal human feature, and it is precisely because of this that it can make the development historically explicable or 'natural' in a way that the other two attributes would not. The point can be made most clear by reflecting on some conspicuous example of sanctity, such as St. Francis of Assisi. Even if his death had been accompanied by some extraordinary experiences, it would still have been very difficult to offer an historically adequate explanation of how a belief in his divinity might have arisen. There is, it seems, rather surprisingly, something rather 'normal' about moral perfection or intimacy with God that prevents the observer from finding the endorsement of a claim to divinity (to being more than a man) natural.

Before considering whether the historian can provide us with evidence that these minimum conditions have been met, a further word of explanation is required. In setting out those pertaining to the Chalcedonian model I mentioned only openness to divine grace, not any demand that there should be a reciprocal movement in the opposite direction, with the divine nature having a similar openness to (i.e. ability to be affected by) the experiences of the human nature. Yet Part III argues that it is only when there is such reciprocity that we are entitled to speak of a single person. There is no inconsistency. Historically, it is very hard to see how evidence for this latter kind of relation could ever be forthcoming, but in any case it is not required. For, if a later stage justifies the postulation of Christ's divinity, we can legitimately argue that this provides retrospective justification for postulating such reciprocity, provided, of course, that there are good grounds for preferring the Chalcedonian model to the Kenotic. Indeed, the Kenotic model itself provides a parallel which is discussed later in this section. For, even if the Virgin Birth is necessary to the coherence of that model, it still does not follow that historical evidence for its occurrence is required. Rather, a similar retrospective argument could be employed.

It remains now to ask whether the historian can in fact supply us with these minimum necessary conditions for conceptual plausibility. The answer should definitely be in the affirmative, but the question is

complex because none of the conditions mentioned admits of straightforward historical testing. This is not to say that they cannot be tested historically at all, but that it can only be done against a carefully thought out conceptual framework. To clarify what is involved, I shall consider first the question of Jesus' moral perfection, then his intimacy with his Father and finally the complex question of the extent to which the Kenotic model is dependent on historical evidence for the Virgin Birth.

(i) The first and obvious point to make is one made by Kant in a well-known sentence: 'Even the Holy One of the gospel must first be compared with our ideal of moral perfection before we can recognise him to be such.'[33] That is to say, there is no way out of making an independent judgment of the moral status of Christ. Kant's thought was that Christ can only legitimately serve as an example, once we have ascertained through reason what the truths of morality are. But in this context his point can be put more strongly. For, as Chapter 2 argued, with the collapse of the test of appealing to miracle, all revelation, including that of Christ, must rely on other tests, of which the moral test is one, and it would be circular to argue from a morality that is already accepted simply on the basis of Christ's authority.

Given the importance of the question, it is surprising how seldom it is discussed by New Testament scholars. An exception is John Robinson in his article, 'Need Jesus have been perfect?'[34] In common with most contemporary theologians he rejects an interventionist account, declaring that 'the supernatural is not a parallel, superior causal sequence, but an interpretation, a *re-velatio* or turning back of the veil, in terms of myth or a "second" story, of the same process studied by science and history.'[35] It is in the light of this that he then goes on to claim that to assert sinlessness or perfection of Jesus 'is to make a theological not a historical judgment'.[36] But at the same time he concedes: 'Yet between the theological judgment and the statement of history the credibility gap cannot be too great. Jesus must have been sufficient to have evoked and sustained the response, "Thou art the Christ, the Son of the living God" (Mat. xvi.16).'[37]

Apart from his rejection of interventionism, there are two main grounds on which Robinson's account might be challenged. The first is his failure to draw any distinction between conceptual and historical plausibility. Yet it is doubtful whether moral perfection played any

[33] Kant, 'Groundwork of the Metaphysic of Morals', in H.J. Paton (ed.). *The Moral Law* (Hutchinson, London, 1948), p. 73 (29:408).
[34] In S.W. Sykes & J.P. Clayton (ed.), *Christ, Faith and History* (Cambridge University Press, 1978 ed.).
[35] Ibid., p. 40.
[36] Ibid., p. 44.
[37] Ibid., p. 44.

major part in determining the exalted status which Christ was given; outstandingly saintly persons have existed without being given such a status, just as the reverse is true, with evil but charismatic persons being treated as divine or semi-divine figures.[38] But, secondly and perhaps more importantly, the grounds on which he rejects the judgment of Jesus' perfection as an historical judgment are inadequately based. He writes: 'For one thing we do not know. We simply cannot say, for instance, that Jesus was *always* loving.'[39] This is true, but does not prevent it being a legitimate historical inference on the basis of the evidence available; such inferences are, after all, surely the very stuff of historical judgment. Of course, it is not a purely factual question that is being raised, but then the more important and more intriguing historical questions rarely are.

In fact, from our point of view the most interesting feature of Robinson's article is the readiness with which he admits the quality of the historical evidence for there being present in Jesus at the very least a high moral character: 'The summary of the memory of him was that he "went about doing good" (Acts x.38), and if that had not been true Christianity would not have survived its detractors for long. It is remarkable that not only do the gospels portray Jesus as having no consciousness of sin or guilt (that perhaps could be attributed to the theological position from which they are written) but they never seem to feel any obligation to defend the moral character of Jesus from Jewish attacks – his sitting light to the law (especially the sabbath and ritual laws) yes, but not his morals. And this is more remarkable considering the freedom with which they represent him as living and the company they represent him as keeping. The gospels report Jesus as referring to his own reputation as a gluttonous man and a wine-bibber, but never think it necessary to refute the charge. It would not have taken much to twist the Zacchaeus episode into living it up with the exploiting classes instead of identifying with the dispossessed. Nor would many a clergyman today be able to survive three circumstantial reports (Mark 14:3-9; Luke 7:36-50; John 12:1-8) in the local paper that he had had his feet (or head) kissed, scented, and wiped with the hair of a woman of doubtful repute. The lack of defensiveness with which such compromising stories are told says a great deal.'[40]

But, it may be said, this is to ignore some inconvenient evidence against Jesus' perfection, evidence which Robinson does not consider in his article, but which is commonly raised as an objection by non-Christians, among them Bertrand Russell in *Why I am not a Christian*. Russell writes: 'There is one very serious defect to my mind in Christ's moral character, and that is that he believed in hell. I do not

[38] An obvious modern example would be John Jones, of Jonestown massacre fame.
[39] Ibid., p. 44.
[40] Ibid., p. 45.

myself feel that any person who is really profoundly humane can believe in everlasting punishment.'[41] He also mentions 'other things of less importance. There is the instance of the Gadarene swine where it certainly was not very kind to the pigs to put devils into them and make them rush down the hill to the sea.'[42] On the former objection the position is enormously complicated by historical uncertainty as to what exactly the precise thrust of Jesus' teaching was meant to be. Thus its best known and most elaborate form is to be found almost exclusively in Matthew, with reference to 'weeping and gnashing of teeth' six times in Matthew and only once elsewhere (Luke 13:28) and 'outer darkness' occurring only in Matthew and that three times.[43] It may well therefore be a Matthean elaboration on something less explicit in Jesus' teaching. At all events, the earliest synoptic Gospel, Mark, records very little on the subject, and such as there is admits quite easily of something much less than the full-blooded interpretation. Thus Nineham points out that Jesus' reference to those who blaspheme against the Holy Spirit being 'guilty of an eternal sin' need not necessarily refer to eternal punishment,[44] while on the Marcan verse, 'it is better for you to enter the kingdom of God with one eye than with two eyes to be thrown into hell where their worm does not die and the fire is not quenched', he comments as follows: 'Whether, as many commentators believe, the subordinate clause is the work of St. Mark or of the first compiler of the passage, or whether it goes back to Jesus himself, it is important to remember that it is not an original saying expressly designed to convey the Christian view about the fate of the "lost" but a quotation of traditional language (Isa. 66:24 – itself based on the imagery of the earthly Gehenna, the rubbish dump outside Jerusalem) designed to call up an image of utter horror. It is difficult to say just how seriously or literally such use of an accepted idea was intended, especially if the image came to Jesus' mind quite naturally on some occasion when he was teaching near Gehenna. Certainly, it affords no grounds for attributing to Jesus the later fully developed doctrines of eternal punishment.'[45]

But, equally, one must be on one's guard against simply brushing inconvenient evidence under the carpet, a danger of which Nineham is aware since the last sentence I quoted is immediately followed by the comment: 'On the other hand we shall probably get nearest the historical truth if we heed the warning of Vincent Taylor against dismissing the words too lightly as simply picturesque metaphor.' In other words, we

[41] B. Russell, *Why I am not a Christian* (Unwin Books, London, 1967), p. 22.

[42] Ibid., pp. 23-4.

[43] 'Weeping and gnashing of teeth' is to be found in Matthew 8:12, 13:42, 13:50, 22:13, 24:51, 25:30. 'Outer darkness' in Matthew 8:12, 22:13 and 25:30.

[44] D.E. Nineham, *Saint Mark* (Pelican Gospel Commentaries, Penguin, Harmondsworth, 1963), p. 125.

[45] Ibid., p. 258.

can be reasonably confident that some stark warning was intended, even if we do not know exactly what. Universalists are reluctant to accept this as so, but, whether historically correct or not (a matter which we can explore in no further detail here), it is interesting as drawing attention to a neglected aspect of the question. This is the fact that, although to avoid circularity the initial judgment on Jesus' moral status must come from independently based moral judgments, this by no means entails that every moral issue must therefore have been resolved in advance.

Rather, once the initial favourable assessment is made, a creative dialogue can take place between the assessor and the subject of his assessment. This is surely in fact what happens in all such cases, where a particular individual is judged worthy of special emulation. Initially the assessor only endorses what he already clearly desires to be present in himself, but commonly his admiration leads him beyond this point to endorse other aspects of his hero's behaviour to which he has hitherto given little or no consideration, or may perhaps have even regarded unfavourably. Of course this does not always happen and further reflection on these other aspects may lead the assessor to withdraw his original endorsement. But it is a common enough pattern in the growth of moral insight that others whom the individual admires can lead him to moral perceptions that he would have been unable to gain for himself. This is a plausible interpretation of what happens in the case of the Christian, especially in respect of the more puzzling aspects of Jesus' teaching and behaviour.

Let us consider two examples. The first is again the question of Hell. The assessor who has already endorsed strongly the central moral features of Jesus' life and teaching may be led to question whether he has hitherto taken the notion of personal moral responsibility seriously enough as a result of noticing the two references in Mark which may be traceable to Jesus himself. Whether he also eventually notices the rationale for denying universalism, that it is incompatible with the notion of a *free* loving response to say that no one can be lost, is beside the point; for what comes first is the creative dialogue, not the reasons that retrospectively justify that endorsement. Similarly, with the question of the anger which Jesus is recorded as having displayed against the Pharisees and also in driving the money-changers from the Temple,[46] it might well be the case that the assessor is led from an initial strong endorsement of Christ's pacifist attitudes to see that anger may none the less have a legitimate place in his own morality simply because of the role he notes it as playing in a life which he has already strongly endorsed.

In drawing attention to this fact I am not simply remarking on a psychological phenomenon, a normal feature of human behaviour, but rather making the stronger claim that people are justified in so behaving.

[46] E.g. Mark 3:5, Mark 12:15ff.

This is because it is a more plausible analysis of morality to suggest that, while there will undoubtedly be many areas in which the individual legitimately has no doubts, there will also be others where he is undecided or open to the possibility of change and here creative dialogue can be justified, with the rationale following the endorsement of the admired individual rather than preceding it. But, if no rationale is found, then of course the original endorsement must be withdrawn. Such an account of growth in moral insight means that the question of Jesus' perfection, though complex, is not necessarily any more complex than any other endorsement of exemplary behaviour. Certainly, there is this difference that in Jesus' case, if perfection is to be maintained, no subsequent qualification to the initial favourable assessment can be allowed. But I have tried to indicate how this might be sustained in two controversial cases, and it is a pattern of argument that admits of general application. So there seems no reason why in principle a claim to perfection could not be defended in detail.

(ii) I turn now to consider the second historical question that needs to be answered at this stage. This is whether the additional minimum conceptual condition set for the revised Chalcedonian model is also satisfied, namely whether there exists sufficient evidence of intimacy with the divine to justify us speaking of two natures in one person. Reciprocity between the human and divine nature, with the experiences of the one being taken into the other, is required, because otherwise, if the process went only one way from the divine to the human, the postulted intimacy would be no different from that claimed by some of the saints, where we have no temptation whatsoever (and no justification) to speak of a single person, both divine and human. But it has already been admitted that the taking of the human experiences into the divine can only be postulated retrospectively. That being so, all that can be sought at this stage is after all only the sort of intimacy displayed by the saints.

An implication of this is that the sort of evidence produced will not of itself tell decisively in favour of the Chalcedonian model rather than the Kenotic. For, though the logic of personal identity does not require such intimacy on the latter model (a human nature only being present), it does seem a reasonable expectation that the other persons of the Trinity would exhibit some interest in the fate of the person from their number who had become a man, and so a similar intimacy be displayed. Such intimacy would not be an internal relation within a single person, but rather an external one of inspiration by other members of the Trinity. But without the already rejected notion of infused knowledge it is impossible to conceive how a human mind could on the basis of his experience draw such a distinction. And in fact this is precisely what we find in the case of Jesus. His words and actions display confusion or at least reticence about whether his relationship with the divine is external

or internal to his person, with him sometimes clearly referring his actions to his Father and at other times apparently speaking in his own right. But such confusion about identity is in any case inherent in the type of religious experience in terms of which his life is most appropriately analysed.

In Chapter 1 I referred to two main types of mystical experience, commonly described as theistic and monistic, the latter characterised by the subject who believes the union to be so close that language of identity is used with the experient talking of himself in divine terms; such a feeling of absorption does not, however, carry with it a belief in one's own divinity, especially since the experience is known to be of only a temporary character. Such indirect evidence as we have of Christ's internal experience suggests that this may well be the best parallel to it that we have – which indeed may be one reason why Christianity has always regarded with hostility (wrongly in my view) other claims to such a monistic union.

At all events, this appears to be the best way of explaining why Christ felt enabled to claim for himself the unparalleled authority I have already noted. It was not just that he was especially intimate with his Father (and of that there is, of course, clear evidence as, for instance, in the way in which he uses 'my Father' but 'never includes himself among the disciples by saying "our Father" '[47] or again, just possibly, the so-called Johannine thunderbolt in the Synoptics),[48] but that he felt the divine presence so directly and powerfully within him that it came naturally to him to make those kind of claims in his own name. Otherwise without this explanation it is hard to see why with only his intimacy with his Father to fall back upon he would not have at all times referred directly back to him as the source of his authority, rather than sometimes claiming to exercise it in his own right.[49]

Of course, this is to rely heavily on inference of the kind distinguished New Testament scholars like John Robinson reject, but it would none the less seem a reasonable inference from the available evidence, and the best interpretation of that evidence. That being so, rather ironically after all our efforts to distinguish carefully minimum conditions for historical and for conceptual plausibility, we have found them in the actual evidential situation that confronts us to have a relation one to the other. For, we have seen that the best way of establishing intimacy is by appeal to the nature of Christ's authority, the very thing which we argued was a necessary condition for guaranteeing an historically plausible account of

[47] Op. cit., p. 16.
[48] Caird treats the passage as authentic, whereas Fenton rejects it. For their opposing arguments, cf. G.B. Caird, *Saint Luke* (Pelican Gospel Commentaries, Penguin, Harmondworth, 1963), p. 146 and J.C. Fenton, *Saint Matthew* (Pelican Gospel Commentaries, 1963), p. 186. – Luke 10:22/Matthew 11:27 is the passage.
[49] Cf. e.g. 'But I say unto you ...': Matthew 5:22, 28, 34, 39, 44.

the development of the doctrine. Such an appeal might not have been necessary, but in fact has proved to be so.

One last comment on the question of intimacy seems appropriate. It is to note that in order to guarantee conceptual plausibility it does not seem necessary to argue that the type of intimacy experienced by the human nature can be seen to have been closer than that experienced by any other human being. This does not seem necessary because what makes the situation unique and guarantees the unity of the person is not a difference in kind with respect to the human experience of unity but the unique openness of the divine nature to the experiences of the human nature. Thus all that is required is that the experiences must have been at least as intimate as those of any of the mystics, and that we think can be satisfactorily established by more detailed investigation along the lines indicated. Of course, in order to justify the claim that it is a single person present one would have to maintain that, unlike with the mystics, such intimacy was a sustained and not merely a temporary phenomenon, but again that would seem a reasonable inference from the available evidence.

The objection most likely to be raised to my last statement is the apparent counter-instance of Jesus' cry of dereliction from the Cross, 'My God, my God, why hast thou forsaken me?'[50] For, it will be argued, this surely shows that on occasion at least Jesus did doubt the presence of an indwelling divine power in his person. There are two points to note about this objection. The first is that it is by no means clear that it is a cry of dereliction. For, as Nineham observes, following Lightfoot, 'such a view assumes a narrator who, interested primarily in historical fact, reports faithfully for posterity a terrible and inexplicable utterance. But all our inquiry has intended to show that ... the Passion narrative was written for the strengthening ... of the Christian communities, not their bewilderment.'[51] This seems confirmed by the way in which only obviously positive comments are recorded by Luke and John,[52] and, as Nineham goes on to observe: 'There is some evidence that among the ancient Jews the opening words of this Psalm were interpreted in the light of the rest of it and recognised as an effective form of prayer for help in time of trouble.'[53] But, even supposing that they were originally intended as a cry of despair, this would not of itself substantially undermine the factual evidence for sustained intimacy, and thus for the unity of the person, any more than the occasional spontaneous outburst of our subconscious in defiance of our conscious wills can be taken to throw serious doubt on the unity of our own personal selves. What

[50] Mark 15:34, quoting Psalm 22:1.
[51] Op. cit., p. 427.
[52] Luke 23:46, John 19:30.
[53] Op. cit., p. 428. The evidence comes from the Mishnah.

matters is the overall picture, not an isolated detail.

(iii) Earlier in the discussion of minimum conditions for this stage I observed that the Kenotic model would provide a parallel case of retrospective justification. For, just as reciprocity between the two natures in the Chalcedonian model can only, if at all, be established by a subsequent stage of the development, so too, if the Virgin Birth is integral to the Kenotic model, because of the nature of the available evidence this can only be justified retrospectively. To clarify why this is so, I shall consider first the extent to which a claim to a Virgin Birth is required, and then the state of the evidence upon which such a claim might be based.

It is certainly true that we find opinion ranged on both sides as to whether it is or is not integral to a doctrine of Incarnation, but discussion is usually at a minimum and far from satisfactory. Machen, for instance, after spending several hundred pages examining the historical evidence, merely remarks briefly on what he sees as its integral character as follows: 'How, except by the virgin birth, could our Saviour have lived a complete human life from the mother's womb, and yet have been from the very beginning no product of what had gone before, but a supernatural Person come into the world from the outside to redeem the sinful race?'[54] However, even the 1938 Church of England *Report of the Commission on Christian Doctrine* was noting that, 'while many of us hold ... that belief in the Word made flesh is integrally bound up with belief in the Virgin Birth ... there are some among us who hold that a full belief in the historical Incarnation is more consistent with the supposition that our Lord's birth took place under the normal conditions of human generation',[55] and it is this latter view which has grown apace in recent years. A conspicuous instance of a major theologian taking this position, one who cannot be accused of offering a watered-down incarnational claim, as would be true of most taking this line, is Wolfhart Pannenberg. He emphatically affirms that 'in its content, the legend of Jesus' virgin birth stands in an irreconcilable contradiction to the Christology of the incarnation of the preexistent Son of God found in Paul and John'.[56] The view that they 'cannot be connected without contradiction conceptually' is repeated a couple of pages later, but this time with the grudging admission that 'the legend is Christologically justified only as the expression of a passing stage in the Christian development of tradition'.[57] Most of Pannenberg's discussion is concerned with a tirade against Barth's acceptance of the Virgin Birth as having Mariological implications, and this seems to have led him both to

[54] J.G. Machen, *The Virgin Birth of Christ* (James Clarke, 1958 ed.), p. 395.

[55] *Doctrine in the Church of England*, Report of the Commission on Christian Doctrine (S.P.C.K., London, 1938), p. 82.

[56] W. Pannenberg, *Jesus: God and Man* (S.C.M., London, 1968), p. 143.

[57] Ibid., p. 146.

mishandle the available historical evidence and to make an elementary conceptual mistake. For, even if Matthew and Luke did intend to mark Jesus' birth as the beginning of the existence of the Son of God, in conscious or unconscious opposition to assigning him pre-existence, it by no means follows that in accepting the Virgin Birth we must necessarily be doing the same; it could easily be seen instead as simply a stage in the existence of the divine Son.

What then is the conceptual position with regard to the two models which we have been considering? Is Machen right about the indispensability of the Virgin Birth? Different answers are required, depending on which of the two models is under consideration. Thus, with the Kenotic model it is clearly essential. This is because, unless the foetus is a miraculous creation, there is nothing for God the Son to be continuous with; the input would have come from a source other than God the Son's voluntary *kenôsis* of his powers into those of a human being, beginning at the stage of a foetus. By contrast, there would seem to be no such demand in the case of our revised Chalcedonian model. This is because here it is simply the uniting of a human nature into an already existing Person, not the transformation of that person into a human nature. A virgin birth is thus not essential to the maintainance of the claim that continuity of identity has been preserved through the major change of the Person being 'enlarged' through the addition of another nature.

However, there are complications in either case which should be noted. In the latter case, while a virgin birth is not necessary to preserve identity, it might be necessary for other reasons. The view, held by numerous theologians from Augustine to Machen,[58] that the Virgin Birth was the only way of freeing Christ from the taint of original sin, is not, I think, something of which we need take much cognizance today, at least when the doctrine is understood in its traditional close relationship to an historical Fall. But some modern reinterpretations[59] do raise acutely the question of whether the ubiquity of Christ's sinlessness can be preserved, unless one envisages his foetus as a special creation. For otherwise it would seem an inevitable implication of a normal birth that he be subject to the inheriting of character traits to whatever degree human physiological investigations eventually reveal. Of course, one might escape this consequence by suggesting that only good traits would be inherited, but that would be simply to throw the problem back one stage; for then very special care would have had to be given to the choice of his parents. This does not seem unreasonable, but a better approach to the

[58] Op. cit., p. 395.

[59] The tendency is to identify original sin with the inevitability of human beings being subject either to bad social influences that are ubiquitous in their particular society or bad psychological dispositions of the universal kind postulated by Freud. The answer given in the text to the latter option applies equally to the former.

problem is to challenge the view that inherited dispositions to evil are of themselves sinful and alienating from God. It is surely actions that should be so viewed, and in any case to allow this aspect to Christ's internal psychology would heighten his identification with mankind in its struggle against temptation. So, on the conceptual level the Virgin Birth is of doubtful relevance to the Chalcedonian model, even when modern views of original sin are taken into account.

But none of this is to deny the possibility that this is how God may have chosen to act. Certainly, the common modern conceptual objection that such a birth would call into question his entitlement to be called human is a nonsense, as though it were the emission of the sperm rather than the subsequent history of the foetus that decisively makes us who we are. However that may be, even with the Kenotic model it is not true that evidence for the Virgin Birth becomes a necessary minimum condition at this Stage, despite its truth being integral to the model. This is because, if one finds oneself justified at a later Stage in believing (a) that Jesus was God and (b) that the Kenotic model of the two better fits the evidence, then one would be justified in inferring back to this first Stage that a Virgin Birth had in fact taken place, despite the absence of available evidence. Of course, this could only be done if the situation were at worst neutral, that is to say, if there were no evidence pointing either way or at least such as there was, was finely balanced. For if the evidence were tilted against, it would of necessity call into question either the (a) or (b) just mentioned.

A brief examination of the historical evidence is therefore in order. That the birth narratives cannot be accepted as historical *in toto* as they stand would now be all but universally conceded. Numerous difficulties are noted by the distinguished Roman Catholic scholar Raymond Brown in his exhaustive examination of the subject, *The Birth of the Messiah*, and these are also acknowledged by his Protestant and Roman Catholic collaborators in their joint study of *Mary in the New Testament*.[60] To mention but two of the problems, the sentiments of the Magnificat 'are not really the appropriate sentiments of a maiden who has not yet given birth to the Messiah; they are much more appropriate if composed by those who know that through the resurrection God has reversed the crucifixion',[61] while there are clear historical conflicts between the two narratives, for example in respect of the flight to Egypt.[62] But such problems do not necessarily mean that the Virgin Birth was also invented with purely theological motives in view. Obviously, this is not the place to argue the case in detail. But it will be useful to indicate what is required if the historically neutral situation is to be preserved that is so

[60] R.E. Brown, *The Birth of the Messiah* (Chapman, London, 1977); R.E. Brown et al. (ed.), *Mary in the New Testament* (Chapman, 1978).

[61] *Mary in the New Testament*, pp. 137-40.

[62] Cf. Matthew 2:14 and Luke 2:39.

essential for a subsequent defence of the Kenotic theory.

Two types of argument are requisite to any such defensive strategy. The first is that there should be no obvious reason for postulating a Virgin Birth other than historical truth. Here explanation might be sought in a number of different factors. It will be sufficient to indicate possible lines of reply if we take what is perhaps the most common. For it is often thought enough to draw attention to the way in which pagan heroes are alleged to have had divine births, as Cartlidge and Dungan do in *Documents for the Study of the Gospels*,[63] or to note the existence of a tradition of extraordinary births within the Jewish context, which is the method adopted by Pannenberg, when he suggests that the following argument led to the creation of the legend: 'How could Jesus have been inferior to the election from birth that the Old Testament reports for Samson (Judges 13:5), for Jeremiah (Jer. 1:5), and for the Servant of the Lord (Isa. 49:5)? And had not Isaiah announced the birth of the Messiah from a virgin (Isa. 7:14 IXX, quoted by Matt. 1:23)?'[64] Raymond Brown[65] has pointed out that the pagan parallels are not really genuine parallels in that the god still impregnates the woman in a human or some other form, while, on the Jewish side, although it has been claimed by Dibelius (whom Pannenberg follows) that both Philo and Paul assumed a virgin birth for Isaac, this has been seriously called into question[66] and, moreover, as Brown again notes, 'we have no evidence that in Alexandrian Judaism the LXX of Isaiah 7:14 was understood to predict a virginal conception, since it need mean no more than that the girl who is now a virgin will ultimately conceive (in a natural way).'[67]

The other type of argument concerns the more general question of historical plausibility. Whereas the first was concerned to establish that, even if the status of the birth narratives is such that they cannot of themselves justify belief, there is no compelling alternative historical explanation, the second must face the objection that, had the Virgin Birth occurred, the story of Jesus' life would have been very different. For, the objection runs, how could Mary have known of the special status assigned to her Son and yet it be the case, as Biblical scholarship is generally agreed, that only a relatively low Christology appeared on the lips of Jesus? In reply, one needs to recall that within the Jewish tradition there was no convention about what such a birth might mean, far less any thought that it might possibly indicate an Incarnation! So, even if Mary spoke to Jesus about it, he need not have drawn any more

[63] D.R. Cartlidge & D.L. Dungan (ed.), *Documents for the Study of the Gospels* (Collins, London, 1980), pp. 129-36.

[64] Op. cit., p. 142.

[65] R.E. Brown, *The Virginal Conception and Bodily Resurrection of Jesus* (Chapman, London, 1974), p. 62 and footnote 104.

[66] *Mary in the New Testament*, pp. 45-9.

[67] *The Virginal Conception*, p. 64.

remarkable a conclusion than that God had a special interest in him; Raymond Brown's worries are thus unnecessary.[68] In any case, reticence on both their parts would surely have been inevitable, since any public claim would have invited the natural response that it was merely a device to conceal an illegitimate birth. Indeed, fear of such a possible counter-explanation may have so inhibited Mary that she did not feel able to speak out until after the Resurrection when her own gradual understanding of her Son's role may well have reached its decisive phase, with a miracle as stupendous at the end of his life as that with which she had seen it begun. All this is, of course, pure speculation. But it shows that the Virgin Birth cannot be excluded as a possibility on the grounds that it would produce an impossible tension with what we know to be the facts of Jesus' consciousness.

My conclusion therefore from an examination of this first stage in the development of the doctrine of the Incarnation is that with more detailed argument along the lines indicated the minimum conceptual conditions required for both models can in fact be met.

The Resurrection events

In the case of Stage Two, the Resurrection events, the unfortunate tendency of the historian to equate historical original with theological truth may also be noted, the temptation being this time to equate the event's significance with the manner in which it was first experienced. The temptation is to suppose that it must immediately have ratified Jesus as divine or not at all. As examples of this danger I shall take first a popular writer on the New Testament, Michael Green, and then at rather greater length a distinguished systematic theologian of wide-ranging interests, Wolfhart Pannenberg.

Michael Green writes as follows in his contribution to *The Truth of God Incarnate*: 'The Gospels abound in indications given by Jesus that after his death he would be vindicated by the resurrection (Mark 2:20; 8:31; 9:31; 10:34; 12:40ff). Let us assume that they are all prophecies after the event: at least the fact of the Resurrection vindicated Jesus' position as Lord and Christ (Acts 2:34-6). It showed that he was defined as Son of God (Rom. 1,4). The Resurrection pulsates through the New Testament as God's decisive act, vindicating his Son Jesus. It was this mighty act which confirmed their Christology.'[69] It is, of course, theoretically possible that a belief in Christ's divinity could have been

[68] Ibid., pp. 46-7 In *The Birth of the Messiah*, while reaffirming that 'the scientifically controllable biblical evidence leaves the question of the historicity of the virginal conception unresolved', he goes on to declare that he thinks it 'easier to explain the NT evidence by positing historical basis than by positing theological creation' (pp. 527-8).

[69] M. Green (ed.), *The Truth of God Incarnate* (Hodder & Stoughton, London, 1977), p. 52.

immediately effected by the Resurrection, but the fact that, as O'Collins remarks in his study on the Resurrection, 'whatever the factual nature of the appearances, historical authenticity can hardly be claimed for any words attributed to the risen Christ',[70] should make us hesitate. For, given the absence of parallelism in the sayings attributed to the risen Christ, it does look as though reflection on the experience was more important in the assigning of the various titles to Jesus than the content of the experience itself. After all, if the content had been decisive, it is hard to explain why greater importance was not attached to preserving the very words of the risen Jesus, which would then have been carefully passed on by the oral tradition, indicating as they did the source from which their knowledge of Jesus' new explicit status was derived. Such an argument holds equally against believing that, while there were no actual words of Jesus which produced this result, the effect of the experience was none the less immediate in inducing the requisite belief. If this were so, would not special care have been taken in preserving the earliest confessions of the disciples of this new status for Jesus? Yet, here again there is a lack of parallelism and the most explicit confession, Thomas's 'My Lord and my God',[71] is to be found in the canonical gospel that was written last.

Pannenberg in *Jesus: God and Man* tries to overcome objections such as these by offering a more sophisticated but equally flawed version of the argument. His strategy is to admit that a simple appeal to the experience will not do, but nevertheless at the same time he claims that the nature of the inferences immediately drawn by the disciples from their experiences is such that we cannot reasonably withold our assent from them. Now it might be thought that such an argument would more naturally be classified as falling under our third Stage, reflection on the experience, rather than Stage two, appeal to the experience itself. But, while Pannenberg does refer us to the reflection of the disciples themselves, the important point to note is that for him such an appeal to the disciples' reflections is not integral to his argument. For in his view it is an inference we can equally well make for ourselves, if we consider the immediate context of the Resurrection. What the disciples claimed on the basis of their experience is thus, strictly speaking, irrelevant to his case. His position thus differs profoundly from what I understand by a Stage Three type of appeal since in this latter case appeal would be made to the disciples' reflections but without any thought of the precise nature of the link between their original experiences and what they claimed on the basis of them being independently accessible and thus assessable by us. Of course, this raises problems about why therefore we should endorse what they said, problems that I shall consider in due course. In the

[70] G. O'Collins, *The Easter Jesus* (Darton, Longman & Todd, London, 1973), p. 26.
[71] John 20:28.

meantime, it should now be clear why Pannenberg's argument is also treated as a second Stage type of appeal; for him the mere fact of the Resurrection event by itself, when taken in context, is sufficient to establish the truth of Christ's divinity.

Pannenberg's appeal is to the context of apocalyptic expectations against the backdrop of which Jesus' resurrection has to be set historically. He summarises his own argument as follows: 'Only at the end of all events can God be revealed in his divinity, that is, as the one who works all things, who has power over everything. Only because in Jesus' resurrection the end of all things, which for us has not yet happened, has already occurred can it be said of Jesus that the ultimate is already present in him, and so also that God himself, his glory, has made its appearance in Jesus in a way that canot be surpassed. Only because the end of the world is already present in Jesus' resurrection is God himself revealed in him. If these apocalyptic ideas are translated into Hellenistic terminology and conceptuality, their meaning is: in Jesus, God himself has appeared on earth.'[72] However, as it stands, there are a number of obscurities in his summary with regard to how the connexion of thought is supposed exactly to proceed. That being so, in order to be fair to his position, it is only proper that we should also quote Allan Galloway's admirable summary of Pannenberg's argument, which, paradoxically, is a rather better synopsis than that offered by the original author.

'God is disclosed through his action in history. But God cannot be fully disclosed in history until the end of history, for the future is always open and further radical novelty is always possible. Apocalyptic arrives at the notion of the totality and completion of history. In that completion or end of history, the Glory of God will be fully revealed. That end or completion of history includes the general resurrection of the dead. This is the only context in which Jewish tradition considers resurrection. Therefore when Jesus rises from the dead there is no option but to treat this event as a foretaste of the end. Therefore the self-disclosure of God is complete in Jesus Christ, risen and glorified. But where self-disclosure is complete it must be a once-for-all event. Any further disclosure would imply the incompleteness of the former disclosure. Therefore the event must be unique. Furthermore, when self-disclosure is complete there must be a real identity of the person disclosed and the disclosing medium. Otherwise the medium would obscure the self-disclosure to some extent and the disclosure would not be complete. Therefore there must be a real identity of God and the risen Christ. Thus the doctrine of the incarnation derives from and is dependent on the recognition of Jesus as the final revelation of God.'[73]

[72] Op. cit., p. 69.
[73] A.D. Galloway, *Wolfhart Pannenberg* (Allen & Unwin, London, 1973), p. 78.

The argument has some obvious flaws in it. To mention one, there is a gap in the reasoning between 'foretaste of the end' and 'complete self-disclosure'; to mention another, even if there is a complete self-disclosure, it surely does not guarantee identity. Thus, for example, the Provost of Oriel College may so completely reveal the character of the College of which he is head, embody it, as it were, that staff and students alike, if asked to describe the nature of the institution of which they are members, will refer the enquirer to contemplation of him but that certainly would not be taken as implying that the Provost was the College in anything other than a metaphorical sense, still less that he was identical with it. Moreover, even if criticisms such as these could be answered, there remains the most basic objection of them all, which is that no justification has been provided as to why we, as distinct from the early disciples, should view the Resurrection in the context of apocalyptic expectations, that is, accept their frame of reference. Indeed, one might argue that of all the aspects of the New Testament this is obviously the least acceptable, precisely because the general belief in the imminence of the end of those most intimately involved in the events was proved so decisively wrong. Indeed, some scholars, e.g. Käsemann, Perrin,[74] specifically exempt Jesus from having held such a belief. Pannenberg would doubtless reply that because God's revelation occurs through the total historical context to give up apocalyptic would be in effect to give up a belief in revelation. But, even if it were necessary to defend apocalyptic in order to defend the notion of revelation (which in light of the model of revelation defended in Chapter 2 it is not), it would not follow from this that all aspects of apocalyptic thereby became defensible; that the resurrection of someone from the dead should be seen as a decisive anticipation of the end might still be a matter of legitimate dispute. In any case, not all scholars (e.g. C. Evans)[75] are agreed that resurrection is an indispensable element in apocalyptic. It is therefore impossible to see how Pannenberg's argument, probably internationally the best known post-war attempt at a defence of the doctrine of the Incarnation, can be satisfactorily sustained.

To judge then from these two examples, it is clear that the historical evidence is such as to preclude any direct argument from the Resurrection to Incarnation. However, as with Stage One, certain minimum necessary conditions must also be met at this stage if the argument is to be successfully carried over to Stage Three, where I shall argue the final decision rests. For it is only if the Resurrection events had in some appropriate sense an objective character that any reflection based on them which assumed their objective character could then be

[74] E. Käsemann, *New Testament Questions of Today* (S.C.M., London, 1969), pp. 111ff.; N. Perrin, *The Kingdom of God in the Teaching of Jesus* (S.C.M., 1963), pp. 198-9.

[75] C.F. Evans, *Resurrection and the New Testament* (S.C.M., London, 1970), pp. 180-2.

argued to have a similar objective status.

Unfortunately, at this point conceptual confusion reigns among New Testament scholars with regard to the conditions under which the Resurrection events might legitimately be described as objective events, as also over the related issue of how the various possibilities might bear upon the question of Christ's divinity. This can best be illustrated by noting the enormous amoung of energy that has been expended in an attempt to demonstrate the fact of the Empty Tomb,[76] as though without such a demonstration the objectivity of the Resurrection could not be guaranteed and thus the truth of the Incarnation vindicated. Typical is O'Collins' decision to preface his examination of the evidence with an endorsement of this comment from Barth's *Church Dogmatics*: 'We may be Protestants or Catholics, Lutherans or Reformed, to the right or to the left, but in some way we must have seen and heard the angels at the open and empty tomb if we are to be sure of our ground.'[77] But it would in fact be a mistake to suppose that establishing the Resurrection as part of the external world in this way is of itself sufficient for the purpose in hand, or even that it is a necessary condition towards that purpose. To show that it cannot of itself be sufficient, consider the case of someone falsely shouting 'Fire!' in a crowded cinema; in such a case one could presumably establish that the shouting was an objective feature in the external world, but nothing would follow from this about the legitimacy or otherwise of the audience fleeing in panic to the exits; in other words, proving the Empty Tomb in a similar way cannot be decisive for determining the legitimacy or otherwise of the conclusions drawn by the disciples from the events in question. It would, of course, be fascinating to learn that such a miracle had occurred, but, as Chapter 2 has already argued at length, revelation even when accompanied by miracles is a highly fallible process and so the truth of conclusions drawn by the recipients from genuine miracles that have happened to them cannot of itself be guaranteed by these miracles. Reflection on the events at Fatima might offer a suitable illustration. For one may believe that a miracle or series of miracles did take place, without thereby endorsing all the claims made by Sister Lucy on the basis of those miracles.[78] More strongly, however, it may also be claimed that proof of an Empty Tomb is not even a necessary condition for the truth of the Resurrection.

The temptation to think that this must be so probably stems from two

[76] There are numerous academic examples, but probably the best-known is F.F. Morison popular best-seller, *Who moved the stone?* (first published 1930, Faber 1958).

[77] Quoted in G. O'Collins, op. cit., p. v.

[78] That something extraordinary happened is strongly indicated by contemporary newspaper reports: for example, that which appeared in *O Seculo* on 15 October 1917 (quoted on pp. 85-9 of D. Walne & J. Flory, *Oh, What a Beautiful Lady,* Augustine Publishing Company, Devon, 1976). But from this it does not follow that one must endorse all the claims made by the ten-year-old girl when she had become an adult nun.

sources, that in some minds operate together and in others independently with only the latter having force. The first source is a conviction that, unless there was an Empty Tomb, we cannot, conceptually speaking, claim that the Risen Appearances represent the continuation of the same person who died and was laid in the tomb. Pannenberg's discussion of the relation between the appearances and the Empty Tomb[79] is not as clear as it might be, but, if I understand him correctly, he is an instance of someone who would endorse this view. For what he seems to be saying is that, while the evidence for the two comes from separate traditions and thus increases the weight of both,[80] even had there not been the tradition of the Empty Tomb, this could have been inferred, once one conceded the objectivity of the appearances; otherwise, it is hard to see why his discussion proceeds immediately from the objectivity of the appearances to a possible objection in terms of the violation of the laws of physics.[81] However that may be, there is no doubt that this is a misplaced worry. For, as I shall argue in detail in Chapter 6 in defending the coherence of the Kenotic model, bodily continuity is not necessary in order to guarantee continuity of identity; what matters is continuity of character and memories. The importance of bodily continuity, like similarity of appearance, merely lies in providing a useful aide-mémoire. Rather than pre-empt such arguments here, it will suffice to note the way most contemporary Christians would conceive of those who enter Heaven having something analogous to their original physical body rather than in any sense continuous with the same original physical particles. If such a discontinuity is acceptable in the case of other human beings, why not in the case of Christ? It cannot therefore be claimed that in either case the discovery of a rotting corpse would undermine the credibility of the contention that the individual in question had survived death.

However, one suspects that it is the other source which is the more decisive in inducing so many scholars to place the weight they do on the Empty Tomb. This is constituted by the same kind of confusion of which we spoke at Stage One, a confusion between the demands of historical plausibility and of conceptual plausibility with the resultant false assumption that the demands of each coincide. For it certainly does seem plausible to suggest that only if the disciples knew the tomb to have been empty would they have been persuaded of the objectivity of their experiences, especially given the beliefs of the time where physical continuity does seem to have been regarded as essential to continued existence.[82] But to proceed from this perfectly correct assumption, that

[79] Op. cit., pp. 88-106.
[80] Ibid., p. 105.
[81] Ibid., p. 98.
[82] C.F.D. Moule (ed.), *The Significance of the Message of the Resurrection for Faith in Jesus Christ* (Studies in Biblical Theology, 2nd series, 8, S.C.M., London, 1968), pp. 8-9.

because of the beliefs of the culture in which they lived it is highly probable that the empty tomb is required in order to tell a plausible story of the origin of their convictions, to an argument that for those convictions to have been justified there must have been an empty tomb would be to confuse two very different questions, questions of historical plausibility and questions of conceptual necessity. Thus one can quite easily imagine circumstances in which, say, the tomb was robbed of the corpse unknown to disciples and general public alike; under those circumstances, this condition for historical plausibility would have been fulfilled; yet, should evidence of this robbery come to light now in the twentieth century, we would still be justified in continuing to believe in the fact of Christ's continued existence precisely because such evidence would be conceptually irrelevant.

Before we pursue further the question of the appropriate sense of objectivity we are seeking, it will be as well to pause at this point to consider whether this demand of historical plausibility has been met. My answer would be that for the theistic historian it has been met. Admittedly, there are difficulties, some of which are more important than others. Thus the fact that Paul fails to mention the empty tomb would seem a matter of no significance either way; it merely shows that personally it was not an issue of importance to him. Rather more problematic are certain strange features of our earliest account of the discovery of the empty tomb in St. Mark's Gospel,[83] an account with which his gospel may originally have ended. Thus rather puzzling is the way in which the women arrive with no one to roll back the stone for them and then ask, 'Who will roll away the stone for us from the door of the tomb?'; puzzling too is the fact that the women come with the intention of anointing the body when presumably given the climate after such a delay it must already have been beginning to decay. But on the first point dramatic licence would seem a legitimate alternative explanation, especially if Mark did intend his gospel to end with the evocative last sentence of the account, 'for they were afraid'; on the latter, it may just be that Mark made a bad guess at their motives for being present at the tomb on that day. The idea of it being a bad guess is O'Collins' suggestion,[84] and it is O'Collins too who suggests a most powerful argument in favour of the tradition's historicity. 'If this discovery story were simply a legend created by early Christians, it remains difficult to explain why women find a place in the story. In Jewish society they did not count as valid witnesses. For legend-makers the natural thing would have been to have pictured Peter and other (male) disciples as having found the tomb empty. But in the oldest tradition the disciples have nothing to do with Jesus' crucifixion, burial

83 Mark 16: 1-8.
84 Op. cit., p. 41.

and discovery of the empty tomb. The role of the women in the story provides a strong argument for its historical reliability.'[85] But, while my inclination would thus be to accept the historicity of the Empty Tomb, it should again be emphasised that this is of no relevance to the conceptual question, to which question I now once more return.

Given that I have already rejected the conceptual necessity for an Empty Tomb in order to guarantee objectivity, it might be thought obvious what the other alternative is, and in a sense it is, namely the objectivity of the disciples' visionary experience. But great care must be taken in elucidating what exactly is meant by objectivity in this context. For it has nothing to do with objectivity in the sense of simply being part of the external world. In that case there would need to be some demonstration of the availability of such visionary experiences to anyone present at the times and places in question, not just the disciples. It is impossible to see how this could be substantiated; but anyway, even if such a suggestion were forthcoming, it would be redundant to our purposes, and for the same reason as I mentioned in the case of the Empty Tomb. As with the man shouting 'Fire!', it is not being part of the external world that makes us accept conclusions drawn from an experience but rather whether the conclusions are legitimately drawn from the experience, irrespective of whether or not it is part of the external world.

That being so, we may express the sense of objectivity required as follows: did the pressure for the disciples to say what they did come from the *object* of their experience ('objective' in this sense) or was it merely a projection of their internal psychology? If the former can be established as a reasonable belief, then it also becomes reasonable to accept conclusions drawn from the experience; for in the process of establishing this kind of objectivity we will have excluded the possibility that the pressure came from any other source, whether internal psychology or some external source other than the object of the vision. Though the point cannot be argued in detail here, this is surely exactly how we reason elsewhere: we accept people's account of their experience precisely to the extent that we feel justified in excluding certain types of reductionist explanation. The suggestion is similar to Swinburne's 'Principle of Testimony', that 'other things being equal, we think that what others tell us that they perceived, probably happened', where 'others things being equal' is explained as 'the absence of positive grounds for supposing that the others have misreported or misremembered their experiences, or that things were not in fact as they seemed to those others to be'.[86] However, there is this difference, that Swinburne appears to think that reports of

[85] Ibid., p. 43.
[86] R. Swinburne, *The Existence of God* (Oxford University Press, 1979), pp. 271-4, esp. p. 271.

religious experience are on a par with other experiential reports, where 'we do not normally check that an informant is a reliable witness before accepting his reports', whereas my view would be that given the contentious nature of the claims even within a theistic context the onus is first on the defence to show that the non-supernatural explanations are implausible. Therefore special care must be taken to check that certain possibilities can be excluded in this case, such as the unreliability of the witnesses, the presence of obvious psychological pressures, the complete cultural determination of the interpretation put on the experience, and so on. But even with these qualifications, it is my view that there is sufficient to tip the balance towards endorsement of the objectivity of the disciples' experiences. Admittedly, this is highly doubtful unless one has already accepted a theistic, as distinct from a deistic, interpretation of God's activity in the world, but I have previously argued at length for this in Part I.

In considering whether these alternative natural explanations can be excluded, it is important to remember that the evidence under examination comes from a definite cultural milieu. Failure to do so would certainly result in an adverse verdict. Thus, by twentieth century standards of reporting the accounts clearly leave a great deal to be desired. For, not only is there reason to doubt whether, as I noted earlier, any of the words attributed to the Risen Christ were ever said by him, but also there are quite a number of inconsistencies between the various reports, the most acute of which is perhaps the conflict between the Jerusalem and Galilean setting for the different appearances, the former being the location set by Luke and John,[87] the latter that set by Matthew and 'Mark'. Various attempts at reconciliation have been made, the most ingenious of which is probably that offered by Moule,[88] but the most likely explanation is that theological motives are dominant, with Luke concerned to emphasise the continuity between these events and the founding of the Church at Pentecost which he goes on to record in Acts and Matthew using Galilee to symbolise the mission of the Church to the Gentile world.[89] But such facts can only be used to undermine the reliability of the evidence for so long as one fails to take account of the very different standards and assumptions of the period in which these events were being recorded. For it seems clear that such licence would have been regarded as legitimate if it were considered to be the most effective way of communicating what was regarded retrospectively as

[87] John 21 has a Galilean setting, but it is normally regarded as a later appendix.

[88] C.F.D. Moule, 'The post-Resurrection appearances in the light of festival pilgrimages' in *NTS* 4 (1957-8), pp. 58ff.; or, more briefly, Moule (ed.), op. cit., pp. 4-5. He is criticised in C.F. Evans, *Resurrection and the New Testament* (Studies in Biblical Theology, 2nd series, 12, S.C.M., London, 1970), pp. 112-13.

[89] O'Collins, op. cit., p. 23. W. Marxsen also suggests that theological motives were at work in Mark's choice of Galilee in 16:7 (*Mark the Evangelist*, 1969, pp. 75ff.).

ultimately true, even if in the process the niceties of historical detail had to be sacrificed.[90]

But, it may be objected, once this much is conceded, why should not the entire narrative come under suspicion, and, instead of comparing the Evangelists to Thucydides or Plutarch for basic reliability, we compare them to the sort of inventiveness that is to be found in the apocryphal gospels? This is in effect what a small minority of New Testament scholars seem to be doing in their treatment of the Resurrection accounts, and so it is appropriate that we should look briefly at their views and assess their tenability. Marxsen, for instance, is only prepared to accept definitely an initial appearance to Peter[91] – rather ironically in view of the fact that, though Paul lists it as the first appearance,[92] there is no detailed account of it, unless it is recorded in John 21, as Evans suggests.[93] However that may be, it is interesting to note the nature of Marxsen's argument: 'Did Jesus have to appear to the others before they were able to believe? ... Anyone who maintains that Jesus had to appear to the other disciples before they were able to believe must be consistent. He must then be prepared to agree that nobody can find faith, even at the present day, unless he has experienced an appearance of Jesus. But this is a proposition hardly anyone would maintain.'[94] He then goes on from this to argue that the other alleged appearances have a functional purpose, and that the accounts are based on a later process of *a posteriori* reasoning, the object being to claim a certain status for the various groups mentioned and also to justify themselves in tracing their origins back to that primary experience of Peter.[95] But the latter suggestion is extremely tenuous without evidence to support it, and indeed it is clear that Marxsen has subordinated the historical facts to theological considerations, the very evil he imputes to the evangelists' sources! From his ultra-Protestant perspective faith simply cannot be allowed to have depended so obviously on a miracle, especially at the very beginnings of that faith. But this is hardly a relevant historical argument; in any case, special factors were at work here that are not present in the case of every Christian, namely a situation of acute despair brought about by the apparent failure of the crucifixion. Dogmatic considerations can equally be seen to be playing the decisive role, when Bultmann declares that

[90] Thucydides (1.22) describes his objective in writing the speeches as 'to make the speakers say what, in my opinion, was called for by each situation'. Again, Plutarch in his *Life of Solon* (27) remarks that 'when a story is so celebrated and is vouched for by so many authorities, and more important still, when it is so much in keeping with Solon's character ... I cannot agree that it should be rejected because of so-called rules of chronology'.

[91] W. Marxsen, *The Resurrection of Jesus of Nazareth* (S.C.M., London, 1970), p. 79ff., esp. p. 89 and p. 93.

[92] I Corinthians 15:5.

[93] Op. cit., p. 53.

[94] Op. cit., p. 89.

[95] Ibid., cf. p. 92.

'faith in the resurrection is really the same thing as faith in the saving efficacy of the cross'[96] and from that goes on to postulate that 'the resurrection itself is not an event in past history. All that historical criticism can establish is the fact that the first disciples came to believe in the resurrection',[97] his view being that 'the resurrection narratives and every other mention of the resurrection' are nothing more than 'an attempt to convey the meaning of the cross'.[98] This *a priori* kind of reasoning is something from which English scholars are not immune, as can be seen in Lampe's strange argument against the historicity of the Empty Tomb that Christ's resurrection ought to differ in no way from our own whose bodies undoubtedly do decay and decompose.[99] It may be thought that this is an instance of the kettle calling the pot black, in the light of my acceptance at Stage One of the possibility that theological considerations might be allowed to determine the acceptance or rejection of the historicity of the Virgin Birth. But the situation was in fact quite different; the suggestion was acceptable only because prior consideration of the historical evidence had produced a fine balance either way, whereas here theology is being used before any assessment of the available historical evidence.

However, it may still be objected that, though I am right to reject this *a priori* attempt at demolition of the narratives, this still does nothing to establish the essential credibility of the accounts. This is true. But the point is that there are no problems of credibility that are specially difficult and peculiar to the resurrection narratives as distinct from the rest of the Gospels; the temptation to think otherwise comes when New Testament scholars are led astray from their proper work by dogmatic considerations. Thus it is true that elsewhere incidents are invented by the evangelists for theological motives, and so this must remain a possible interpretation of the Resurrection accounts. In the case of miracle, an example is the turning of water into wine at Cana; a non-miraculous instance the composition of the *Magnificat*. But in proposing this we need not rely on prior dogmatic considerations. Earlier in the chapter I gave a reason why the Magnificat is unlikely to be historical; it reflects the victory of the Resurrection. Likewise in Chapter 2 I noted criteria for determining whether a particular miracle is historical or not, in terms of which that at Cana fared badly. Thus it is possible to consider the historicity of Gospel events without prior prejudice in respect of their miraculous content, and this is how it should be with the Resurrection. Elsewhere good theological reasons can

[96] In *Kerygma and Myth*, ed. H.W. Bartsch (trans. R.H. Fuller, S.P.C.K., London, 1972 ed.) vol. 1, p. 41.

[97] Ibid., p. 42.

[98] Ibid., p. 38.

[99] G. Lampe & D.M. MacKinnon, *The Resurrection: A Dialogue* (Mowbrays, London, 1966), p. 58ff.

normally be detected for invention or the restructuring of events. Even then there is a basis in fact, and so the essential reliability of the evangelists is not called into question. So in the case of the two illustrations mentioned above, the invention of the Magnificat presupposes a victory of Jesus over death, and that at Cana that Jesus had miraculous powers and the ability to bring new life. In the case of the Resurrection I can detect no such good theological reason, nor an adequate historical foundation as a basis for such a major claim. It could only be viewed as invention in the worst sense, which is not the evangelists' practice elsewhere.

Apart from deliberate invention, the next most obvious natural explanation is probably the psychological one, the suggestion that the experiences did take place but are none the less to be accounted for naturally in terms of some sort of mass wish fulfilment. The argument that some supernatural fact is needed to account for the way in which the disciples are transformed from frightened and downcast individuals[100] into men of zeal and enthusiasm who no longer see the crucifixion as a defeat is thus, as it were, turned on its head; the need for an explanation is accepted, but their former low morale is used as a ground for expecting some sort of wish fulfilment subjectively to take place. However, there are at least two good reasons for rejecting this suggestion. The first is that the appearances seem to have taken place over a period of time, in different places, to different people and to different numbers of people. Paul's list indicates the difficulty: 'He was seen of Cephas, then of the twelve; after that, he was seen of above five hundred brethren at once ...; after that, he was seen of James, then of all the apostles; and last of all he was seen of me also.'[101] I know of no psychologically induced visions that have as complicated a structure as this. The nearest parallel which I can think of is the vision at Knock which was seen by a number of people over the space of several hours,[102] but this is still a long way short, and in any case there seems no good reason to deny the veridical character of Knock as well. The other reason is to be found in considerations that have been advanced by Christopher Evans. He argues plausibly that a doctrine of resurrection was not firmly fixed in Judaism and that it is largely absent from the teaching of Jesus. If this is so, then 'particular attention is focused on the actual resurrection of Jesus. It may be suggested that only this event, whatever it may have been, could have brought it about that there emerged in Christianity a precise, confident and articulate faith in

[100] Mark 14:50.

[101] I Corinthians 15:5.

[102] The apparition which was complex in character (a lamb on an altar with three attendant figures) was seen by a number of different people, whose ages ranged from six to seventy-five, in the pouring rain on 21 August 1879. Though a watch was kept for the next few days by those who had seen the vision, nothing further was seen.

which resurrection has moved from the circumference to the centre.'[103]

The last of the natural explanations to be considered is the possibility of cultural conditioning. Here the thought is that, even though the precise cause may be unclear, the value of the experience for validating doctrine is negligible because inevitably the interpretation of the experience has been culturally determined. In a previous chapter I admitted that many religious experiences are heavily culturally conditioned both in the form they take and in the manner in which they are described, but it was pointed out that this is very different from admitting cultural determinism where it is understood to be all just a matter of input from the particular culture concerned. In the case of the Resurrection this is especially implausible simply because of the great variety of ways in which the Risen Christ is described both in the immediate context of the experiences and in the proclamations made soon after on the basis of those experiences. For instance, the accounts differ greatly in respect of the emphasis they place on the physicality of Jesus, St. John's Gospel being the most explicit.[104] Again the evidence is firmly against there having arisen only one particular christology as a result of the experiences, as also against any single title as initially having been regarded as uniquely the most appropriate. It would be impossible to claim, for example, that either the fact of, or the interpretation of, the disciples' experience was simply induced by their beliefs about an expected Son of Man who would come in glory; the pattern of the experiences and the claims made on the basis of them are just too diverse to make this a feasible option, and indeed suggest that causation was probably in the opposite direction, with the experiences producing the inference that their object must be identified with the Son of Man rather than all their experiences having had self-evidently this character.

If argument along the lines indicated is accepted, rejecting natural causes such as the three I have discussed, then it becomes legitimate to endorse a description of the Resurrection as 'objective' in the sense outlined. But before proceeding to consider what further may be made of the Resurrection on this basis, it will be useful to note the extent to which the approach adopted here contrasts with that to be found in most New Testament scholars, including what is perhaps the best known and most extensive recent treatment of the topic, namely that in Edward Schillebeeckx's *Jesus*. Consideration of this work will also enable me to highlight the dangers inherent in failing to make philosophical questions central to the discussion. Schillebeeckx shares a similar emphasis on the importance of religious experience, but accords it a very different treatment precisely because of underlying assumptions that are nowhere

[103] Op. cit., pp. 39-40.
[104] John 20:27.

fully analysed or justified.

Before criticising him, it will be helpful to summarise his position. His treatment of the evidence is far more radical than that adopted here. He is unprepared to regard any of our present accounts as historical. For example, 'the initial story of the women's going to Jesus' tomb is an aetiological cult legend';[105] ' "on the third day" ... tells us nothing about a chronological dating of the resurrection';[106] Mark, we are told, did not accept the tradition of the Jesus appearances;[107] Luke is supposed to have modeled his on 'divine miracle-man' concepts 'so as to help Greeks to "empathize" with the gospel'[108] and it is from within this type of model that 'the tradition of Jesus' "appearances" would seem to have arisen';[109] even St. Paul's Damascus vision 'has evidently been constructed' with traditional Jewish conversion stories in mind.[110] At the same time he is at pains to distinguish his position from that of Marxsen who regards the Easter 'experience' as simply an interpretation of the disciples' experience of the earthly Jesus. By contrast, Schillebeeckx declares: 'The question is surely whether the Christian interpretation, after Jesus' death, rests solely on experiences after his death. This is the crucial point it seems to me. And I mean, not experiences of an "empty tomb" or of "appearances" (themselves already an interpretation of the resurrection faith), but experiences such as I have already enumerated: the "conversion process" undergone by the disciples, their "encounter with grace" after Jesus' death.'[111]

That Schillebeeckx is prepared to state unqualifiedly that Jesus is still alive on the basis of such experiences emerges clearly at a later stage, when he is once again engaging in debate with Marxsen.[112] But I am extremely doubtful whether they can bear the weight he wishes to put upon them. Symptomatic of the source of my worry are comments like the following: 'There is not such a big difference between the way we are able, after Jesus' death, to come to faith in the crucified-and-risen One and the way in which the disciples of Jesus arrived at the same faith.'[113] A form of reductionism in fact seems to be going on, in terms of which all religious experience is reduced to the one basic form of experience, the experience of grace that is the dominating theme of his later book, *Christ.* So, of the appearances he comments: 'The matter of "substance" of the manifestation is supplied out of the concrete life of the Church as

[105] E. Schillebeeckx, *Jesus: An Experiment in Christology* (Fount Paperback, London, 1983), p. 336.
[106] Ibid., p. 532
[107] Ibid., p. 418.
[108] Ibid., p. 426.
[109] Ibid., p. 427.
[110] Ibid., p. 383.
[111] Ibid., p. 394.
[112] Ibid., pp. 644ff., esp. pp. 645-6.
[113] Ibid., p. 346.

the "community of Christ". Worship, adoration, is the answering response to the experience of an act of grace: they see Jesus and they worship him. Structurally, within the story, the "appearance" is an extrapolation of the grace characterising it.'[114] However, when one then attempts to probe further as to the nature of this experience of grace, almost all one finds is some very general conviction of hope, that, no matter how adverse things may seem, God will win through in the end. 'I ... believe that in the face of the historical fiasco of Jesus of Nazareth not history, but the benevolent one opposed to evil – God – has the last word. This the early Christians try to express with their credal affirmation of Jesus' resurrection. That wording may be subjected to criticism – and rightly so. However what I as a Christian believer will not give up is *this*: for anyone who believes in a "God of creation and covenant" the historical failure of Jesus of Nazareth cannot possibly be the final word ... Human history – with its successes, failures, illusions and disillusions – is surmounted by the living God.'[115] But what one wants to know is the grounds for such confidence, and it is far from clear that Schillebeeckx's primary 'resurrection' experiences can provide this.

Thus, his analysis of this initial experience of 'grace' has two elements, both of which raise more questions than they solve. There is the element of 'conversion', as the disciples, beginning with Peter,[116] resume again 'following after Jesus', and, integral to that renewed following, the 'forgiveness of sins', when the disciples experience a sense of forgiveness for their temporary disloyalty to Jesus ('thrown off balance rather than deliberately disloyal').[117] Indeed, perhaps the most important passage in the whole book is the brief section, 'The experience of grace as forgiveness'. For there he gives his explanation of how the conviction of Jesus being alive probably arose. His suggestion is that the New Testament connection between resurrection and forgiveness of sins should be reversed, and asks: 'May it not be that Simon Peter – and indeed the twelve – arrived via their concrete experience of forgiveness after Jesus' death, encountered as grace and discussed among themselves (as they remembered Jesus' sayings about, among other things, the gracious God) at the "evidence for belief": the Lord is alive? He renews for them the offer of salvation; this they experience in their own conversion; he must therefore be alive ... A dead man does not proffer forgiveness. A present fellowship with Jesus is thus restored.'[118]

The motivation for all this is not hard to detect. It is that Schillebeeckx is a deist. Thus, he affirms that 'God's activity in history is not some "interventionist activity", a statement which is expanded on the

[114] Ibid., p. 358.
[115] Ibid., p. 639.
[116] Ibid., p. 389.
[117] Ibid., p. 382.
[118] Ibid., p. 391.

following page with the comment that 'the religious language of faith adds nothing new, no "new information", to what the non-religious language has already said.'[119] Instead, he talks of "disclosure" experiences in which we are able 'to discover in our history "traces" of God's saving presence passing on its way'.[120] In the light of this his attitude to Jesus' miracles is hardly surprising. Only cases of healing and exorcism are retained,[121] i.e. those that most readily admit of a natural explanation. The rest are a matter of 'epic concentration'[122] with, for instance, the raising of the dead based simply on Old Testament models.[123] So far as the Resurrection itself is concerned, even where independent argument is offered, it is hard to resist the suspicion that the primary motive is to rationalise away the heavy element of the miraculous that is present. So, for instance, his insistence that Luke is modelling himself on existing 'rapture' models is supported in the text by appeal to a novel and to a mythological figure,[124] surely very different from treating an actual historical individual in this way, and in the footnotes by appeal to Enoch, Moses and Elijah,[125] where again there is the significant difference that in the brief reference to their being caught up into heaven nothing is made of the fact.

However that may be, more seriously there are three decisive objections that may be made against Schillebeeckx's position. The first is that, with his rejection of intervention he has also lost the case for the objectivity of the disciples' experiences. For, especially given his treatment of Christ as no more than a man, it needs to be remembered that there is no way in which a dead man can continue to communicate with those still in this world than by a violation of the laws of nature, and a major one at that. Of course, the conviction of Jesus continuing to be alive could have arisen naturally, as Schillebeeckx wishes to maintain. The point is that, if so, then we would have as little reason for believing the disciples' conviction as we have for taking a wife or husband's conviction that their recently deceased spouse is alive as good evidence that it is indeed so. In both cases a divine source for the belief is an unnecessary additional postulate; the simpler explanation is overbelief caused by grief.

Secondly, despite a passing allusion to the need to make the 'transformation at any rate psychologically intelligible', it seems to me that Schillebeeckx's version in fact makes the whole thing more puzzling, not less. Thus, what we seem to have is an overwhelming conviction that

[119] Ibid., pp. 627, 628.
[120] Ibid., p. 634.
[121] Ibid., p. 189.
[122] Ibid., p. 188.
[123] Ibid., p. 186.
[124] Ibid., pp. 340-4, esp. pp. 341, 342.
[125] Ibid., note 50, pp. 704-5.

Jesus is alive, and that would surely be more readily explicable if actual visual appearances of the allegedly dead person had occurred. Indeed, so far as his account of the primary experience is concerned, one essential step in his argument is clearly flawed, namely the claim that it was reasonable to deduce that Jesus was alive from the fact that 'a dead man does not proffer forgiveness'. On the contrary, one has no difficulty in envisaging just such an experiential conviction, based purely on the dead man's past character – 'if he were alive, this is precisely what he would do'.

Finally, so far as our three tests are concerned, as we have already seen, he offers precisely the sort of psychological explanation that would preclude objectivity in the relevant sense. Not only that, with the two other tests of the reliability of the evidence and the possibility of cultural conditioning, he concedes so much (unjustifiably) that it is hard to see why any authority should attach to what he regards as the disciples' pristine experience. After all, if one has to rely on documents that are so essentially unreliable as to the facts, that must inevitably make any attempt at retrieving the original experiences highly conjectural. Moreover, even if the retrieval was successful, there would still be the problem that Schillebeeckx's characterisation of the documents is such as to demand suspicion of any experience coming from a culture where overbelief was, apparently, the order of the day.

Schillebeeckx's approach to the Resurrection, then, can safely be rejected and my earlier claim to the objectivity of the experiences continue to be maintained. That being so, had the accounts been clearer, it might have been possible to argue for Christ's divinity simply on the basis of the content of the experiences, but, as I have already noted, this cannot be done. What, however, can and must be done is evidence be offered that the experiences share features that would make the proclamations based on them justified. For one must anticipate the objection that, even though the experiences were objective, the proclamation exceeded what could legitimately have been felt as part of the data of the original experiences.

That such evidence is forthcoming is not in doubt. For, all the accounts share the conviction that the Risen Christ is now a highly exalted figure. Eduard Schweizer's comments in *Lordship and Discipleship* are particularly interesting in this respect: 'That the exaltation really dominated the thought of the early Church is shown by the fact that the oldest tradition barely distinguishes between Easter and Ascension ... in the Gospel according to St. Matthew the risen Christ appears to his disciples as the One to whom all authority in heaven and on earth has already been given (Matt. 28:18). Also according to John (John 20:17) the ascension takes place on Easter morning before the appearances. It may well be asked if the reports of the first appearances (I Cor. 15:5ff.) have been lost because they told of Jesus' exaltation to God and on

account of that were not sufficiently realistic in the eyes of a later generation. At any rate, this would explain why Paul places his appearance on the road to Damascus entirely on the same level as the appearances to the twelve ... the view that the event of Easter was the appointment to heavenly glory can still be traced behind the synoptic tradition of the resurrection. This is the case with the Son of Man tradition.'[126] Much of this is pure speculation of a kind which it is impossible to substantiate, but that their essential element was exaltation rather than just survival or the resuscitation of a corpse is confirmed by an examination of the accounts. Thus Evans, in opposition to Moule, comments on the appearance in Matthew[127] as follows: ' "Resurrection appearance" in the sense which is generally attached to that phrase in the light of other stories, is a misnomer. It is an exaltation scene, and becomes a resurrection appearance only by its present position after the death and grave scenes.'[128] But the same is also true of the records in the other evangelists in that Luke describes how the Risen Christ 'lifted up his hands and blessed them',[129] and even John for all his emphasis on the physical nature of the appearances has Thomas confess 'My Lord and my God',[130] which, though historically unlikely as explicit belief in his divinity is clearly a late development, does indicate, I think, that the tradition on which John was drawing was of encounter with an exalted figure, in terms of which John's addition of 'my God' seemed to him entirely apposite.

In this connection one might also note the extensive use of imagery drawn from Psalm 110, with Christ 'sitting at the right hand' of the Father, usefully examined by David Hay in his monograph, *Glory at the Right Hand*. From a number of factors,[131] including the fact that three allusions[132] are near identical in form and yet do not have a single word in common with the Septuagint, as also the fact that some allusions[133] seem superfluous, suggesting traditional formulae, he concludes that we have access to a primitive church confession about the present status of Christ. Of particular interest is an objection he raises against Hahn, as it will also apply to Schillebeeckx's more recent work,[134] with its view that Mark conceives of Jesus as now totally absent and only to be exalted at the Parousia. As against Hahn's view that Mark 14:62 represents the exaltation as only beginning at the end of the world, he comments: 'This

[126] E. Schweizer, *Lordship and Discipleship* (Studies in Biblical theology, S.C.M., London, 1960 ed.), pp. 38ff.

[127] Matthew 28:16-20.

[128] Op. cit., p. 83.

[129] Luke 24:50 [130] John 20:28.

[131] D.M. Hay, *Glory at the Right Hand* (Society of Biblical Literature Monograph series 18, Abingdon Press, Nashville, New York, 1973), pp.39ff.

[132] Romans 8:34, I Peter 3:22, Colossians 3:1.

[133] E.g. Colossians 3:1.

[134] *Jesus*, p. 420.

view is most unlikely, first just because so many other early Christians attest a general conviction that the *session* began with Jesus' resurrection, secondly because 14:62 describes not the enthronement of the Son of Man but the revelation of him as enthroned. The *kathémenon* indicates not the beginning of a *session* but its continuance. When Jesus comes on the clouds he will have the authority and might of the one sitting at God's right hand. Probably, then, Mark concurred in the general opinion that Jesus sat down beside God with, or directly after, his resurrection. The evangelist's interest, however, was concentrated on the parousia revelation, when Jesus' claims will be proven true.'[135]

Attempts have, of course, been made to distinguish between the experience of resurrection and that of exaltation, the latter being associated with the Ascension. For example, such an attempt is made by O'Collins,[136] and Moule argues for the necessity of an Ascension as follows: 'The decisive cessation of the appearances ... was clearly something needed by the friends of Jesus who had known him so closely as an earthly friend and intimate that for them the problem was how to be weaned of this audio-visual, quasi-physical relationship.. A decisive withdrawal by absolute cessation was, perhaps, for them the needed message.'[137] But it is hard to see why the very different experience of the Holy Spirit's indwelling presence should not have performed this role. None of this is to call into question the more physical aspects of the resurrection appearances; it is merely to draw attention to the fact that they are not just resurrection experiences; they also contain as a central element the experience of Christ as an exalted figure. The main argument against the tradition of an Ascension is Paul's willingness to place his own later experience on a par with that of the earlier disciples, but, as Evans suggests,[138] this may simply be an instance of Pauline 'egoism'. But in any case it should be noted that a denial of an Ascension experience is in no way integral to our argument; there may have been one experience that had more of this 'parting' character than any other. What *is* integral is the supposition that all the experiences had this element of encounter with an exalted figure, and not just the Ascension.

To have established this much, however, is still a long way from a doctrine of Incarnation. For an exalted figure need not necessarily be a divine figure; an angelic being would be an obvious exception. Moreover, the nature of the accounts we possess is such that it is no longer possible to recover in detail the exact form this exaltation took in the visions. Was it the manner in which he spoke, or his garments or being surrounded by an angelic host that indicated his exalted nature? The answers to such

[135] Op. cit., p. 66.
[136] Op. cit., pp. 50-2.
[137] Op. cit., p. 5.
[138] Op. cit., p. 46.

questions are now shrouded in the mists of time, especially, given the fact that, as I have already noted, the earliest vision to Peter seems to have been lost. All we can do is examine the proclamation made immediately on the basis of these visions, and infer back from this to what the nature of the exaltation must have been. However, such backward inferences need not concern us here. The important thing for our purposes is that the Resurrection event has been shown to be an *objective* experience of encounter with an exalted figure, in terms of which we will therefore be justified in accepting proclamations of such exaltation, derivable, as they were, from the appearances in question.

All therefore now hangs on the precise nature of this early proclamation, to the examination of which I next turn. As we shall see, it is impossible to claim historically that the earliest proclamation was a proclamation of divinity, but, despite that, I shall give grounds for believing that it does commit us to a belief in Christ's divinity.

Post-Resurrection reflection

To suppose that because the earliest proclamation made on the basis of the Resurrection appearances makes no reference to Christ's divinity he could not therefore have been divine would in fact be to make exactly the same mistake that we have criticised at the two previous stages. For, just as Christ may have made no claim to be divine and yet be divine, and just as the Resurrection may be regarded as the permanent exaltation of human nature into divinity and yet not have been seen as such at the time, so reflection on the event might not have led to the expression of an explicit commitment to Christ's divinity and yet it be none the less such a commitment implicitly. What I have in mind is the possibility that by the language they adopted and the actions they performed as a result of their experience of the Resurrection, the disciples will be found in effect to have committed themselves to a belief in the divinity of Christ, though this belief was perhaps only explicitly formulated for the first time in the Gospel of St. John. Such a slow growth in the acceptance of what is regarded as the truth may seem implausible, but I think that it only remains so for so long as one continues to adhere to a model of revelation that fails to respect human freedom; once one adapts one's model to take account of this, as I tried to do in Chapter 2 with the suggestion of a voluntary dialogue, then misunderstanding and slow comprehension would seem inevitable.

In assessing the attitudes of the early Church, a contrast is commonly made between a functional and an ontological use of the titles assigned to Christ. By 'functional' is understood a reference to the function or role Christ is performing in the scheme of salvation; by 'ontological' a statement about what he is in himself in which a particular status is assigned to him without any qualification of that status as his only in

virtue of a role having been given him by the Father. With this distinction there goes a common assumption that, if ontological titles are assigned to Christ, they are evidence for a belief in divinity, whereas, if only functional language can be found, the case for his divinity becomes impossible to substantiate. But once it is conceded that a distinction can be drawn between explicit belief and the implicit and perhaps unknown implications of that belief, it is no longer clear that the incarnationalist has lost the argument, even if he concedes that all early post-Resurrection descriptions of Christ are functional rather than ontological. For it may be the case that, though they have every appearance of being merely functional, their implications compel them to be treated as ontological. The point has, I think, once again been obscured by the persistent and false equating of historical original with theological truth, in this case the assumption being that it is only the disciples' intentions that we may legitimately adopt as our own. Another factor may be an unreasonable prejudice for Biblical terminology over Hellenic.

The sort of way in which functional language can have ontological implications without one realising it can perhaps best be illustrated by drawing a comparison with the status of Protestant taunts that some Roman Catholics, particularly before the Second Vatican Council, were tending to treat the Virgin Mary as herself of divine status. Confusion reigns because of a failure to clarify exactly what kind of treatment of Mary would constitute her divinisation. The plethora of titles that have been applied to her is often thought to be relevant, but is in fact quite irrelevant. 'Queen of Heaven', 'Mother of Mercies' and so on are all compatible with a non-divine status; what really matters is the extent to which power and authority have been delegated to her, which she can then exercise without reference to her Son or the Father. Thus, for example, in respect of prayer the vital question to be answered is whether, and to what extent, she is seen as herself granting requests or, alternatively, whether she does this only through petitioning her Son. Likewise, in respect of miracle the vital question is whether she performs them in virtue of her own power or has to intercede that these things happen. It is particularly important to note that with such questions the answers of the devotee are not necessarily the most important element in determining the truth. Thus they may reply that they have no intention of ascribing divinity, and yet that be precisely what they are committed to by their behaviour and attitudes.

Similarly, then, with respect to the views of the early Church, it is quite possible that Paul or Luke or Mark, if pressed, would have denied that they were ascribing divinity to Christ and yet that be still exactly what they were doing. That is to say, the pressure of the Resurrection experience, confirmed no doubt by their post-Resurrection life in general, may well have compelled them to ascribe a role to Christ which can only

appropriately be regarded as divine, but which, because of the strong Jewish commitment to monotheism among the early disciples, they would have been very reluctant to endorse, and indeed because of this commitment would have in all probability denied as being part of their overall conceptual framework.

That functional language predominates in the early period would seem self-evident. Paul's use of the phrase, 'God was in Christ',[139] is symptomatic. Indeed, Frances Young's view, as expressed in *The Myth of God Incarnate*, that 'Jesus ... was the embodiment of all God's promises brought to fruition ... represents New Testament christology better than the idea of incarnation'[140] is a statement with which I would have no quarrel, provided, that is, it is seen as an expression of their intentions rather than the net effect of all their attributions. I would also be quite happy to admit, again with Young, that 'Paul neither calls this figure God, nor identifies him anywhere with God.'[141] One might also concede to her that, given the similar expression applied to all Christians in Ephesians 3:19, even the famous phrase of Colossians about 'all the fullness of God dwelling in him' (Col. 1:19) may well be functional rather than ontological.[142] Even the transfer of well-known monotheistic passages from God to Christ, as with Isaiah 45:23 in Philippians 2:10ff. or Daniel 7:9 in Revelation 1:14, may not indicate any conscious ascription of deity. After all, transfers had been made before in respect of Wisdom and the Torah. Of course, this time a person is involved, but I suspect that the writers concerned may well have been no more conscious of the implications of what they were doing than many a devotee of Mary. Indeed, if challenged, they might well have withdrawn, or apologised by drawing the parallel with passages where similar treatment is accorded Wisdom or Torah without there being any intention to add to the number of the divine persons.

But even to concede this much is still not to go as far as Cullmann who concludes his major study of the christological titles by declaring: 'Because the first Christians see God's redemptive revelation in Jesus Christ, for them it is his very nature that he can be known only in his work – fundamentally in the central work accomplished in the flesh. Therefore, in the light of the New Testament writers, all mere speculation about his nature is an absurdity. Functional Christology is the only kind which exists.'[143] R.H. Fuller in *The Foundations of New Testament Christology*, despite an impressive start, gives Cullmann what in the end turns out to be only a very gentle rap over the knuckles. Thus he begins: 'One can hardly say with Cullmann that the Christology

[139] II Corinthians 5:19.
[140] J. Hick (ed.), *The Myth of God Incarnate* (S.C.M., London, 1977), p. 19.
[141] Ibid., p. 21.
[142] Ibid., note 23, p. 45.
[143] O. Cullmann, *The Christology of the New Testament²* (S.C.M., London, 1963), p. 326.

of the NT is purely functional. Much of it certainly is, especially in the purely Jewish phases. Yet even the Palestinian kerygma does not confine itself to statements of what God has done in Jesus. It also applies to Jesus christological titles: Son of man, Lord, Messiah, servant.' But he then so qualifies his argument that the force of the criticism is almost entirely obliterated: 'These christological titles are, however, almost without exception used in sentences which speak of action ... These statements are really functional in character, not affirmations about the 'nature' or being of Jesus. They affirm what he is doing or what he will do'.[144] Admittedly, he goes on from this to claim on the following page that 'the Gentile mission advanced beyond this to make ontic statements about the Redeemer', and refers us to Paul's description of Jesus as 'being in the form of God'.[145] But, while the intention could well be ontological, caution is certainly necessary; the main influence might well have been the metaphorical treatment of Wisdom and Torah to which we have already referred as a possible explanation of later verses in the same chapter of Philippians, while of the meaning of the Greek word we can be certain of no more than that Jesus had the 'stamp'[146] of God upon him, which could mean a wide variety of different things. However, whether St. Paul's intention was ontological or not, we may leave unresolved. For Cullmann and Fuller are arguing about the shadow rather than the substance in that, given Fuller's admission that ontology is a later development, it will remain questionable whether such ontology is a legitimate development unless it can be shown that it is implicit in the earliest functional declarations made on the basis of the Resurrection experience. Of course, there is also the point that the incarnationalist need not worry about proving the existence of ontology, if functional language can in effect involve precisely the same sort of commitment.

That being so, we must first clarify the conditions under which it may legitimately be claimed that a person is treating another individual as a god. For only then will we be in a secure position from which to comment on the early disciples' functional christology. Clearly there is a difference between a heavenly being and a divine being, and I have already hinted at what this difference might amount to in my discussion of the status sometimes assigned to the Virgin Mary. Of course, one might solve the problem of differentiating by applying the test of whether all the traditional attributes of God are present _ omniscience, omnipotence, etc. – but this is clearly an inadequate solution since the history of religion reveals many figures who have been treated as a god but would none the less fail this test. The heart of the concept obviously lies

[144] R.H. Fuller, *The Foundations of New Testament Christology* (Fontana, London 1969), p. 247.

[145] Philippians 2:6.

[146] This translation, which retains the ambiguity in the Greek, is the one proposed by Beasley-Murray in *Peake's Commentary on the Bible* (Nelson, Edinburgh, 1962), p. 986.

elsewhere in the notion of worship, the conviction that awe and reverence are due to the individual concerned. However, distinguishing between this notion and that of respect is far from easy, and that is why it is easier to make the distinction in terms of the divine being's perspective. Here, surely, what makes the difference is what is sometimes labelled aseity, that is, complete independence of action in the ability to realise one's objectives without the need for help from men or other divine beings.[147] The rationale of my treatment of Mary thus becomes clear. Clarification too, I think, is brought to the question of worship. For it may be regarded as the other side of the coin, as it were, in that worship can be distinguished from respect by its acknowledgment of dependence. In worship it is conceded that certain things cannot be achieved without the divinity's aid. None of this should be taken as implying the obviously false claim that one cannot be a god unless one is worshipped. Clearly, it is the second condition that determines divinity. But from the human perspective it is assumed that this aseity normally brings with it an interest in human affairs and so one's concerns cannot but be affected by one's relation to the divinity in question. That being so, it will be of interest to note whether both aspects are fulfilled in the case of Christ, though, as we have already remarked, it is only the aseity condition which is essential to the notion of deity.

In the case of worship, we find Matthew's Gospel recording that two of the appearances were accompanied by worship;[148] a reference is also to be found in the Lucan account[149] but it is based on an inferior manuscript tradition. What value, if any, these have it is difficult to say, given the fact that they are to be found authentically only in one gospel tradition and the doubts already expressed about the details of the Resurrection accounts. Cullmann offers a different approach: 'It was the experience of his lordship which first gave the real impetus to a consistent formulation of Christology in terms of Heilsgeschichte. This new understanding was given to the first Christians in *Common worship*, above all in common meals, and confirmed in the various expressions of their life together. Together with Jesus' earthly work and the experience of Easter, the main root of New Testament Christology is this experience in worship of Jesus as the present Lord who was now prayed to (Maranatha) and confessed (Kyrios Christos)'.[150] But there are a number of problematic features about this account. For a start, his arguments for tracing the title of Kyrios back to a Palestinian milieu[151] are unpersuasive and, if that is so,

[147] This might seem disproved by the primitive notion of offering food to the gods. But the thought was not that they needed to obtain food in this way, but rather it was intended as a sign of the worshippers' willingness to show dependence.

[148] Matthew 28:9 & 17.

[149] Luke 24:52.

[150] Op. cit., p. 320.

[151] Ibid., pp. 203ff.

then 'mari', the Aramaic for 'my Lord', will stand on its own and much less impressively so since, unlike Kyrios, the word is not used of God.[152] Indeed, although it is certain that the early disciples' worship centred round the remembrance of Jesus' sacrifice in the Eucharist, there is unfortunately no clear evidence to suggest that this constituted worship of him; the disciples may have seen it as no more than a celebration of thanksgiving for the functional role that had been assigned to him by the Father. At most it might legitimately be inferred that the primitive ejaculation of Maran-atha (Come, O Lord!), as recorded by Paul,[153] may well be indicative of cries uttered in worship directly to the Risen Christ without thought of ultimate reference to the Father.

But, if apart from this small exception my argument does not seem to fare well by the criterion of worship, the situation is very different when the other test is taken. In any case it was to be expected that on the test of worship it was unlikely to succeed since it is a presupposition of the argument that the disciples were not conscious of his divinity and, if that is so, they are unlikely to have accorded him worship except in a semi-unconscious way, as with this ejaculation. However that may be, it is to an examination of their unwitting commitment to his divinity through their use of functional language in their preaching and writing that I now turn.

In fact, the truth seems to be that from the Resurrection onwards this exalted figure was conceived of as having had enormous powers delegated to him, so extensive that the only possible appropriate description of him is to assign him the status of divinity, whatever the disciples' intentions may have been. Thus, for example, St. Paul clearly tells us in his First Epistle to the Corinthians that Christ's kingdom extends over all that exists and will last to the end, and 'when all things shall be subdued unto him, then shall the Son also be subject to him that put all things under him, that God might be all in all'.[154] In other words, although he is eventually to return his power to the Father, for the moment he is conceived of as exercising absolute, independent sway over the world. It is the same kine of pattern that we find in the Resurrection accounts in the Gospels. Thus the Risen Christ in Matthew is made to claim: 'All power is given unto me in heaven and earth'.[155] Luke has the disciples ask at the Ascension, 'Wilt *Thou* at this time restore again the kingdom of Israel?'[156] and in one of his resurrection incidents he recounts that Jesus instructs the disciples that 'in *His* name repentance bringing the forgiveness of sins is to be proclaimed to all nations',[157] a power which is

[152] Fuller, op. cit., pp. 50 and 67-8.
[153] I Corinthians 16:22.
[154] I Corinthians 15:28.
[155] Matthew 28:18.
[156] Acts 1:6.
[157] Luke 24:47; cf. John 20:23.

made even more explicit in John's account. Finally, in the appendix to St. Mark's Gospel we have the Risen Christ promising that 'in *My* name shall they cast out devils etc'.[158] Now, of course, for reasons already given it is doubtful whether the very words are original, but this is no reason to call into doubt whether they are an accurate reflection of the sentiments felt at the time, that in the light of the Resurrection Christ was conceived of as having an independence of power that logically is only appropriate to divinity. For, wherever we turn in the New Testament, we find this to be so.

But some will, no doubt, object that I am exaggerating the independence of action accorded to Christ. Thus, for example, it might be pointed out that, while in the first missionary speech of Acts, Peter certainly says of Jesus: 'being by the right hand of God exalted, and having received of the Father the promise of the Holy Ghost, he hath shed forth this, which ye now see and hear',[159] he also speaks of 'Jesus of Nazareth a man approved of by God among you by miracles and wonders and signs which *God did by Him* in the midst of you',[160] and again declares: 'This Jesus God hath raised up.'[161] However, all this shows is something that certainly must be conceded, that in the earliest period Christ's earthly life was regarded as having no such independence of action, but then that is no part of our present concern. For the moment, all that is needed is recognition of the fact that the exalted Jesus was recognised as having such independence of power from the start. Of course, such power was conceived of as having been the gift of God the Father and, of course, it was also conceived that the exalted Christ would do nothing incompatible with the will of God but, even if this much is conceded, it must surely also be recognised that it was an independence of power, one in which God trusted the exalted Christ to exercise this power at his discretion; one too in which it was conceived that constant reference back to its source in virtue of it being derived power was unnecessary, since it was now independently exercised. Hence the reason why Stephen can say at his stoning: 'Lord Jesus, receive my spirit' and 'Lord, lay not this sin to their charge'.[162] Of course, 'Lord' may perhaps not be original, but even so it is extremely probable that the words of Christianity's first martyr would be remembered, and these are directly addressed to Jesus as determinative of Stephen's fate, not to God the Father.

If to all this it is still objected that it remains delegated authority, not power in its own right, that is irrelevant. It is still the power of divinity. Any attempt to draw a parallel with instances of delegated authority

[158] Mark 16:17.
[159] Acts 2:33.
[160] Acts 2:22.
[161] Acts 2:32.
[162] Acts 7:59 and 60.

where the corresponding title is refused will be found to rest on a mistake. For example, a Regent may exercise all the authority of a king, and yet be refused the title of king. But kingship is commonly thought to depend on certain hereditary principles and so, even when he has all the powers of a king, the Regent may still not legitimately be so called. The situation is obviously quite different in the case of God. Admittedly Paul in I Cor. 15:28 in effect treats Christ as a sort of Regent who will in due course hand his authority back to the Father. But that does not alter the conceptual point that, for so long as Christ possesses all the powers assigned to him, he is a divine being.

Of all the New Testament writers it is probable that only St. John saw clearly the ontological implications of such extensive functional language. For in what seems to me the most brilliant and imaginative of all the writings in the New Testament, St. John in effect rewrites the account of Jesus' life to bring out explicitly the fact of his divinity, with ontology at last firmly replacing the raw materials of functionalism. Whether it was simply the reflections of his native intellect or whether it was eased by him writing in a different milieu where Jewish insistence on monotheism was less stressed we can safely leave to New Testament historians to determine, but it is beyond doubt that the transition took place. At all events, I find Young's attempt in *Incarnation and Myth* to make St. John's christology also purely functional simply incredible. She writes of St. Thomas' confession, 'My Lord and my God': 'Jesus is God for Thomas because he has come to stand for God; but he is not himself God, for a few verses earlier he himself said, "I am ascending to my Father and your Father, and my God and your God" (John 20:17).'[163] But all this surely shows is that St. John is still working within a delegated, subordinationist framework, as indeed he indicates elsewhere with the phrase 'My Father is greater than I',[164] not that Jesus has not been explicitly acknowledged to be divine; perhaps the nearest parallel is the subordinationist 'second God' of the later second century Apologists.[165] Young is, of course, not the only New Testament scholar to take this view. Cullmann is another. He writes: 'With R. Bultmann we conclude that the Logos Jesus Christ can ... not be a second God beside God, nor an emanation of God, but God only in his self-revelation. This is the only sense which expresses the intention of the statement in John ... that the Father, to whom Jesus returns after he completes his life's work, is "greater" than he.'[166] But his grounds are unpersuasive and in violation of the natural reading of the text. One cannot help suspecting that the resistance of so many New Testament scholars to this admission really

[163] M. Goulder (ed.), *Incarnation and Myth* (S.C.M., London, 1979), p. 182.
[164] John 14:28.
[164] E.g. Justin Martyr, *First Apology*, ch. 13.
[166] Op. cit., pp. 308-9; cf. pp. 265-6.

has a doctrinal impetus, born of an unwillingness to concede that a 'pagan' pluralism in the divinity is to be found even at the heart of the New Testament ('pagan' because the nearest parallels are in Middle Platonic philosophy).

But, even now, my justification for believing in the doctrine of the Incarnation is still not quite complete. For, strictly speaking, all I have shown is that there are grounds for endorsing the disciples' implicit judgment that at least from the Resurrection onwards the Risen Christ must be treated as a divine being. What I have not offered is justification for extending that divinity backwards to his earthly life and beyond to a pre-existence. Such backward projection is also a subject which the New Testament writers consider, though not, of course, in terms of any ascription of divinity; rather, what interests them is the precise point at which Christ's commission to exercise the role he did in salvation began, and to that question they offer various answers such as his baptism, his birth or a pre-existent commission. The precise reasoning by which their conclusions were reached is now not readily accessible to us, and so it will be simpler to offer independent argument.

So far as his earthly life is concerned, this seems straightforward enough. For, the experience of the resurrection was certainly such that the disciples regarded the exalted Christ as the same person as the earthly Jesus, and, if that is so, then as a matter of logic we are entitled to say with the earliest gospel message that Jesus was the same person as he who became divine or, putting it another way, the earthly Jesus was that same divine person, even if he either did not or could not exercise any characteristic divine power during the time of his earthly existence. But we can go further than this and say that it was not merely the same person who became divine at the Resurrection but that he was also divine during his earthly life. This is because, as we saw at Stage One, the necessary conditions that would allow us to make such an assertion have been fulfilled. Thus evidence was offered there of his moral perfection, as also of a possible special relationship to a divine nature. That being so, the simpler hypothesis is to postulate that he was divine throughout his earthly life but was necessarily limited in the exercise of divine powers because of his unique relationship to a human nature, whether that was substituted for a divine, as in the Kenotic model, or combined with the divine in a single person, as in the Chalcedonian model. One suspects that the motivation behind the New Testament backward projection was rather different, that the emphasis was on the memory that he had exercised, though on a much smaller scale, a similar unparalleled authority to that which the disciples encountered in their Resurrection experiences. At Stage One I argued that the existence of such authority was conceptually unnecessary, but none the less of importance historically in two ways, as guaranteeing historical plausibility for the development of belief in Jesus' exalted status and as providing evidence

for the existence of a special relationship to a divine nature. To these may now be added a third, which is in some ways simply the reverse of the first, namely the need for such authority to account for the 'naturalness' of the disciples projecting back this exalted status to Christ's earthly life at such an early stage in the development of the doctrine.

With pre-existence, however, logic and the disciples' reflections coincide entirely. Cullmann describes the disciples' reflections as follows: 'But there was still another result of the Christological reflection about the "Lord" ... The one upon whom all power was conferred, to whom all the Old Testament passages which speak of God could be applied, must have been at work already before his earthly life. If this life was now conceived as the decisive revelation of God's redemptive will, then the redemptive line must also extend in the direction of past history to his pre-existence. Jesus was recognised as the Revealer as such: wherever God has revealed himself, there is Christ'.[167] In other words, the argument was that Jesus' role was so decisive in salvation that it was unreasonable not to project this role backwards both because those living before his time would otherwise be deprived of any relationship with him and, more important perhaps, because, if the final and decisive dénouement was entirely in his hands, it would be reasonable also to think of the preparations having been in his hands, the span of Old Testament history and indeed creation itself. More philosophically, the argument can be expressed thus: the Resurrection revealed Jesus as having been delegated such vast powers that it is simpler to use Occam's razor and say that such powers must always have been his than attempt an alternative explanation. Both the philosophical argument and New Testament reflection thus appeal to the extent of Christ's delegated power and argue from this on the basis of simplicity. They differ only to this extent: whereas for the New Testament the emphasis is on it being simpler to see such delegated power as evidence of a plan in operation throughout history, for the philosopher the appeal is to simplicity *per se*.

Before considering how the further move to equality of the Persons might be justified, it will be interesting first to compare the approach adopted above with the most important recent major historical study of the question of pre-existence, James Dunn's *Christology in the Making*. He subtitles the work 'An Inquiry into the Origins of the Doctrine of the Incarnation' and, although he refuses to define the term,[168] it is clear from later usage that he equates its significance with a claim to pre-existence. So, for instance, on the penultimate page[169] 'incarnation' is contrasted with 'resurrection', a contrast which would have no clear sense in terms of the usage adopted in this book where 'incarnation' is

[167] Ibid., p. 321.
[168] J.D.G. Dunn, *Christology in the Making* (S.C.M., London, 1980), p.9.
[169] Ibid., p. 267.

intended to refer to Christ's life as a whole. Not only that, but it emerges with equal force that, despite his best efforts at historical impartiality,[170] the move of the Church in this direction is not one with which he is in sympathy. Thus for no obvious historical reason his analysis of Colossians 1:15-20 in non pre-existent terms is described as offering 'on closer analysis an assertion which is rather more profound',[171] while we are repeatedly warned [172] against attempting to merge the different christologies of the New Testament into a single pattern.

He conveniently summarises his own view in the claim that 'the most obvious explanation of all this is that the first Christians were ransaking the vocabulary available to them in order that they might express as fully as possible the significance of Jesus'.[173] In the light of this, various models are tried, implying different degrees of backward projection. Thus, on the basis of passages such as Romans 1:3ff. and Acts 13:33 he concludes that 'primitive Christian preaching seems to have regarded Jesus' resurrection as the day of appointment to divine sonship, as the event by which he became God's son.'[174] From this basis further developments then occur. 'Just as Paul complemented the earlier formula by asserting Jesus' divine sonship of his earthly life and especially his death, and just as Mark did the same by suggesting that the moment of Jesus' divine begetting was at the very beginning of his ministry rather than at his resurrection, so the tradition of a conception by the power of the Spirit complemented (or corrected) the earlier tradition by asserting the moment of Jesus' divine begetting as his conception – he was the Son of God from the first, there was never a time in his life when he was not Son of God.'[175] That St. John's Gospel stands at the culmination of this process he is happy to admit. Commenting on its first chapter he remarks: 'Here we have an explicit statement of incarnation, the first, and indeed only such statement in the New Testament.'[176] The remark is significant, as he believes himself to have eliminated at an earlier stage of his discussion all other possible candidates. Thus he insists that pre-existence language in the Epistle to the Hebrews should be set in the context of Platonic idealism,[177] while of the two best-known passages in Paul he interprets one (Philippians 2:6-11) in terms of an Adam christology,[178] and the other (Colossians 1:15-20) as based on non-hypostatic Wisdom imagery.[179]

[170] Ibid., pp. 9-10.
[171] Ibid., p. 194.
[172] Ibid., e.g. pp. 62, 266.
[173] Ibid., p. 196.
[174] Ibid., p. 36.
[175] Ibid., p. 51.
[176] Ibid., p. 241.
[177] Ibid., p. 54.
[178] Ibid., pp. 114ff.
[179] Ibid., pp. 188ff.

There are I think two major questions raised by his account of christological developments. The first and less important of the two for my argument is whether he is right in placing ontological pre-existence language so late in the process. Doubts are raised in particular by the way he treats the two Pauline passages. Thus, as against his Adam christology interpretation of Philippians, not only does one observe that there is no explicit reference to Adam to facilitate the reader's comprehension, but also it is hard to see where the element of choice could be introduced that is essential, if a contrasting reference to Adam was intended. Dunn is aware of this objection,[180] but provides no satisfactory answer. For surely, given the inherited character of original sin as it was understood then, Jesus, unless pre-existent, would have had no option but to assume the form of a 'slave'. Likewise, it is hard to follow Dunn in reading the Colossians passage as simply 'the writer's way of saying that Christ now reveals the character of the power behind the world'.[181] Dunn doubts whether the question of Christ's pre-existence would ever have occurred to Paul because his 'thought of personified wisdom was wholly Jewish in character'.[182] But, in reply, one wants to ask whether the process of using such imagery of a concrete individual could not help but raise in anyone's mind the question of whether it was merely an image, and so have led to a conviction of Christ's pre-existence, though not, of course, necessarily thereby to his divinity.

However that may be, the more important question is whether, irrespective of the early or late character of 'incarnational' language, the move backwards can be seen to have an adequate justification. This is not an issue to which Dunn addresses himself. However, this is not to say that he offers no ammunition with which to reinforce my earlier argument. Far from it. For the major consequence of his extensive study he expresses as follows: 'In short, we have found nothing in pre-Christian Judaism or the wider religious thought of the Hellenistic world which provides sufficient explanation of the origin of the doctrine of the incarnation, no way of speaking about God, the gods, or intermediary beings which so far as we can tell would have given birth to this doctrine apart from Christianity.'[183] The only concession he makes to external pressures is that the idea of pre-existence only really became thinkable at the end of the first century as part of a general movement of dissatisfaction with current options that shows itself just as much in Jewish and pagan thinking, but with Christianity probably giving the lead.[184] Thus, if he is right, opponents of the doctrine cannot object that the doctrine is simply a product of the market place, with Christianity

[180] Ibid., p. 120.
[181] Ibid., p. 190.
[182] Ibid., p. 189.
[183] Ibid., p. 253.
[184] Ibid., pp. 259-61.

trying to outbid its competitors.

But, unfortunately, precisely because he fails to consider more formal arguments for pre-existence of the kind already outlined, he is induced into treating incarnational language as only one possible option with the other biblical models, as we have seen, being regarded as equally valid. Philosophically, two points need to be made. The first is that historical incompatibility between the models and logical incompatibility need to be sharply distinguished. Thus Dunn is no doubt right historically that the sending of the Son and the Virgin Birth as the divine begetting were seen as incompatible alternatives,[185] but logically this need not be so. The Kenotic model offers just such a combination. So it would be wrong to see ourselves as bound by the way in which the Biblical writers viewed the relationship between the different models. Secondly, it is impossible to avoid, in the way Dunn attempts to do, the ontological implications of the functional language employed. Thus, of Colossians and related material, he declares that since Paul was 'firm in his monotheism' 'to understand the Wisdom passages as ontological affirmations about "Christ's eternal being" is most probably to misunderstand them'.[186] He ignores the possibility that Paul may have attributed pre-existence to Christ without realising all its implications. But, even if we accept Dunn's reading of the passage, it carries clear ontological implications. Paul he says is declaring that 'Jesus is the exhaustive embodiment of divine wisdom',[187] or again he suggests that Paul is urging us to think 'of Christ as embodying and expressing (and defining) that power of God which is the manifestation of God in and to his creation'.[188] But, if we take these claims seriously, the backward projection to pre-existence simply cannot be resisted. For otherwise the metaphor becomes an absurd exaggeration. How could a short life with so many issues unresolved provide an 'exhaustive embodiment' of God's relation to the world? It is only if that same power has manifested itself in the past and is believed to be directing the world's future with its continued guidance that the claim even begins to make sense.

What, then, our examination of Dunn has revealed is the same desperate need for dialogue between the philosophical theologian and the Biblical scholar that we observed also to be necessary, for example, in the case of Schillebeeckx's treatment of the Resurrection. As we have seen, Dunn expresses indifference between the competing New Testament models. The historical fact of this variety cannot be denied. But to say that as an historian is one thing; it is quite another to recommend it as a justified position for theological belief.

It remains now to consider one last question, the equality eventually

[185] Ibid., p. 58.
[186] Ibid., p. 195.
[187] Ibid., p. 195.
[188] Ibid., p. 194.

accorded the Son at the Council of Nicaea in A.D. 325. The arguments which led to such a conclusion were partly Biblical, partly soteriological. Neither type, it seems to me, can command assent today. Why this is so need not be discussed here. Suffice it to say that in rejecting those arguments as inadequate I am being no more dismissive of the patristic period than I have been of the New Testament in this chapter, where equally we have seen a gradual dawning of the truth, bereft of any clear logical rigour. Indeed such gradualism is precisely what would be expected from the model of revelation defended in Chapter 2.

In fact the best justification once again takes the form of an appeal to simplicity. For once it is appreciated that the pressure of the Resurrection experience was such that the disciples had in effect accorded Christ the status of God, the question that raises itself is why a being with such vast powers should continue to be regarded as inferior to the Father. It was true that they were seen as delegated powers and so presumably were conceived of as ultimately removable back to source, but the difficulty of comprehending why such powers should ever have been conceded in the first place by the Father forces one to the simpler hypothesis that they must always have been the Son's in his own right and that therefore the Father and Son are best understood as two equal divine persons. The notion of Christ as a created being is then seen as simply a hangover from the disciples' earlier misunderstandings of the full implications of their experience.

Evidence of a common identity of purpose had already been amply afforded from the life of Christ. So, with equality of powers now also admitted, the final transition to the one God in two persons seems natural and justifiable as underlining the fact that there is identity of being both from their point of view and from ours: identity from their point of view in that they share in common the same attributes and purposes (more, obviously, needs to be said than this, but it is a start and a large section of Chapter 7 is devoted to the question); from our point of view in that as worshippers we are committed equally to the worship of both, given the joint role Revelation reveals them as having in the plan of our salvation, as two divine persons acting in perfect cooperation for our benefit.

It will, no doubt, be noted that I end the chapter without resolving the question of which of the two models for the Incarnation is more historically justified on the basis of the available evidence. This is deliberate, as both seem to me equally defensible. Nor can the issue be resolved on philosophical grounds, as Chapter 6 defends both as logically coherent. Of course, one or other of the two procedures must have been adopted, but I can see no way of definitively resolving which.

Chapter Four

Holy Spirit: the Argument from History

As we shall soon see, very different problems arise in attempting to justify the postulation of a third Person of the Trinity from those which emerged when we were considering the divinity of Christ. For in the latter case the separate personhood of Christ was never really in doubt; rather it was his divinity. By contrast, it is clear that the divinity of the Holy Spirit has never really been in question; instead, the point at issue has been whether he may legitimately be regarded as a separate person, indeed, more fundamentally, whether he may be conceived of as personal at all. In fact, the difference is more complex than this, but to put it thus starkly does capture the essence of the different nature of the problems in the two cases. However, before proceeding to a detailed examination of the issues, it will help further clarify the task before us if I first present the case for the denial of the doctrine in as strong a light as possible.

The case against

The full divinity of the Holy Spirit as a distinct and equal member of a three-personed God was in fact not declared an article of the Christian faith until the Council of Constantinople in A.D. 381. This Council condemned the faction known as the Pneumatomacheans, the 'Spirit-fighters', as heretics, and added to what we now call the Nicene Creed the section that deals with the Holy Spirit:[1] 'And I believe in the Holy Spirit, the Lord and giver of life, Who with the Father and Son together is worshipped and glorified, Who spake by the prophets.' But, not only was the acceptance of the doctrine later than in the case of the Incarnation – and much later if one judges by general consensus rather than official conciliar pronouncements[2] – but also a plausible case may be made to the effect that both the arguments employed at the time fail and, even more important, the New Testament does not contain enough evidence to warrant the conclusion in question. The term 'plausible' is

[1] At Nicaea the clause had simply read: 'I believe in Holy Spirit.'

[2] So, for example, J.N.D. Kelly contrasts the way the Apologists treat the Second and Third Persons of the Trinity in the following terms: 'As compared with their thought about the Logos, the Apologists appear to have been extremely vague as to the exact status and role of the Spirit' (*Early Christian Doctrines*,[4] A. & C. Black, London, 1968, p. 102).

used advisedly. For, as will become apparent, though a strong case can be made out against the doctrine ('plausible' in this sense), it is none the less my contention that a convincing case can be made on the other side. But, first, to indicate the 'plausible' character of the alternative, let me initially draw the reader's attention to some unfortunate facts about the New Testament evidence – unfortunate, that is, from the point of view of justifying the doctrine – and then go on from there to note the general inadequacy of the actual arguments employed in the fourth century, particularly by Athanasius and the Cappadocian Fathers.

In the case of the New Testament itself, one fact is immediately obvious, the paucity of references to the Spirit in Jesus' teaching. There are, of course, important chapters in St. John's Gospel,[3] but in view of the way in which his portrait of Jesus' consciousness in the speeches is out of keeping with the Synoptics, we can have no more reason for believing references to the Spirit in the discourses to be historically based than we have for supposing the accounts of his own nature which are ascribed to him to be records of his own words. This is, of course, quite different from denying their ultimate truth, as we shall see; it is simply to acknowledge their worthlessness as evidence for Jesus' own position. But, even when we turn to the Synoptics, there are surprisingly few references that can with confidence be attributed to the lips of Jesus, and certainly they can give us no grounds whatsoever for talking of a third person of the Trinity. Thus, of the best known, the trinitarian baptismal injunction with which St. Matthew's Gospel concludes cannot possibly be original because it is clear that baptism was originally in Jesus' name alone;[4] again, the Matthean reference to 'casting out devils by the Spirit of God' is unlikely to be genuine since the parallel passage in Luke, despite Luke's fondness for talking of the Spirit, speaks of 'the finger of God';[5] the word about the unforgivable sin against the Holy Ghost is certainly genuine, at least in its simplest form in Mark, but it tells us next to nothing apart from the fact that Jesus was supremely confident of acting with a divinely given power, so confident in fact that he sees those who offer a diabolical interpretation of his ministry as beyond the pale of divine forgiveness for so long as they adhere to that particular view;[6] finally, there is the quotation of Isaiah's 'The Spirit of the Lord is upon me', with which according to Luke he inaugurates his public ministry at Nazareth, words which in the view of Swete 'disclose the consciousness of a unique relation to the Spirit which is presupposed by all that Jesus

[3] John 14-16. One has also to reckon with the view of some scholars that the Paraclete passages are later additions.

[4] Matthew 28:19. Contrast Acts 2:38. There is the added difficulty that Eusebius normally quotes the verse in the form: 'Go ye into all the world and make disciples of all the Gentiles in my name.'

[5] Matthew 12:28; Luke 11:20.

[6] Mark 3:28-30.

taught about Him',[7] but which we at most can regard as only possibly spoken by Jesus in view both of the absence of parallels and of the alternative explanation that it is a Lucan expansion of Mark designed to underline what is for Luke the continuing involvement of the Spirit in Christ's ministry.[8]

If we turn from the teaching of Jesus to the experience and teaching of the disciples, again there are no clear indicators. Initially, for example, it is tempting to draw a parallel with the Resurrection and say that Pentecost played as fundamental a role in the development of this doctrine as the Resurrection played in the divinity of Christ, but the evidence, at first sight at least, is obviously more ambiguous than was the case with the Resurrection. For, whereas with the Resurrection there is merely disagreement about the number, location and details of the Resurrection appearances, with Pentecost there seems such a fundamental disagreement between the accounts in Luke and John that one begins to doubt whether the event occurred at all. At the very least it is open to question whether it was the definitive experience Luke claims it to be. Thus in the first chapter of Acts we have Jesus at his Ascension telling his disciples to wait in Jerusalem 'for the promise of the Father which ye have heard of me. For John truly baptised with water; but ye shall be baptised with the Holy Ghost not many days hence', and the account of the receiving of the Spirit then follows shortly thereafter in the subsequent chapter.[9] But in St. John's gospel Christ gives his disciples the gift of the Spirit during the course of his Resurrection appearances and before his Ascension:[10] 'And when he had so said, he shewed unto them his hands and his side. Then were the disciples glad, when they saw the Lord. Then said Jesus to them again, Peace be unto you: as my Father has sent me, even so send I you. And when he had said this, he breathed on them, and saith unto them, Receive ye the Holy Ghost.'[11] Conservative scholars commonly attempt some kind of reconciliation of the accounts. For instance, James Dunn in an early book suggests two separate outpourings of the Spirit,[12] but this seems very forced, especially as John nowhere even hints at the possibility of a second

[7] H.B. Swete, *The Holy Spirit in the New Testament* (Macmillan, London, 1909), p. 115.

[8] This is a plausible explanation because of the frequency of reference to the Spirit in Luke as compared to the other Synoptics. Indeed, the passage is introduced by a reference to the Spirit (Luke 4:14).

[9] Acts 1:4-5; Acts 2:1-13.

[10] For John the 'Ascension' may mean as for Luke 'the cessation of appearances', but 20:17 is compatible with the view that he identified the Resurrection and Ascension.

[11] John 20:20-2.

[12] J.D.G. Dunn, *Baptism in the Holy Spirit* (S.C.M., London, 1970), ch. 14. 'It may well be best to interpret the Paraclete promises of 14:16 and 26; 15:26 and 16:7, not of 20:22 (which is not naturally described as a 'sending' of the Spirit, especially by or from the Father), but of a later bestowal of the Spirit, following Jesus' final return to the Father ... John's account could then dovetail chronologically into the Acts narrative'(p. 177).

Pentecost. The initial impression must be that the historical credibility of each account is undermined by the existence of the other.

Finally, so far as the teaching of the earliest disciples is concerned, while Luke in particular is careful to keep Christ and the Holy Spirit distinct, the same cannot be said for the apostle whose writings were the first to appear, namely St. Paul. Indeed, it is very difficult to resist G.S. Hendry's conclusion that 'the manner in which Paul describes the Christian situation indifferently as "in Christ" and "in the Spirit" shows that he drew no distinction between the presence of the Spirit and the presence of Christ'.[13] Thus an examination of the relevant texts endorses the view that for Paul these phrases are merely two ways of referring to the same phenomena rather than indicative of two distinct persons of the Godhead. The following verses offer particularly strong confirmation, being representative, as they are, of the indifferent way in which Paul switches back and forth, now referring to Christ, now to the Holy Spirit. In the Epistle to the Romans he writes: 'But ye are not in the flesh, but in the Spirit, if so be that the Spirit of God dwell in you. Now, if any man have not the Spirit of Christ, he is none of his'; in Philippians: 'If there be any consolation in Christ, if any comfort of love, if any fellowship of the Spirit'; and in Galatians: 'O foolish Galatians, who hath bewitched you, that ye should not obey the truth, before whose eyes Jesus Christ hath been evidently set forth, crucified among you? This only would I learn of you, Received ye the Spirit by the works of the law, or by the hearing of faith?'[14] But the most striking example of Paul's apparent identification of the Spirit with Christ is to be found in the Second Epistle to the Corinthians: 'Now the Lord is that Spirit, and, where the Spirit of the Lord is, there is liberty'.[15] Although the identification is commonly accepted,[16] it has not gone without challenge, as, for instance, by Dunn who describes the New English Bible translation as 'superb', 'Now the Lord of whom this passage speaks is the Spirit', since he sees the sentence as referring back to the extract from Exodus 34 which Paul has just quoted; if this is so, the whole passage could be seen as exclusively about the Spirit.[17] It is a view in which he is followed by Moule,[18] but, even with the allusion to Exodus accepted, it is more natural to take the quotation as referring to Christ rather than the Spirit: 'when one turns to the Lord, the veil is removed'; this is because for Paul turning to Christ would seem the more natural of the two sentiments, with the Spirit, in so far as it is conceived to be a distinct notion, acting more as a prompter of which one

[13] G.S. Hendry, *The Holy Spirit in Christian Theology* (rev. ed. S.C.M. London, 1957), p. 22. There is in fact some difference of stress, as I shall note later: more usually 'in Christ' than 'Christ in you'; more usually 'Spirit in you' than 'in the Spirit'.

[14] Romans 8:9, Philippians 2:1, Galatians 3:1-2.

[15] II Corinthians 3:17.

[16] E.g. by J.V. Taylor, *The Go-Between God* (S.C.M., London, 1972), p. 110.

[17] Op. cit., p. 136; cf. also *JTS* 1970, pp. 309ff.

[18] C.F.D. Moule, *The Holy Spirit* (Mowbrays, London, 1978), p. 26.

is not always fully conscious.[19] Of course, the truth is that for each of these passages a defence can be offered which preserves Paul for subsequent orthodoxy. But the more natural reading of such passages is surely that, while Paul may have been struggling to maintain a distinct area of activity to be labelled the work of the Spirit, the overwhelmingly Christocentric nature of his thought meant that he was fighting a losing battle with himself. The result was the overlaps amounting to identification which we have found. Whether or not there was such a struggle in his mind – a matter to which I shall return later in the chapter – one thing seems beyond reasonable doubt, namely that the looseness of his language must indicate that for him the struggle was not a particularly important one; that it was only a matter of appropriate terminology rather than anything as fundamental as the existence of a third person in the Trinity.

It does seem, therefore, that the case against the distinct personality of the Holy Spirit on the basis of the available Biblical evidence can be made very plausible indeed. If, however, we now turn to the patristic period in the hope of finding some firm grounds for belief in the fourth-century arguments that led to the expansion of the Creed at Constantinople, we shall soon find ourselves disappointed. Athanasius, for instance, offers two main types of argument in his *Letters to Serapion*, neither of which is at all convincing. The first, as Shapland points out, really takes advantage of a situation which had become an embarrassment in the Church since 'inasmuch as the activity of the Word was gradually correlated with the whole activity of God, it became harder and harder to think of the Spirit at all, and faith in him became largely a matter of reaffirming the baptismal tradition'.[20] Athanasius therefore argues that, since the external operations of the Son and Spirit are the same, if the Son is divine, then the Holy Spirit must also be accorded the same status. The argument is sufficient to establish equality of divinity, but it does nothing to prove the separate personal identity of the Holy Spirit, which is what really interests us. Athanasius believed otherwise, but the supposition is only plausible on a very literal reading of scripture. In particular, he appeals to certain of the Psalms, where the Spirit seems to be assigned an equal creative function to the Word.[21] But modern Biblical criticism has long since established that such passages have no personal reference, and indeed we need to take the same care with the New Testament; the occurrence of the word, 'Spirit' can do nothing of itself to establish a reference to the Holy Spirit in the

[19] As in the two classic 'Abba' passages, Romans 8:15 and Galatians 4:6. Perhaps the difference can be expressed by saying that for Paul the Spirit is never more than a prompter, whereas Christ is also someone to whom one can be consciously related.

[20] St. Athanasius, *Letters to Serapion*, ed. C.R.B. Shapland (Epworth Press, London, 1951), pp. 36-7.

[21] Ibid. 3.5, p. 174; cf. Psalm 104:29-30 and Psalm 33:6.

full doctrinal sense. Athanasius' other argument, which is soteriological, is equally ill-founded. It is a repeat of an argument he had already used to establish the divinity of Christ. In the latter case he argued: 'If the Son were a creature, man would have remained mortal as before, not being joined to God'; now in the case of the Holy Spirit he argues: 'if this is your attitude, what hope have you? Who will unite you to God, if you have not the Spirit of God, but the spirit which belongs to creation?'[22] Even if the argument in general has any force – which I doubt – it cannot do double duty. For at most one will need only one, not two, divine agents to make us divine in the sense of immortal. That being so, clearly neither of the two arguments that were popular at the time can do anything to restore the balance in favour of orthodoxy. In any case, it can hardly be too strongly emphasised that the pre-occupations of the period were rather different from our own. For, given a very different conception of revelation, it was simply assumed that the name 'Spirit' must stand for something. The net result was that for the fourth century the real argument was about the relative status of the Holy Spirit vis-a-vis the other persons, i.e. his full divinity, rather than as it is for us his separate identity.

What this brief survey reveals, then, is very strong grounds for doubting whether the Church's postulation of a distinct third person of the Trinity was in fact justified. We may add that one way of viewing the Church's history, particularly in the West, is to see such a suspicion as always having been there, bubbling just beneath the surface and not infrequently implicitly expressing itself. If that is the case, then current detractors could be seen as part of a continuing stream of doubt, with their contribution being merely to make explicit the doubts that have always, if somewhat surreptitiously, been there. This would make the situation very different from that which holds with respect to the divine personhood of Christ, where it is impossible for the demythologisers to claim any such historical continuity, though, interestingly enough, the Holy Spirit's detractors seem likewise disinclined to claim such a continuity.

The reason for suspecting the existence of such a continuity is the tendency throughout the tradition to treat the Holy Spirit as different from the other two persons, in particular to treat Him as a thing. Indeed, even today the neuter pronoun comes more naturally to the lips of the average Christian. But it is a feature that may be observed equally well in other periods of the history of the Church. Thus, it is particularly marked in the medieval tendency to think of grace as a *'habitus'* of the soul, a good disposition that inheres in the soul and has been given to the individual by God; for as soon as this is identified as the characteristic work of the Spirit, the gift then inevitably passes on to the Spirit its own

[22] Ibid., 1.29, p. 138. The earlier argument is to be found in *Contra Arianos* 2.69.

salient feature of being a thing.[23] But, equally, the same attitude is found to be present in the patristic period, especially with Augustine's influential treatment of the Holy Spirit as a relation of love that exists between the mind and its knowledge of itself.[24] Cyril Richardson acknowledges as much, when he writes that 'a relationship cannot properly be described as possessing personality.'[25] Moule concurs, and then goes on to observe: 'This difficulty is endorsed by the tendency to speak of the Spirit as "it" and the fact that personal representations were actually avoided, Christian art using the symbol of the dove or rays of light.'[26] Interestingly, he does not see the insertion of the Filioque into the Creed as part of this general movement. For he writes a few pages earlier: 'The alternative (and equally scriptural) phrase representing the Spirit as given equally by the Father and Son together was ... a simultaneous gesture towards the dignity of the Son and the Spirit.'[27] But this was surely not what was going on. For the historical evidence suggests, as both Swete and Kelly point out,[28] that initially at least the primary motive was exclusively Christological since 'evidently the doctrine was regarded as clinching the case against Arianism', with which the Spanish Church was plagued at the time. But, whatever the intention, there is no doubt that the effect has been still further to reduce the status of the Spirit to a thing-like instrument of both the Persons from whom he is derived. It was presumably partly to avoid any hint of parity with the Spirit that popular Spanish piety insisted on such an emphatic declaration of the Son's equality with the Father and so gained what Swete calls 'the doubtful honour of being the first Church in Christendom to add the Filioque to the Catholic faith'.

The present malaise in the position of the doctrine can therefore be seen as the natural culmination of a long historical process. Certainly it is true that the Holy Spirit as a distinct person of the Trinity finds few friends today in contemporary theology. Thus, the tendency seems to be either to move to unitarianism, as with Lampe's *God as Spirit* or, more commonly perhaps, binitarianism, as with Moule's *The Holy Spirit*. Thus, Lampe, defending his right to deliver the Bampton Lectures despite their founder's intention that they should be a defence of the Creed, ends his book by declaring that 'I believe in the Divinity of the Holy Ghost, in the sense that the same one God, the Creator and Saviour Spirit, is here and now not far from every one of us'; the divinity of Christ had already been treated in the same reductionist way with Lampe

[23] So, for example, Aquinas talks about a 'supernatural something' – 'quiddam supernaturale in homine a Deo proveniens' (*Summa Theologiae*, 1a, 2ae, 110).

[24] E.g. *De Trinitate* 9.4.

[25] C. Richardson, *The Doctrine of the Trinity* (Abingdon Press, New York, 1958), p. 106.

[26] Op. cit., p. 50.

[27] Ibid., p. 48.

[28] The first quotation is from Kelly, op. cit., p. 361, the second from Swete, op. cit., p. 343.

admitting his divinity only 'in the sense that the one God the Creator and Saviour Spirit, revealed himself and acted decisively for us in Jesus'.[29] But it is Moule who probably better represents current trends, with his view that a binity is a more natural deduction from scripture: 'It is easier to understand how a doctrine of a 'binity' arose. Christ was a vivid personality. He had been known by his contemporaries as a friend and companion ... But why include Spirit in this plurality? "Spirit" is, after all, only one of several terms denoting divine action or divine intention or (especially) divine immanence – that is, God in his activity within his creation. In a statement about God's activity, "Word" (or Logos) and "Wisdom" can perform this function; so, in some contexts, can God's "Name", or his "hand" or his "finger". And Jesus Christ was identified by his followers as that divine Word and Wisdom. Why, then, should it not be natural to identify him also with Spirit, and to stop at a "binitarian" view?'[30] All this he admits despite the fact, already noted, that he rejects a Pauline identification of Son and Spirit.[31] It is perhaps therefore not surprising that, while he goes on to acknowledge the intelligibility of the Church's move to trinitarianism inasmuch as 'side by side with but distinguishable from the Christian experience of being "members of Christ", incorporated in him, was the experience of Christ's character being imparted to each Christian, and Christ's attitude to God being reproduced in each Christian', his final position is that 'threefoldness is, perhaps, less vital to a Christian conception of God than the eternal twofoldness of Father and Son'.[32] This seems merely a cautious way of endorsing the view that the doctrine is only a form of words that reflects nothing fundamental or intrinsic about the nature of the Godhead. However that may be, it is an opinion that is to be found among many other contemporary writers who would normally be regarded as 'orthodox', as, for instance, John Taylor, who writes in his best-seller on the work of the Holy Spirit, *The Go-Between God* that 'the strict trinitarianism of orthodox Christian doctrine has probably led the church to draw too sharp a distinction between the Word or Logos and the Holy Spirit'.[33] It is also interesting to observe that Taylor, unlike Moule, continues the ancient practice of using impersonal language of the Spirit, as, for example, in the following: 'You cannot commune with the Holy Spirit, for he is communion itself'.[34]

Given such a strong case against, it might be thought obvious that, in the light of the previous chapter, I too must also now subscribe to

[29] G.W.H. Lampe, *God as Spirit* (Clarendon Press, Oxford, 1977), p. 228.
[30] Op. cit.; cf. p. 46.
[31] Ibid., p. 26.
[32] Ibid., p. 51.
[33] Op. cit., pp. 58-9.
[34] Ibid., p. 43.

binitarianism. Apologetically, this could be made very much easier by arguing, as I have suggested above, that binitarianism has in fact been the underlying assumption of the Church for a very long time. Any work traditionally assigned to the Holy Spirit could then be re-assigned to Christ, as, for example, has been done very effectively in Schillebeeckx' *Christ the Sacrament*. For him, following, as he believes, St. John, 'the essential Christian Pentecost is an Easter event'[35] and so it becomes natural for him to see 'the work of the Spirit' as in effect the work of Christ. But the temptation must be resisted. Apart from the existence of a competing theological tradition in the East, I contend that a re-examination of the evidence will after all suggest the more orthodox course.

To see why this is so, as with the doctrine of the Incarnation, the matter is best approached by stages. Stage One concerns the teaching of Jesus. For, if an historical defence of the doctrine is to be plausible, it will be important to provide some reason for the absence of any significant teaching on the personhood of the Spirit from the recorded words of Jesus. After all, looked at from an a priori perspective, it would seem reasonable to expect God Incarnate to have something definite to say on such an important matter as a putative distinct person of the Trinity, distinct, that is, from the Father. Chapter 3 explained in brief (something Chapter 6 does at greater length) why on neither of the two suggested models could Jesus be conscious of his own divinity. But such *kenôsis* cannot be the answer here. His perfect communion with the divine ensured his knowledge of the Father; so why not an equally clear perception of God as Holy Spirit? Stage Two then deals with the experience of Pentecost. Here I shall argue that there are in fact good grounds for believing something like the incident described by Luke in Acts to be historical. I shall also suggest that, while there is nothing in the experience as such which establishes the separate personality of the Spirit, it was none the less this experience which convinced the early disciples of its/his separate identity ('its' from the point of view of the disciples' view at the time).

Stage Three is the most crucial to the argument. Here I deal with the status of post-Pentecost reflection in the New Testament. In summary, my argument will be that such reflection, particularly that to be found in Paul, has seriously misled the Church, especially the present-day Church. For, while he rightly saw that personhood must be assigned to the Holy Spirit, he wrongly inferred this to mean the collapse of the relative separateness of Spirit and Christ already deduced by the earliest disciples from their Pentecost experience. As with the Incarnation, so here again on my view St. John's Gospel turns out to be the most

[35] E. Schillebeeckx, *Christ the Sacrament of the Encounter with God* (Sheed & Ward, London, 1975), p. 34.

perceptive of New Testament documents, with its unambiguous talk of 'another Comforter'.[36] Of course, such a claim means showing that there is more reason to suspect Paul's development of the tradition than John's. Such reason will be given. Two aspects may be distinguished: an argument to the effect that it was 'natural' that Paul should misinterpret the Pentecost experience; and an independent argument that such access as we have to the nature of the Pentecost experience suggests the postulation of a distinct personal element in the Godhead to account for the type of indwelling involved.

Obviously in a summary as brief as this, it is impossible to draw attention even to all the main features of the argument, but such an outline should still aid comprehension of what follows. In some ways the pattern is similar to that employed in the previous chapter. For instance, there is the necessity of showing the objectivity of Pentecost, just as I argued for the objectivity of the Resurrection experiences. But there are differences. Thus, although I once again both admit and attempt to justify the existence of development within the New Testament, there is the difference that in this case it was one that almost went disastrously wrong with St. Paul. In addition, it is my view that, while a convincing case can be made on the basis of the available Biblical evidence, it can only be made absolutely watertight by appeeal to descriptions of non-Biblical religious experience, and this was clearly not so with the Incarnation.

That being so, there is a fourth Stage, where it is hoped remaining doubts will be silenced. Stage Four, however, can also be seen as offering an independent strategy to justify the doctrine. For it can be argued that a realistic account of religious experience in general, including that to be found in other religions, demands such a separate postulation. This is, on the one hand, partly because of the implausibility of describing intimate experiences of the divine as experiences of the Son, when the recipient of such experiences is totally unaware of the Being in question's essential incarnational nature (identification with the Son excluded); and, on the other hand, partly because mystical experiences are commonly described as an encounter of God with God, which suggests that the indwelling God is being experienced as the *subject* of an encounter with another person of the Godhead who is thus conceived of as distinct from that subject (identification with the Father excluded). As can be seen from the above synopsis, the argument *in toto* and at its various stages is somewhat complex. Its cogency the reader can now judge for himself as each of the four stages is presented.

[36] John 14:16. This is not to say that he was always perceptive. John's Christ is almost docetic, and his teaching on love, unlike Luke's, very inward-looking.

The teaching of Jesus

Here we are concerned exclusively with a negative task, namely to ensure that the absence of any significant reference to the Holy Spirit in the teaching of Jesus does nothing to undermine the plausibility of my subsequent argument. For, without an explanation for such silence, it would always be possible for a detractor to object that, even if my subsequent argument seems convincing, there must be something wrong with it because the human nature that came into closest contact with the divine apparently knew nothing of the existence of this separate person of the Godhead.

As a start towards replying to such a critique, C.K. Barrett's book, *The Holy Spirit and the Gospel Tradition*, is particularly interesting. Besides offering an explanation of his own for Jesus' relative silence, he notes three other possibilities.[37] It will be useful to record all four, as this will provide an indication of the range of options available and the kinds of problems they raise. E.F. Scott suggests in *The Spirit in the New Testament*[38] that the silence is part of Jesus' general hostility to the intermediate powers of pre-Christian Judaism because they undermined the possibility of direct communion with the Father. As he puts it, 'an idea like that of the Spirit removed God to a distance, or put an abstract power in place of him'. Against, Barrett notes first Flew's point that 'this would argue Jesus less skilled in spiritual discernment than Paul' and secondly the fact that in any case Jesus seems to have accepted current beliefs in demons and angels. Vincent Taylor's proposal[39] is that, so confident were the early Christian communities in their possession of the Spirit that they felt no need to keep in mind Jesus' sayings about the Holy Spirit. But, again I think rightly, Barrett objects that it seems implausible that controversy would be the only factor in preserving a particular tradition; thus, for instance, Luke's Gospel opens with a declaration that it is recording 'those things which are most surely believed among us'. Finally, among the possibilities which Barrett rejects, is the view of Flew[40] that, like the title 'Messiah', it was too seriously open to misconstruction to be immediately usable. Barrett in his subsequent examination of Old Testament attitudes[41] concedes the ambivalence of prophetic attitudes. Thus, for instance, in striking contrast to Ezekiel, Jeremiah never attributes his prophetic inspiration to the Spirit, the ambivalence being due to a desire on the part of some of the prophets to use this means as a way of dissociating themselves from

[37] C.K. Barrett, *The Holy Spirit and the Gospel Tradition*, (S.P.C.K., London, 1966 ed.), pp. 140-3.

[38] E.F. Scott, *The Spirit in the New Testament* (London, 1923), pp. 77-80.

[39] V. Taylor, *The Holy Spirit* (Headingley Lectures, 1937), pp. 53-5.

[40] R.N. Flew, *Jesus and his Church*[2] (London, 1943), p. 70ff.

[41] Op. cit., pp. 145ff.

the more degenerate kind of prophet[42]. Having conceded this much, Barrett is unable to offer as decisive an objection in this case as with the other two, and indeed the criticism he does make is not very satisfactory. Thus, he expresses doubt whether Flew has offered a sufficient explanation on the grounds that in the parallel problematic case for possible misunderstanding, namely Messiahship, teaching was offered to his intimate disciples, whereas no such teaching seems to have been forthcoming in the case of the Holy Spirit. But the parallel is a contentious one, relying as it does on such verses as, 'he began to teach them that the Son of Man would suffer much',[43] where an alternative explanation is available in terms of post-eventum 'prophecies' introduced by the Evangelist to make more explicit the culmination for which Jesus was preparing his disciples. But, of course, even if there are some grounds for doubting whether he gave any very clear secret teaching to his disciples on the question of his messiahship, this still fails to explain adequately why such a lack of explicitness was also extended to the question of the Holy Spirit. For in the case of Messiahship, a plausible reason would be his kenotic lack of a messianic consciousness, whereas from such a *kenôsis* nothing clearly follows about a lack of awareness of the working and status of the Holy Spirit, especially given his unparallelled intimacy with the divine. A worry about possible misunderstanding, as Flew suggests, seems scarcely adequate on so important a matter. Equally, if he did after all teach privately his messiahship but gave no teaching about the Spirit, Barrett is quite right to say that we need some strong differentiating reason to explain this fact.

That being so, it is especially interesting to note what Barrett's supplementary explanation is: 'The period of the humiliation and the obscurity of the Messiah and his people was to continue until its climax and the day of final glorification. In the former period, the general gift of the Spirit was inappropriate; it would have divulged the secret of Jesus' Messiahship and it was not yet within the range of the kingdom, which was not yet *en dunamei*. In the latter period it was not a sufficiently significant feature of the eschatological hope to be mentioned. If the Messiah was coming on the clouds of heaven, what point was there in saying that he had the gift of the Spirit? If his followers were as angels of God, what need was there to stress that they were not inferior to the prophets? ... He did not bestow the Spirit upon his followers, because that gift was a mark of the fully realised Kingdom of God and did not lie within the province of the germinal Kingdom which corresponded to his veiled Messiahship. He did not prophesy the existence of a Spirit-filled community, because he did not foresee an interval between the period of

[42] Cf. Amos 7:12.
[43] Mark 8:31, etc.

humiliation and that of complete and final glorification. He did not distinguish between his resurrection and parousia, and accordingly there was no room for the intermediate event, Pentecost.'[44] To this he adds the following footnote: 'No doubt, if he had been questioned, Jesus would have said that, at the final manifestation of the glory of God, the Spirit would be given; but there were other more important things that might be said about that time, and in any case Jesus was not in the habit of painting elaborate pictures of the last days.'[45]

Barrett's own proposal is certainly plausible, but also not without its difficulties. Three in particular come to mind.

(i) The first and most straightforward of these is its reliance on a number of 'facts' which are a source of considerable dispute among New Testament scholars. Is it the case, for instance, that talk of the Holy Spirit would inevitably have suggested a claim to Messiahship? In particular, might he not have claimed the gift for himself, like a prophet, without any such embarrassment? There is also the question whether Jesus expected his own immediate glorification or that of a distinct Son of Man. If the latter, a reference to a future gift of the Spirit could have been made without any inference thereby being implied about Jesus' own status. More fundamentally, one might challange the thesis that Jesus did believe the parousia to be imminent. For, while a verse such as 'Ye shall not have gone over the cities of Israel, till the Son of Man be come'[46] does seem to imply as much, at other points in his teaching Jesus denies that he knows when the End is to come: 'But of that day and hour knoweth no man, no, not the angels of heaven, but my Father only.'[47] Moreover, as Bornkamm and Schweizer both point out, his use of parables and images suggests a certain caution about the future,[48] as also do his occasional references to the present reality of the Kingdom.[49] It is possible, therefore, to argue that Jesus, while expecting the parousia, had no firm view about how exactly imminent it was, and that its very close imminence was in fact an inference drawn by the disciples in the light of their Resurrection and Pentecost experiences, which they then inferred back into the teaching of Jesus. If this was the historical situation, again one might have expected Jesus to have said something about a future gift of the Spirit. But, in this the majority of New Testament scholarly opinion is against me, and so it will be wise, provisionally at least, to

[44] Op. cit., p. 160.

[45] Ibid., p. 160, footnote 2.

[46] Matthew 10:23.

[47] Matthew 24:36, Mark 13:32.

[48] G. Bornkamm, *Jesus of Nazareth* (Hodder & Stoughton, 1973 ed.), p. 67; E. Schweizer, *Jesus* (S.C.M., London, 1971), p. 23.

[49] Luke 11:20 and 17:21. Bornkamm (p. 67) and Schweizer(p.24) disagree, but surely any emphasis on its present reality must detract from thought of it as a future reality (which is then seen as less important).

accept their view and go on to consider what further problems are raised as a result.

(ii) The second difficulty to be noted is a conceptual one. For such an admission raises difficulties in comprehending the nature of Jesus' consciousness. For, while I argue in the previous chapter and in Chapter 6 that on either of the two models proposed certainty about his divine nature would have been impossible for Christ, there seems no reason why the type of knowledge in question here could not have been successfully communicated to him, given his intimacy with the divine. Now, of course, as I observed in Chapter 2, such knowledge of the future is something that is not normally communicated in revelation, but there is no reason in principle why it should not be. Furthermore, it does sound an extraordinary notion that the Father should in effect abandon the Son to such a fundamental misunderstanding of his role while on earth, with Jesus believing that he is inaugurating the end instead of which he was founding a Church destined to last for at least two thousand years. This is rather different from, say, dying without being aware of a subsequent earthly resurrection. For in that case only a limited insight into the truth is involved, not an actual falsehood, and moreover it is not a fact that would have led Jesus to act any differently, whereas with belief in the imminence of the *parousia* it is arguable that the urgency in Jesus's teaching springs from this source and this source alone. One cannot help but be irritated by the glibness with which such problems are treated by the 'orthodox'. Thus, Vincent Taylor merely remarks that 'it is the glory of the Incarnation that Christ accepted these limitations of knowledge which are inseparable from a true humanity'.[50] One surely wants rather more than that.

Two possible lines of approach suggest themselves. The first consists of expanding the meagre hint offered by Vincent Taylor. For it might be argued that, although the Father could have communicated such information, he chose not to do so in order that the Son might experience the human condition to the maximum extent possible without sin. That is to say, the perfection of his spiritual intimacy with the divine would still be kept intact and so, there being no separation in this respect, there would be no sin. But, historical facts not being integral to such intimacy, the Father could abandon the Son to such misperception of the truth without any sin being involved. He would then be like any other human being who misperceives the truth, but is not thereby counted 'guilty' in God's eyes. Yet, while this argument undoubtedly makes sense, there is still something strange in the notion of the Son being kept in the dark about so important a matter, especially as there is no reason to believe that God always keeps human beings from a supernatural knowledge of the future. (This would rule out all prediction, and, while Biblical

[50] V. Taylor, *The Gospel according to St. Mark* (Macmillan, London, 1959), p. 523.

examples seem in general dubious, the same cannot be said for all claims to 'second-sight'.)[51] However, it is a strangeness that can be largely removed by emphasising the divine purpose behind such concealment, that Jesus was thereby enabled permanently to record in the divine memory his direct experience of the ambiguities of the human condition. God's identification with man thus becomes complete. For, just think how 'uninvolved' would his perspective have been, if he had not accepted the apocalyptic vision of his time but instead had had privileged access to the wider horizons of future history. Any hint that he might be founding a new religion would inevitably put him at an enormous distance from the perspective of his contemporaries. It is to be noted that this proposed solution has nothing to do with conceptual limitations intrinsically inherent in the concept of Incarnation. Rather, it is a soteriological solution, depending on God's desire for a total identification with man.

An alternative way of dealing with the problem would be to bring in the fact of divine omniscience. For, if the Father knew in advance the final outcome, then it is arguable that he would take this into account when deciding what to communicate to the Son. Thus, if he knew in advance that because of the overwhelming nature of their experiences of the Resurrection and Pentecost the disciples were bound to get it wrong and infer the imminence of the end anyway, there would be little point in enlightening the Son since whatever he said would then be overthrown by the character of their subsequent experiences. Of course, one might object by suggesting that Christ could also have successfully warned them against such a misinterpretation of their experience, but it is noticeable that once one starts expanding the possibilities like this one soon ends up with something like an infallibly communicated revelation of the kind already rejected in Chapter 2. The disciples would have become mere instruments, instead of freely responding to their experience as they see it. Interestingly, such an approach can also be used to deal with the possibility of Jesus having expected a Son of Man, distinct from himself. For in this instance omniscience would then have taken account of the process working in exactly the opposite direction. That is to say, just as there was no way of avoiding the disciples' misinterpretation of their experience without imposing an interpretation on them, so in this case there was the certainty that the disciples would as a result of their experience identify Jesus as the Son of Man, whatever he may have said to the contrary during the course of his teaching. There was thus no need on the part of the Father to disabuse Jesus of his misunderstanding of his own status.

Whether taken singly or, perhaps preferably, together, these considerations seem sufficient to deal with the problem. But, as already

[51] Cf. footnote 49 to Chapter 1.

noted, I do not regard it as incontestable that the problem arises since Jesus may have spoken of the nearness of the Kingdom without specifying that with it was to come the parousia within the disciples' own lifetime. However that may be, either way a reason for Jesus not speaking about Pentecost is provided. For, either we accept Barrett's view and then silence becomes inevitable because of the imminence of an end in which any giving of the Spirit would be overshadowed by other things, or, on the alternative scenario, Jesus had no such false consciousness but equally had no specific vision of the future to communicate to his disciples.

(iii) But, if a lack of any reference to Pentecost can be dealt with in this way, there still remains the last of our three difficulties, and from the point of view of the doctrine of the Trinity the most fundamental of all. For we still need some account of why it is that Jesus seems to have said so little about the presence of the Spirit in his life, especially as his spiritual relationship with the divine is alleged to have been perfect. Given such an assumption, Barrett's explanation is scarcely adequate. In any case, some account of what was happening in the internal psychology of the Incarnate One is still required to ensure that the postulation of a third person of the Trinity is in no way incompatible with such a psychology. Accordingly, it is necessary to examine how the two incarnational models employed in the previous chapter fare in the face of such problems. What such an examination reveals is that, while his psychology was in no way incompatible with a third person in the Trinity, it was precisely the nature of that psychology which militated most strongly against Jesus saying anything of importance about the Spirit.

The situation with respect to each of the two models is quite different. Thus, if we take the Chalcedonian model first, the mind of Christ would clearly have no way of distinguishing his own divine nature from the work of the Holy Spirit. They would both be felt as an inner divine prompting. If one wished to preserve a trinitarian pattern for Christ's life, the following pattern might be proposed: the Spirit indwelling the human nature inspiring its perfect response to the promptings of the divine nature. But the point is that, though conceptually this is possible and perhaps essential as a theological postulate, experientially it would have been impossible for Christ to distinguish between the two types of prompting. After all, the distinction between a first initiative and a second initiative to respond is a rather subtle one, to say the least. By contrast, on the Kenotic model he must have had a strong consciousness of the promptings of the indwelling Spirit that would have been clearly distinguishable from the workings of his divine nature, since on this model his divine nature is temporarily suppressed. But, whether the operations of the Holy Spirit could thus in theory be experientially distinguished from his sonship or not, in neither case does it follow that

he would necessarily have been led to speak of the separate personhood of the Holy Spirit. This is because the question of whether such an indwelling Spirit is distinct from the Father is ultimately conceptual, not experiential. That is why, even if he had spoken of an experience of an indwelling Spirit, it would still be in order to challenge his description and argue, if that were deemed appropriate conceptually, that he had in fact misidentified his own divine nature. Indeed, this may well have been a real possibility, given my view that he could not have believed himself divine; for, then it would have been natural for him to attribute to the Holy Spirit what was in fact the activity of his own personal divine nature.

In short the mere record of Christ's experience, whatever it was, cannot be allowed to have the final say conceptually. Even so, this hardly explains the lack of reference to the Spirit; indeed, in some ways it makes it more puzzling still, in that even with the Chalcedonian model a reference might have been expected as the natural way for the human nature to account for the activity of the divine nature. It is a puzzle which the available historical evidence does not allow us to solve decisively, but the following explanation seems plausible. On the Kenotic model, Jesus felt the Spirit's presence so powerfully that, paradoxically, he identified that power with himself and spoke for it in his own name. The suggestion is, of course, not as paradoxical as it sounds. My fourth stage will in fact suggest that this is quite a common experience: for an individual to feel the Spirit so close that reference to his presence as a distinct entity seems redundant; each has, as it were, become the other. In other cases, this is very much a fleeting experience, but with Christ it may have been felt permanently, and this would then explain the unparalleled confidence with which he acted in his own name. On the Chalcedonian model, as the previous chapter noted, an alternative explanation for such unparalleled authority exists, namely the influence of his divine nature. But that in turn explains why no reference would be made to the Holy Spirit. For, presumably, if trinitarianism and this model are true, what happened was that the divine nature was felt so intimately by the human nature that it was led to speak in its own name (though, of course, without realising that this implied ultimately its own divinity). In other words, the effect of the divine nature's activity was the same as that encountered in cases of extreme intimacy with the Holy Spirit and, that being so, any reference either to the divine nature or to the workings of the Holy Spirit would be regarded by the human nature as redundant. That is to say, so far as his experience is concerned, Jesus just *is* divine power.

Obviously, my explanation depends heavily on it in fact being the case that under certain circumstances individuals do assume an identity with the divine power indwelling them such that any reference to that divine power as a separate entity is seen as redundant; experientially, however

fleetingly, they see themselves as being just exactly that power. The sort of evidence I have in mind is discussed at Stage four, and so there is no need to repeat it here. But if this is indeed the case, we are now a position to provide an explanation of why Jesus' experiences might have been such as to lead him to say little about the Spirit. Not only that, but also the distinction between the experiential and the conceptual enables us to argue successfully that, although Jesus' own view of his experience was almost certainly not trinitarian, whichever of the two models is adopted, this is no bar whatsoever to analysing them as trinitarian. Indeed, if sufficient grounds can be given for postulating a third person of the Trinity, not only would it seem natural to assume the involvement of all three persons in so momentous an event as the Incarnation, but also on the interpretation just proposed of Christ's experience one can actually point to which features of that experience indicate the involvement of the Holy Spirit in this supreme instance of divine intervention in human affairs, whatever the chief participant may have thought in his human nature to the contrary.

That said, we may now turn to Stage Two, and consideration of the problems raised by the disciples' Pentecost experience, and of what may legitimately be deduced from that experience.

The 'Pentecost' experience

Determining what status to assign to Pentecost raises a number of different issues, the first and most basic of which is the question of its historicity. While the reliability of Acts is, as we shall see, not indispensable in establishing either the basic historicity of the experience or its original interpretation, my argument would be greatly strengthened if Acts were treated with less suspicion that is commonly the case with so many New Testament scholars. Since that is so and in any case the best known account of the experience occurs in Acts, I begin my discussion of the historicity of the experience by discussing the reliability of Acts in general.

An enormous range of positions has in fact been adopted by New Testament scholars, as even a cursory glance at Haenchen's excellent survey of critical opinion[52] soon indicates. Haenchen's own view is that the speeches cannot possibly be historical,[53] and that the author's reliability is further undermined by the fact that he is unlikely to have been a companion of Paul.[54] This is a view that is endorsed among contemporary New Testament scholars by, for instance, Conzelmann[55]

[52] E. Haenchen, *The Acts of the Apostles* (Blackwell, Oxford, 1971), pp. 14-50.

[53] Ibid., p. 82. The reason he gives is that there is no evidence of care having been taken to preserve the original words.

[54] Ibid., pp. 112-16.

[55] J. Conzelmann, 'Luke's place in the development of early Christianity' in L.E. Keck & J.L. Martyn (ed.), Studies in Luke-Acts (S.P.C.K., London, 1968), pp. 307-9.

and J.C. O'Neill;[56] in fact, the latter makes him a contemporary of Justin Martyr. But the reasons offered for their doubts are far from conclusive. Thus, Haenchen gives three reasons why the author cannot be the companion of St. Paul: that Luke is unaware of the Pauline solution to Gentiles without the law, that Paul is presented as a miracle-worker and outstanding orator both of which conflict with the Epistles,[57] as does the failure to treat him as on a par with the other apostles, and finally that the source of the conflict with the Jews is misidentified in terms of a claim to resurrection instead of attitudes to the Law. But all this shows surely is that Luke was no mere mouthpiece of Paul, and that either he misunderstood Paul or disagreed with him or believed that Paul's personal history must be sacrificed, where necessary, for the greater edification of the Church. The last would certainly explain the absence of any reference to the conflict between Peter and Paul,[58] as also perhaps an imaginative reconstruction of speeches delivered by Paul, just as 'Athens has to be the place of encounter between Antiquity and Christianity, even though the historical centre of the mission was Corinth', a point made by Dibelius.[59]

In this connection it is important not to overlook the much more positive assessment given to the historicity of Acts by Martin Hengel in *Acts and the History of Earliest Christianity*. Not only does he remind us that 'at many points Acts is connected with other contemporary historical sources';[60] he puts Acts in the context of the general reliability of Luke's Gospel: 'Going by ancient standards, the relative reliability of his account can be tested in the gospels by a synoptic comparison with Matthew and Mark. We have no reason to assume that he acted completely different in Acts from the way in which he composed his first work, and that he made up his narrative largely out of his head.'[61] Following on from this, he is prepared to talk of sources, including an Antiochene or Hellenist source and a collection of stories about Peter.[62] As for points of conflict with Paul, he writes: 'The difference between the picture of Paul in Acts and Paul's original letters, which are certainly considerable, may be explained by the interval of about thirty years between the events in which Luke shared and the composition of his work, and further by the fact that Luke presumably did not know Paul's letters. He may have known that Paul sometimes sent letters to his churches, but these were no longer available to him at the time when he wrote, between 80 and 90. When he finally became Paul's companion all

[56] J.C. O'Neill, *The Theology of Acts* (S.P.C.K., London, 1970), e.g. p. 175.

[57] II Corinthians 10:10. The verse could possibly be an instance of litotes, but that is unlikely in Paul.

[58] Galatians 2:11-14.

[59] Personal letter to Haenchen, 10 February 1947; quoted p. 40.

[60] M. Hengel, *Acts and the History of Earliest Christianity* (S.C.M., London, 1979), p. 39.

[61] Ibid., p. 61.

[62] Ibid., pp. 65-6.

these letters – with the exception of Philemon and perhaps Philippians – had already been written'.[63] If the unavailability of Paul's letters seems implausible, one needs to recall a point he made earlier in the book, that Paul's letters are also not mentioned by Papias or Justin.[64] Again, because of the presence of christological developments in the speeches (for example, the early use of an adoptionist christology or the single early mention of the title, Son of Man)[65] he is lead to the affirmation that 'to deny in principle the presence of earlier traditions in the speeches composed by Luke makes them incomprehensible and is no more than an interpreter's whim'.[66] Thus, while F.F. Bruce's claim[67] that the speeches reproduce more or less verbatim the text of sources available to Luke is implausible because of their suspicious similarity of pattern, it is illegitimate to dismiss them entirely as evidence for primitive conceptions and presumptions within the Church.

That being so, Luke's record of the events of Pentecost cannot automatically be dismissed as unhistorical. Far from it. At the same time, because of the difficulties noted caution is still necessary. In fact, as we shall see, it is possible to defend the historicity of its core in a way that cannot be done for the incident, as recorded, in its entirety. However, this will not go without challenge. Thus, Lampe suggests the following: 'The story of Pentecost is a theological construction in which the phenomena of the descent of the Spirit, the appearance of fire, the great sound, and the proclamation to all the peoples of the world, representatively, in their own languages is modeled on the Jewish traditions of the giving of the Law at Sinai, the parallels with Philo being especially close. Luke is not telling his readers about a charisma possessed by all the members of the Church as such, but dramatically proclaiming the truth that the Law has been been superseded by the Spirit that inspires and empowers the proclamation of the gospel of repentance and forgiveness through the exalted Jesus who has himself taken the place of Moses as the agent of God's covenant with men. He is also presenting a dramatic preview and summary of the theme which is to occupy the rest of his book: the actual carrying of the gospel to the ends of the earth by the apostles and their associates.'[68] So far as the last sentence is concerned, Lampe must have truth on his side. For, as W.L. Knox observes, the idea of 'Jews, devout men, out of every nation under heaven ... hearing we every man in our own tongue' fails to carry conviction since 'in reality it is most unlikely that any Jew of the

[63] Ibid., p. 66.

[64] Ibid., p. 6.

[65] Acts 2:36 and Acts 7:56.

[66] Ibid., p. 104.

[67] F.F. Bruce, *The Speeches in the Acts of the Apostles* (Tyndale New Testament Lecture 1942, published London, 1943).

[68] Op. cit., p. 68.

Dispersion would have understood such native dialects as survived in the remoter regions of the Middle East, since the Jews of the Dispersion were almost entirely city-dwellers'.[69] Again, 'Luke may have taken the Medes and Elamites from the Bible, for the name "Medes" had long been past history, as had also the country of "Elam", north of the Persian Gulf'.[70] It does therefore seem a rather desperate subterfuge on the part of C.S.C. Williams in his commentary to suggest that glossolalia sometimes includes the speaking of foreign tongues.[71] Either St. Luke did not understand what was involved in glossolalia, which seems unlikely at that period of Christianity's history, or he is indulging in dramatic license in order to highlight the nature of the Church's mission for the benefit of his readers.

But even if this much must be conceded, this is very far from acknowledging the whole incident to be 'a theological construction'. Knox[72] had already suggested that Pentecost symbolised the replacement of the old Law, and there is no reason to regard Lampe's advocacy of the theory as any more persuasive than Knox's. For a start, it assumes a well-informed readership for Acts to whom clear clues are unnecessary, and yet the obvious readership for Acts is Gentile. Moreover, such a construction would in any case need something like the experience of Pentecost to provide its motivation. For the purely formal contrast between law and spirit found in Paul's writings,[73] would hardly do; not only does Acts indicate the acceptance of an element of law,[74] but also, and more importantly, the gift of the Spirit is not thought of in terms of freedom from law, but in terms of power, the power of glossolalia, miracle etc.

However, to dismiss this extreme suggestion of pure invention as implausible, is hardly to put all further difficulties at an end. Barrett, for instance, follows Harnack and remarks that 'we cannot be sure when this took place, or if it took place on one occasion only. There may be two accounts preserved in Acts itself. But again we need not hesitate to affirm that some such event did happen.'[75] Barrett refers to Acts 4:31 but more commonly it is John 20:22 that is held to be the major obstacle to regarding Acts 2 as historical. Personally, I fail to see why the 'Johannine Pentecost' should be regarded as a problem. For, given the way in which, as we have already seen with respect to the Incarnation, John

[69] W.L. Knox, *The Acts of the Apostles* (Cambridge University Press, 1948), p. 83.

[70] Haenchen, p. 170.

[71] C.S.C. Williams, *A Commentary on the Acts of the Apostles* (A. & C. Black, London, 1957), p. 63.

[72] His view is rejected by Haenchen p. 172.

[73] Cf. II Corinthians 3:6.

[74] Cf. e.g. the legislation at the Council of Jerusalem (Acts 15:20).

[75] Op. cit., pp. 159-60. The footnote refers to Harnack and mentions Acts 2:1-4 and Acts 4:31.

subordinates historical truth to theological truth, what could be more natural than that the same policy should have applied in respect of the Holy Spirit? Thus, given the infrequency of reference to the Spirit in the Synoptics, it is extremely unlikely that the great Johannine discourse on the promise of the Spirit[76] is historical; John has simply rewritten history in order to bring out the relation between the Incarnate One and the Spirit, as the Church now, he believes, knows it to exist. So, similarly, it seems natural to him to anticipate Pentecost, in order, as it were, to complete the story; he is thus enabled to indicate the continued presence of God through the Spirit in the life of the Church, without the reference appearing as an unnatural appendix demanding further continuation of the story in the early life of the Church.

As for Acts 4:31, Haenchen's comment on the verse is particularly interesting: Luke's point is that 'it is the Holy Spirit which bestows the fearlessness with which the Christian message is proclaimed in the face of danger. Luke is not referring to a pneumatic "possession" given vent in ecstatic utterance: when Harnack saw this episode as the "real historical Pentecost", he was chasing a will-o'-the-wisp.'[77] Perhaps such confidence is not quite in order; it may be the case that Luke has interpreted his sources as indicating two events when there was in fact only one. Alternatively, the mention of a Gentile Pentecost[78] may hint at a series of such events that jointly led to the disciples' conviction that possession of the Spirit was an indispensable mark of the Christian.

Absolute certainty about the number of incidents involved is impossible for us now. Even St. Luke's dating of the major event to Pentecost is seriously open to challenge since the main motive for this may have been theological, a desire to symbolise the dawning of the new age of the Spirit as contrasted with the festivals of the Old Covenant. That is why in describing Stage Two I have placed 'Pentecost' in inverted commas. But even if the precise dating is in doubt, we can be certain that either one such event, or a small group of such events, must have led to a strong conviction on the disciples' part that possession of the Spirit is indispensable to the Christian. Otherwise it is impossible to explain the central and unchallenged importance attached to this test, not only in Acts but in the New Testament in general.[79] One need only think of Paul's question to the Galatians, 'Received ye the Spirit?',[80] the form of the question even suggesting a datable experience; or again in I Corinthians 14 Paul expresses the wish that they should all have the gift of tongues, while at the same time emphasising his own superiority in this respect.[81]

[76] John 14-16.
[77] Op. cit., p. 228.
[78] Acts 10:44-6.
[79] Cf. Acts 1:5, 11:16, 19:1-7; Mark 1:8; Matthew 3:11; Luke 3:16; John 1:33.
[80] Galatians 3:2.
[81] I Corinthians 14:5 and 18.

Not only that. Despite doubt about his dating of the event to Pentecost, there is every reason to trust Luke rather than John, that the incident was not part of an explicit Resurrection appearance. Reasons have been given above, but in any case any direct comparison of the historical reliability of the two gospels of Luke and John would surely force such a conclusion. But if that leaves the historicity of 'Pentecost' as a distinct historical event secure, this does nothing to establish the relation that was held to exist between the experience and the Risen Christ. For, though not involving an appearance, it might still have been regarded as essentially his work. To the question of the interpretation originally assigned to this definitive experience we therefore next turn.

Quite commonly it is claimed that the experience was felt as the gift of the Spirit of Christ. Harnack's summary of Acts, for instance, runs as follows: 'a historical presentation of the power of the Spirit of Jesus in the Apostles.'[82] Again, Dunn contrasts Luke and Acts in this way: 'Where up till then only Jesus had experienced life in the new age, now they too can experience that life – for they share in his life. Where only he had participated in the Spirit, now the Spirit comes to all his disciples as his Spirit.'[83] To give one last instance, Lampe comments: 'Luke makes it clear that the Spirit in the Church's mission is the same Spirit that rested on Jesus; it can be called "the Spirit of Jesus". On at least one occasion Luke comes close to identifying Jesus with the Spirit. The promise that those who testify to Jesus in times of persecution will receive direct inspiration is given by Luke in two parallel forms. In one of these Jesus says, "The Holy Spirit will teach you in that very hour what you ought to say"; in the other he says, "I will give you a mouth and wisdom which all your opponents will not be able to withstand or refute"; and in telling how these promises were fulfilled in the preaching of Stephen Luke writes, "They were unable to withstand the wisdom and the Spirit in which he spoke".'[84]

But there can be little doubt that all such attempts to present the Spirit in such christological terms are totally out of keeping with the general tenor of Acts. Thus Lampe himself, despite his general desire for a unitarian position is forced to go on to admit that 'Luke was, in fact, unable to make a simple identification of the glorified, "post-existent" Jesus with the Spirit in the Church. He believed that the exalted Lord is not here but in heaven. His picture of the Ascension is admittedly a theological construction, composed of Old Testament imagery, but there is no reason to suppose that Luke did not believe that he was narrating an actual event.' The opposing case can in fact be put more strongly than this. For, not only is there no reason to suppose 'a simple identification';

[82] A. Harnack, *The Acts of the Apostles* (Williams & Norgate, London, 1909), p. xviii.
[83] op. cit., p. 43.
[84] Op. cit., pp. 70-2. (Scriptural passages referred to are: Acts 16:6-7; Luke 12:12 and 21, 15; and Acts 6:10).

there is no reason to suspect any identification whatsoever. Thus, at most the passages quoted by Lampe show that Luke believed the Spirit to be ultimately the gift of the exalted Lord and thus subordinate to him, just as he was subordinate to his Father; they do nothing to show a belief in an intimate and continued dependence of the Spirit on Christ when at work in the daily life of the believer.

Confirmation that the interpretation I am suggesting is correct comes from these words of Haenchen: 'Luke knows no counterpart to Paul's "being in Christ". Jesus is dwelling in heaven, which must receive him until the Parousia. Only on exceptional occasions (above all at the call of Paul) does he interfere, through "visions" and appearances, in earthly happenings. It is only in 16:7 that Luke speaks of "the Spirit of Jesus", and even here the effect is no different from that of "the angel of the Lord" or "the Spirit (of God)", namely to give a direction at a specific juncture of the mission.'[85] Conzelmann, in *The Theology of St. Luke*, makes a similar remark: 'It has often been pointed out that no real function of the Exalted Lord is expressed in Luke. The only relevant saying is the one to the effect that he is seated at the right hand of God and will one day appear as Judge.'[86] It is a comment for which he is taken to task by Dunn,[87] and thus expressed there is no doubt that the contrast is too stark, but it is in any case one which Conzelmann modifies on the next page when he notes that the Exalted Lord's activity is constantly 'presupposed when the community prays to him (as it is in Acts 7:59), and above all when it acts "in the name" of Christ'. Finally, even that most Christocentric of writers Professor Moule finds himself in honesty bound to admit the force of the contrast: 'Acts is marked off from the Pauline writings, at any rate, by its conception of Jesus as now no longer "on earth" but "in heaven". The narrative of the ascension in Acts 1:9-11 is consistently presupposed throughout the story. In Acts 2:33 the exalted Jesus is described as having poured out the Spirit. In Acts 3:21 heaven must receive him until the proper time comes. When he appears to Paul on the Damascus Road, it is a special visitation from heaven (9:3; 22:6; 26:13). On the only other occasions when he "appears" at all it is only in a vision (9:10; 22:17-18; 23:11 – by implication); otherwise it is by the Spirit (or by his Spirit) or by an angel that action is taken on earth (8:26,29,39; 11:28; 12:7; 13:4; 15:28; 16:6-7: 20:23; 21:11; 27:23). More consistently than in any other New Testament writing, Acts presents Jesus as exalted and, as it were, temporarily "absent", but "represented" on earth in the meantime by the Spirit (except that, undeniably, in the vision of Acts 18:10 Jesus says *egô eimi meta sou*).'[88]

[85] Op. cit., pp. 97-8.

[86] H. Conzelmann, *The Theology of St. Luke* (Faber and Faber, London, 1969), p. 176.

[87] Op. cit., n. 14, p. 43.

[88] C.F.D. Moule, 'The Christology of Acts' in L.E. Keck & J.L. Martin (ed.), op. cit., p. 179.

Such comments demonstrate conclusively that, as far as Luke was concerned, the entire history of the early Church springing from 'Pentecost' was a history of a community which believed itself to be living in the power of the Spirit, a Spirit that, though derived ultimately from Christ, was neither identified with him nor constantly referred back to him. Now, of course, this might be no more than Lukan theology, but I have already given grounds why doubts about the essential reliability of Acts are exaggerated. In fact, the only major obstacle in the way of accepting that this is how the early disciples viewed their experience is the very different view recorded in Paul. At Stage Three, when I discuss inferences made on the basis of such experiences rather than as in this section the nature of the experience itself, I shall indicate why there is good reason to distrust Paul on this matter. But in the meantime in order to alleviate any lingering doubts on the part of those still distrustful of Acts, I add two further arguments to strengthen my case: first that this view of Acts is supported by our earliest Gospel, Mark; secondly that a priori reflection suggests that in any case this is how such an experience would have been originally perceived.

Later in the chapter I argue that St. John's Gospel has a similar view of the distinctiveness of the Spirit over against Christ. This is not a negligible point since increasingly New Testament scholars seem prepared to endorse the view that, though in many ways less historical than the Synoptics, e.g. in the speeches, it does preserve an alternative early historical tradition. However, even if this is disputed, the argument is still not lost. For our earliest Gospel also reflects a sharp distinction between experiences of Christ and of the Spirit. Such at any rate is the view of Schillebeeckx.

My own view would be that he identifies the wrong motive for this. To me it seems most naturally interpreted in terms of the disciples' own perception of the two types of experience as radically different. For Schillebeeckx 'Mark's is the gospel of "Jesus' absence", and Jesus is thought of as absent until his reappearance in exaltation at the Parousia. That being so, present experience must be identified with the work of the Spirit and not Christ. For anyone who, like Mark, links exaltation with Parousia will not be prepared to acknowledge the celestial but operative presence of Jesus in the Church.'[89] This point is then pursued further in a footnote: 'Thusing denied this, because the Spirit's presence in the community is a gift of the heavenly Jesus. But it is very much a question whether this gift of the Spirit, in which Mark does indeed concur, actually stands, *within the Markan gospel*, in a direct and intrinsic connection with the risen Jesus himself; nothing points in that direction, rather to the contrary (e.g. Mk. 3:28-9; cf. Mk. 13:11 with Lk. 21:15).

[89] E. Schillebeeckx, *Jesus: An experiment in Christology* (Fount Paperback, London, 1983), p. 421.

Even the Didache says: "You shall not judge a prophet speaking in Spirit" (17:27). This articulates a theology which acknowledges the Spirit as primate over the Son of Man.'[90] As already indicated, I do not accept that Mark actually rejected the appearances, as Schillebeeckx suggests. But, even if he has got the motive wrong, his comments here are valuable as indicating the way in which even our earliest Gospel feels it necessary to distinguish sharply between experiences of the Spirit and experiences of Christ.

A priori reflection points in a similar direction. For it is arguable that such relative distinctness was in any case the natural outcome of the type of experiences to which the disciples were subject. For, just consider how different the two types of experience, Resurrection and Pentecost, must have felt to those who encountered them. In the one case we have visions of an exalted Lord whom the disciples had already known as the subject of personal experiences, whether directly or indirectly through the reports of those who had known him in his earthly life; that being so, both his separateness from the Father and his personhood were natural inferences to draw. In the other case we have, by contrast, an experience with no obvious personal marks about it; if anything at all was seen or heard, it was entirely impersonal ('a sound from heaven as of a rushing mighty wind' and 'cloven tongues as of fire');[91] central to the experience was rather its internal, 'felt' character, 'being filled with the Spirit'. What could be more natural than that the object of the experience should be thought of as something that had taken control of them and as quite distinct from the very personal characteristics displayed by the object of their Resurrection experiences?

Yet at the same time their Pentecost experience was such that it would be natural for them to ascribe divinity to its object in a way that it would not be natural to do in respect of the Resurrection experience. For in the latter case both the fact that they had known Jesus as a human being and the militant monotheism of the Jewish cultural milieu in which they lived must have acted as a considerable constraint on any vague subconscious inclinations they may have had. But with Pentecost there were no such restraints; the thing or power which they now encountered they had hitherto not experienced in any other form and its thing-like quality meant that there was no hint of possible conflict with the dictates of monotheism; moreover, an ascription of divinity must have seemed especially appropriate in view of the supernatural powers with which they now felt themselves endowed – glossolalia, miracles, oratory, etc., as well as perhaps a 'divine' sense of well-being.[92] So, even if Acts was shown

[90] Ibid., note 45, p. 714.

[91] Acts 2:2-4. 'Tongues of fire' may be a description borrowed from Enoch to draw attention to the element of divine power present in the experience. Cf. Enoch 14:8-15 and 71:5 (referred to by Haenchen, p. 168, n.2).

[92] Note also the supernatural character of most of the gifts listed in I Corinthians 12:4-11.

to be a late document that has no basis in the early attitudes of the Church, provided the claim can be sustained that the 'Pentecost' experience was quite distinct from Resurrection appearances, it would still seem to me that 'Luke' had got it right, and that those were precisely the sort of attitudes likely to have emerged from the particular juxtaposition of the two types of experience.

All this is, of course, still a long way from a third person of the Trinity. The only firm conclusion we have so far is that the Spirit was originally viewed as a divine power distinct from the Father and the Son, a power that inheres in the individual believer, but there is as yet no hint of him having a distinct personality. Indeed, the accounts in Acts sound more like the hiving off of a thing, divine energy as it were, and it is therefore open to the philosophical theologian to argue in either direction, that is to say, either that a stop should be put to the hiving off and the 'thing' reintegrated into the person whose property it is or, as I intend to argue, that this hiving off should be institutionalised into a third person of the Trinity.

Indeed, in attempting to demonstrate by a priori reflection that the primary datum of 'Pentecost' was of separate, non-personal divinity, it may be objected that I have overplayed my hand. For it may be said that this understanding of the experience has been shown to be so 'natural' in its particular context that there ceases to be any pressure on us to give any particularly prominent role to either the experience or the original interpretation in the formation of our own thought; it emerges as merely a creature of its time. Such a view contains elements of both truth and falsehood: truth, since I have already noted my intention to argue against the postulated impersonal character of the Spirit; overwhelming falsehood because sufficient grounds exist for regarding 'Pentecost' as objective in the sense defined in the previous chapter. That is to say, the cause of the experience lies in a divine initiative, not in a natural explanation, and we are therefore bound to adopt the primary datum of the experience. The only way round this is to argue that the primary datum was not fully understood by the early disciples; this is what I argued in the case of the divinity of Christ and it is what I shall argue here in respect of the separate personality of the Spirit.

But, first, possible grounds for denying such objectivity must be considered. The most obvious of these has in effect already been dismissed. For to the possible argument that Pentecost was the result of expectations created by the teaching of Christ, the answer has been given that the Spirit played no significant part in his teaching. A more complex type of natural causal explanation, however, is possible. The following remarks of G.S. Hendry may serve to introduce it: 'The incidence of the Spirit is interpreted in the New Testament as the fulfilment of Old Testament prophecy, which had given a place of central importance to the Spirit in the eschatological hope of Israel. In the latter days of Israel's

history, when the visitation of the Spirit had ceased to be known as a present reality in the life of the people and had become an object of future hope, this hope received a definite shape in the prophecy of an outpouring of the Spirit which would be permanent and universal. In contrast to the heroes, kings, and prophets of the past upon whom the Spirit came only as an occasional and temporary visitant, the promised shoot of Jesse is one upon whom the Spirit of the Lord will *remain* (Is. 11:2). Permanent endowment with the Spirit is also a prominent feature of the Servant of the Lord in Second Isaiah (Is. 42:1-4). The expectation of the inspired Messianic king or Servant of the Lord leads on to the vision of an outpouring of the Spirit upon the whole people of God and ultimately upon all flesh. The wish expressed by Moses that God would put his Spirit upon all the Lord's people (Num. 11:29) becomes a recurring feature of the prophetic eschatology. According to Ezekiel (36:26-28) and his dramatic vision of the valley of dry bones (37:1-14), the hope of the Spirit is the essential ground of the renewal of Israel. And the high point is reached in the prophecy of Joel (2:28ff.).'[93] Now, if all this is so, might a natural causal explanation of the Pentecost phenomena lie in the fact that the disciples' Resurrection experiences so convinced them that the last days had come that they were led to expect the promised outpouring of the Spirit upon them which then duly happened, having been induced through the strength of their expectations? Indeed, according to Luke, does not Peter in his explanatory speech about Pentecost actually refer to the passage in Joel?[94]

However, there are a number of reasons why this will not do. In the first place, I have already noted the absence of any claims on Christ's own part to be Spirit-filled. There could therefore be no strong motive for the disciples to see themselves as Spirit-filled, even when the Resurrection took place. For, if Christ could inaugurate the new age without making a claim to possession of the Spirit, what need, a fortiori, had lesser mortals like themselves to make such a claim? Of course, the converse is certainly true, but fortunately this does not affect the argument. That is to say, once the disciples believed themselves to be Spirit-possessed, there was then a strong motive for them to attribute a similar possession to Christ. In fact, there is every reason to believe that this was the order of events, and that the experience of Pentecost came, as it were, out of the blue, thereby forcing the disciples to conclude both that their Resurrection experiences were at an end and that, if such a gift of the Spirit was theirs, it must also have been Christ's, even though he never definitively laid claim to it. A second reason for doubting the

[93] G.S. Hendry, *The Holy Spirit in Christian Theology* (S.C.M., London, 1957), pp. 17-18.
[94] Acts 2:16-21.

natural explanation is that the initial experience seem to have been primarily that of glossolalia, and yet that was not what would have been expected on the basis of the life of Christ or Old Testament passages already referred to; indeed, although Joel is quoted, it makes no mention of speaking in tongues nor even of miracles and oratory, the other characteristic features of the work of the Spirit in Acts, but instead refers to cataclysmic happenings in the heavens, prophesying and visions, none of which occupies a central place in the account of the life of the community in Acts. A third and final reason for doubt is that, if the Old Testament expectation was of an outpouring that would be 'permanent and universal',[95] as Hendry claims, it is significant that neither aspect in the New Testament turns out to follow exactly the lines indicated by the Old. Thus, so far as permanence is concerned, Acts nowhere makes such a claim, and it is only with Paul that a notion of permanent indwelling is indisputably to be found; indeed, it reads more like fleeting, though admittedly regular, visitations.[96] Similarly, universality is hardly present in the sense of extension to 'all flesh'; rather, 'exclusivity' is a more natural term to use of the New Testament attitude. In Acts it has clearly become the test of whether a person is a Christian or not, the presence of the Spirit being held sufficient to elicit baptism[97] and baptism of itself being regarded as incomplete without the confirming presence of the Spirit.[98] For all these reasons then the natural explanation is inherently implausible. At most, it might be conceded that some of the later experiences of the Spirit could have a natural explanation as being psychologically induced by the desire to establish entitlement to membership of a community, which as a result of the primal experience seems initially to have demanded evidence of Spirit-possession as a *sina qua non*.

In short, then, our conclusion so far is that Pentecost was an objective experience, and so assent is demanded from the theist for the data provided from it. Of course, data are sometimes subject to misinterpretation, and so a further question arises as to whether the original interpretation given to the data was in fact the correct one. It is to Biblical reflection on this question that we now turn, and particularly to the thought of St. Paul.

Biblical reflection

At the previous Stage I concluded that the original interpretation given

[95] Op. cit., p. 17; cf. also p. 27.

[96] Cf. Acts 2:1ff. and 4:31. Note also the way in which 'Spirit' seems to be used in the same was as 'angel of the Lord', which again suggests a fleeting visitor (cf. Acts 8:26 and Acts 8:29).

[97] Cf. Acts 10:47.

[98] Cf. Acts 8:12-17.

to 'Pentecost' understood the Spirit as a distinct divine entity, but a non-personal one. That this was the original interpretation I noted might be challenged on the basis of evidence from Paul, but said that reasons would be given at this present Stage for distrusting Paul as a more valuable historical source *on this question* than Acts or, for that matter, Mark and John. This I shall now do. But that is by no means the end of the argument. For, if the data of religious experience can be misinterpreted, then it is open for an advocate of Paul to argue that, though his position was not the earliest view taken in the Church, it is nonetheless that which is most congruent with the experience and whatever other facts we know about God. That being so, a further task awaits us of assessing Paul's interpretation. Paul's position, as we shall see, differs in two respects from the original position. The Spirit is acknowledged to be personal, but at the same time the strong sense of distinctness between Son and Spirit is withdrawn. It will be my contention that Paul was right to make the first move, but wrong to make the second. But, first, the reasons must be given for distrusting Paul as a good historical source for determining the Church's original conception of the Spirit.

They concern the nature of Paul's Resurrection experience. Paul himself puts it on a par with the other Resurrection appearances,[99] and indeed regards it as the sole source of his apostolic authority,[100] in striking contrast to the picture presented in Acts, both in respect of the extent of Paul's first contact with Jerusalem and also the role the other apostles played in the circumcision issue.[101]. No doubt, the discrepancies are in part to be explained by Luke's edifying rewriting of history which suppressed facts embarrassing for his emphasis on the Church's unity. But equally there is a danger of too easily endorsing Paul's own version of the situation. For, though Galatians is earlier, and directly from the hand of one of the participants in the events in question, this surely does not of itself necessarily make it a more reliable source than Acts. One has after all to reckon with natural human vanity and the tendency of us all to exaggerate the extent of our role in shaping affairs. So, it may well be that Paul was far more deferential to the other apostles than his letter would lead us to believe.

Indeed, it is hard to imagine Paul opposing Peter to his face,[102] someone who had personally known Jesus and on Paul's own account had been the first to see the Risen Lord, unless he felt sure that he was merely pointing out an inconsistency in Peter's practice with what Peter had already firmly accepted for himself in theory with regard to the Church's

[99] I Corinthians 15:5-8.
[100] Galatians 1:11-24.
[101] (1) cf. Galatians 1:18-20 and Acts 9:26-28; (2) cf. Galatians 2:1-14 and Acts 15:1-29.
[102] Galatians 2:11-14.

attitude to the Gentiles. Again one notes that nowhere does Paul acknowledge his debt to another human being for his instruction in the faith, but such instruction he must have had, especially with regard to the facts of Christ's earthly life, to which we find him making reference in his letters, when he discusses the institution of the Eucharist, Jesus' teaching on marriage and the order of the Resurrection appearances.[103] That being so, Paul's Resurrection experience may well not have been quite as formative ('without consulting any human being, without going up to Jerusalem to see those who were apostles before me')[104] as he would like his readers to believe. None of this is to deny its decisive character, but it is to challenge the common reading of Paul at face value, as though he were immune from natural human failings; for instance, it is surely difficult to defend him from elsewhere having given clear indications of pride.[105] Moreover, if Luke is thought to have suppressed aspects of the story for apologetic reasons, why not also the apostle for the same reason, but in this instance additionally tinged with human vanity? Thus, while it is undoubtedly clear that when writing Galatians a couple of decades after his conversion experience it alone seemed important to him in his formation ('no man taught it me; I received it through a revelation of Jesus Christ'),[106] the probabilities are that the actual historical facts are far more complex. For, not only must there have been some antecedents to the experience, of which we are unaware, whether of the psychological kind proposed by Jung or of the reflective sort suggested by Bornkamm,[107] but also those seventeen mysterious years[108] that elapsed between his conversion and his attendance at the apostolic council at Jerusalem, from which time dates his leading role in the life of the Church, must surely have contained many occasions on which by means of conversations, letters, the hearing of oral tradition, etc, he thoroughly familiarised himself with the life, death and Resurrection of Christ.

That Paul's version of events cannot always be relied upon is being increasingly acknowledged. So, for example, Holmberg in *Paul and*

[103] I Cor. 11:23; I Cor. 7:10-16; I Cor. 15:5-8.

[104] Galatians 1:16-17.

[105] II Cor. 11:21-9. It is difficult to read this passage without thinking that Paul is enjoying giving the list, despite his formal denial.

[106] Galatians 1:12.

[107] Bornkamm suggests that the catalyst was arguments with Hellenistic Christians in Damascus (G. Bornkamm, *Paul*, Hodder & Stoughton, London, 1971, p. 23), while Jung bases his interpretation on the fact that 'fanaticism is only found in individuals who are compensating secret doubts': 'Unable to conceive of himself as a Christian, on account of his resistance to Christ, he became blind and could only regain his sight through ... complete submission to Christianity' (C.G. Jung, *Contributions to Analytical Psychology*, trans. H.G. & C.F. Baynes, 1945, p. 257). Even if the latter account is correct, that would not necessarily exclude the possibility that it was an experience of Christ. To suppose otherwise would be to commit the genetic fallacy, though it would lessen the weight that could be put on its contents as 'objective' (in the sense explained in the previous chapter).

[108] Galatians 1:18-21.

Power undermines the credibility of Paul's account of events in Galatians in various ways, among which the following is worthy of mention. 'Anyone reading Paul's report in Gal. 2:1-10 must get the impression that he stood quite alone before the "pillars", their equal and a match for them. This impression is deceptive. Paul was in reality, together with his equal Barnabas, a delegate from the church of Antioch. The only sign of this in Paul's report, apart from the "with Barnabas" in v.1, is the mention of the fact in v.9 that the "pillars" gave to him *and Barnabas* the right hand of fellowship. This signifies, not just a cordial farewell at the end of the proceedings or a personal acknowledgement of the two Gentile missionaries (with Barnabas probably enjoying the higher status in both Antioch and Jerusalem), but the making of a formal agreement between two churches',[109] with Antioch very much in the position of a daughter church which has sent delegates. Likewise, Hengel complains of Paul that 'he is completely silent about the obligations of the Antiochene community and treats his companion Barnabas in a very niggardly way'.[110] At the same time he suggests that only Barnabas accepted the compromise of 'the apostolic decree', and that Luke himself was aware of this.[111]

However that may be, it is into precisely such a context of guarded suspicion about his historical reliability where his personal status is concerned that we must fit the claims he makes about his Resurrection experience and what he may have deduced from it. In fact, the experience is something of which Paul tells us surprisingly little. In Galatians he describes it as a 'revelation' and twice in I Corinthians he speaks in terms of a vision ('Have I not seen Jesus our Lord?'; 'And last of all he was seen of me also').[112] All of this sounds as though his experience must have been parallel to the sort of visions that are recorded in the Gospels, but it is intriguing to note that in none of the three occasions on which the vision is mentioned in Acts[113] is it implied that Paul actually saw the Risen Lord, and commentators in general seem agreed that from his Letters it clearly emerges that it was really the interior character of the experience which mattered to Paul.

Haenchen comments on the first account in Acts 9 as follows: 'From verse 7 ('he heard the voice but could see no one.'), 26:13 ('I saw a light') and 22:14 (Paul was appointed 'to see the Righteous One'), taken in conjunction with 26:16 ('a witness' that 'you have seen me'), it seems to follow that Saul saw Jesus only inasmuch as he beheld this tremendous blaze of light. Presumably, however, Luke imagined the occurrence in such a way that Saul's companions saw only a formless glare where he

[109] B. Holmberg, *Paul and Power* (GWK Gleerup, Lund, Sweden, 1978), p. 18.
[110] Op. cit., p. 120.
[111] Ibid., p. 117.
[112] Gal.1:16, I Cor. 9:1 and 15:8.
[113] Acts 9:1-18, 22:1-16, 26:1-18.

himself saw in it the figure of Jesus. This would make it more understandable that Saul should apostrophize the being, addressing him with *Kurië*.'[114] But it seems to me that Haenchen's first thought was the more perceptive, and for five reasons. The first is that 'I saw a light from the sky ... and then I heard a voice'[115] is an extremely odd way to describe a vision of a person, if there were indeed any features other than the voice which indicated the presence of a person. Secondly, given Luke's fondness for detailed descriptions of the Resurrection appearances he records in his Gospel, it would seem certain that he would have recorded more, if there had been anything more to the 'vision'. Thirdly, the use of the personal address occurs after Paul has heard the voice, and that would therefore seem sufficient to account for that. Fourthly, the voice says, 'Saul, Saul, why persecutest thou me?'[116] which seems to imply, as John Robinson has pointed out that 'the appearance on which Paul's whole faith and apostleship was founded was the revelation of the resurrected body of Christ, not as an individual, but as the Christian community'.[117] Now, if that is so, it would seem extremely unlikely that any personal characteristics would have been noticeable, since these would inevitably have detracted from thought of the Church as a corporate body, and directed his mind to Christ as an individual. Finally, it is extremely hard to envisage what form Christ could have taken if there was a vision, since Paul did not know the earthly Jesus and we have no reason to believe that there were as yet any clear precedents that would have aided recognition, as later, non-Biblical visions were aided by contemporary representations in art. In fact, it is clearly the verbal claim that was of importance in identifying the object of the 'vision', and so an appearance of Christ could not have served any useful additional role.

When one turns to look at what Paul himself has to say, doubts similarly arise. Indeed, Bornkamm suggests that 'reveal' in Galatians should not be thought of primarily in relation to the experience at all. Thus, he argues on the basis of the way in which the word is used elsewhere in the Epistle that ' "revelation" ... must have another meaning. The word is taken from apocalyptic, and ... means an objective world-changing event through which God in his sovereign action has inaugurated a new aeon.'[118] His overall conclusion is in fact that 'as in Philippians 3, then, Paul's testimony in Galatians 1 about his call shows that the lines of any understanding of his conversion and mission are entirely dictated by the subject matter of his preaching and theology,

[114] Op. cit., pp. 321-2.
[115] Acts 26:13-14.
[116] Acts 9:4.
[117] J.A.T. Robinson, *The Body* (Studies in Biblical Theology no. 5, London, 1952), p. 58. D.E.H. Whiteley offers some criticism in *The Theology of St. Paul* (Blackwell, Oxford, 1964), p. 193.
[118] Op. cit., p.21. Gal. 3:23-4 is the passage referred to.

and not by any arbitrary claim to reception of *revelatio specialissima* (special revelation)'.[119] Whether one can demote the importance of the experience for Paul that far is doubtful. Nevertheless Bornkamm's comments are important as indicating that 'reveal' may well have no suggestion of a personal vision of Christ. Further confirmation is provided by Lampe's remark that 'it is possible that the expression *en emoi*, which could mean simply 'to me' but might have the sense of 'within me', indicates that Paul regarded the revelation as an inward experience.'[120] But, it may be said, the two references to 'seeing' Christ remain as an insuperable obstacle to this interpretation. That I doubt, because the fact of the light might well have been deemed sufficient by Paul to justify his talk of seeing Christ, especially if the voice was heard to emanate from within the blaze of light. Indeed, Paul himself may allude to the vision of light: 'The same God who said, "Out of darkness let light shine" has caused his light to shine within us, to give the light of revelation.'[121] As for him placing his experience on a par with the other apostles, if it involved no actual sight of the Risen Lord, it could well have been Paul's belief that there was no significant difference, especially if a blaze of light played an integral part in other Resurrection appearances now lost; indeed, if, as was once commonly proposed, the story of the Transfiguration is in fact a transposed original Resurrection appearance,[122] then an obvious parallel to Paul's own experience of light would have existed.

I have examined the nature of Paul's experience and the claims he made on the basis of it at such length because, if it really was as indefinite as our investigation of the available evidence has tended to suggest and if there is also no reason to believe that his placing it on a par with the other Resurrection appearances was ever accepted by the Church as a whole,[123] it becomes comprehensible why he might have been led in consequence to fudge the distinction between Son and Spirit, and why we need not take such fudging to be representative of the earliest attitudes of the Church. Two features of the experience stand out, its vagueness and the personal element present within it, insofar as a voice was heard, and both are features that would seem naturally to militate in favour of Paul obfuscating the distinction between Son and Spirit. Thus its vagueness must have sounded to Paul very much like the descriptions given by the disciples of some of their Pentecost experiences; his sight was affected just as their tongues had been in the original experience and so both seemed to share the element of being grasped by a

[119] Ibid., p. 22.

[120] Op. cit., p. 147.

[121] II Corinthians 4:6.

[122] The arguments against this once popular view are given by C.H. Dodd in D. Nineham (ed.), *Studies in the Gospels* (Blackwell, Oxford, 1957), p. 25.

[123] As Acts indicates.

supernatural power. Moreover some of the early accounts of the work of the Spirit actually refer to an external voice, as with Peter's conversion to the Gentile mission, which is likewise accompanied by a vision, though the work is attributed to the Spirit and not to Christ. Such vagueness meant to those disciples who had known Jesus personally during his life that it was not felt as a personal experience of their Lord. The voice, if externalised, presumably did not sound like his voice and the power by which they felt themselves grasped in glossolalia, miracles and the like was presumably experienced to be indwelling them to such a degree that it was more natural for them to think that some of the divine energy had been hived off to indwell them than to understand the power as still under the direct personal control of Father or Son. By contrast, Paul had no such standard of comparison, having never known the earthly Jesus; little wonder then that he might be tempted to identify the two types of experience.

For all we have said so far, it might well have been the case that Paul would have been led to speak exclusively in terms of experiences of the Spirit. Indeed, scholars are not wanting who connect the feeling of being overpowered which is so conspicuous an element in his conversion experience with his attitude to the Spirit in general. Thus Gunkel and Holmberg[124] are among those who emphasise Paul's pneumatic endowment, and in particular the connexion he commonly makes between Spirit and power, e.g. 'Our gospel came to you not only in word, but also in power and in the Holy Spirit and with full conviction'.[125] Holmberg also draws attention to the way in which Paul turns his inability to heal himself despite his gift of tongues, prophecy and healing into an argument for the source of that power: 'In himself Paul is so weak and disease-ridden that nobody can believe that the mighty work he does is due to his own efforts – there is only one other available conclusion, it is God who works through his apostle.'[126] But more directly relevant to our present concerns is the way that Paul's occasional apparent explicit identification of Spirit and Christ can be explained in terms of this equation of his between Spirit and power. As Gunkel put it in *The Influence of the Holy Spirit*: 'It is easy to see how Paul came to this equation of *pneuma* and *Christos*. Indeed, Paul's conversion did not occur through others' bringing him to faith in Jesus the Christ. The Lord himself appeared to him in his divine glory and seized him. Paul's first pneumatic experience was an experience of the Christ. From then on Christ was for him *to pneuma*.'[127]

But, of course, there were some powerful factors pulling him in the

[124] H. Gunkel, *The Influence of the Holy Spirit* (Fortress Press, Philadelphia, 1979), p. 92ff; Holmberg, op. cit., p. 77ff.

[125] I Thessalonians 1:5.

[126] Op. cit., p. 78.

[127] Op. cit., p. 114.

opposite direction. The most obvious of these is the fact that the gospel being proclaimed was a gospel about Jesus. A less laudible factor may well have been his desire to claim equality with the other apostles by placing the experience on a par with their Resurrection experiences, despite its considerably less explicit character and the absence of the exaltation features which I suggested in the previous chapter were probably constitutive of the earliest Resurrection events. But there was also another feature present in the experience itself, namely the personal element in the voice. Added to which, of course, is the fact that the voice claimed to be the voice of Christ in words which may well be original, given the reference to 'Saul'.[128] But it is to be noted that, apart from the address, there was nothing in the experience which could have been checked by the original disciples to confirm that it was indeed an experience of the Risen Lord rather than the voice of the Spirit. In saying this it is *in no way* my intention to deny that Paul did indeed have an experience of Christ. Rather, my point is that Paul's experience was such that the early Church's distinction between Son and Spirit must have seemed very puzzling to him; he was convinced that his decisive experience was of the Risen Lord and yet its features were not all that different from what the original disciples described as an experience of Spirit. The difference was that it contained a personal element, and this presumably was one major factor which led Paul to conclude that the Spirit also must be conceived of in personal terms. Theological considerations may also have played a part, but it is interesting to note that there is no need to go beyond the Damascus Road experience to explain the two new features introduced by Paul into the Church's understanding of the Spirit, namely the personal character assigned to the Spirit and the collapse of the distinction between Son and Spirit into sometimes little more than a mere form of words.

There are therefore sufficient grounds for discounting Paul as of any service in determining the original attitude of the Church to the Spirit. There were just too many special factors involved in his case. Indeed the fact that he continued to use the language of Son and Spirit may well be evidence of the fact that, despite his incomprehension, he none the less felt compelled to use the terminology, precisely because the distinction was so deeply embedded in the early Church. But even this is not the end of the argument since, as already noted, experiences are subject to interpretation. So the next question which we must consider is whether Paul might after all be right in respect even of the data of the original experiences of those who had known Jesus on earth. Though not the original interpretation, might he none the less be right that a binitarian account is the one that best fits all the facts, both for those first

[128] Robinson, op. cit., p. 58, n.1: 'The lapse into Aramaic for the spelling of Paul's name, found nowhere else, is some evidence that we have here an indelible personal reminiscence.'

'Pentecost' experiences and for all subsequent experiences of the 'Spirit'?

There are two principal and quite decisive arguments against any such revision, though during the course of our discussion it will be observed that the lesser of Paul's two revisions is accepted, namely the personality of the Holy Spirit. Of these two arguments, one can only be given in bare outline, and so it will be presented first.

(i) Whereas the second is concerned with the nature or structure of the experience, this first is concerned with the order in which it occurs, and its relation to providence. Basically, the point is that, if the God of theism really was using this as the decisive period of history in which to communicate his essential nature, as we already have grounds for believing on the basis of our discussion of the Incarnation, then it is extremely puzzling why certain objective (i.e. interventionist) experiences were allowed to occur which suggested to the recipients the presence of a third distinct aspect in the deity if that was not intended. It would after all have been so easy to ensure that they were automatically viewed as an experience of Christ present in a new way. For instance, the Spirit could have been given immediately in the context of the Resurrection experiences. This is, of course, what a surface reading of St. John suggests happened, but I have already given reasons for discounting his historicity on this matter. Again, it might be argued that there had to be two sets of very different experiences in order to ensure that the disciples realised that Jesus could not always be available to them in such a personal manner as the Resurrection experiences suggested; in other words, there was a need for a different type of experience in order to wean them from the past towards a very different future. But, in the first place, as our researches in the previous chapter indicated, the Resurrection experiences seems also to have contained within them an essential element of exaltation, so that they began the process of weaning inasmuch as the disciples must have in consequence realised that the level of intimacy they had known with the earthly being was now no longer possible in view of his exalted state. Secondly, even if this were not so, it is surely the case that a minimum christological element could have been introduced to avoid the possibility of misunderstanding without thereby appearing to endorse the continuation of the old type of relationship; for example, the first Pentecost experience might have taken place during the course of a Eucharist. My conclusion, therefore, is that, if one accepts the theism (i.e. interventionist God) of Chapter 1 and that on this matter at least Acts is more to be trusted than St. Paul, then the only viable option is to accept that God's intention was to reveal a third, distinct aspect of deity; for otherwise the ordering of providence seems to border on, if not be tantamount to, incompetence.

To such an appeal to providence two features of my earlier discussion may be raised by way of objection: first, that in Chapter 2 I defended a model of revelation that emphasised divine acceptance of the

inevitability of misunderstanding of his will and purposes; secondly, that I have already contended for a particular instance of this at the time of the decisive events in question, namely Paul's lack of clarity about the distinction between the Son and Spirit. But in respect of the model of revelation an important difference should be noted. It is one thing for such confusion to occur as a result of human prejudices and lack of perception; it is quite another that God should act indifferently between actions that may or may not be likely to produce such a result. There thus remains good reasons why God would have chosen carefully between the occurrences of the first pneumatic experience in the context of Resurrection appearances or, as I have contended, a quite separate setting.

But this does little to explain how it is compatible with an alleged providential guidance towards the revelation of a third person in the Trinity that Paul might have succeeded in turning the Church in a quite different direction. Of course, Chapter 2 acknowledged that in the course of the divine dialogue such wrong turnings have taken place in the past, but these were the fault of human prejudice (e.g. in respect of narrow Jewish nationalism). This can only partly account for Paul's obfuscation of the distinction (i.e. through his prejudiced qualitative equation of his own experience of the Risen Christ with that of the original disciples). Two further points need to be borne in mind. First, what God could have done to avoid any possible misunderstanding on Paul's part was in any case limited. Simply because Paul had never known the earthly Jesus, even if his conversion experience had contained a visionary element, this would have been insufficient to distinguish sharply its import from pneumatic experience. This is because there could be no remembered features present in the one case but absent in the other that would compel a distinction to be drawn between two different objects of the two types of experience. His experience of Christ was inevitably less sharply personal than that of the original disciples, and so he had less reason to see that experience as essentially different from that of the Spirit acting upon him. Indeed, much the same could be said of all subsequent such experience in that again the lack of remembered features precludes definitive identification of the experiences as belonging to two elements in the divinity rather than one; hence the indifferent way in which contemporary Christians speak of their experience as being now of one Person, now of another. The other point is that the danger of Paul misleading the church was in fact less then than now. This is because not only, as I shall shortly observe, did Paul on the whole attempt to follow the Church in maintaining some kind of distinction, but also, given the way in which texts were read at the time, he was less likely to be interpreted as undermining the distinction. For, as subsequent Biblical exegesis in the patristic period shows, argument tended to centre round a literal reading of particular texts rather than the interpretation of an

author as a whole, and in that kind of setting there are no shortage of passages in Paul that apparently imply trinitarianism.[129] Thus it is in no way incompatible with a providential ordering of events that Paul was vouchsafed an experience of the Risen Christ. The danger of misconceptions comes only if we pull Paul out of his historical context in that ordering of events.

(ii) Incontestably, my first argument against a binitarian revision depended on interventionist premises, but since this is not true of the second it will be of more interest to the deist. Here I are concerned with the nature or structure of the experience itself and for this we may legitimately use evidence from St. Paul. For, although his pneumatic experience was not one of the original formative experiences and he read into it one crucial feature that was not there, there is no reason to doubt that, stripped of its interpretative overlay, his experience was essentially the same as the other apostles.

Earlier I rejected a natural explanation of Pentecost as produced or induced by the expectation of an apocalyptic outpouring of the Spirit. The absence of any teaching on the subject on the part of Christ was noted, as too was the fact that there were significant differences between expectation and reality as recorded in Acts. There was exclusivity rather than universality, and no clear hint of permanence. But with Paul not only is exclusivity accepted,[130] but also permanence is emphatically and unconditionally endorsed.[131] What is interesting about such endorsement is that not only does he make no reference to Old Testament prophecy, but also he often seems to assume that it is Christ who is responsible for such activity and not the Holy Spirit. It is thus equally impossible to apply the expectation-fulfilment argument in his case. However, Paul is so emphatic about the continuous activity of God within the Christian individual that one is compelled to re-examine the evidence of Acts. Such a re-examination shows that Acts is in fact compatible with Paul; it is just that Luke thinks more in terms of the Spirit being, as it were, quietly present and only now and then breaking forth to the surface,[132] whereas for Paul the indwelling power of God is always at work, whether consciously or otherwise. In that case, my earlier comments on permanence in Acts should be emended to the effect that Luke's account exhibits no tendency to stress permanence, so that even in this small respect the natural explanation remains implausible. There is also the obvious point that, if permanence means the Spirit being present without always manifesting itself to the individual's consciousness, this must obviously be an inference, and cannot be a primary datum of experience.

[129] Cf. A.W. Wainwright, *The Trinity in the New Testament* (S.P.C.K., London, 1962), pp. 241-3.

[130] E.g. I. Cor. 12:3.

[131] Cf. Rom. 5:5 and Gal. 4:6 and II Thess. 2:13.

[132] For breaking to the surface, cf. 2:4, 4:8, 4:31, 15:28.

Therefore, the alternative explanation for the discrepancy between Paul and Luke is that Paul made the inference, whereas Luke did not.

Either way, whether fleeting or permanent in its influence, and however named, it is incontestable that the early Church conceived of the Holy Spirit as an indwelling power. Indeed, if Moule is right, when it is a question of the name for this particular experience, even Paul seldom diverges from what we have seen to be the Church's original tradition: 'Rarely, Paul does refer to Christ as "indwelling" each individual (Rom.8:10 Gal.2:20), or as among Christians and "indwelling" the Christian community (Col. 1:27). But this is only rarely. And although "in Spirit" occurs fairly often, it seldom, if ever, seems to mean anything comparable to the incorporative phrase "in Christ" or "in the Lord" ... Roughly speaking, the tendency is to speak of Christians as "dwelling" in Christ, whereas the Spirit is spoken of as "dwelling" in Christians.'[133] However that may be, it is this incontestable aspect of indwelling, the experience of divine power working from within rather than without that would seem to constitute the heart of the nature of the 'Pentecost' experience and, that being so, it is this aspect that we must further analyse to see whether anything more can be deduced from the experience about the nature of the deity. I have already noted that Paul's Resurrection experience must have played a major role in determining his two main general differences from Acts. However, what I want now to do is show that, even if he started purely from an analysis of this core of indwelling, the inference he drew in one case was right, and in the other wrong.

First, then, the respect in which he was right: the personal character of the Spirit. That this is overwhelmingly Paul's view is beyond doubt. Admittedly, as Lampe points out, there are occasional instances to the contrary: 'Thus Paul says that the gospel came to Thessalonica "not by word only, but by power and by Holy Spirit and much assurance"; the Thessalonians have to be urged not to "quench" the Spirit; Paul's initial preaching at Corinth was accompanied by a "demonstration of the Spirit and power"; and "power" is again linked with "Spirit" in the concluding section of the Letter to the Romans.'[134] But these are rare exceptions. As Earle Ellis remarks, 'although its manifestations may not always appear to be so, the Spirit is personal: it "bears witness", it "intercedes", "comprehends", "teaches", "dwells", "wills", "gives life", and "speaks".'[135] As to why we should follow Paul in his respect, appeal could be made to the range of personal experiences which he mentions. These

[133] Op. cit., p. 74.

[134] Op. cit., p. 91. He refers to I Thess. 1:5 and 5:19, I Cor. 2:4, Rom. 15:13.

[135] E. Ellis, 'Christ and Spirit in I Corinthians', in B. Lindars and S.S. Smalley (ed.), *Christ and Spirit in the New Testament* (Cambridge University Press, 1973), p. 269. Relevant references are Rom. 8:16 and 26; I Cor. 2:11 and 13, I Cor. 3:19, I Cor. 12:11 and II Cor. 3:6.

must certainly carry some weight, but cannot carry the day, unless reinforced by some account of why the disciples were wrong to regard the earliest definitive experiences as impersonal. In fact, it is possible to point to two major pressures towards impersonal language which were regarded at the time as decisive but which there is no such compulsion on us to so view. One of these I have already somewhat indirectly alluded to: namely, the fact that, since the disciples were convinced that the experience was not an experience of Christ, if they did conceive of it as personal there would have been a puzzle as to who this person could possibly be; God the Father was equally ruled out as someone who in their experience was beyond such intimate comprehension. However, the major impulse towards the use of non-personal language lay elsewhere in the very structure of those early definitive experiences. For with such phenomena as glossolalia and the power of miracle it is very easy to see how an individual might become very confused as to what was the appropriate account of the experience, personal or impersonal, and why therefore he might opt for what seems the simpler option, the use of non-personal language. On the one hand, such an experient is aware that it is himself who is acting – it is his limbs that move, and he endorses and welcomes the actions involved; on the other, he is convinced that a greater power than himself is at work. Yet at the time of the original 'Pentecost' experiences there seemed insuperable difficulties in the way of directly identifying this power as a person. Not only was there the already noted problem of who this person could possibly be, since both Father and Son were apparently ruled out by the disciples' prior experiential knowledge. There were also considerable conceptual difficulties, given the cultural assumptions of the time, in making sense of the notion of one person acting from within another. For it was a common assumption in the first century that all persons, including God, existed locally in one place rather than another (In God's case in Heaven). There was also the allied assumption that the activity of one person in a particular case was commonly taken to imply the absence of any other. So two persons could not operate simultaneously in the same place. With such assumptions, the simplest solution would be to say that it is the individual himself who acts but that he is aided by a special input of divine power. This is in fact the model which Acts adopts. But neither of the conceptual assumptions from which it is derived is plausible. We have no reason to think of God as localised in Heaven and equally there need be no difficulty in comprehending the notion of two persons acting simultaneously in the same place, provided we think of the human agent becoming a free, cooperative channel for the expression of the will of the divine indwelling power. There can therefore be no reason to follow the earliest disciples in adopting an impersonalist model.

But, it may be objected, this does not give us sufficient grounds for adopting a personal model. After all, it may be said, the definitive

experiences are in any case the sort that would be felt as impersonal – strange words bubbling forth that the speaker does not understand and the like. But this is true only a limited sense that does not affect the argument. For they are felt as impersonal only in the sense that the individual is convinced that the complete explanation cannot be that it is his person that is acting; it feels, as it were, too much like a take-over bid. Thus, descriptions of the experience as impersonal do not intend exclusion of an ultimate personal explanation, but rather exclusion of a claim that it felt like one of the human agent's own personal actions. But, the objector may continue, even if this is part of the explanation, it cannot be the whole explanation: the intention must also be to exclude the possibility that what the individual relates to in the take-over bid is felt as personal. Two important point must be made in reply to this. The first is that to talk of relations at all in such a context is meaningless. In experiences like the definitive ones comparable accounts suggest that the take-over is so sudden and so complete that the individual is not quite sure what has hit him; it is only subsequent reflection that reveals to him that he must have been related to something. Secondly, irrespective of how it feels, what is accomplished by the take-over is in any case best characterised as personal rather than impersonal; thus, even in glossolalia the words are invariably regarded as comprehensible to someone, even if this is not always the agent whose vocal chords are used.

My conclusion then is that, once the illegitimacy of contemporary conceptual assumptions is noted, along with the misleading implications of the term 'impersonal', the only appropriate course to adopt is to follow Paul and use personal language to describe what is taking place. That said, we may now turn to a consideration of the case for firmly rejecting Paul's other main innovation, his collapse of the distinction between Christ and Spirit. One reason has already been given in terms of the providential ordering of the 'Pentecost' experience. Here, as with the personality of the Spirit, our concern will be more with the structure of the experience.

What is meant by the central element in that structure, indwelling, immediately presents problems as soon as it is recalled that one is dealing with a being who is by definition omnipresent, namely the divine. For, though indwelling sounds like a lively and important metaphor, first reflection suggests that it might well turn out to be after all a self-contradictory notion, with the omnipresent being somehow allegedly more present in one place than in another. But such a difficulty can, I think, be successfully resolved. A parallel may be drawn with the presence of other spiritual beings. In drawing such a parallel I am concerned solely with the manner in which such beings are conceived to be present; no assumptions are made about whether or not they actually exist. Consider two cases, one in which an individual claims to be assailed by demons and the other in which the person describes his

experience as one of demon possession. The difference surely amounts to this: the former still feels that his person is intact but that it is under attack from without, whereas the latter sees himself as no longer in full control of his own personhood. Indeed, he either regards the demon as now the appropriate subject of all his actions or he views the situation as in flux, with his own will sometimes to the fore and sometimes suppressed, the demon then being the exclusive subject. There are many aspects of the parallel which one would not wish to press, but clearly indwelling is parallel to possession in this respect at least, namely that, as we have seen especially with regard to the definitive experiences, the only possible subject is not the human individual but the indwelling divine power, the Holy Spirit; for in calling the experience impersonal the individual in acknowledging that he sees himself as no more than a vehicle or channel for the Spirit's power in action. Thus the contrast turns out to be nothing at all to do with the in any case absurd suggestion of presence as contrasted with absence, but rather with the question of whether God is present as subject or not. Also excluded, one may note, as the point of the contrast is any suggestion that it is merely a matter of whether God is active upon the individual or not. Thus the person who believes himself assailed by demons is in no doubt that they are active and produce an effect on him, but yet he exhibits no inclination to use the interior language of possession. Thus the point of the terminology of indwelling is neither to localise the divine presence nor merely to indicate divine activity *per se*, but rather to describe a special form of divine activity, in which God is seen as the true subject of the individual's actions.

But, if this is the essential element in indwelling, how is such action best conceived? The answer can best be ascertained by once again looking at the question of demon possession. Invariably, when the individual would claim to have been at his most demon-possessed, he would also say that at the time in question he was totally unaware of it. He had become a pure channel, with the demon in complete control. It is the other times that are agonising for the individual, when he is aware of the demon attempting to move from an object of his experience (i.e. from being another as in the experience of being assailed by demons) to being the subject of his experience (i.e. his deeper, his true self, as it were). This has a happy analogue in the case of the Spirit; for he at least is wanting to be the subject of good actions but does not wish to become the subject through overriding the individual's free will.[136] Now, if this is what is happening, the appropriate description for indwelling becomes something like the following: God as subject or pressing to become subject (though a pressing that is without compulsion). By the latter half

[136] Many theologians have taken the opposing view, but this is refuted by the analysis of revelation offered in Chapter 2.

of the account I mean that it may also be viewed as an experience of indwelling if the Spirit is experienced as an object but an object so close, so intimate that he is felt as an object pressing to become a subject, so that the individual will then become an uninterrupted channel of divine grace.

Given such an account, it at last becomes clear why Paul's ambivalence on the Spirit's status as a distinct person will not do. For the question arises whether sense can be made of the notion of the same person being experienced both as pressing to become subject and as pure object. Admittedly, at first sight there would seem to be no problem. Thus, although it is the case that in all the experiences we have looked at the Spirit is either already subject or pressing to become such whereas the Father and Son are experienced as objects (i.e. distinct other beings), as with the Resurrection or awe at the Father's work of creation,[137] it might be argued that the distinction points to no fundamental difference. The alternative remains open that there is one person who is called Father or Son when an object experience is in question and Holy Spirit when a subject experience is in the offing. Indeed, support might be drawn from our earlier parallel with the treatment of demons since no one doubts that it might conceptually be the case that it is the same demon who now is assailing the individual and now is in possession of him.

At this point, therefore, it becomes crucial to draw attention to a type of ambiguity in the notion of the Spirit always pressing to become subject which philosophers sometimes label 'scope ambiguity'. This occurs when there is ambiguity about the range or scope over which a particular qualification is meant to apply. For example, 'the wild animal keeper' could mean 'the keeper of wild animals' or, admittedly less naturally, 'the animal keeper of wild appearance or behaviour'.[138] So in this case if it is meant merely that when God is experienced as Spirit he is always experienced as subject or pressing to become such, there could be no obstacle from this direction to Paul's proposed conceptual revision. But in fact rather more seems to be implied in accounts of such experience, and this is where the relevance of scope ambiguity arises. Thus it is not that always when experienced the Spirit is experienced as pressing to become subject but rather that when experienced he is experienced as pressing to become a subject always; in other words, that he be enabled to act exclusively in that way. So the import of 'always' is not to isolate one form of experience of God which can then be appropriately labelled 'Holy Spirit'; rather it is to indicate a universalisable intention present in the divine subject of the experience.

[137] If objection is made that creation is equally the Son's work, an indisputable case of the Father as object would be the Son's earthly relation to Him.

[138] The example is taken from W. Hodges, *Logic* (Penguin, London, 1977), p. 76ff.

In support of the view that this is how pneumatic experience was perceived there is no need to quote particular passages. The whole emphasis of the New Testament on the permanence of the Spirit in the Christian, notably and ironically including Paul himself, underlines the desire for the pure experiences to be not the exception but the rule: it was thought that perfect indwelling meant the Spirit as always subject with the individual Christian permanently a pure channel of grace. And it is, of course, a phenomenon that it is not unique to Christianity. Andrew Louth remarks: 'Plotinus was, perhaps, the first to see that self-consciousness, self-awareness, can be a hindrance to the soul's progress. It is sickness of which we are aware, for example, he remarks, whereas when we are in health we are normally unaware of it (V.8.11). Again, if we are conscious of the fact that we are reading, it is a sure sign from that our attention is wandering.'[139] A few pages later he notes the inference Plotinus draws from this about our relation to the divine: 'This is why in that other sphere, where we are deepest in the knowledge by intellection, we are aware of none.' With his view that Plotinus was original in this respect I would have to disagree, given my view that such an attitude is already implicity in the New Testament, but, however that may be, the interesting point for our present concerns is once more the conviction that the ideal is of God always as subject, and – something new – the point that when evidence of this is demanded, as Louth again observes, 'since we pass beyond self-consciousness, we cannot say that when the *experience* has passed, the state of union with the divine has passed.'[140] It is probable, then, that the argument that I am about to present could be built on the basis of the universal experience of God as indwelling, but at this stage I shall continue to confine myself to Christianity.

Basically, the point is that with 'always' in its new position there is after all a conflict that can only be resolved by postulating distinct aspects of the deity. For, if the Spirit is always striving to become subject at all times, then the only way to avoid treating object experiences as inferior experiences, which they must always be in terms of the Spirit *qua* Spirit's intentions, is to see them as involving the intentions of a difference aspect or person of the deity. To say otherwise would be to suggest that there is an inherent inferiority in, for example, an experience of encounter with the Risen Christ in one of his Resurrection appearances or, again, in an experience of religious awe before the creation. Any such contention would surely be unjustified. Certainly there is a difference in kind, but this need not necessarily imply difference in the quality of the relationship.

[139] A. Louth, *The Origins of the Christian Mystical Tradition* (Clarendon Press, Oxford, 1981), p. 43.
[140] Ibid., p. 49.

To avoid any suggestion of inferiority in non-Spirit experiences we must therefore postulate two different aspects or persons in the deity. Of the two labels 'person' seems preferable, since two very different conceptions of the nature of the relation to individual human beings is involved. Let me return once more to the demon parallel. Paul's rejection of the distinction would have been acceptable had the situation with regard to the Spirit been parallel to that of a demon who was content now to be assailing an individual, now to be possessing him. But that is not so; instead the position is like that of a demon who feels that his intentions are never realised except when he in full possession. Such a sharp contrast does this suggest between what are in this case essentially subject experiences and what are in other types of religious experience essentially object experiences (i.e. experiences of God as essentially other) that it seems more appropriate to speak of the experiences as springing from two different persons, rather than merely two aspects, of the deity. An added pointer in this direction is that any weaker analogy for distinct instigators of such formally opposed intentions, such as the conscious and unconscious aspects of a single person, is very likely to suggest a superior and inferior relation, something that is, as we have seen, unwarranted by consideration of the various types of religious experience.

However, while such different intentions seem to me to imply different persons, this is a secondary point, relevant only to the choice between a personalist (Augustinian) or a social (Cappadocian) model for the Trinity. For, even if the reader prefers 'aspect', the argument is not lost. Its main objective has been to demonstrate that a distinction between two 'somethings' must necessarily be drawn, if any hint of inferiority in non-Spirit experiences is to be avoided. From there it is but a short step to trinitarianism. For the previous chapter defended a distinction between Father and Son, both of whom in the present terminology are naturally regarded as 'objects' in 'object experiences', as, for instance, in the Resurrection appearances. So, when combined with this subject of essentially 'subject experiences', we have a Trinity in the Godhead.

In the past soteriological argument played a major role in defending the doctrine of the Trinity, particularly the Incarnation, as in Athanasius and Anselm. I have not mentioned these in the present work because for reasons too complex to mention here they are not persuasive. Soteriology can only be a consequence of Incarnation, not something to be determined in advance of it. But in the case of the Holy Spirit it is possible to offer a soteriological argument though it is of limited force. So I add it to the two major arguments above as a brief appendix. Its inclusion here is particularly appropriate because of the attention I have paid to the New Testament emphasis on the permanence and exclusivity of possession of the Spirit as the distinguishing mark of the Christian.

Just as from the soteriological point of view one might argue that the

relation between a particular human nature and divine nature must be maintained for all eternity if the effects of the Incarnation are to be permanent, so it can be maintained that, if it is only in virtue of the permanent indwelling of the Spirit that the community of the faithful is redeemed, then as part of its redemption, namely its complete fulfilment in Heaven, it can only be by the continued presence of the Spirit in the Church, even in Heaven, that this is achieved. That is to say, just as the need to have God's total identification with man permanently recorded leads to the postulation of a permanent identity between a particular human nature and divine nature and thus the postulation in effect of a second person of the Trinity, so the need to have the permanent indwelling of the Spirit in the Church, the body of the faithful, in Heaven as on earth, must lead to the assertion that there is a third person of the Trinity who is equally a permanent, eternal feature of the reality and nature of God. The soteriological need for different aspects of God to be permanently identified in the one case with a particular human nature and in the other the Church in general would thus be the soteriological source for the maintenance of the distinction between the Persons.

In the previous chapter I treated St. John's Gospel as the legitimate culmination of a particular historical process of development. In the case of the Holy Spirit, unlike that of the Incarnation, this is not possible. For, as we have seen, with St. Paul the development almost went disastrously wrong. Nevertheless, while the Fourth Gospel cannot be seen as the inevitable conclusion of a continuous and uninterrupted process of development, it can be viewed as the closest approximation within the New Testament to what would have been the legitimate culmination of the process of development, had that development continued on the course that was implicit in the primary datum of the early disciples' experiences. Admittedly, some would contest this. For instance, Lampe[141] sees no essential difference between the position of Paul and John, while Johnston in his monograph comes to the conclusion that 'the spirit of God in John 14 – 16 is defined as the spirit of Jesus the Christ, and so its ministry is related intimately and fruitfully to the historic ministry of Jesus'.[142] Now, of course, there is a sense in which this is true, but from the context of the particular chapter as whole,[143] it is clear that Johnston's concern is to undermine the emphasis on the distinctiveness of the Spirit claimed in particular by Raymond Brown, especially as it is his contention that 'the author of the Fourth Gospel combined 'spirit of truth' with 'paraclete' in a deliberate rebuttal of heretical claims for an angel-intercessor as the spiritual guide and guardian of the Christian

[141] Op. cit., pp. 10-11.

[142] G. Johnston, *The Spirit Paraclete in the Gospel of John* (Cambridge University Press, 1970), p. 126.

[143] Ibid., chapter 8, pp. 119-26.

Church[144]. Obviously, this is not the place to go into the question of the origin of the term 'Paraclete', suggestions for which have included proto-Mandean Gnosticism and late Jewish angelology, particularly Qumran.[145] But it is appropriate to remark that, if Johnston's statement is indeed polemical, it is very weak polemic, given (i) the use of the personal term, (ii) talk of the Spirit as 'another paraclete', and (iii) the Spirit's undertaking functions which Jesus will only perform in his own person again on his return. This last fact is, rather strangely, used by Lampe and Bultmann to argue for the identity of Jesus and the Spirit. Bultmann remarks: 'When in relation to Jesus the Spirit is called 'the other Paraclete' (14:16), he appears to be Jesus' substitute, so to speak, after Jesus' departure. Actually, it is Jesus himself who in the Spirit comes to his own, as is indicated by the correspondence between the promise of the Spirit (14:16ff.; 16:12-15) and the promise of Jesus' return (14:18-21; 16:16-24).'[146] But this would be true only if we think of the promise of Jesus' return as referring to the Resurrection experiences; this is implausible since no explanation is then available as to why John should attribute two promises to Jesus when the import of both would then in effect be identical.

It is preferable then to accept Brown's suggestion[147] that an interval is being assumed and that the promise of Jesus' return refers to the Parousia. This will then enable us easily to make sense of the expression 'another Paraclete' in that it will then indicate the nearest thing to 'the presence of Jesus when Jesus is absent'.[148] If this is accepted, then not only does John emphasise the personal character of the Spirit more than any other New Testament writer through his use of the term *Paraclêtos* (a personal emphasis which would be further increased if we follow Sanders and Martin in regarding the explicit identification with the Spirit at 14:26 and 15:26 as unnecessary editorial interpolations),[149] but also he successfully underlines his separate identity by this temporal distinction of roles at least until the Parousia. Such then are the grounds for regarding John as the most perspicacious of New Testament writers on the doctrines of both Incarnation and Holy Spirit.

However, even when the Spirit is personalised as the Paraclete, He remains without the same degree of definite personal identification that

[144] Ibid., p. 119.

[145] Summarised in R. Brown, *The Gospel according to John* (The Anchor Bible, Chapman, London, 1971), pp. 1137-9; discussed in more detail in Johnston pp. 80-118.

[146] R. Bultmann, *The Theology of the New Testament* (S.C.M., London, 1955), vol. 2, pp. 89-90.

[147] R.E. Brown, op. cit., pp. 729-30: 'Much of what John reports in 16:16ff. anticipates a more permanent union with Jesus than that afforded by transitory post-resurrectional appearances' (p. 729).

[148] Ibid., p. 1141.

[149] N. Sanders & B.A. Martin, *A Commentary on the Gospel according to St. John* (A. & C. Black, London, 1968), p. 329.

we associate with Christ – a human life history at a certain point in time etc. That being so, one might expect non-Biblical experiential evidence for the existence of the separate personhood of the Holy Spirit to be at least a possibility in a way that could not be so for the second person of the Trinity, tied as the latter is to a definite form of identification. It is with an investigation of that possibility that our fourth and final stage is concerned.

Non-Biblical experience

Chapter 1 has already referred to the extraordinary variety that exists within religious experience, and the difficulties of interpretation which accordingly arise. However, there is no dispute that this variety takes both a transcendent and an immanent form. That is to say, the Godhead is experienced both as externally related to the individual, i.e. as transcendent, and as internal to him, as in some sense the deeper well-springs of his being, i.e. as immanent. The former is naturally suggested by what was identified in Chapter 1 as numinous experience, a concept there associated with Otto's *The Idea of the Holy*, while the latter conjures up the notion of mystical experience, the experience of intimacy as distinct from awe. Now, of course, the fact that both types of experience are to be found in all the major world religions to varying degrees – in Islam the experience of transcendence tends to dominate, in Buddhism and Hinduism immanence, with Christianity more finely balanced between the two – can show nothing of itself about possible distinctions within the Godhead. All that might be indicated is that one and the same single person who is God acts in two rather different ways, or rather is felt by the experient as acting in two different ways, since in the absence of spatial location for God it might be argued that from his perspective no essential difference will be seen between the two activities. But, while this much is undoubtedly true, I would wish none the less to argue that an adequate analysis of mystical experience does drive us to postulate a distinction between immanent and transcendent aspects of the deity, between what in Christian terminology may appropritely be called Spirit and Father.

However, before proceeding to the argument proper, a number of caveats must be issued. The first is that the argument is in no sense simply to the effect that all transcendent experience must be assigned to one aspect of the Godhead and all immanent experience to another. Admittedly, it is my view that in general the Holy Spirit should be associated with immanent experience and the Father with transcendent, but such a generalisation cannot be universalised and has nothing to do with the argument here. On the contrary, I take only one of these types of experience, the immanent, and argue from it and it alone to the necessity

of postulating at least a twofold aspect in the Godhead. The second major caveat concerns the status of the second person of the Trinity. It is commonplace to find both transcendent and immanent activities attributed to him, transcendent as, for instance, with the sensory experiences discussed in Chapter 1, immanent as, for example, with variants of St. Paul's claim, 'Nevertheless I live; yet not I, but Christ liveth in me'.[150] Indeed, given this impetus one notes a tendency in much modern theology to ascribe all immanent activity to Christ, not only in a specifically Christian context as with Schillebeeckx' *Christ the Sacrament of the Encounter with God*, but also in respect of religious experience in general as with Pannikar's *The Unknown Christ of Hinduism*.[151] That being so, it might be questioned why the subsequent argument omits all reference to Christ. The explanation is that the second person of the Trinity is pre-eminently identified in a particular way by reference to his incarnate life, so that it would pre-empt various issues if he were referred to in advance as necessarily the object of certain experiences that in themselves give no such indication. That is to say, some further argument would be required in order to legitimise such identification, whereas it has, of course, been the contention of previous sections of the chapter that the natural way of arguing to such an identification cannot be endorsed. In addition, this way of proceeding is in any case less condescending to other world religions. It should, however, be noted that this is not to say that what is in fact an immanent experience of Christ can never be experienced anonymously; it is only to claim that such an identification belongs naturally to a later stage of the argument, either through Pentecost being identified as an experience of Christ (something I deny) or through an argument that veridical mystical experience of Christ can be established from other contexts (particularly I suggest at the prompting of the Holy Spirit). This last sentence, of course, applies to anonymous immanent experience. So far as anonymous transcendent experiences of Christ are concerned, the issue seems more straightforward; the question to be asked would be whether there was anything in the experience that necessarily identified the object of the experience with the Incarnate One, for example in his behaviour or words.

So much then by way of preamble. My argument will proceed by two stages, first by drawing attention to what is, I believe, a hitherto neglected aspect of Christian mystical experience, and then by going on from there to consider whether the point can be generalised to non-Christian mystical experience. The further stage is necessary

[150] Galatians 2:20.
[151] E. Schillebeeckx, *Christ the Sacrament of the Encounter with God* (Sheed & Ward, 1975); R. Pannikar, *The Unknown Christ of Hinduism* (Darton, Longman & Todd, London, rev. ed. 1981).

because it might be objected that all I have shown by the first stage is that as a result of prior doctrinal conditioning Christian mystics so characterise their experience as to suggest a basic distinction within the Godhead.

As a matter of fact, the precise form of language to which I am about to refer is not inevitable even in Christian mystics, which casts doubts on whether it can simply be a matter of prior doctrinal conditioning. I shall give two examples, one from the fourteenth century and the other from the sixteenth. Jan van Ruysbroeck, reflecting on his own mystical experiences, writes as follows in *The Spiritual Marriage*: 'The inward lover of God, who possesses God in fruitive love, and himself in adhering and active love, and his whole life in virtues according to righteousness; through these three things, and by the mysterious revelation of God, such an inward man enters into the God-seeing life. Yea, the lover who is inward and righteous, him will it please God in his freedom to choose and to lift up into a super-essential contemplation, in the Divine Light and according to the Divine Way ... And to it none can attain through knowledge and subtlety, neither through any exercise whatsoever. Only he with whom it pleases God to be united in his Spirit, and whom it pleases Him to enlighten by Himself, can see God and no one else. Few men can attain to this Divine seeing, because of their own incapacity and the mysteriousness of the light in which one sees ... But he who is united with God, and is enlightened in this truth, he is able to understand the truth by itself. For to comprehend and to understand God above all similitudes, such as He is in Himself, is to be God with God, without intermediary, and without any otherness that can become a hindrance or an intermediary.'[152] The fascinating thing about this passage can be summed up in a phrase to be found in the last sentence – 'to be God with God'. Clearly, for Ruysbroeck the common contrast between monistic and theistic mysticism, between identification and intimacy, is a false one. For him at least both are true; there is such identification with the indwelling Spirit that he can speak of himself as God, while through such identification there comes what is rather a union of intimacy with the Father, being 'God with God' so that here some sort of separate identity is still being maintained. If that is so and this is the correct account of the experience, then what we seem to have is a record of a human individual himself experiencing a distinction within the Godhead, with the Spirit so catching him up into his own life as to make him part of his own experience within the Godhead in relation to the Father. As Ruysbroeck puts it elsewhere in *Seven Steps of the Ladder of Divine Love*, it is an indwelling Love that pushes the individual towards participation in the second type of experience: 'The Holy Spirit works in us, and we, together

[152] J. van Ruysbroeck, *The Spiritual Marriage* III, 1, 3, 4; quoted in F.C. Happold, *Mysticism: A Study and Anthology* (Penguin, London, rev. ed. 1970), pp. 289-90..

with Him, perform all our good deeds. He cries in us with a loud voice and yet without words: Love the Love which loves you eternally. His cry is an interior contact with our spirit. His voice is more terrifying than thunder. The lightnings that break from it open up heaven to us and show us the Light and eternal Truth.'[153] Now, whether he is right that love is the motivation that makes the Spirit allow the individual who has totally identified with him participate in his relation with the Father or whether it is simply an inevitable concomitant of being totally related to one Person that one participates in his relations within the Godhead, we need not discuss here. All that is vital to note is that Ruysbroeck claims not only to have had both types of mystical experience (identity and intimacy) but to have experienced them both simultaneously such that they could not possibly both have the same object. It is also worth underlining the fact that he makes the observation without any reference to the type of argument which I am now offering, but merely in the context of describing his experience.

However that may be, further support can be found in the reflection of that great sixteenth-century mystic St. John of the Cross. At one point in his *Spiritual Canticle* he expresses himself thus: 'Then the two natures are so united, what is divine so communicated to what is human, that, without undergoing any essential change each seems to be God – yet not perfectly so in this life, though still in a manner which can neither be described nor conceived.'[154] 'Each seems to be God' bears a marked similarity to Ruysbroeck's phrase 'to be God with God', and indeed there are quite a lot of comments which suggest the notion of the indwelling Spirit making us 'Gods'[155] who are then enabled to take part in the relational life of the Godhead. The general tenor of his thought perhaps comes out most clearly in the following passage: 'This breathing of the air is a property which the soul says that God will give her there, in the communication of the Holy Spirit, who, as one that breathes, raises the soul most sublimely with that his Divine Breath, and informs and habilitates her, that she may breathe in God the same breath of love that the Father breathes in the Son and the Son in the Father, which is the same Holy Spirit that God breathes into the soul in the Father and the Son, in the said transformation, in order to unite her with himself ... And this said aspiration of the Holy Spirit in the soul, whereby God transforms her into Himself, is so sublime and delicate and profound a

[153] Quoted in P. Fransen, *Divine Grace and Man* (Mentor-Omega, New York, rev. ed. 1965), pp. 88-9.

[154] Quoted in Happold, op. cit., p. 99 (but without reference).

[155] Cf. e.g. *Spiritual Canticle* B, Stanza XXXIX, 6: 'Wherefore souls possess these same blessings by participation as He possesses by nature; for the which cause they are truly gods by participation, equals of God and his companions' (*Complete Works of St. John of the Cross*, tr. & ed. E. Allison Peers, Burns & Oates, 1943, vol. 2, p. 397). Cf. A Stanza XVII, 11, p. 105.

delight to her that it cannot be described by mortal tongue, nor can human understanding, as such, attain to any conception of it. For even that which passed in the soul with respect to this communication in this temporal transformation cannot be described, because the soul united and transformed in God breathes in God into God the same Divine Breath that God, when she is transformed in Him, breathes into her in Himself. And in the transformation which the soul experiences in this life, this same breathing of God into the soul, and of the soul into God, is very frequent, and brings the most sublime delight of love to the soul, albeit not in a degree revealed and manifest, as in the next life.'[156] Now, of course, it has to be admitted that St. John is expressing himself here in highly theological language, language that becomes more theological still later in the same stanza when a particular model for the Trinity is assumed in the question, 'For since God grants her the favour of uniting her in the most holy Trinity, wherein she becomes deiform and God by participation, how is it a thing incredible that she should also perform her work of understanding, knowledge and love?'. None the less, under this heavy overlay of interpretation there is still clearly visible a claim to have had experience analogous to that described by Ruysbroeck, with the identification of deification – 'tranforming her into Himself' – being distinguished from the relationship that the indwelling Spirit makes possible – 'breathing in God into God'. At any rate, unlike most of the doctrinal overlay which St. John presumably sincerely believes to be genuinely implied by his experience, I take it that this much at least would be experientially distinguishable. That is, one could successfully distinguish within one's experience not only between an experience of intimacy and an experience of identity, the latter involving the feeling of being taken over as in modern claims to demon possession, but also between such an experience of identity and an experience of the identifying agent relating one to some third thing. There is therefore no a priori difficulty in appealing in this way to accounts of experiences such as those had by Ruysbroeck and St. John.

If there is a difficulty, it will lie in the possible suspicion that, though such a confirmatory experience could conceivably have been had by any human being, records of them are confined to the Christian tradition. The easiest way out of this problem would be, of course, to follow Zaehner[157] and suggest that experients in other world religions have only been the recipients of an inferior type of experience. But this is inherently unsatisfactory because once the universality of mystical experience is admitted, which seems hard to avoid given the similarity of accounts existing across religious frontiers (as noted in Chapter 1), it is

[156] Ibid., B Stanza XXXIX, 3-4, pp. 395-6.
[157] R.C. Zaehner, *Mysticism Sacred and Profane* (Oxford University Press, 1957), pp. 204-6.

implausible to suggest that necessarily only inferior forms are to be found in other religions. That being so, I shall take two non-Christians cases, Hinduism and Islam, to see if any parallel to this experience of God encountering God is to be found.

So far as Hinduism is concerned, it is a major problem that there is no unanimity as to how the key texts should be interpreted, in particular the 'Tat tvam asi' of the Upanishads,[158] the two major interpreters offering very different analyses, Sankara in the ninth century proposing a monistic account and Ramanuja in the twelfth a denial of complete identity. I shall not enter here into the question of who is historically the more faithful exponent. What rather matters to our present purposes is that both Sankara and Ramanuja reflect aspects of Hindu mystical experience, so that it is interesting to investigate the possibility of whether within their accounts they find themselves forced to accommodate the alternative perspective. For this is what we would expect to find if my suggestions about Christian mystical experience are correct. Thus, there should be not only the immanent experience of identity with the indwelling Spirit but also through this experience there should come a relation to some further divine element that transcends purely immanent experience. In this light it is intriguing to discover that according to Lott, in *Vedantic Approaches to God*, both Sankara and Ramanuja acknowledge an immanent and transcendent element in experience of Brahman. For the theist Ramanuja this comes out pre-eminently in his Self-body analogy, according to which the experient sees himself as a body in a dependency relationship to the Supreme Self (Atman) which is God (Brahman). None the less, that body is itself a field of divine activity for 'the Inner Controller' and 'Support' that directs the individual outwards in worship; he is even prepared to describe the individual soul as 'part' of Brahman.[159] However, just as there is indisputably an immanent aspect to Ramanuja's thought, so there seems to be a transcendent emphasis in the monistic position of Sankara. For, although he places most emphasis on the discovery of the identity of one's real Self with Brahman, he draws attention to a stage beyond this, when one discovers Brahman at his most transcendent, Brahman nirguna (attributeless). Lott observes: 'Speaking from the level of qualifiable Brahman' – Brahman saguna (with attributes) – 'of course, his reality has to be accepted, and on this basis worship will be offered to him. In so far, therefore, as these two levels of reality exist, two Brahmans also exist ... It is only from the absolute standpoint of the realisation of a Brahman devoid of any such qualifying attributes that this 'other' Brahman does not really exist. Whether described as "lower Brahman" or as "Lord" ... a personal being endowed with glorious

[158] 'Thou art that': *Chandogya Unpanishad* 6, 14.
[159] E. Lott, *Vedantic Approaches to God* (Macmillan, 1980), pp. 52-3.

attributes is, even to Sankara, an unavoidable necessity. A personal Brahman is required to account for the relative reality both of created existence and of the ultimate enlightenment.'[160] Now, of course, as this quotation makes clear, the experience of two Brahmans is supposed to mark merely a transitional phase for Sankara, just as for Ramanuja the experience of the 'Inner Controller' is not supposed to mark an ultimately different entity from the external reality of Brahman which one is then motivated to worship. But, that said, one notes that, though this is obviously true at the level of belief, at the level of experience not only is it the case that an immanent and a transcendent aspect are distinguished but also knowledge of the transcendent aspect is held to come through the initial experience of the Godhead as immanent, as with the accounts of Ruysbroeck and St. John of the Cross referred to earlier. To be sure, the language of 'God encountering God' does not seem to be used, but that is in effect what apears to be the import of the experience since it is in the prior experience of identity, of God as one's 'Inner Controller' or real Self that the subsequent acknowledgment of God as transcendent is brought about. With Sankara there is of course a further complication in that Brahman nirguna is finally held to be the only reality, but this cannot be part of the individual's experience since no sense can be made of the notion of experiencing oneself as attributeless: in other words, at most it can be an inference from what is experienced.

Turning now to Islam, of all the world religions there is no doubt that it is the most transcendent in emphasis. From that one might deduce that its own mystical movement of Sufism would exhibit the same type of character, and so do little to endorse the twofold aspect of divine mystical experience we have found exhibited within Christianity and Hinduism. Certainly, a surface reading suggests that the primary datum of the experience is that of being caught up into God's transcendence in a monistic union. Confirmation appears to come from Ghazali's description of their experience: 'The mystics, after their ascent to the heavens of Reality, agree that they saw nothing in existence except God the One ... Nothing was left to them but God ... One of them (Hallaj, crucified in 922 for the claim) said, "I am God (the Truth)". Another (Abu Yazid) said, "Glory to me! How great is my glory!"[161] Again, Abu Yazid puts his prayer for such experiences in transcendent terms: "Once He lifted me up and placed me in his presence and said to me, O Abu Yazid, verily my creatures long to see thee. And I said, Adorn me with thy unity, and clothe me in thy I-ness and raise me up to thy oneness so that when thy creatures see me, they will say, We have seen Thee."[162]

But, appearances notwithstanding, it is clear that such a belief in

[160] Ibid., p. 122.
[161] Quoted in Zaehner, op. cit., pp. 157-8.
[162] Quoted in Zaehner, ibid., p. 162.

transcendental identity stemmed from an initial experience of immanent identity. Thus there was a tradition of the Prophet having said, 'There is a polish for everything that becomes rusty, and the polish for the heart is the remembrance of God', and, according to Margaret Smith, 'this idea of the rusty mirror and the need for polishing it was a favourite one with the later Sufis'.[163] Certainly, it is easy to find instances. The Persian poet and mystic, Jami, who died in 1492, puts it thus: 'From all eternity the Beloved unveiled his beauty in the solitude of the Unseen/He held up the mirror to his own face, He displayed his loveliness to himself/He was both the spectator and spectacle: no eye but his had surveyed the universe/... Though he beheld his attributes and qualities as a perfect whole in his absence/Yet he desired that they should be displayed to him in another mirror,/And that each of his eternal attributes should become manifest accordingly in a diverse form.'[164] Again, Attar's *Conference of the Birds* ends thus: 'All you have been and seen and done and thought,/Not you but I have seen and been and wrought/ ... And your arrival but Myself at my own door/Who in your fraction of Myself behold/Myself within the mirror Myself hold/To see myself in, and each part of Me/that sees himself, though drowned, shall ever see./Come, you lost atoms, to your Centre draw,/And be the Eternal Mirror that you saw;/Rays that have wandered into darkness wide,/Return, and back into your Sun subside.'[165] This image of the mirror is fascinating since, despite Islam's doctrinal emphasis on strict monotheism which would seem naturally to preclude any explicit reference to a dualist notion of God encountering God of the type we have been considering, this is in effect what we have in these accounts of mystical experience expounded in terms of this notion of a mirror. Thus, the Sufis first enjoin that one polish up the mirror that is oneself (by asceticism, contemplation, etc.) and realise thereby one's identity with God; as a further stage one is then led on to see that the reflection must also be identical with the ultimate transcendent reality which it is reflecting. Now, of course, as with monistic Hinduism, the stage at which the polished mirror is seen to be divine and yet because only a mirror still distinct from the ultimate transcendent reality is held to be only a transitory phase without ultimate ontological significance. But that does not alter the fact that, so far as accounts of such mystical experience are concerned, it represents an identifiable element in the experience.

But why, it may be asked, should we regard this identifiable element as indicative of some ultimate distinction in the Godhead, and not merely just a transitory phase in the experience? The appropriate answer

[163] M. Smith, *The Way of the Mystics* (Sheldon Press, London, 1976), p. 147.

[164] Quoted in Happold, op. cit., p. 252.

[165] Quoted in Happold, ibid., pp. 262-3. The image is also used by Abu Yazid: 'For thirty years God most high was my mirror ... Behold, now I say that God is the mirror of myself' (quoted in Smith, op. cit., p. 243).

is basically the same as that given in respect of Hindu monistic claims. The problem there was that no clear sense could be attached to the alleged next stage of the experience, that of a felt identity with that which is beyond all attributes. So similarly in this case. There is surely no difficulty in envisaging an experience in which one becomes convinced that God is the true subject of one's actions (the experience of immanent identity), nor any difficulty in conceiving that through such experience one gains the further experience of being intimately related to God as transcendent; rather the difficulty comes in making the final move to an experience of identity with God as transcendent. For that must mean, if it means anything, an experience of oneself having the characteristic attributes of God as transcendent, such as omnipotence, omniscience and omnipresence, and, although this is precisely what was claimed by some Sufi mystics, as, for instance, Abu Sa id,[166] it seems so obviously false as to demand no serious consideration.

My conclusion, then, with regard to non-Biblical experience is that, although explicit support for a distinction within the Godhead based on God as immanent and God as transcendent can only be found in records of Christian mystical experience, our brief foray into other world religions indicates that they too indirectly provide confirmation. For even in accounts that claim to be purely monistic when the experience is analysed there is a constitutive element which is most naturally seen in terms of God encountering God. Moreover, this is not an eliminable element since no clear sense can be attached to the further description of God as immanent catching up the individual into an experience of identity with God as transcendent.

Edvard Schweizer begins his account of the Biblical view of the Spirit with the words: 'Perhaps the skeptic was right after all when, back in the days of the stage coach, he declared that ... when it came to the Holy Ghost he felt as if he were dealing with a third horse, the extra held in reserve: you always had to pay to keep it ready even though you never actually saw it and it probably did not exist at all.'[167] If the arguments of this chapter are anywhere nearly right, this is very far from being the case. Not only are there good Biblical grounds for believing in the separate existence of the Spirit, but also religious experience in general points in the same direction, whether it be in the experience of the Divine Being that is always pressing to become subject or in the experience of the encounter of God with God with which we have just dealt. Indeed, in terms of quantity of experiential evidence, the Spirit seems better placed than the Son, since most claims to experience of the Son admit of other interpretations, apart, of course, from the Resurrection and other such sensory religious experiences.

[166] So Zaehner, op. cit., p. 185.
[167] E. Schweizer, *The Holy Spirit* (S.C.M., London, 1981), pp. 1-2.

PART III
The Coherence of the Doctrine

Chapter Five

Coherence and Available Models

In Part II grounds for belief in the doctrine of the Trinity have been examined, and the conclusion reached that there are sufficient grounds for believing in three distinctive elements in the Godhead, especially when this is set against the sort of considerations advanced in Part I in favour of an interventionist account of divine activity. Thus Chapter 3 demonstrated that, despite the considerable complexity of the historical evidence, a belief in Christ's divinity remains the most reasonable interpretation of that evidence, while Chapter 4 argued that, whether one took the timing of 'Pentecost' or the inherent nature of such experience, both compelled assent to the view that the divine subject of the experience could be neither Father nor Son.

In reaching these conclusions I largely avoided discussing the extent of the difference between the three elements. This was deliberate. Partly it was because the question could be treated more adequately in this part of the book, but the main reason was that in order to defend a trinitarian view of God what is required is an essential and permanent distinction between the three elements, not that this be found to operate to some specified degree. As will be obvious from subsequent discussion 'person' in the formula 'three persons in one God' has been subject to a wide variety of interpretations, and need not be taken as equivalent to anything like the modern sense of person. At the same time it should be observed that the net effect of Part II has been to defend a stronger emphasis on distinctiveness than would normally have been the case in the past. The explanation lies in the rather different grounds given for belief in the separate divinity of Son and Holy Spirit. Chapter 3 defended the former while accepting a very limited self-consciousness in Jesus; this cannot but mean a much sharper distinction between Father and Son than was held, for example, in the patristic period. Equally, the defence of the separate divinity of the Holy Spirit in Chapter 4 involved postulating intentions uniquely attributable to the Holy Spirit; again this argued for a greater degree of distinctiveness than the rather wooden justifications of the past, often little more than mere appeals to the use of a different word and always in danger of collapsing into binitarianism.

However, if little was said except by implication on the degree of

distinctiveness of the three elements or 'persons' in the Godhead, even less was said on the question of their ultimate unity. But it is not hard to see its rationale. There are two obvious and intuitively plausible justifications that may be mentioned at this point. The first is that revelation of this threefoldness occurred in the context of an already existing belief in a divine unity. Of course, this is an irrelevance to someone who refuses to accept the Old Testament as revelation. But, if the argument of Chapter 2 is endorsed, all revelation takes the form of a continuing divine dialogue in which truth is only gradually revealed. In those terms it makes most sense to suppose that what occurred later in the dialogue and from the perspective of Chapter 2 at its culmination should be interpreted in the light of what had gone before, which in this case means the strong Jewish emphasis on monotheism. The divine plan is thus most naturally interpreted as first securing a strong belief in the divine unity against the background of which a trinitarian revelation could then occur. The second form of justification is rather different. It concerns the question of which would be the less misleading to the worshipper, to speak of three gods or one. The answer is undoubtedly to speak of one God or Godhead, so different is this trinitarian God from the gods of, for example, the Greek or Hindu pantheon. The New Testament reveals such a strength of common purpose that to speak of the three elements as three gods would be to direct the worshipper in entirely the wrong direction, as though in discovering the purposes and character of one 'person' one had not discovered all that is most important about all three. As St. John makes Christ declare: 'He that hath seen me hath seen the Father.'[1]

Obviously, it is necessary to say a great deal more than this, and that is why Part III is so essential. But at least it makes clear that the subsequent discussion is historically based; that is, it stems from a need to clarify what theistic historical investigation discloses as a secure deposit of revelation. In the Introduction I mentioned two reasons for postponing discussion of the coherence of the doctrine until now: first, since the likely readership of the book will consist mostly of theologians without much knowledge of philosophy, it made more sense to leave the more technical discussion to the end of the book; secondly, in any case serious interest in defending the coherence of a doctrine will only be generated if there are thought to be good grounds for the belief. To these two considerations a third factor might have been added, that questions of coherence depend on the precise form of the claim being made and the form regarded as appropriate is largely determined by the nature of the historical evidence. But though placed last in the order of our discussion this should not be taken to indicate diminished importance. On the contrary, it is arguable that this is a more important and fundamental

[1] John 14:9.

question than that of the grounds for the belief. For, if a doctrine is logically incoherent, it cannot even get off the ground, as it were, as a legitimate object of belief, since one's belief would then be literally 'non-sense'. That being so, it constitutes a prior necessary condition for justified belief, logically prior to the admittedly complex question of whether there are sufficient grounds for justified belief.

Given the importance of the question it is disappointing to note how little discussion is devoted to the problem of coherence. On the radical side, the issue is more often than not summarily dealt with in some such throw-away remarks as the following comments on the Chalcedonian definition of Christ's person: John Hick writes that it 'is as devoid of meaning as to say that this circle ... is also a square,'[2] while Don Cupitt declares that it is 'simply the making of a self-contradictory assertion;'[3] neither offers any argument in support. But in fairness it cannot be said that conservatives in general[4] deserve any more respect; their approach is equally slipshod. One detects an underlying supposition that, if the grounds for the belief seem good, then the logic must be right; or perhaps there is the additional thought that God is in any case beyond logic and so the question of coherence cannot be raised. In response to the first point, it may be noted that establishing incoherence does not necessarily totally undermine grounds for belief; what it does is to show that the grounds cannot have legitimately established a belief of precisely that form; but what they point to may be only slightly, if still significantly, different, rather than necessarily totally different. Thus the supposition that if the grounds for the belief seem good, then the logic must be right is not all that far from the truth. The grounds, if good, may reasonably be interpreted as indicative of something approximating the truth. But logical investigation may reveal that a shift (not necessarily a major one) in the form of the belief must be made if there is to be congruence between the admittedly good grounds and logic. But suppose the conservative resorts to the stronger position and puts God above logic, as indeed many, including some philosophers,[5] have done, what then? My answer is twofold. First of all, this sort of ploy, an all too frequent resort on the part of theologians, exacts its price: nothing more may properly be said, since any attempt at further characterisation must be arbitrary, unless tests of consistency are employed, which is to bring back logic, the

[2] J. Hick (ed.), *The Myth of God Incarnate* (S.C.M., London, 1977), p. 178.

[3] In M. Goulder (ed.), *Incarnation and Myth* (S.C.M., London, 1979), p. 132.

[4] E. Mascall is an obvious exception: for example, in *Theology and the Gospel of Christ* (S.P.C.K., London, 1977), p. 121ff. and in *Whatever Happened to the Human Mind?* (S.P.C.K., 1980), p. 28ff.

[5] For example, Descartes seems to entertain the possibility in Meditation I, and indeed in Reply to Objections V he explicitly makes God the creator of mathematical truths (*The Philosophical Works of Descartes*, tr. E.S. Haldane & G.R.T. Ross, Cambridge University Press, 1911, vol. 2, p. 226).

very tool that has already been rejected; secondly, as Aquinas[6] pointed out long ago, it is not a case of imposing limits on God but rather of admitting that such logical tests are a presupposition of all thinking; otherwise, how may one distinguish between what can and what cannot be said?

Newman in *A Grammar of Assent* tries a rather different tack to obviate the necessity of defending the coherence of the doctrine. His argument is that, provided a number of distinct propositions that together make up a complex belief like the doctrine of the Trinity are separately well-grounded and easily apprehensible, that is all that can be required for 'real assent'. To demand more, that an analogy be produced for the overall belief and it thus be rendered clearly intelligible and coherent, is in his view illegitimate since there are limits beyond which the human mind cannot go, where it is only possible to speak of mystery. So he is prepared to concede of the doctrine of the Trinity that 'a man of ordinary intelligence will be at once struck with the apparent contrariety between the propositions one with another which constitute the Heavenly Dogma'.[7] But from this he deduces not the impropriety of the belief, but that, provided real assent to the constituent beliefs is justifed, 'notional' or formal assent to the doctrine as a whole remains justified. 'But the question is whether a real assent to the mystery, as such, is possible; and I say it is not possible, because, though we can imagine the separate propositions, we cannot imagine them altogether. We cannot, because the mystery transcends all our experience.' As a palliative towards explaining how pellucid truth when combined might produce a murky lack of clarity he draws an analogy with colour: 'Break a ray of light into its constituent colours, each is beautiful, each may be enjoyed; attempt to unite them, and perhaps you produce only a murky white. The pure and indivisible Light is seen only by the blessed inhabitants of heaven; here we have but such faint reflections of it as its diffraction supplies; but they are sufficient for faith and devotion. Attempt to combine them into one, and you gain nothing but a mystery, which you can describe as a notion, but cannot depict as an imagination.'[8]

Some of what Newman says makes good sense. It is absurd to suppose that finite human minds could ever completely comprehend the nature of God, and so an element of mystery must be integral to any adequate account of human knowledge of such an infinite Being. But to admit that much is very different from conceding Newman's main point. If one acknowledges 'contrariety' between constitutive beliefs, as he does, this cannot but undermine the credibility of both the overall belief and those constitutive beliefs. For it is only by applying this test of contrariety that

 [6] *Summa contra Gentiles* 2.22.3; cf. also 2.25.
 [7] J.H. Newman, *Grammar of Assent* (Doubleday & Co., New York, 1955), ch. 5, p. 115.
 [8] Ibid., pp. 116-17.

our beliefs are open to the possibility of change. Abandon the test and all beliefs become equally valid and so also equally invalid. Nor will it do to express his claim more weakly by putting it in the following form: provided there is no obvious contrariety, the overall belief may be held without any further attempt to demonstrate coherence. This will not do because, unless some handle is given with which to grasp the overall sense, the suspicion will remain of some lurking incoherence. Some assurance is needed that the combination of beliefs has not just produced empty words without meaning.

In this sad situation, then, of the modern neglect of such an important issue, the following chapters are offered as at least a starting point to a more thorough investigation of the various logical and conceptual difficulties involved. No more grandiose term than 'starting point' is used, because considerably more investigation of the issues is required than is offered here. But at least the problems are delineated not only with the contribution of the past in mind but also against the background of the often very different setting of contemporary philosophical and historical presuppositons. Perhaps more important, appropriate avenues of defence are explored, wherever possible.

But how exactly, it may be asked, does the problem of coherence raise itself with respect to these two doctrines of Incarnation and Trinity? As we shall shortly see, the relation between the two questions is a close one, and in fact in one case the coherence of a particular model of incarnation is dependent on a particular model for the trinity being coherent, with no other models able to rescue the incarnational model in question from incoherence. Not only is the relation between the two questions sometimes a close one, but also the questions raised in both cases are very similar, so that the shape our discussion takes can be almost exactly paralleled for both doctrines. The central difficulty concerns what is commonly labelled the problem of identity, namely the question of what would justify us in speaking of one entity rather than of a plurality of entities; that is to say, talking of one person rather than two in the incarnational case and of one God rather than three in the trinitarian instance. Other problems are in fact variants on this central question, but from the point of view of presentation it will be easiest in each case to reserve the core of the problem of identity to the end of the chapter, singling out other aspects that can most helpfully be dealt with at an earlier stage. Thus, in the next chapter on the Incarnation I deal first with analogy, attributes and the special problem of fallibility before dealing with the core of the problem of identity, while in the following chapter the same procedure is followed with the obvious omission of fallibility, since the problem only rises for a doctrine of Incarnation. The advantage of this method of procedure is that the case for regarding the doctrines as, under certain conditions, coherent can be built up gradually, and thus perhaps more plausibly, with what are in many ways

the easier questions being resolved first. For instance, without a suitable analogy for the model it is unlikely that anyone could be persuaded that there are even prima facie grounds for supposing that sense can be attached to the claim, far less be prepared to pronounce definitively that the doctrine is coherent. The reason is that, if clear sense is to attach to them, models for such unfamiliar areas of discourse do require some sort of backing by means of analogies drawn from the familiar areas of our experience.

However, before we proceed to such questions, one last major point of clarification must be made; some justification must be provided for the choice of models that will be considered in the subsequent chapters. I do not wish to claim that these are necessarily the only models that will truly instantiate incarnational or trinitarian claims, so that if they are shown to be incoherent, the doctrines are of necessity incoherent. But it is my contention that these are the most natural models to consider, largely because of the role they have played in the Christian tradition. So rejection of their coherence cannot but be a matter of concern to theologians, even if they believe alternative coherent models to be available. More contentiously, and of particular relevance to those who believe in the existence of such alternative coherent models, it is also my view that with one exception, the Kenotic model, all of the most commonly canvassed alternatives to the traditional models can only with impropriety be classified as truly instantiating incarnational or trinitarian claims.

To clarify the reasons governing the choice of models considered in the two subsequent chapters, I shall now briefly examine such alternatives as are commonly mentioned, indicating which I accept for further consideration or reject as not instantiating the appropriate claim, taking first models for the doctrine of the Incarnation.

Models for incarnation

Here six options may be listed, three from the patristic period and three from modern theology. Of these Chapter 6 will consider only one model from the patristic period, the Chalcedonian model, and one from the modern period, the Kenotic model. Why this should be so can best be indicated by looking briefly at each of the six models in turn.

 (i) Chalcedon: The fourth ecumenical council of the Church, the Council of Chalcedon which took place in A.D. 451, marked the culmination of a long period of christological debate, primarily between the two rival theological schools of Alexandria and Antioch. The Chalcedonian definition which resulted is sometimes described as 'a hopeless compromise', that is, between the emphasis on the divinity of Christ in the Alexandrian school and the stress on his humanity in the Antiochene school. It is also true that today it finds very few supporters

among academic theologians. A notable exception is Eric Mascall[9] who defends the definition in very much its traditional form, including a high doctrine of the consciousness of Christ with his fallibility excluded. More normally, however, its modern advocates offer a more limited defence, as does Lonergan who suggests that it be seen negatively as a heuristic device for setting bounds to subsequent discussion.[10]

The definition, including the preamble which rejects various alternatives as heretical, is given here in full:

The Synod is opposed to those who presume to rend asunder the mystery of the Incarnation into a double Sonship, and it deposes from the priesthood those who dare to say that the Godhead of the Only-Begotten is passible; and it withstands those who imagine a mixing or confusion of the two natures of Christ; and it drives away those who erroneously teach that the form of a servant which he took from us was of a heavenly or some other substance; and it anathematizes those who feign that the Lord had two natures before the union, but that these were fashioned into one after the union.

Wherefore, following the holy Fathers, we all with one voice confess our Lord Jesus Christ one and the same Son, the same perfect in godhood, the same perfect in manhood, truly God and truly man, the same consisting of a reasonable soul and body, of one substance with the Father as touching the godhead, the same of one substance with us as touching the manhood, 'like us in all things apart from sin'; begotten of the Father before the ages as touching the godhead, the same in the last days, for us and for our salvation, born from the Virgin Mary, the Theotokos (the God-bearer), as touching the manhood, one and the same Christ, Son, Lord, Only-Begotten, to be acknowledged in two natures, without confusion, without change, without division, without separation; the distinction of natures not in any way being abolished because of the union, but rather the characteristic property of each nature being preserved, and concurring in one person and one subsistence (hypostasis), not as if Christ were parted or divided into two persons, but one and the same Son and Only-Begotten God, Word, Lord, Jesus Christ; even as the prophets from the beginning spoke concerning him, and our Lord Jesus Christ instructed us, and the creed of the Fathers has handed down to us.[11]

I have quoted the definition at such length for three main reasons. The first is that until the collapse of notions of 'orthodoxy' in modern times the definition has in fact been regarded as the standard test of christological orthodoxy. That being so, it obviously demands our attention, if not in its own right, at least because of the key historical role it has played. But – and this brings me to my second reason – precisely

[9] Cf. footnote 4.

[10] His position is well summarised by what he says of dogmas in general in *Method in Theology* (Darton, Longman & Todd, London, 1973), that 'the permanence attaches to the meaning and not to the formula' (p. 323), but 'once they are revealed and believed, they can be better and better understood' (p. 325).

[11] *Creeds, Councils, and Controversies*, ed. J. Stevenson (S.P.C.K., London, 1973), pp. 336-7.

because of this historical role it is entitled to determine when a particular model may legitimately be described as 'incarnational'. For, if this is the Council which had most influence in fixing the sense of the word for the subsequent history of the Church, as indeed it was, the wisest course must be to test any alleged 'incarnational' claim against the intentions of this Council. Otherwise, 'incarnation' will become yet another instance of the confusion that is endemic in theology because of the desire to retain traditional language even when the meaning is transformed almost out of recognition. To reply that the Bible must always be the final arbiter of doctrine and so in this case of what is to count as incarnational doctrine would be to totally misrepresent the course of Christian history. While I would agree that the language of incarnation appears in St. John's Gospel, a clear doctrine of incarnation only finally emerged with Chalcedon (and even that is not particularly clear!) In any case throughout most of the Church's history the Bible has been interpreted in the light of the Chalcedonian definition and not vice versa. Moreover, though widely differing interpretations of Chalcedon have been offered, they agree in fundamentals in a way that is not true of interpretations of St. John. For, as I observed in Chapter 3, not all Biblical scholars would accept the view that St. John had moved beyond the earlier purely functional Christology into the kind of ontological commitment that is so characteristic of incarnational claims. That being so, all models must be tested against this Chalcedonian definition. However, that does not mean loyalty to every aspect. Some of it reads suspiciously like trying to have one's cake and eat it, or as the Victorians more strikingly expressed the impossibility, trying 'to eat one's cake and have it'; for instance, it is hard to see what sense can be made of the demand that the two natures be, on the one hand, 'without division, without separation' and, on the other, 'without confusion, without change'. But, clearly, this is not the central incarnational demand of Chalcedon. Rather, it is that Christ be viewed as fully human and fully divine and yet one person – 'the characteristic property of each nature being preserved, and concurring in one person and one subsistence'. In short, the appropriate test to be derived from Chalcedon is whether the model under examination can deliver an identity claim, that there was a single person in Jesus who none the less ought to be regarded as both human and divine.

My final reason for the quotation is to ensure that nothing more is regarded as integral to incarnational claims than what I identified in the previous paragraph as the essence of the Chalcedonian definition. I have already given one instance of a subordinate aspect of Chalcedon whose importance can be exaggerated – 'without confusion, without change, without division, without separation'. The phrase must be regarded as of secondary importance: it earned its place not in its own right but because the Fathers at the Council believed that the first half of the phrase was

the only way of preserving the distinctive characteristic of the divine nature; for them divinity was taken necessarily to imply immutability. Whether they were right in this assumption is an issue that will have to be discussed in due course. In the meantime I simply note its secondary character, and hence the legitimacy of refusing to regard this aspect as integral to an incarnational claim.

But the danger of supposing too much to be required for an incarnational claim comes not only from within the Chalcedonian formulation, but also from without. All too commonly various elaborations that have traditionally gone into the exposition of the position have been treated as indispensable elements in a doctrine of incarnation. The result has sometimes been severely to impede the possibility of offering a defence of the doctrine's coherence. Two examples may be given. First, the prevailing assumption until the twentieth century was that, if a personal union of the two natures was to be assured through the absolute rule of the divine nature, this necessitated an 'anhypostasia', an impersonal human nature consisting of the normal human attributes but with no distinctive personality of its own. It is a position which both Baillie and Relton[12] attribute to St. Cyril of Alexandria, one of the main architects of Chalcedon, though he had died seven years previously in A.D.444. Relton[13] insists that even as early as the sixth century theologian Leontius of Byzantium there was a move in the direction of a doctrine of enhypostasia, the view that a distinctive individual human personality was after all present, though still animated by the divine nature; but, even so Newman's assertion remained typical until modern times, that 'though Man, He is not, strictly speaking, *a* Man'. That such a move towards enhypostasia is essential cannot be denied. For, while anhypostasia undoubtedly secures the unity of the person, it does so at the cost of calling into question the presence of a truly human nature, so integral is individual personality to our conception of what it is to be human.

My other illustration is the assumption, again held for most of the Church's history, that Chalcedon involves a commitment to Christ's infallibility. It was an assumption which was held by both the main theological schools of the time, Alexandria and Antioch. The explanation probably lies in a conviction that perfection necessarily implies infallibility. But it is not part of the original definition, and indeed in the next chapter I shall argue that, apart from being in violation of the historical facts, it also raises the conceptual problem of being once again tantamount to a denial of the presence of a truly human nature.

In what follows, therefore, I shall assume that an incarnational claim involves no more than (but equally no less than) assent to the following

[12] D.M. Baillie, *God was in Christ* (Faber, London, 1961 ed.), p. 85. H.M. Relton, *A Study in Christology* (S.P.C.K., London, 1929), e.g. p. 223.
[13] Ibid., p. 69ff.

two propositions: (a) the identity claim that Christ was a single person, and (b) the constitutive claim that he possessed both a fully human and a fully divine nature. From this it might be deduced that any alternative incarnational model to Chalcedon is inconceivable. But this would be a mistake. For it is only if a third proposition is added that we have what is, strictly speaking, a Chalcedonian model: (c) that the two natures were simultaneously present in the one person. Admittedly, the Fathers at the Council entertained no other possibility. But (c) was clearly less central to their concerns, and that is why we may legitimately distinguish between incarnation in general and a specific Chalcedonian model. C is less important because what the Fathers were most concerned to secure was an assertion of the divinity of Christ in such a way that his full humanity was also maintained, and that demand is adequately expressed in (a) and (b); (c) is merely the means employed to secure this end. Their motive for (a) and (b) was primarily, thought not exclusively, soteriological, whereas (c) was simply the most natural reading of the Scriptures at the time. In this book the soteriological motive has been replaced by the historical argument of Chapter 3. In any case, as I observed in passing in the previous chapter, soteriology can only be a consequence of incarnational doctrine; its character cannot be determined in advance. More directly relevant to my present contention that a distinction can be drawn between Chalcedon and incarnation, historical considerations can also play a key role, as we shall see, in providing an alternative model under (c). However, given the extent to which in theology talk of two natures is taken to imply simultaneous presence, I shall use TNC as an abbreviation for a two-nature christology of this type, despite the fact that because of (a) and (b) all incarnational models must imply in some sense the presence of both natures.

(ii) Apollinarianism and (iii) Nestorianism, the other two patristic options, which the Church rejected, can be discussed more briefly. Although this would be contested by some scholars, it does seem to me that so far from being heretical extremes they can in fact be taken as very representative of their respective schools, that is to say Apollinarianism of the Alexandrian tradition and Nestorianism of the Antiochene school. Thus, if one takes St. Athanasius (d. 373) and St. Cyril of Alexandria (d. 444) as the two most obvious representatives of Alexandrian orthodoxy, both can be accused of making Christ a single person at the cost of denying him a fully human nature, which is precisely the feature of Apollinarius' thought which was condemned at the second ecumenical council, the council of Constantinople in 381. Athanasius, unlike his friend Apollinarius, never actually denies the presence of a human soul in Christ, but equally it is assigned no role, which is surely tantamount to denying him a fully human nature; similarly, although St. Cyril moves beyond the position of St. Athanasius in assigning the human soul no role, a view to be found in his earlier works, his later position, as already

noted, fails to safeguard the existence of a fully human nature, at least if the assumption of an entirely impersonal humanity is seen as integral to it. One could, therefore, with considerable justification claim that Apollinarius was simply making explicit a major flaw, the denial of a fully human nature, that was already implicit in all Alexandrian theology. Indeed, one might go further and say that he was more honest than his fellow Alexandrians in the sense that he admitted that the strong Alexandrian emphasis on the regency of the divine nature as the means of guaranteeing the unity of the person must inevitably lead to the denial of the human nature, or at least to the reduction of its significance to a point tantamount to denial, as, for instance, with St. Gregory of Nyssa's suggestion that a human mind is present but swallowed up in the divine like a drop of vinegar in the ocean;[14] that being so, Apollinarius seems justified in saying that on such a model one might as well exclude a human soul, provided, of course, one does not then claim that Christ was a union of two complete natures – something he readily admits, as in Fr. 45: 'He is not a man, though like a man; for he is not consubstantial with man in the most important element.' The Apollinarian/Alexandrian model must thus be rejected from consideration because, though it preserves an identity claim that there was one person, it fails to preserve the equally essential human nature in the method it employs (the divine nature's absolute sway) to guarantee the unity of that person.

But, if Apollinarianism can be taken as representative, rather than atypical, of the Alexandrian tradition, so also can Nestorianism of the Antiochene school. The most famous representative of the school after St. John Chrysostom, who was not an original thinker, is Theodore of Mopsuestia (d. 428). Though the discovery of his *Catechetical Homilies* in 1932 has done much to redeem his reputation from his posthumous condemnation at the fifth ecumenical council, the second Council of Constantinople in A.D.553, it is still very doubtful whether he can escape being tarred with the same brush as his likely pupil, Nestorius, who was condemned at the third ecumenical council, the Council of Ephesus in A.D. 431. The reason for this is as follows: Nestorius was condemned because he bought the reality of the human nature at the expense of the unity of the person, with his model in effect denying an identity in one person, there being merely a perfect unity of purpose, though, as he points out in his apologia, the *Bazaar of Heracleides*,[15] the term *prosôpon* (the Greek for 'person') could still be used because of its other meaning of 'face' or 'presentation' (divine and human thus present a common 'face' to the world); now, while Theodore does go beyond Nestorius in talking

[14] Letter to Theophilus of Alexandria; quoted in A. Grillmeier, *Christ in Christian Tradition*[2] (Mowbrays, London, 1975), p. 376.
[15] Nestorius, *The Bazaar of Heracleides* (ed. by G.R. Driver & L. Hodgson, Clarendon Press, Oxford, 1925); cf. esp. p. 55 and 233.

not merely of 'conjunction' (*synapheia*) but of a unity of two natures in one person, particularly in the Eighth Homily, it is far from clear, first, how he is using *prosôpon* and, secondly, even if he is taken to be using it in the full sense, what he believes the grounds to be for postulating a single person, given his rejection of the Alexandrian conception of the automatic rule of the divine nature.[16] The Nestorian/Antiochene model has, of course, one great merit which its Apollinarian/Alexandrian rival lacks, namely it guarantees the reality of Christ's human nature, particularly by giving it the power to originate action, as, for instance, is clear from the following argument of Theodore's: 'it is indeed clear that the strength of sin has its origin in the will of the soul ... it was therefore necessary that Christ should assume not only the body but also the soul.'[17] But this merit is counteracted by the exorbitant cost paid in the dissolution of the unity of the person, since a unity of will in a common purpose, no matter how complete, would not justify us in speaking of a single person rather than two persons. In the first place it would remain a contingent unity (one person could will differently from the other and so break the unity at any moment) and, secondly, there remain vast areas of personhood which still would not be united, there continuing to be no unity of common experience, despite the common purpose. For these reasons then the Nestorian/Antiochene model must also be excluded from consideration.

At this point, it might be objected that I have been very unfair to both schools. For it could be argued that all they were attempting to do was fill out in some sort of plausible way the kinds of demands that were eventually built into the TNC of Chalcedon, and in support of this it might be noted that it was the debate between the two schools that produced Chalcedon as an agreed compromise formula. From the point of view of history, this is a fair objection; Chalcedon was never intended as a new model but only as the bare bones of what could be mutually agreed upon, and even then only with difficulty, as is evidenced by the formation of minority Nestorian and Monophysite (Alexandrian) churches. None the less, it does, I think, remain important from the conceptual point of view to keep Chalcedon as a model distinct from what was offered in either of the two schools. This is because, as we have seen, incoherence is built into the models used in both the schools in a way that is not the case with TNC, although it could, of course, be argued that any attempt to fill out TNC will inevitably produce just such a result. In support of such a contention one might mention St. Cyril of Alexandria's use of TNC language and yet his implicit denial of Christ's humanity through his attempt to guarantee the unity of his person by

[16] Note especially the passages quoted in R.A. Greer, *Theodore of Mopsuestia: Exegete and Theologian* (Faith Press, London, 1961), pp. 51-2.

[17] *Catechetical Homilies* 5.11.

making the divine nature always the subject or instigator of action. But the next chapter will in fact attempt just such an elaboration of a TNC model which does not, I believe, inevitably result in incoherence.

Turning now to modern models, I shall first consider (iv) the Kenotic model. This is a model which, despite similarities of language in St. Paul, has only a relatively short modern history.[18] The explanation for this is obvious. Only with the rise of modern Biblical scholarship has the possibility, if not the necessity, of postulating a limited consciousness in Christ forced itself on theologians. It is a model which seems to have been first popularised by Lutheran theologians of the nineteenth century; it subsequently gained favour in Britain for a time, but is now seldom advocated, a notable exception being John Austin Baker in *The Foolishness of God*.[19] The model is found at its clearest in one of its earliest exponents, W.F. Gess who in the plainest terms talks of the divine nature, the Logos, having 'entered into that night of unconsciousness in which our life begins';[20] in other words, the model is of the divine nature literally abandoning its characteristic divine powers and thus experiencing a *kenôsis* or self-emptying which reduces it to a human nature, initially no more than a foetus. In short, in contrast with TNC which thinks of Christ as God-man, the Kenotic model conceives of Christ as the God who has become man.

This is the second incarnational model which I shall consider in Chapter 6 (henceforth abbreviated to KM). Given present attitudes in theology, it may not seem an obvious candidate; so some justification must be given for the choice. Basically, my reasons are threefold: first, the model is like TNC at least in this respect, that it instantiates what is incontestably an incarnational identity claim, that the human Jesus was the same person as the divine Christ or Word; secondly, the model is not obviously incoherent; finally, it is a plausible interpretation of the historical evidence.

Objections will be dealt with at length in Chapter 6, but a few preparatory remarks on likely objections to the first two reasons are in order at this point. So far as the first is concerned, it might be objected that the model does not in fact make Christ divine since during his earthly life he has a purely human nature. But the claim inherent in the model is, of course, that he is nonetheless divine because of the continuity that exists between this purely human nature and his pre-existent and post-existent divine nature. As for incoherence, the problems raised by the model are substantially the same as those raised

[18] Philippians 2:5ff. F. Loofs (Article s.v. 'Kenosis' in *Encyclopaedia of Religion and Ethics*, T. & T. Clark, Edinburgh, 1908) find traces of the view throughout the history of the Church. Even in the patristic period it finds popular expression, but the first serious academic interest occurs in the nineteenth century.

[19] J.A. Baker, *The Foolishness of God* (Fontana, London, 1975).

[20] *Die Lehre von der Person Christi*, 1854: quoted in Relton, op. cit., p. 211.

by the notion of reincarnation, where the reincarnation of a human being as some inferior animal nature is envisaged; that being so, the model is as entitled to further examination as the notion of reincarnation in general, and that is surely something more than immediate dismissal.

My final reason was that it was one plausible interpretation of the historical evidence. I have already observed that in the patristic period TNC was the most natural reading of the historical evidence. But in Chapter 3 we discovered that it was only with the Resurrection that Christ's divinity began to become apparent to his disciples, and even then only slowly. That being so, the obvious interpretation of the evidence is that his divine powers had been suppressed, or possibly even were non-existent, until then. Some such account seems the simpler explanation; so, if TNC is to remain a serious candidate, it too will have to offer some explanation of these historical facts. Not only that; it will have to be as good an explanation, unless KM is regarded as markedly inferior on grounds of coherence. Whether this is the case will be considered in the next chapter. In the meantime we may simply note that there is a choice between two strikingly different explanations, both of which meet the basic incarnational demands set by (a) and (b), one of which, TNC, envisages the two natures being simultaneously present, the other of which, KM, conceives of them as successively present.

But to express the matter thus is to suggest that both models are on a par in contemporary theology, whereas, as I have already indicated, this is far from being so. But if the explanation for this model's present unpopularity lies neither in the logical nor the historical aspects considered so far, wherein does it lie? The probable explanation may be sought in two directions: the model has been frequently, and not without irony, reduced to incoherence by its own advocates; secondly, certain objections raised by its opponents have normally been regarded as decisive.

Thus, on the first point, advocates of the Kenotic theory have repeatedly been tempted to combine with it certain elements drawn from the alternative model of TNC which inevitably reduces KM to incoherence. Among its earliest exponents the temptation is seen in Thomasius. He exempts the divine ethical attributes from the process of *kenôsis*,[21] a supposition of doubtful coherence in so far as it undermines Christ's full humanity. The only form of defence which I can envisage is the thought that these ethical attributes are present in the foetus on the analogy of inherited dispositional attitudes to certain patterns of behaviour rather than already being there as actual possessions. But, if this is what Thomasius means, while it might possibly be a valuable step in ensuring continued personal identity, its truth depends on the truth of certain controversial theories about the origin of human goodness. Such

[21] G. Thomasius, *Christi Person und Werk*[3] (1886-8), vol. 1, p. 412.

theories are in conflict with the traditional Christian emphasis on the freedom of the human will (central, for example, to the argument of Chapter 2); so to accept Thomasius' proposals would inevitably produce an unacceptable inconsistency in the overall position being advocated.

The theory was kept in its relative purity by some British theologians including P.T. Forsyth and H.R. Mackintosh.[22] But the modifications introduced by the theory's most influential exponent in England, Charles Gore (d. 1932) and adopted by Martenson and Weston[23] among others, are even more dubious than those advocated by Thomasius. Gore proposed a two centres of consciousness model for the second person of the Trinity, according to which 'in some manner the humiliation and self-limitation of the incarnate state was compatible with the continued exercise of divine and cosmic functions in another sphere',[24] though later in the same book he has to admit that 'we cannot conceive' how such a combination is possible.[25] The reason why this is incoherent can be simply put: the split personality it postulates in the divine nature of the Son is so intense as to make it incomprehensible ('we cannot conceive') why we should continue to speak of only one person being involved in the two contrasted types of activity. Unfortunately, it is a conceptual confusion continued by John Austin Baker who, having argued that we must speak of God becoming man because 'when God chooses to exist within the terms of our environment a man is what he becomes' (given that 'manhood is the only mode of being in which God can do justice under such conditions to what he is'), nevertheless goes on to admit 'a real metaphysical difficulty': 'we find ourselves bewildered by the notion of a single person existing at once within the terms of the created order, and also being continuously present to that order as its Creator. It may well be, however, when we think how relative and fluid is the whole system of Space and Time, and how elusive of our grasp, that this in fact presents no obstacle at all.'[26] Once again, no hint as to how coherence might be achieved is offered, and so the objection I raised against Gore remains as forceful as ever. KM thus exactly parallels TNC in that a presupposition of incoherence is made because of additional elements assumed to be integral to the theory but which in reality need play no part at all in it. In Chapter 6 I shall return to Baker and show how this two centres of consciousness model is an unnecessary construct, born of a failure to take seriously an alternative model for the Trinity.

The second cause of KM's present unpopularity is the strength that

[22] P.T. Forsyth, *The Person and Place of Jesus Christ* (first ed. 1909, ninth impression 1961); H.R. MacKintosh, The Doctrine of the Person of Christ[2] (T. & T. Clark, Edinburgh, 1913).

[23] Their views are outlined in Relton, op. cit., pp. 213-18.

[24] C. Gore, *Dissertations on Subjects connected with the Incarnation* (John Murray, 1907), p. 93.

[25] Ibid., pp. 206-7.

[26] Op. cit., pp. 319-20.

the objections raised by its opponents are believed to have. These are usefully summarised in Donald Baillie's book, *God was in Christ*:[27] (a) 'What was happening to the rest of the universe during the period of our Lord's earthly life?' – an objection first raised by Archbishop William Temple[28] – (b) 'it seems more like a pagan story of metamorphosis than like the Christian doctrine of the Incarnation', and (c) 'on the Kenotic theory ... He is God and Man, not simultaneously ... but successively – first, divine, then human, then God again. But if that is what the theory really amounts to ... it seems to leave no room at all for the traditional Catholic doctrine of the permanence of the manhood of Christ.' These objections are a strange mixture: the first is a logical one, the second seems a mere propaganda point, while the final one is purely theological. The first gives the motivation behind the two centres of consciousness model in Gore and Baker, but, as already indicated, the next chapter will give an alternative way of dealing with the problem, using a model for the Trinity different from that normally advocated in western Christendom. The second objection is often thought to be the most powerful.[29] But, in the first place, the parallel is dubious since in most cases of metamorphosis the gods seem to retain their powers in full; they merely change their shape or appearance. Secondly, even supposing the parallel established, one fails to see why it should be a negative indicator; after all, truth is undoubtedly sometimes to be found in paganism and so it might well be argued that, if there are legends paralleling KM, they should be taken as indicative of the apparent intuitive plausibility of the coherence of the notion. Finally, why Baillie thinks the preservation of the humanity important is obscure, but it is in any case preserved to some degree in KM in that the human nature is retained as a remembered experience of the second person of the Trinity.

I turn now to (v) the model of grace, which is undoubtedly the most popular of contemporary christological models, and, therefore, one to which detailed attention should be given, especially as it is my intention to reject it. Donald Baillie and John Robinson may be taken as representative of the position.[30]

Donald Baillie argues that the notion of paradox is central to Christian theology, as seen in the paradox of *creatio ex nihilo* and the paradox of providence ('whole texture of our life in this world ... network of causes and effects ... but every Christian believes that whatever comes to him comes from God, by God's appointment, God's providence'). But the

[27] Op. cit., pp. 96-7.

[28] W. Temple, *Christus Veritas* (Macmillan, London, 1924), pp. 142ff.

[29] Cf. these harsh words of Hermann Bauke on Gess: 'Eine so ungeheuerliche Ketzerei wie nie selbst der Arianismus nicht gewagt hatte. Der Treitheismus, d.h. der Polytheismus, war ganz klar' (*Religion in Geschichte und Gegenwart*,[2] Tubingen, 1927, vol. 1, p. 1632, s.v. Christologie II).

[30] Their position seems to have been anticipated by Origen in *Contra Celsum* 4, 5-8.

central paradox is the paradox of grace: 'Its essence lies in that conviction which a Christian man possesses, that every good thing in him ... is somehow not wrought by himself but by God.' Jesus perfectly expressed this paradox; as Barth put it, the God-man is the only man who claims nothing for himself, but all for God. 'If Christ can be regarded as in some sense the prototype of the Christian life, may we not find a feeble analogue of the incarnate life in the experience of those who are His "many brethren", and particularly in the central paradox of their experience: Not I, but the grace of God?' So, his model for incarnation becomes a model of perfect relationship between human and divine, with everything dependent on a particular man's response. 'When at last God broke through into human life with full revelation and became incarnate, must we not say that in a sense it was because here at last a Man was perfectly receptive?' Following this general pattern, the doctrine of Christ's pre-existence is likewise treated in terms of grace, as underlying the fact that grace is always prevenient: 'This does not mean, it need hardly be said, anything like a conscious continuity of life and memory between Jesus of Nazareth and the pre-existent Son' ... but that ... 'the initiative is always with the divine; so that we are bound to say: God sent forth his Son.'[31]

Baillie's book has been very influential on many theologians, including John Robinson who described it as 'a great book' in *The Human Face of God*, published seventeen years later in 1973.[32] Robinson objects to traditonal accounts as involving a 'supernaturalistic projection': 'In other words, they locate the most real in another realm above or beyond this world, from which it comes into this world, impinging upon it from without.' Instead, he advocates a functional approach according to which Christ emerges naturally as a product of a God-directed evolutionary process. This leads him to talk about 'emergent humanity and expressive deity'. 'The seed of the Logos (to use the old phrase) was there from the beginning; it is thrown up by the process, it surfaces, breaks out, expresses itself. There is eruption rather than inruption ... There is a divine necessity about the flowering, a waiting to take flesh, to blossom and burst. Yet everything is dependent on the human response'.[33] He quotes with approval Norman Pittinger: 'The most complete, the fullest, the most organic and integrated union of Godhead and manhood which is conceivable is ... a full, free, gracious unity of the two in Jesus Christ, who is both the farthest reach of God the Word into the life of man and also (and by consequence) the richest response of man to God.'[34] Robinson admits the similarity of his position to the Antiochene tradition: 'There is no contradiction between a man "living" God and

[31] The quotations are from op. cit., pp. 111-12, 114, 129, 149 and 150.
[32] J.A.T. Robinson, *The Human Face of God* (S.C.M., London, 1973), p. 40.
[33] Ibid., pp. 195, 202, 203.
[34] N. Pittinger, *The Word Incarnate* (James Nisbet, 1959), p. 188.

God "living" a man. For, as Nestorius put it, in words St. John would have approved, "to have the *prosôpon* of God" (or, as we should say, to be the personal expression of God) "is to will what God wills, whose *prosôpon* he has". And for that, to be fully and independently a man is an essential qualification, not a disqualification.'[35] Finally, we may note that his views coincide with Baillie's on the question of pre-existence: 'a life, power or activity ... which is not as such a person', though it may come 'to embodiment and expression (whether partial or total) in an individual human being'.[36]

A number of comments on this model seem appropriate. First, one notes the assumption of a non-interventionist framework, something which emerges clearly from Baillie's account of providence or Robinson's contrast between his own view of a God-directed evolutionary process and what he calls 'supranaturalistic projection'. This is interesting because it confirms my claim in Chapter 1 that belief or non-belief in an interventionist God is integral to the question of what will be said about the nature of any possible incarnation. This model is in fact as near as one can get to an incarnational claim, if one denies an interventionist God; hence the desire on the part of its advocates to claim that they are indeed espousing an incarnational position. But – and this brings us on to our second point – it is doubtful whether it can claim to constitute an incarnational stance since, as Robinson himself admits, it is in essence just the Nestorian/Antiochene model in modern dress[37] and so subject to the same kind of objections. That is to say, while it succeeds in guaranteeing a fully human nature and undoubtedly offers a coherent model, it fails to provide justification for speaking of one person being involved in the event, of whom it is possible to predicate both a fully human and a fully divine nature, which we have seen properly constitutes an incarnational claim. Baillie and Robinson do seem to be at least partially aware of this problem, but as our third comment we may note that their attempt to strengthen the unity between the two persons in order to make it more plausible for us to speak of one person is a failure. The tactic they resort to, particularly Robinson, is to use their interpretation of pre-existence to suggest that a more than contingent identity of wills was involved. At least that is how I read Robinson's claim that Christ is the product of a God-directed evolutionary process, with 'a divine necessity about the flowering'. But, apart from the problem that it would still only be an identity of wills and not of experiences, there is a crucial ambiguity in the claim, namely whether it

[35] Ibid., pp. 199-200.

[36] Ibid., p. 147ff.

[37] But it is important to note the different motivation behind modern Nestorianism. As the quotations from Robinson demonstrate, the desire is to avoid the problem of intervention, rather than safeguard transcendence or the soteriological significance of Christ's moral development.

was God's will that some individual should arise or that particular individual. The latter would bring the model much nearer to TNC, but yet in the very next sentence after speaking of 'a divine necessity' Robinson goes on to say that 'everything is dependent on the human response'. The tension in his position is clear: for he wants more than a mere contingent identity of wills but anything more would mean either divine intervention, which he clearly rejects, or a very tight causal nexus, which would rob him of his emphasis on the quality of Christ's free human response; that being so, the necessity he is entitled to claim can be no more than that some individual respond, a matter, given his other assumptions, that is presumably merely known to divine fore-knowledge rather than predetermined. He thus fails to strengthen the claim that one should in this instance speak of one person.

One way in which someone might respond to these objections is to suggest that, whereas TNC offers an entity who is simultaneously God and man and KM a God who became man, this model of grace should be understood in terms of 'the man who became God'. Sense could then be made of this by drawing an analogy with the way in which psychological predicates are commonly described in the philosophy of mind as supervening on the physical. So similarly, it may be said, given a particular set of human attributes, divine attributes then supervene. This would then ensure identity of wills, just as, again drawing the parallel with the philosophy of mind, identity, or at any rate indiscernibility, is commonly postulated between the necessary physical neural states and the corresponding psychological intentions. But this is still not enough to provide an incarnation since, though the qualities that supervene might be called 'divine' or 'godlike', they are not divine in the strict sense that would entitle us to use the term, 'God'. For, while one would have moral perfection and probably also a sense of awe because of the resultant distance set between this person and others in the created order, this would still fall well short of the most obviously defining divine attributes such as omnipotence and omniscience.

Perhaps the basic problem with the model of grace can be brought out by drawing attention to what Aristotle says on a related area, the relation between teaching and learning. In the *Physics*[38] he observes that the actualisation of teaching and learning can sometimes be described as the same thing, at least where they operate with respect to the same sphere, i.e. the same learning person; success in the one is obviously totally dependent on success in the other. But to establish that the two processes are in some legitimate sense the same thing is quite different from establishing a personal identity between teacher and taught. Where the model of grace errs is in supposing that it is sufficient to offer an identity of processes, with Jesus as the perfect pupil, as it were, whereas what in

[38] *Physics* 3.3.

fact is required for an incarnational claim is a unity of personhood.

Pannenberg's *Jesus: God and Man* shares this same model of grace, but with interesting additions that attempt to bolster the position against the kind of objections which I have been raising. He insists that the starting point for all christology must be 'from below', i.e. from the humanity, and that it is the man Jesus who must be the subject of all the attributes. But he also insists that such an *a posteriori* approach inevitably leads to an admission of his deity in the full sense because of his resurrection/apocalyptic argument which I have already criticised in Chapter 3. Leaving aside such criticisms, the question then arises of whether Christ only became God the Son at the Resurrection. Pannenberg answers this by distinguishing between a temporal and an eternal viewpoint: 'This can be expressed in the form of the concept that the "intention" of the incarnation has been determined from all eternity in God's decree' ... But 'what is true in God's eternity is decided with retroactive validity only from the perspective of what occurs temporally with the import of the ultimate.'[39] The manner of his expression leaves something to be desired, but his meaning is clear: God from his timeless eternity has foreseen that this man would respond perfectly to divine grace and has therefore decreed from all eternity that he should be elevated to godhood at his resurrection; that being so, we may properly speak of him as the man destined to become God or, in a sense, because of the identity, already God at the incarnation. Human freedom is thus on this view perfectly preserved. But a fresh problem arises. For, despite Pannenberg's rejection of KM as involving 'the impossible idea of a resignation of certain divine attributes at the incarnation',[40] he now seems to have modified the model of grace into a version of KM, but with the additional complication that it is now entirely an upward movement to a higher entity and it by no means follows that, if KM is coherent, then so also is this notion. KM involves diminution and restoration of powers, whereas in Pannenberg there is only transformation into a being of vastly different powers and so there is not the same sense of continuity of inherent potential. Whether this suffices to render his suggestion incoherent we may leave on one side, because it will obviously make more sense to devote attention to considering KM, as the more likely of the two to be coherent; more likely because on Pannenberg's model there will be even less grounds for claiming continuity of identity than on KM and so, if KM fails, so must Pannenberg. Moreover, it has already been argued in Chapter 3 that the backward projection of the divinity of Christ which occurred in the history of the early Church was in any case the simpler explanation. For otherwise a 'surd' element would have been introduced, with the definitive role assigned to him in future history having no

[39] W. Pannenberg, *Jesus: God and Man* (S.C.M., London, 1968), p. 321.
[40] Ibid., p. 322.

corresponding significance in the past. In addition, it sounds very odd, to say the least, that deity should be the reward for such a life as that of Jesus; yet this is the most natural reading of Pannenberg's man who became God.

(vi) the mythological model may be dealt with very briefly. This is the view, typified in *The Myth of God Incarnate*, that the language of incarnation is mythological in the theological sense of telling some truth about God in story form. Wiles expresses the truth being conveyed thus: 'First that Jesus' own life in relation to God embodied that openness to God, that unity of human and divine to which the doctrine points. And secondly that his life depicted not only a profound human response to God, but that in his attitudes towards other men his life was a parable of the loving outreach of God to the world.'[41] An interesting feature of this suggestion is that, while it offers a demythologised parallel that corresponds exactly to the human nature's relation to the divine in TNC, no such exact parallel is offered in the reverse direction. For, instead of the divine nature reaching out to the human nature in Jesus, we merely have Jesus' human nature acting out a parable of God's love. This fact illustrates very effectively the thoroughly non-interventionalist character of the model, with God set very much at a distance from the world, and further underlines the importance of the argument of the first part of this book, if an advocate of the model is to be swayed from his position. The model is, of course, coherent and so cannot be faulted on grounds of logic. It is also in many ways a natural progression from model (v) in that, as we have already seen, advocates of the model of grace fail to justify their continued use of identity language to speak of the relation between Christ and God; one might, therefore, argue that model (vi) is in many ways a more honest approach for those who are convinced that a non-interventionist framework is the only viable option. But, if my argument in Chapter 3 is right, then we must insist on a model which instantiates just such an identity claim, and so models (v) and (vi) may be dismissed from further consideration.

Models for the Trinity

Here the position is fortunately much less complicated. As with Incarnation, so mythological interpretations of the Trinity are not wanting, some of which like Mackey's *The Christian Experience of God as Trinity*[42] offer a more positive assessment of the traditional language than others. If the argument of Part II is correct, however, all such are inevitably ruled out of court. But, as we shall see, apart from this option there is not the same range of alternatives as was the case with the

[41] J. Hick (ed.), *The Myth of God Incarnate* (S.C.M., London, 1977), p. 162.
[42] J.P. Mackey, *The Christian Experience of God as Trinity* (S.C.M., London, 1983).

Incarnation. The choice of candidates and of serious candidates is in effect co-extensive, with two types of model available, both of which are examined in detail in Chapter 7. There is also one other difference from the situation with respect to incarnational models. Whereas in that case the definitive ecumenical council did offer a model, i.e. TNC, in the case of the Trinity the two relevant Councils of Nicaea in 325 and Constantinople in 381 merely set the limits within which subsequent discussion should proceed if it was to be truly trinitarian in its approach.

First, then, something must be said about the general requirements laid down by these two councils – two, because, though the consubstantiality of the Father with the Son was promulgated at Nicaea, the Holy Spirit was only accorded the same dignity at the later council and even then only by implication ('who with the Father and Son together is worshipped and glorified') rather than by an explicit use of the same terminology. Nicaea met to deal with the Arian claim that Christ was a created being and in the past it was often thought that in condemning Arius the Council must have put forward some definite alternative theory. But there is now general agreement among scholars, not only that *homoousios*, 'of the same substance', was chosen only with reluctance as, though non-Biblical, the only way of excluding the Arian position, but also that agreement was only reached because the term was so ambiguous. However, the range of that ambiguity and whether there were any implicit victors are still matters of some dispute among scholars, as can be seen by comparing Kelly's views in *Early Christian Creeds* (1972) and Stead's in *Divine Substance* (1977).[43]

Kelly mentions three rival interpretations of *ousia*, a generic sense, denoting a class of individuals (Aristotle's 'second substance'), an individual (Aristotle's 'first substance') and stuff or matter, which was the sense given to it by Arius.[44] He seems to think that the natural reading of Nicaea is the second sense, offering in support the fact that Nicaea's staunchest advocates were in this tradition: 'Only a comparatively small group, consisting of the handful of Western bishops St. Alexander, St. Eustathius of Antioch, Marcellus of Ancyra and a few others, wholeheartedly welcomed the language of the creed, realising that it entailed, at any rate implicitly, that theory of identity of substance between Father and Son which they wanted to push into the foreground',[45] i.e. numerical identity. But Stead presents a very different picture. For, not only does he argue against a theory of Western influence in its genesis,[46] something which would lend additional support to Kelly's interpretation, but also his thorough examination of pre-Nicene

[43] J.N.D. Kelly, *Early Christian Creeds*[3] (Longman, London, 1972); C. Stead, *Divine Substance* (Oxford University Press, 1977).

[44] Op. cit., pp. 243-4 and 245-6.

[45] Ibid., p. 254; cf. p. 261.

[46] Op. cit., pp. 251ff.

theological usage of the expression reveals that it is practically always used in an elastic generic sense: 'Homoousios guarantees very little; it can be used of things which resemble one another merely in belonging to the created order, or to the category of substance; it can relate collaterals to each other, or derivatives with their source; it does not exclude inequality of status or power. Secondly, however, the term is often used to indicate a relationship which in fact is closer than merely membership of the same species or similar material constitution, for instance that of a stream to the actual fountain from which it flows, or that of an offspring to his own parent.'[47] That being so, it seems natural to interpret Nicaea as a much more open formula than was once thought, with no particular bias present apart from the exclusion of the Arian position; indeed, if anything, the bias lies in the opposite direction to that suggested by Kelly, with the emphasis being on the generic sense. Stead in particular draws our attention to the absence of any reference to the equality of the persons in the formula,[48] and notes that even Athanasius, who is often regarded as a champion of numerical identity, provides no clear examples of other than generic uses in his thought, and indeed hierarchical elements are still present.[49] We may conclude, therefore, that Nicaea leaves open the question of the nature of the divine unity, whether it is numerical or generic, but that, if anything, its bias seems to be in the latter direction. So no required stance on the nature of the divine unity can be derived from these Councils. All that needs to be noted is the basic identity demand that requires to be fulfilled for any truly trinitarian claim: that the three 'elements', however united, are united in one God.

But there is also a second essential feature that needs to be observed. This concerns the status of these three 'elements'. The meaning of the term 'hypostasis' in the formula, 'three hypostases in one ousia' (which was accepted as the epitome of trinitarian orthodoxy from the Council of Constantinople onwards) can be dealt with relatively briefly. Originally, its meaning was interchangeable with 'ousia' in the sense of substance, and it is so used by Origen, and, somewhat ironically, by the anathemas appended to the Nicene Creed in its version of 325. It was the Cappadocian Fathers who were largely responsible for clearing up the terminological confusion and so ensuring a standardisation of usage at Constantinople. But, whatever the terminology used, it is clear that the intention was the same, to ensure that the permanence of the distinction was maintained. It is not just a matter of an 'economic' Trinity, of God merely manifesting himself to the world in three different ways, but of God as he is in himself, the so-called 'immanent' Trinity. Thus, for

[47] Ibid., pp. 247-8.
[48] Ibid., pp. 233 and 241-2
[49] Ibid., pp. 262-6.

instance, the Canons of Constantinople, after reaffirming the faith of Nicaea, go on to condemn unequivocally two types of exponent of the former view (the Sabellians and Marcellians), as well as two which assigned an inferior position to Son or Holy Spirit (the Arians and Pneumatomachi). The West, of course, expressed the formula as 'three persons in one substance', but one has to recall that a very different range of meanings attached to the Greek and Latin words, *prosôpon* and 'persona', from their nearest modern English equivalent. That is an issue to which I shall return later. As we shall see, person in the modern sense has been identified with both the individual hypostasis and the ousia. But for the moment suffice it to note this second basic trinitarian demand, that, as the word hypostasis clearly implies, some substance-like entity should be identified with each hypostasis that will then serve to mark a permanent distinction in the deity.

If the reader is puzzled why compliance to these two demands is necessary, apart from a desire for consistency of meaning in terminology, the following answer may be given. Reasons for emphasising the divine unity have already been mentioned at the beginning of the chapter, while in Part II I argued that the nature of the Incarnation and experience of the Holy Spirit were such that they could not be interpreted otherwise than as marking a permanent distinction between three entities.

Before considering what models are compatible with these demands it will be helpful to note where numerical identity did in fact first emerge, since it is commonly thought to be part of the teaching of the Church. The answer appears to be that, while Augustine advocated a non-generic view that can be interpreted as postulating numerical identity and certainly was responsible for the decline in the popularity of the generic view in the West, it was not until the Fourth Lateran Council in 1215 that the position was enshrined in one of the councils of the Church; 'we, therefore, with the approval of the sacred council, believe and confess with Peter Lombard that there is one supreme reality, incomprehensible and ineffable, which is truly Father, Son and Holy Spirit; at once the three persons taken together and each of them singly, and so in God there is only a Trinity and not a quaternity, because each of the three persons is that reality, that is the divine substance, essence or nature.'[50] The origin of this pronouncement was a debate between Peter Lombard and Joachim of Flora, the former being accused by the latter of teaching 'not so much a Trinity as a quarternity of three persons with that common essence as a fourth',[51] while Joachim's own solution was to speak of three really distinct but very like substances, for which he was condemned as a tritheist at the Council. It may in fact be possible to defend Peter Lombard as offering a composition view of a kind I note Augustine

[50] Denzinger-Schonmetzer, *Enchiridion Symbolorum*[36] (Herder, Freiburg, 1976), no. 804.
[51] E.J. Fortman, *The Triune God* (Theological Resources, vol. 3, Westminster, Philadelphia, 1972), p. 196.

defending in Chapter 7, but one thing seems certain, and that is that the Council that met fifty-five years after his death lapsed into complete incoherence in its desire to defend the divine unity. For, despite the identity of the three persons singly with the entire reality, one is not allowed to use the attributes of the persons singly of that entire reality, as the passage I have already quoted goes on to make clear: 'And that reality is not generating, nor generated, nor proceeding, but it is the Father who generates, the Son who is generated and the Holy Spirit who proceeds.' The only way out of the problem would be to say that Father, Son and Holy Spirit are the same reality but viewed under different eternal aspects, but this would still not preclude us from applying those aspect attributes to the undifferentiated whole. A more radical solution would be, of course, to abandon the basic assumption, the identity of the persons singly with the whole. The latter would be more loyal to Nicaea/Constantinople with its insistence on a substance-like status for the three hypostases; it would also be more loyal to the degree of distinctiveness towards which we found the historical evidence pointing in Chapters 3 and 4. I therefore dismiss a numerical identity claim of this strength from further consideration, though, as already noted, it can be made coherent at a price.

The two models which can make some claim to be loyal in both respects, and which I shall therefore consider in Chapter 7, may be distinguished by calling one a Unity Model (henceforth abbreviated to UM) and the other a Plurality Model (henceforth abbreviated to PM). UM may be characterised as the belief that what is ultimately a unity, the Godhead, is also fundamentally a trinitarian plurality; PM as the belief that what is fundamentally a trinitarian plurality is also ultimately a unity in the Godhead. In short, the difference is constituted by whether one starts with the one as given or the threefoldness. Augustine will be taken as the obvious representative of the former approach with his *De Trinitate*, begun in 399 and written over twenty years; the slightly earlier Cappadocian Fathers of the latter model, particularly Gregory of Nyssa.

So far as the coherence of either is concerned, that what is one can also be fundamentally three or what is three be in some ultimate sense one certainly sounds possible. The difficulty lies rather in the way in which either claim might be expanded, and it is the coherence of such I shall examine in Chapter 7. But one word of caution is in order. The different exponents of PM in many ways form a more natural grouping than advocates of UM in the sense that the former from the time of the Cappadocians to present-day exponents such as Leonard Hodgson and Moltmann[52] all share the same details of interpretative framework,

[52] L. Hodgson, *The Doctrine of the Trinity* (James Nisbet, 1943); J. Moltmann, *The Trinity and the Kingdom of God* (S.C.M., London, 1981).

whereas this is not true of advocates of UM. Thus with PM we always have what is essentially a social model, with 'person' understood in something like its modern sense, and the claim being that there is some more ultimate categorisation, i.e. God that legitimises talking of the three persons as ultimately one. By contrast, while advocates of UM are agreed that the ultimate categorisation is God, there is no such agreement about what constitutes the fundamental category which Nicaea/Constantinople labels 'hypostasis', except that it does not mean person in the modern sense. Even Augustine offers more than one suggestion, and since his day the options have proliferated. Some bear a sort of family resemblance to Augustine's own proposals, which concern solely the internal psychology of God, such as in Karl Rahner's *The Trinity*[53] where the immanent Trinity is conceived of as Self-Communicator, Truth and Love. But at first sight Barth's suggestion that the three hypostases correspond to Offenbarer (the Revealer), Offenbarung (Revelation) and Offenbarsein (the state of Revelation),[54] based as it is on analysis of the salvific event, appears to have little in common with Augustine. But despite the wide diversity there is justification for treating them all as falling under a single model. For they all share the same psychological emphasis with God understood as a single person, and the three 'hypostases' either as three permanent elements of his internal psychology, though there is no agreement as to which three, or as the structure of his personal action vis-à-vis the world, assuming, as Barth does, that one may legitimately infer from this a corresponding internal trinitarian structure. Chapter 7 will therefore be justified in treating UM as a single model with a common psychological theme, but care will have to be exercised to ensure that we do not dismiss the model on inadequate grounds by assuming that the incoherence of one psychological analogy demonstrates the incoherence of all versions of UM. Thus, though my discussion will concentrate on UM's most distinguished representative, St. Augustine, the possibility that a more adequate version of the psychological thesis is to be found elsewhere has not been discounted.

To summarise: in the next two chapters two models for the Incarnation will be tested for coherence, TNC and KM, and two models for the Trinity, PM and UM.

[53] K. Rahner, *The Trinity* (Burns & Oates, London, 1970), pp. 101-3.
[54] K. Barth, *Dogmatik in Entwurf* (Munchen, 1927), p. 126ff.

Chapter Six

The Coherence of the Incarnation

The reader is reminded that the meaning of the abbreviations used in this chapter, TNC and KM, has been explained in Chapter 5, as also the reason for the order in which the four objections to coherence are discussed here, namely (i) analogy (ii) attributes (iii) fallibility and (iv) identity.

Analogy

Here the objection would be that no model is available which could render credible the idea of Jesus being both God and man (TNC) or God literally becoming man (KM). But is this really so?

(a) TNC. Aquinas offers us a suitable model:[1] 'Conjunction with something higher does not weaken, but increases power and dignity. An analogy: the sensory soul in animals constitutes their species, since it is taken to be final and determining; in man it does not constitute his species, yet it is of higher dignity and power, and this by reason of its conjunction with the rational soul with its fuller and nobler perfection.' In effect Aquinas is arguing that, as animal is to man, so man is to Jesus Christ, the God-man. That is to say, just as in the creation of man the addition of a rational soul did not destroy man's animal nature but enhanced it, so there is no reason to suppose that the union of human nature with divine would destroy human nature; if anything, one would expect an enhancement. The objection that it would create a 'monstrous hybrid'[2] is thus misconceived. Certainly, the person thus formed is more than a man, just as the creation of man creates more than an animal, but that does not make him a monster any more than man is a monster.

However, to all this it may be objected that the analogy is less effective now than it was in Aquinas' day, since for Aquinas, living long before the discovery of evolution, there was a dramatic discontinuity between man and animal that could plausibly be drawn as a parallel to the discontinuity between man and the God-man. This is true, but, while it

[1] *Summa Theologiae* 3a.2.5.
[2] So A.D. Gallaway, *Wolfhart Pannenberg* (Allen & Unwin, 1973), p. 84.

weakens the force of the analogy, it does not, I think, destroy it altogether. For even with evolution it still remains true that man is both at a very different level of being from the rest of the animal creation and yet still fundamentally animal, and so a parallel difference and similarity in the case of the God-man also becomes conceivable. Of course, the analogy breaks down, if pressed too far, since, *pace* Teilhard de Chardin,[3] the God-man could not be thought of as an emergent creation in the same way as man is from animal. But then all analogies break down at some point; that is why they are merely analogies. The success of an analogy has to be measured by whether it gives us enough of a grasp on the meaning of some alleged claim at least to conceive of it as having some intelligiblity, and by that criterion Aquinas' analogy is successful. Whether the new input, as it were, comes from inside evolution as with man or from outside as with the God-man does not matter. It is not essential to our understanding of the meaning of 'man' that his distinctive features should have been created in one way rather than another. So the comparison is not undermined by the absence in the God-man of a relevant essential feature of man.

It should, of course, be added that offering a successful analogy is only very much the beginning in establishing coherence. All it shows are *prima facie* grounds for further investigation; that there is a possibility of coherent meaning. But further and detailed investigation of the concept, particularly in relation to the problem of identity, could well refute even this possibility.

(b) KM. Here a suitable analogy is required for a greatly superior being becoming an inferior one.

Gore draws an analogy with our sympathetic identification with those inferior in consciousness to ourselves:[4] 'But, it may be asked, is such a process as that of abjuring the exercise of consciousness really thinkable? In a measure it is, because it is realised in all sympathy. There are two ways of helping others. We may help them from the secure platform of a superior position ... But we may help them also by the method of sympathy, and this means a real entrance into the conditions of another's consciousness. By this method, the grown teacher accommodates himself to the child's mind, the educated to the mind of the savage, and thus, mind acts upon mind by the way of force infusing itself from within, rather than of alien information conveyed simply from without. In such action, there is involved a real abandonment of the prerogatives which belong to a superior state of consciousness, and those will most easily understand this who have been at most deliberate pains to cultivate the life of sympathy. Beyond this we can readily conceive

[3] His view is explained most simply in H. de Lubac, *Teilhard Explained* (Paulist Press, New York, 1968), pp. 58-62.
[4] C. Gore, *The Incarnation of the Son of God* (Murray, London, 1891), pp. 159-61.

that the attributes and powers of God must be more wholly, than is the case with us, under the control of the will. They must be less mechanical and more voluntary. God cannot act against the perfect law of reason, but what the divine love and reason demand, that the divine will can make possible.' But thereafter he goes on at once to admit the analogy's severe limitations: 'But, after all, we shall not, if we are wise, expect to understand the whole matter. It has been well said that we must all be agnostics, if we only put our agnosticism in the right place. We do not know God really ... Thus, if our own deliberate acts of sympathy have in them something analogous to the act of God in incarnation, they do not reach all the way to the explanation of it, for sacrifice ourselves as we may one cannot enter into a new state of being, or pass through any transition comparable to that involved in the incarnation of the Son of God. It must have involved an act of self-limitation greater than we can fathom, for the eternal to begin to think and act and speak under conditions of humanity.'

Put thus, Gore's attempt at an analogy can be seen to achieve very little. For the admitted limitation is a very severe one, namely that unlike KM in any such sympathetic identification we remain fully conscious of our powers. Gore, of course, as I noted in the last chapter, does not offer a straightforward KM but has a two-centres model of consciousness, but even if we grant coherence to this, something denied in Chapter 5, this would still not help his analogy here since he wants to claim that the kenotic centre of consciousness is truly kenotic, involving more than mere sympathetic identification. In short, the problem with the suggested analogy is that in sympathy we merely imagine ourselves different from what we are; we do not become something different. There is also the further difficulty that it is far from clear whether the notion of sympathy makes sense when extended to something of which one has had no experience at all. For, how can one 'feel with' someone, if one has never felt anything comparable? This being so, there is doubt about whether the notion of sympathy can be properly applied to a being (i.e. God) who by definition experiences no emotions or physical sensations.

By contrast with Gore's brief and unsuccessful attempt at an analogy another well-known exponent of *kenôsis*, P.T. Forsyth, offers an extended discussion,[5] during the course of which four analogies are suggested. The first is the tale of a foolish young Sultan and a venerable vizier. When an attempt is made to poison the former, the only way in which the vizier can save his life is by offering a pledge in exchanged cups. As a result of drinking the poison, the vizier dies slowly with greatly impaired mental faculties. However, the ruler subsequently learns of his devotion and in consequence is led to change his life style. Forsyth is at

[5] P.T. Forsyth, *The Person and Place of Jesus Christ* (first edition, 1909, ninth impression 1961), p. 296ff.

pains to emphasise that the crucial factor in the vizier's loss of powers 'was not the drug, but the love, the will, the decision to take it with open eyes, and to part with all that made his high place and peace, when no other course could save the youth he loved'. His second analogy concerns a great musical genius in pre-revolutionary Russia who is a passionate sympathiser with the people. So strong is his commitment to democratic principles that he becomes involved in sedition, and in consequence is exiled without his violin to Siberia, where his musical ability is lost. Once again it is important to Forsyth that the tale be told in a particular way to emphasise that what happens is 'all as the consequence neither of a spiritual process, nor of a mere indiscretion, nor of martyrdom only forced on him, but of a resolve taken clearly and gravely at a point in his spiritual life'. His third instance is of a philosophy student of high promise, who is the only son of a large family. His father's early death obliges him to support his family by learning a trade, where his philosophical promise is soon blunted. Forsyth's comment in this case is particularly interesting: 'He loses a life, but he finds his soul. Is this not a case where a moral and sympathetic volition leads to a certain contraction of the consciousness; not indeed by a single violent and direct act of will, but by a decision whose effect is the same when it is spread over a life? He has put himself (*sich gesetzt*) in a situation where he is put upon (*gesetzt sein*). And, in applying the illustration to the theology of a kenosis in Eternity, where a thousand years are but as one day, the element of time between choice and result in the earthly case is negligible.'

His final analogy we may quote in his own words: 'Speaking more generally, is there not often in our experience a connection between the resolutions and the limitations of our personality? By certain deliberate and early acts of freedom, love and duty we so mortgage and limit ourselves that in due course, as we follow them up, the moral consciousness ripens ... We may soon grow weary in the course we have taken up. The very physical, or psychical, nature which was the organ of our first resolve assists itself, and makes us feel its cloudy power as we pursue the path to which only our freedom, our supernatural self, committed us. By our will we have come where our will is itself often obscured and hampered; and our first estate, where the choice was made, is recalled but in a dream. So also Godhead, by the same free and creative will which gave His creation freedom, may pass into a state where He is not only acted on by that creation but even submerged in the human part of it ... He lives out a moral plerosis by the very completeness of his kenosis; and he achieves the plerosis in resurrection and ascension. And thus he freely subdues to Himself the freedom which in His creative freedom he made.'

What Forsyth offers us in these four closely related analogies certainly overcomes the major problems we noted with Gore's proposal. It is a real

kenôsis, not merely an imagined one. However, it also is not without difficulties. Two in particular may be mentioned, the first of which is easier to deal with. This lies in the fact that Forsyth failed to note one major difference between such cases of *kenôsis* and any possible *kenôsis* as applied to God, i.e. that in the human situation such *kenôsis* becomes inevitable because of limitations of power or opportunity. The violinist cannot create a violin out of thin air in Siberia; likewise, the student cannot concentrate on his philosophy at the same time as he performs hard manual labour, and so on. But such limitations by definition do not apply to an omnipotent being. Admittedly, Forsyth tries to alleviate the force of a similar objection by emphasising that all the cases are the result of free decision, including the first where a drug is taken, but he does not appear to have noted that there is still one major difference, that the free decision is made in a context where limitation in some direction or other is inevitable: either a vizier with mental capacity intact or one who has failed to protect his master; either an accomplished violinist or an active revolutionary likely to be banished to Siberia and so on. But, while this is true, it does little in fact to undermine the force of the analogy. For, while God is not subject to such limitations of power, he is subject to limitations of logic and so, if he wishes to become a man, he has to choose freely to let his power be limited (in virtue of what it means to become a man),[6] just as much as the individuals mentioned by Forsyth freely choose to put themselves in situations where their power will be limited (in virtue of certain contingent facts about the world). The source of the limitation is thus different in each case, but this does not substantially affect the intelligibility of the analogy. The difficulty of conceiving how an omnipotent being could bring about his subjection to such diminution of his powers might be thought a more serious problem, especially as the obvious ways of effecting a reduction in the human case depend on physical laws, as, for instance, the use of drugs. Forsyth's other illustrations may be of some use here with their suggestion that lack of use might expel certain capacities, as with the violinist and promising philosopher. For perhaps it is possible to conceive of God thinking away his powers, that just as relentless toil might drive away thoughts of philosophy, so the deliberate attempt to cultivate a blank mind might produce in God the Son's case the preface to foetal existence. The difference from Forsyth's examples would then be merely that instead of relying on physical exhaustion to produce this effect, it is caused entirely by mental determination. A more apposite analogue might thus be, not the philosophic mind deadened by toil, but the Buddhist monk's cultivation of the blank mind he calls Nirvana.

[6] This, of course, presupposes that God's primary intention was to become incarnate. If the incarnation were willed just as a means to man's salvation, then the objection from omnipotence would have force.

However that may be, whether it be seen as a helpful model or not, what must certainly be conceded is that God can reduce his powers; for, despite the apparent paradoxes that result,[7] it would be a severe limitation on omnipotence to deny the possibility of abandoning it.

If my first difficulty with the analogies, in the different manner of loss of power, thus resolves itself, the second raises more acute questions. All of Forsyth's illustrations involve a difference of degree, not of kind; yet it is arguable that God's becoming man falls into the latter category, not the former. Forsyth would presumably reply that it is a diminution of mental powers that is involved in both cases, but, of course, in the case of God becoming man it is not just that mental powers are lost; he also becomes a psycho-somatic unity with all that involves, such as the inter-dependence of mind and body. The change is thus in some ways more like a man becoming, say, a dog rather than, as with Forsyth's illustrations, a man remaining a man but becoming intellectually inferior to what he once was. I have added the qualification 'in some ways' because man shares his most significant attributes, such as those to do with freedom, reasoning and morality, with God but not with the animals, and one could plausibly contend that these are also God's most significant attributes, though not, of course, what defines him as God. From that one might then go on to argue that the difficulty in conceiving that God could become a man cannot be as great as envisaging that a man could become a dog. In the former case the most important attributes have been retained, whereas in the latter they have disappeared. But it would also be possible to argue the other way, that man's most significant attribute is in fact shared with the animals and not with God, i.e. that he is enmattered. It is not a view I share, but in the light of the complexity of the issues perhaps the best one can do is to say that appropriate analogies in both directions are required: that is to say, both in the manner indicated by Forsyth and in a more radical manner as demanded by a change of kind and not merely of degree.

The question therefore arises whether some such suitable analogy is forthcoming. I have already noted the limitations of drawing a parallel with a man becoming a dog, but there is none the less some point in the parallel in that the addition of the physical to a formerly purely mental entity would seem to be at least as dramatic a discontinuity as the loss of characteristic mental activity would be in the case of a man becoming a dog. Are then such dramatic changes in kind of being conceivable? So far as the level of reduction of capacity is concerned, there is no problem. We are all aware of reductions of capacity befalling human beings, in some cases reducing them to well below the level of a dog, particularly in those instances where the individuals concerned are commonly described as

[7] Cf. R. Swinburne's discussion in *The Coherence of Theism* (Oxford University Press, 1977), pp. 149-61.

'human vegetables'.

In fact the difficulty lies not in envisaging the reduction of capacity, but in defending the claim that it is still the same person involved, despite the change in type of being. For the conceivability of changing from one form of being to another has, of course, been denied by many philosophers, among them for instance, Peter Geach.[8] However, to consider the matter in detail at this stage would involve anticipating later discussion which is more appropriately dealt with under the heading of 'identity'. Suffice it to say at the moment that the problems raised by this aspect of KM are paralleled by a much more commonly discussed issue, namely the possibility of reincarnation, and that a similar type of defence would be required in the absence of continuity of bodily identity, i.e. through resort to a defence in terms of continuity of character and eventual (post-Ascension) continuity of memory. Again, however, as with Aquinas' analogy for TNC, so here with KM, we may say that the parallel with the common concept of reincarnation enables us to get enough of a handle on the meaning of the claim to pronounce the analogy a success in establishing a *prima facie* case for coherence, even if a more thorough investigation of the problem of identity is required before we are entitled to pronounce definitively on the matter.

In case there is still any lingering confusion with Gore's very different two centres of consciousness model, it should perhaps be added that on KM, as I understand the model, there is an exact parallel with reincarnation in the sense that it is all of God the Son who becomes a man, not merely just some aspect of Him. This demands a strong doctrine of the distinctiveness of the persons of the Trinity since, quite literally, there was a time when one of the persons of the Trinity was bereft of his divine powers, even to the extent of having for a time no more than those of a foetus. KM is thus heavily dependent on adopting what the previous chapter labelled the Plurality Model for the Trinity, with the Trinity being conceived more like a family than a single individual. Within such a framework, the notion of one person temporarily ceasing to exercise his divine functions is readily intelligible, since it leaves the other two persons in full charge, as it were, of the running of the universe, for so long as the Incarnate one remains bereft of his powers. By contrast, the Unity Model for the Trinity cannot be used with KM because no clear sense could then be attached to KM. Not only would the analogy with reincarnation collapse, but also we would be left with the incoherent notion of a part or aspect of a person (the one divine person) becoming a complete and fully human person, with God the Son thus being in some inexplicable sense both a person and not a person. Yet, despite the incoherence of the alternative, present-day advocates are still reluctant to accept the full implications of KM for the doctrine of

[8] P. Geach, *God and the Soul* (Routledge & Kegan Paul, London, 1969), pp. 1-16.

the Trinity. Thus, the passage from John Austin Baker, criticised in Chapter 5, in which he appeals to mystery rather than attempt an explanation or analogy, goes on to reject out of hand the very solution which I have suggested here is the only coherent option: 'One thing, from the theological angle, is clear: we cannot invoke some conception such as the doctrine of the Trinity to answer this question. God is not a committee, one of whose members can be detached to serve for a time on a foreign posting. Even if we wish, as well we may, to think that something analogous to society and relationship exists within God, yet God himself must remain indivisible, and be wholly committed to all his acts.'[9] Unfortunately, what exactly is intended by the objection is far from clear, except that the Plurality Model is held somehow to involve God being seen as some sort of 'committee' with each member not being 'wholly committed' to the work of all. What degree of unity is possible on PM, and why it is important, is something which will be discussed in the following chapter, but even without much prior reflection we can obviously think of closer forms of unity than that suggested by 'committee', as, for instance, the notion of a family. The related point about different degrees of commitment resulting from the model, is a muddle because, whether one opts for KM or TNC, as we shall see, there must still be certain experiences that are uniquely those of God the Son, if coherence is to be defended, but this does not mean that the commitment of the other two persons of the Trinity is therefore necessarily less. There is the same commitment based on a shared, common purpose; the fact that only one person acts merely shows that only one is required to act, but it is an act to which all are equally committed and one which all are equally willing to undergo.

Attributes

The objection here would be that the doctrine of the Incarnation is inevitably shown to be incoherent, as soon as one tries to apply both human and divine attributes to the one person, a hopeless, irresolvable muddle being the result, the type of muddle typified by speaking of Christ on the Cross, as seems demanded by TNC, 'really suffering and yet remaining impassible'. It will be my contention that there is no such muddle or incoherence. It should, however, be noted that, though TNC, even when properly understood, still needs careful elucidation in order to avoid conceptual confusion, most attacks on the coherence of the doctrine of the Incarnation are characterised not only by no such care, but also often by an illegitimate fusing of the two models in order to 'demonstrate' incoherence. The language appropriate to one model is used to attack the coherence of the other, thus ensuring an easy victory.

[9] J.A. Baker, *The Foolishness of God* (Fontana, London, 1975), p. 320.

For instance, the doctrine may be attacked by saying that it must involve change in God and yet God is claimed to be immutable, whereas the appropriate response to this is to say that on one model, KM, of course God is not immutable, while on the other, TNC, he can continue to be seen as such, provided that careful distinctions are made. What these careful distinctions are I shall now endeavour to elucidate.

(a) TNC. On this model both divine and human attributes are to be ascribed to Christ during his earthly existence. This, it is said, makes it impossible to speak intelligibly of the suffering and death of Christ since in this allegedly one person the more important part or aspect of him, the divine, by traditional definition neither suffers nor dies; the Cross is thus reduced to a meaningless charade in which no clear sense can be attached to the suffering and death of the person apart from obvious external manifestations such as the apparent cessation of bodily activity.

But is the difficulty really any greater than applies to our use of both physical and mental predicates in relation to man? Thus both types apply to the whole man, and yet neither is reducible to the other. In the case of suffering we can and do sometimes speak of a man 'suffering gladly', meaning thereby that he experiences physical pain, but at the same time has a mental attitude that triumphs over the pain because he believes himself to be doing what is right. So, similarly, in the case of the God-man of TNC it is possible to envisage his divine nature having such a total perspective on pain and its ultimate meaning and purpose that it legitimises the use of the term 'impassible'. That is to say, just as mental and physical predicates in man have separate domains, yet apply to the whole person and can affect one another, so also in the case of the divine and human nature of the God-man the divine and human attributes would have their separate domains, yet apply to the whole person and be capable of producing transformations in attitudes comparable to the 'suffering gladly' of the man who knows what he is doing is right.

But it may be objected that the comparison still does not solve the problem since, while it may help to give substance to the notion of a single person, it leaves us with an impassible one whose attitudes have so transformed his physical suffering that it has ceased to exist for Him. This does not, I think, follow. It will still remain entirely legitimate to speak of Him enduring real physical suffering, no matter how his mental consciousness views this suffering, because it is still part of his given experience. But some may continue to regard this response as unsatisfactory since it seems to deny to Christ any possibility of the emotional suffering that is so commonly the human lot; at most, it may be said, he is like the Stoic[10] good man who gladly goes to the rack, but only because he is indifferent to his emotions. There are two points to note about this comment. The first is that, even if this is conceded, it

[10] Though in what is perhaps its best-known mention in Cicero's *Tusculan Disputations* (2.7.17), the attitude is attributed to Epicurus.

does nothing to undermine the coherence of TNC; it merely shows that, though fully human, Christ's view of his suffering would be very different from most of us in the same situation. This may be unsatisfactory in terms of what the Biblical evidence suggests or in terms of our desire to see Christ the Saviour as closely identified as possible with mankind in its sufferings, and KM may be indicated on those grounds at least as a more satisfactory model; but, as already underlined, none of this is relevant to the question of conceptual coherence. But, secondly and more important, it is far from clear that TNC does demand such a total triumphing over suffering. For a human soul is present which could certainly experience emotional traumas of the type under consideration. Now, of course, if the divine nature automatically communicates to the human nature its knowledge, then the situation will be as envisaged with an impassible attitude to suffering present in the human soul, the certainty that it is all going to be right in the end. But, as my discussion of (iii) fallibility will make clear, there are grounds for doubting the coherence of such automatic communication. If this is so, we may think of the divine nature remaining impassible, but the human soul after all experiencing the emotional traumas that were mentioned, simply because its perspective remains limited. There would then be clearly distinguishable three levels of suffering in the God-man: the physical, the human soul, and the divine nature.

Similar distinctions must also be drawn with regard to the question of Christ's death. For, while one must indeed speak of the death of the God-man, it does not follow from this that one is entitled to talk of the death of God, as is sometimes supposed, any more than it follows from the fact of one being justified in speaking of a man's death that one must therefore talk of the death of his soul, of his being *qua* mental predicates. This is something which is accepted not just by Christian philosophers but also by agnostics like Sir Peter Strawson,[11] and so the attempt to show coherence by a parallel of this kind should win credence not merely from those already sympathetic to the model. As Strawson puts it: 'Each of us can quite intelligibly conceive of his or her survival of bodily death. The effort of imagination is not even great.'

But, it may be suggested, so far I have ignored the real heart of the objection which is that the Incarnation introduces an element of change into the Godhead, and this is incompatible with any assertion that the divine nature maintains all its traditional attributes in the person of the God-man. The notion of divine immutability has in recent years increasingly come under attack from both philosophers and theologians,[12] philosophers being concerned about the coherence of a

[11] P.F. Strawson, *Individuals* (Methuen, London, 1964), p. 115.

[12] For a philosophical attack cf. R. Swinburne, op. cit., p. 210ff. and A. Kenny, *The God of the Philosophers* (Oxford University Press, 1979), pp. 38-48. For a theological attack, cf. Process Theology and J. Moltmann, *The Crucified God* (S.C.M., London, 1974), pp. 267-78.

divine relationship with the world on such a schema given that it also involves a commitment to the timelessness of God, theologians worrying about the implied inactivity of God and the resultant distancing of him from his creation. There is no need to adjudicate on this dispute now. All that is necessary here is to show that TNC is compatible with divine immutability since it is part of TNC's claim that a complete divine nature with all its attributes is present in the one person of Christ, and not only traditionally but still commonly immutability is thought to be one such attribute, the present dispute still not having been resolved decisively in one direction or the other. The Incarnation can thus be considered in isolation because the standard objections to immutability have no immediate relevance to the doctrine and normally no reference is made to it in the discussion, though, of course, if the incoherence of immutability were shown, then this would affect just as much what was said about the divine nature in the Incarnation.

Aquinas provides a successful way out of any suggestion that change must necessarily be predicated of the Godhead in respect of the Incarnation on the TNC model. He does so by distinguishing between real change in the godhead and what he calls change 'secundum rationem',[13] that is to say, as it is seen from our point of view. 'The union we speak of is a relation taken to exist between the divine and human nature as they come together in the one person of the Son of God. As noted in the Prima Pars, every relation between God and a creature exists really in the creature, for the relation is brought into being by the change of the creature. It does not exist in God really, since it does not arise from any change in God, but only in our way of thinking. Thus we must say that this union is not in God really, but only in our way of thinking. In the human nature, however, which is something creaturely, it really exists. And thus it is necessary to say that the union is something created.' Some advice in interpreting these words of Aquinas is perhaps necessary. For he should certainly not be interpreted as denying that the union is really in God in one sense of union, i.e. with it viewed as a timeless, eternal divine intention that a human nature be united with him at a specific point of time, and since taken into God's timelessness presumably also always timelessly present to him, though with a datable beginning. It is just that, as the first sentence indicates, 'union' in the passage is being used exclusively in an active sense of uniting and in that active sense there was nothing new happening to God that was not already timelessly present to him. Perhaps the point can be made clearer by drawing a parallel with answers to prayer on a timeless view of God. For, just as then intervening in the world to answer our prayers would constitute no real change in God, such intervention being part of God's purposes from all eternity, so on this view neither do the changing events

[13] *Summa Theologiae* 3ae.2.7.

of Christ's life. All the God-man's attributes *qua* God remained unaltered; it was only his attributes *qua* his relationship with the world that appeared to change, and such 'changes' as these, like answers to our prayers, must be viewed as being eternally present to the timeless, changeless mind of God.

So here once again, as with suffering and death, one has to distinguish carefully between saying (correctly) that the God-man experienced change and asserting (incorrectly) that he experienced change *qua* God. It is thus not the case that the TNC model of the Incarnation raises any new or special problems for divine immutability. Indeed, even the fact that the human nature of Jesus is eventually taken into the timelessness of God has its parallel in the taking up of all the redeemed into the eternity of Heaven.

(b) KM. Here the situation is quite different. For there can be no question of attributing immutability to God on this model. God has become man, and this cannot be viewed otherwise than as a real change in God, since there is a change of substance that involves him in becoming a temporal being.

Before considering the implication of this for other divine attributes, brief consideration must be given to a basic objection to such an abandonment of divine immutability, that so integral is this attribute to what we mean by 'God' that its abandonment on this incarnational model cannot fail to render the concept of God incoherent. In reply a response at two different levels may be made. First, one may observe that the main reason why immutability is so deeply imbedded in the Christian tradition is not a sound one. It is because the formative period for Christian doctrine was heavily influenced by Greek philosophy in which change was almost invariably associated with decay. Indeed, the extent to which assumptions in the classical world on this matter differed from ours can be illustrated in a number of different ways. For instance, the Golden Age was placed in the distant past (in the Age of Saturn), whereas modern attitudes are typified by the mythology of Marxism which assigns the withering away of the state to a distant future. Again, Aristotle regarded rest as the natural state of things, requiring no explanation, whereas for Newton and his successors motion is as natural as rest and an explanation is only required for its cessation (i.e. through the action of some external force). But the fact that the modern world, unlike the ancient, has no suspicion of change does not, of course, establish the legitimacy of its application to God. I turn therefore to the other level of response, which consists in challenging directly the claim that it must be an essential attribute of God. Religious motives for immutability are given a lyrical defence by Von Hugel,[14] but the desire to

[14] F. Von Hügel, *Essays and Addresses* (Dent, London, 1926) 2nd series, VII, pp. 165-213, esp. p. 210.

see God as essentially beyond the human condition does not seem a sufficient ground. God will be just as much God, i.e. a fitting object of worship, if he is within time and subject to change. More worrying is the contention that change is always for the worse or better and so, even if in God's case it is always for the better, this would still impugn his divine perfection. But, provided his moral perfection is maintained, it is hard to see how this could constitute a serious challenge to the concept of God. That God should be enriched by experiential knowledge acquired in the Incarnation does not mean that he previously lacked certain factual knowledge; only that he lacked a certain form of knowledge, the experiential, that could in any case only be acquired by becoming incarnate. When there is added to this the logical difficulties in the notion, discussed for example in Kenny's *The God of the Philosophers*,[15] immutability does seem an unnecessary complication in our conception of God.

That acceptance of KM means abandoning along with immutability predicates like 'timeless' and 'impassible' goes without question. In fact, on this model one must speak of God's death simpliciter, i.e. admit that there was a time when God the Son was not,[16] but there is no failure of internal coherence as a result, since simply in virtue of adopting the model one also abandons any claim that God is essentially changeless. Likewise, the Resurrection/Ascension must be viewed as a further major change in God the Son, some point on this continuum presumably being the point at which all his powers of divinity were restored to him. (A degree of vagueness is necessary because, although I argued in Chapter 3 that the Resurrection was what led the disciples implicitly to acknowledge Christ's divinity through worshipping him, it does not follow that the attributes of divinity were already present to him; indeed, one might wish to argue that, if some of the intimate details of the appearances stories are to be taken literally, then *kenôsis* must still have been operating, since it is otherwise difficult to explain why the disciples did not come immediately to an explicit acknowledgement of Christ's divinity.)

The treatment of other attributes is equally straightforward. All one need say is that divine attributes apply exclusively before the Incarnation, human attributes exclusively to the period of the Incarnation and divine attributes again exclusively to the post-Incarnation period, and both divine and human predicates to the one continuing person who is the subject of all these experiences, when no temporal segment is indicated. Of course, one may dislike the model, but that is very different from saying that the model is logically incoherent, which it is not.

[15] Op. cit., pp. 40-8.

[16] At least this is so, if one rejects the immortality of the soul. Of course, if maintained, the implications are less radical.

Fallibility

This is an objection affecting only one of the models. It is argued that historical investigation of the Gospels clearly reveals Jesus to have been subject to human error. KM can easily explain this in terms of a self-imposed 'starting from scratch',[17] whereas TNC has no means available, it is argued, for allowing this. The God-man, simply in virtue of continuing to possess all the divine attributes, must have been omniscient, and so, even if TNC is not internally incoherent, historical investigation has now rendered it incoherent as a model for the Incarnation since it would involve the simultaneous ascription and denial of omniscience to Christ.

Assuming, then, the historians to be right, and it thus being no longer possible to claim for Christ the type of knowledge taken for granted in traditional defences of TNC like Aquinas's,[18] as I think we must, what may be said about the coherence of the model? Of course, if it were just a matter of small things like the Mosaic authorship of Deuteronomy,[19] one could say that Christ knew, but did not choose to say so, because it would have diverted people from his central message. But if, as I argued in Chapter 3, it is a mater of more substantial questions as, for instance, whether he was at all conscious of his divinity, then a very different kind of answer will have to be sought.

Fortunately, the Chalcedonian definition has within its own resources the means of dealing with the problem. For it is arguable that the Thomistic notion of Christ's human nature having perfect, intuitive, infused knowledge is in fact a violation of the Chalcedonian demand that the two natures should remain unconfused, neither become absorbed into the other. If that demand is taken seriously, it must surely mean the divine nature, in its communication with the human nature, accepting the limitations of understanding inherent in human nature: to do otherwise would be to impose knowledge, not to let the human nature acquire it through the constant relationship with the divine nature in the one person. This distinction between imposed and acquired knowledge is in fact crucial, if one is to maintain the reality of the God-man's human nature, a reality that is surely incompatible with Aquinas' suggestion that the human nature had perfect, infused, i.e. imposed, knowledge from birth: 'One must say that the perfection of knowledge has a twofold sense. One is according to essence as the perfection of knowledge is increased. The other according to effect: just consider how someone having the same and equal knowledge may show it at first less than others but thereafter more extensively and more subtly. It is in this

[17] Or rather, more accurately, starting from whatever human beings start from which, given genetic coding, is not quite 'scratch'.

[18] *Summa Theologiae* 3a.9-12.

[19] Mark 10:3.

second way that it is clear that Christ grew in knowledge and favour as with years: because with advance of years, he did greater works which showed his greater wisdom and favour. But, so far as the possession of knowledge is concerned, it is clear that his possession of infused knowledge was not increased, since from the beginning all knowledge had been infused into him. And still less could sacred knowledge be increased in him.'[20] We see, of course, what Aquinas is trying to do, and sympathise. For, it does initially sound as though the unity of Christ's person must be threatened unless the mind of the human nature shares fully in the mind of the divine nature, since otherwise it may be suggested that there is not perfect interchange between them. But it is highly dubious whether unity bought at this price can continue to claim to be unity with a human nature. For the method of knowing is so radically different without knowledge gained through experience; there is none of the trial and error that is such a characteristic feature of the gradual growth of human understanding. Admittedly there is an analogue in the intuitive knowledge that to varying degrees philosophers would admit exists in man as, for instance, with respect to moral intuitions or linguistic capacity,[21] but it forms so small a part of man's knowledge that to universalise it, as Aquinas' model would demand, produces such a very different type of mind that it is doubtful whether we would be justified in speaking of a human mind at all. Whether as a result of rejecting such infused knowledge we would no longer be justified in speaking of a single person is obviously now a question that raises itself in an acute form, and it is therefore a matter to which I devote attention below and under (iv) identity. Ignoring conceptual questions for the moment, it has, of course, considerable advantage from the historical point of view, in its ability to explain, as I pointed out in Chapter 3, why Christ might never claim divinity for himself, despite his alleged divinity.

However that may be, to accept this necessary modification of the model will mean adding yet another attribute to the list of apparently opposing attributes, though with the negation this time applying to the human nature: 'He knew, and yet he did not know'. In the case of suffering and death, we saw how the opposing predicates could be rendered intelligible by drawing analogies from human experience. The same can be done here. For in the case of weakness of will, it makes good sense to say of someone both that he knows the good and yet does not know the good,[22] in the sense that he has theoretical knowledge but his mind is unable to communicate such knowledge through action, it not as

[20] Op. cit. 3a.12.2.

[21] The claim that conscience is innate has had a long history. For a discussion of Chomsky's theory of linguistic 'innate ideas', cf. H. Morrick (ed.), *Challenges to Empiricism* (Methuen, London, 1980), p. 230ff.

[22] Cf. Romans 7:14-25.

yet being part of his practical, dispositional knowledge, not yet part of the way he would naturally tend to act. In the case of Christ, the limiting factor is not dispositional, but conceptual, the nature of the human mind, but, just as a divorce in ourselves between theoretical and practical knowledge does not justify us in speaking of a split personality, so neither does the existence in the God-man of different aspects of himself in respect of which he equaly knows and does not know.

To this analogy it may perhaps be objected that it has rather unfortunate overtones, since comparison is being made between a perfect being, the God-man, and an imperfection, weakness of will. To some extent this is true, but it should be noted that from the divine side of things the limitations of human knowledge are in fact an imperfection , not, of course, *qua* human, but *qua* the perfection of knowledge possessed by the divine. There is thus after all a parallel imperfection, though, admittedly, with this disanalogy, that in the one case (the weakness of will) the higher element desires that the imperfection be overcome immediately, while in the other the intention is to delay the perfecting of the human knowledge until the closer relationship which is possible in Heaven.

But, the objector may continue, the disanalogy is more striking than that, since, while few of us may succeed in achieving a complete unity between theoretical and practical knowledge in the one consciousness, at least it remains a possibility in virtue of us being a species of a certain kind, whereas on this version of TNC there is no such possibility while the Incarnation lasts. That this is a major difference must be conceded, but how much it shows is unclear. After all, complete integration is only delayed, not permanently impossible, and there is a clear rationale for the delay, so that the human mind can exercise normally its faculty for the experiential acquisition of knowledge. At the last stage in Heaven the objection to infused knowledge bridging the gap disappears since the vast fund of knowledge experientially acquired on earth will justify us in continuing to speak of the presence of a human mind. Moreover, it should not be forgotten that the main point of this analogy has not been to provide the closest possible analogue to the type of unity involved, but to justify the coherence of postulating the simultaneous presence and absence of knowledge in a single entity ('knows and does not know'). In this much at least the analogy surely succeeds. Whether, despite the very different ways in which knowledge is acquired, there is still sufficient interrelation between the two natures to justify us in speaking of one person is the question to which I next turn.

Identity

This is undoubtedly the most important of the various types of objection that can be raised against the coherence of the doctrine of the

incarnation, namely the objection that there are insufficient grounds to justify us in saying that the divine and human natures share the same identity in the one person, rather than being two quite distinct entities. With TNC the identity problem is raised synchronically: the question is why we should not speak of two persons, instead of one, existing at the same time, though admittedly in close relationship. With KM the identity problem is a diachronic one: the question is why we should speak of different successive temporal phases of the one person rather than simply of different persons, divine and human.

(a) TNC. In the previous chapter various models were rejected as failing to guarantee the unity of the person, among them Nestorianism and the model of grace, while others were rejected, particularly Apollinarianism, as failing to guarantee the existence of a fully human nature. In the previous section I noted how further modifications were necessary to traditional interpretations of TNC if it were not to fall foul of the objection to Apollinarianism, but at the same time drew an analogy with weakness of will to suggest that such modifications do not inevitably expose it to the contrasting objection that this necessarily implies two persons. But much more obviously needs to be said on the subject if the reader is to be convinced that the only appropriate language when TNC is under review is talk of one person.

The question that needs to be asked is what would force us in the direction of speaking of one person. In the previous chapter it has already been noted that a common external presentation is insufficient. That Jesus did the sort of things that God would have done were he ever a man does not show that the language of TNC is justified, only that it is possible for a man to reflect the character of God. If only this was claimed, Jesus would have been God in no more significant a sense than the sense in which Hitler was the Devil. It is logically a position to which any human being could aspire.

Clearly what is required to justify passing beyond such metaphor is a reference to internal psychology, that indicates some kind of ontological bond between the two centres of consciousness. Mention of schizophrenia and recent work on split brains will help to clarify the nature of the problem. Even in the most extreme cases I suspect that there would still be a reluctance on the part of the ordinary man to speak of two persons being present because of our hope for eventual re-integration into a common identity in the one body. But no such hesitation is evident in speaking of two distinct personalities, and so it is unclear why talk of two persons is unjustified. Certainly Roger Sperry, whose work on the surgically divided brain won him the Nobel Prize for Medicine in 1982, endorses talk of 'two separate mentalities',[23] while, though the philosopher Thomas Nagel is not prepared to go that far, he does draw

[23] R. Sperry, *Science and Moral Priority* (Blackwell, Oxford, 1983), p. 37.

the implication that 'our own unity may be nothing absolute, but merely another case of integration, more or less effective, in the control system of a complex organism.'[24] The details of this debate need not concern us here. What is important is the way in which any suggestion of such distinct personalities can be avoided. For the same kind of demand will apply to TNC, if it is to be successful as an identity claim. This demand can be expressed both negatively and positively; negatively by the absence, so far as possible, of dissonance between the two personalities; positively by the degree of interaction between the two centres of consciousness. It is possible to detect a desire to fulfil this demand in Aquinas' insistence on Christ having infused knowledge from birth. For then at least there will be the maximum 'flow' possible from the divine nature to the human. Unfortunately, not only is this incompatible with the presence of a fully human nature, Aquinas, like all exponents of traditional versions of TNC, fails to offer any clear account of a unique 'flow' the other way, i.e. from the human nature to the divine. Yet it is only if there is such a reciprocal flow that talk of a single person becomes more appropriate than an account in terms of one person inspiring another.

But, it may be objected, however far one proceeds along this path of maximum interchange or 'flow' between the two natures, a justification for talk of a single person will not have been provided because there remain two centres of consciousness and a 'theoretic duality of mental life is incongruous with an intelligible psychology.'[25] In response one may begin by asking how the situation differs from an analogy with our own internal dialogue between our conscious and subconscious selves. For we do not hesitate to speak of one person in that case, even when our conscious and subconscious provide us with radically different views of ourselves and our relationship with the world. That being so, it may legitimately be asked why we should hesitate to speak of one person in the case of the Incarnation, provided this criterion of maximum possible flow is met. Perhaps it may be objected to the parallel I am offering that in a fully integrated person, rather than someone with schizophrenic tendencies, the subconscious will have ceased to exist, and it is only by a charitable extension that we treat the latter as persons, whereas any closer integration in the case of the Incarnation would run counter to the demands of TNC. But, against this, it may be pointed out that, while psychologists would obviously regard certain aspects of the subconscious and unconscious as unhealthy and requiring elimination, it does not follow from this that the ideal is seen as the complete elimination of the subconscious and unconscious by them being taken up into the conscious

[24] T. Nagel, *Mortal Questions* (Cambridge University Press, 1979), p. 163.
[25] Quoted as an objection in R.V. Sellers, *Two Ancient Christologies*, (S.P.C.K., London, 1940), p. 256.

level. Not only is this in any case impossible because of the richness of their separate input, as for instance is seen in Jung's notion of the 'collective unconscious',[26] but also it is held that certain types of experience are most effectively dealt with by the human psyche at a level other than the fully conscious.[27] At most what is required of the healthy personality is a conscious awareness of what processes are occurring at other levels, not their elimination.

So clearly, if we take human personality as our model, 'flow' is also the criterion here of when we are most prepared to speak of a fully integrated personality or single person. The conscious element is able to accept without conflict the workings of the unconscious, while the unconscious continues its work but because of its very different manner of operation expresses the nature of the personality in a strikingly different way.

However that may be, applying this flow account to the Incarnation what we need to say is that the human nature experienced and still experiences, to the maximum extent compatible with it remaining a human nature, all the internal life of God the Son in his trinitarian relations, and that the divine nature, again to the maximum extent compatible with it remaining a divine nature, all the experiences of the human nature. In the case of the human nature the limits would be in the ability to understand, and I have already noted that this would include failure to realise that it was indeed such a divine relationship in which it was participating, there just being no experiences which could indisputably convince a human nature that it was this which it was experiencing rather than, for instance, mystical union. Of course, in order to justify us in saying that the relationship was in fact this close, we need the support of historical evidence that it was not outshone by any other recorded religious experiences of intimacy, but this is forthcoming, particularly with respect to the intimacy of Jesus' mode of address to the Father and perhaps also some recorded experiences, such as the Transfiguration, which may be based on fact. In Chapter 3 I observed that the explanation of why Jesus spoke with such authority is probably to be found by drawing a parallel with a common phenomenon in mystical experience. The subject has such a strong sense of union with the divine that he feels himself compelled to speak directly in the persona of the divine person of the relationship. Such experiences are normally relatively short-lived, but, if Jesus' life took anything like this form, this would account for his usurpation of the divine authority in pronouncing forgiveness or in the Sermon on the Mount ('But I say unto you ...'). Such mystical usage of 'I am', especially if it were based on sustained experience, surely argues for a degree of relationship between

[26] Cf. F. Fordham, *An Introduction to Jung's Psychology* (Penguin, London, 1966), pp. 47-68.

[27] As, for instance, with Freud's 'Oedipus Complex'.

the two centres of consciousness that begins to call into question any absolute distinction between them.

But this is not as yet to establish the legitimacy of talk of 'one person'. For, as noted earlier, if the flow goes only one way, the simpler assumption would be to talk of inspiration or even the 'possession' of the human personality by the divine rather than of them sharing an identity in one person. Unfortunately, traditional accounts of TNC have only acknowledged the problem to the extent of insisting on the legitimacy of applying the human predicates to the whole person. They have not considered what justification could be given for claiming that in the case of this human nature and this one alone the divine nature was uniquely affected in some way, with a unique flow of experience from the human nature to the divine. Of course, as with the human nature there would be limits set by the very different nature involved to the capacity to receive the flow untransformed. In the case of the divine nature these would consist in being subject to the transformation that an omniscient, total understanding provides, and to this account it may be objected that God knows all human experience in any case through his omniscience, and so the relationship, viewed at least from the divine nature, would be no different in kind from its relationship with any other human nature. Part of the answer is that there would be at least one vital difference. For in this case and this case alone, because of the union it would always be knowledge freely communicated and freely flowing from human nature to divine, never *despite* the will of the human nature. But this cannot be the whole answer, since it is not just a flow of knowledge, but also a flow of shared experience. That is to say, again in this case and in this case alone, God allows himself to be directly affected by human experience in some sense beyond that of merely knowing that certain things are happening. The difficulty lies in specifying what this further sense is, but such specification remains vital if talk of one person is to be justified. Unfortunately, defenders of TNC do not seem to have appreciated the difficulty, and so no attempt is made to distinguish God's unique experientially acquired knowledge in this case and his ordinary manner of knowing.

It is at this point that further modification to TNC becomes necessary, something which can best be illustrated if I take an attribute already considered earlier in the chapter, namely impassibility. For to say that the divine nature remains entirely impassible in the union would, I think, undermine any claim to there being a single person present, since there is then no way of distinguishing between God the Son's relationship to that particular human nature and any other human nature. But this does not mean that the doctrine of impassibility must therefore be abandoned. Rather, it shows that 'impassible' cannot be used in exactly the same sense when applied to the divine nature in the Incarnation, as when applied to the Godhead at other times. This has already been

hinted at in my earlier discussion, where I spoke of the divine nature in the Incarnation 'having such a total perspective on pain and its ultimate meaning and purpose that it legitimises the use of the term impassible'. For, clearly, while the divine nature will view the sufferings of the human nature's body and the mental traumas of its mind with an omniscient sense that they have a meaning and purpose of which the human mind is only dimly aware, this will not guarantee the immunity from pain that characterises the normal experiences of the Godhead. Perhaps a suitable parallel might be the human mind's attitude to undergoing a painful operation that it knows will have a successful outcome; pain is none the less endured, though very differently viewed from the situation in which uncertainty is the order of the day. But there will be a certain calmness of mind that could appropriately be described as 'impassibility'.

Such a treatment could presumably be extended to deal with other mediated experiences of the divine nature. For instance, the divine nature would experience death as in some sense a personal loss of body with the cessation of certain communicated experiences. Another example would be experience of the partiality to which all human emotions are subject with, for instance, one individual being loved more than another. But, once again, this would be subject to transformation in the divine nature's consciousness at least to the extent that such partiality would not be allowed ever to be at the expense of concern for another's welfare, which is inevitable in the case of the human mind, given its finite capacity. But, though the transformation in all such cases is not insignificant, one should observe that such openness to experiences mediated by the human nature is much closer than mere sympathy. It actually involves being the subject of the experiences in much the same way that we are the subject of our physical pains, even though their character may be transformed by the mental perspective we put upon them. That being so, just as the mystical analysis of the flow from divine to human made us call into question any absolute distinction between two centres of consciousness, so the same must be said here of the flow in reverse. This is not to deny the presence of two centres of consciousness, but it is to insist not merely that the extent of the flow each way makes such language highly misleading, but also that any talk of 'inspiration' or 'possession' is ruled out because of the unique way in which the divine nature is also affected by this particular human nature. The only reasonable course therefore is to speak of one person.

One last aspect of the problems of identity raised by TNC must be commented on before I turn to a consideration of KM. This is the fact that, whereas on the traditional account of TNC, in for instance Cyril of Alexandria or Aquinas, the divine nature is seen as the primary subject of the person, the modifications I have found it necessary to make in order to defend the coherence of the model make it doubtful whether this can any longer be maintained. This is because the human nature has very

much ceased to be just a mere cipher; it is its thoughts, commitments and experiences receiving explicit expression in word and deed rather than those of the divine nature. This is, of course, not to deny the commitment of the divine nature to what is happening in the single person; it is just to note that through these necessary modifications the position seems almost reversed in that it is now the divine nature that experiences things, as it were, at second hand through the medium of the human nature rather than vice versa, i.e. the human through the medium of knowledge infused from the divine. Fortunately, the change does nothing to undermine the tenability of the model since we do not at all think it necessarily the case that it must be the highest aspect of consciousness that most easily reaches expression if the entity in question is to be properly spoken of as a person; the lives of too many human beings themselves prove the contrary!

It may also be possible to find some small backing for this type of language in the history of the use of TNC. For, although Luther is often and rightly accused of 'confusion' and 'contradictions',[28] one thing is clear about his theology, despite his theoretical commitment to the divine nature as subject: the way in which his theology starting from the man,[29] combined with his strong emphasis on the *communicatio idiomatum* with complete interchange of predicates between the two natures, leads him to talk in language that is most naturally interpreted as making the human nature the primary subject, even though this was admittedly not his intention. Thus not only is he willing to say that 'the boy who nurses at the breast of the Virgin Mary is the creator of all things', but also, when applying his *communicatio idiomatum* in reverse, it is the most elemental human features that he chooses to emphasise as applying to God in virtue of the union, such as 'Mary makes broth for God' or 'Mary suckles God with her breasts, bathes God, rocks and carries Him'.[30] All this suggests to me at least that for Luther the most important incarnational experiences and events come from the human nature to the divine, and not vice versa, and so his account may provide some slight anticipation of what is being suggested here (slight because, apart from his inconsistencies, as with other advocates of TNC there is no constraint on what the human receives from the divine). But, of course, whether this is accepted as a correct interpretation of Luther or not, the important point is the change in the primary subject necessitated by my modifications to TNC. Luther shows not only that such modifications need not step entirely outside the traditional framework of TNC but also that they may be used theologically through

[28] P. Althaus, *The Theology of Martin Luther* (Fortress Press, Philadelphia, 1966), p. 198; I.D.K. Siggins, *Martin Luther's Doctrine of Christ* (Yale University Press, New Haven, 1970), p. 238.

[29] Cf. Althaus, op. cit., p. 181ff.

[30] Quoted in Althaus, op. cit., p. 194 and Siggins, op. cit., p. 232.

emphasis being put on the exposure of the divine nature to the full range of human experience as human experiences.

(b) KM. With this model the problems of identity are very different; for it is a matter of continuity of identity, where questions of degree of interchange are irrelevant. What one must establish is the coherence of claiming that Jesus was God in virtue of his human person being identical with the divine person he was before the Incarnation and after the Resurrection/Ascension. On this model at the Incarnation his divine powers would shrink to those of a foetus, on the Cross he would literally die with no more surviving than is the case with any other human being, and then be raised again, finally to ascend to have his full powers of deity restored to him. Some might well object that it all sounds beneath the dignity of God, but that kind of objection applies to the doctrine of the Incarnation in general, though admittedly to this model in a more acute form. But it is with its logical coherence that I shall concern myself exclusively here.

That the problems involved are very closely paralleled by issues raised by the concept of reincarnation has already been noted. I also observed that in some ways KM was less problematic than reincarnation, especially where the latter is envisaged as including reincarnation into a non-human species, such as in my illustration of a man becoming a dog. This is because at least man and God share their most significant features in common (rationality, morality and freedom), whereas these are lost if man were to become a dog. Even so, some philosophers would still deny the coherence of reincarnation when confined within the human species. So the grounds of their objection must first be challenged, if there is to be any hope of defending the coherence of the more radical change envisaged in KM.

Apart from some contemporary interest in what makes for the unity of the person at some instant of time, as for example in Nagel's discussion of brain bisection,[31] philosophers have overwhelmingly been pre-occupied with the problem of identity in the sense of continuity, and there is thus a great deal of philosophical reflection to fall back upon.[32] Three criteria are commonly mentioned as justifying talk of X being the same person at two different points of time, continuity of memories, character and bodily continuity. Some insist that bodily continuity is a necessary condition. Clearly, if this is so, reincarnation into another human body is incoherent. So a defence of reincarnation must begin by challenging the necessity of fulfilling this criterion.

As a start the reader may usefully be referred to Quinton's discussion in *The Nature of Things*[33] for some helpful thought experiments which

[31] Op. cit., pp. 147-64.
[32] Cf. e.g. the selection in J. Perry (ed.), *Personal Identity* (University of California, Berkeley, 1975).
[33] A. Quinton, *The Nature of Things* (Routledge & Kegan Paul, London, 1973), pp. 88-97.

argue powerfully that if an exchange of brains were to take place between two bodies, our intuitions on identity would go with the brains rather than remain with the bodies, so strongly are we committed to holding memories and character to be what makes someone who he is. However, while accepting this much, Quinton says of reincarnation that 'it flies too violently in the face of our broad psychophysiological assumptions about the causal dependence of character and memories on the body';[34] hence his use of Shoemaker's story of the transfer of brains since it 'neatly exploits the fact that the causal dependences in question relate ... not to the body as a whole, but to a small if crucial part of it'. But once, I think, the principle is accepted that in such test cases we would decide on the basis of character and memories rather than bodily continuity, the way is open to defend the coherence of reincarnation. For, obviously, while psychophysiological dependence is clear, it is not clear that it is dependent on only one particular body; one can imagine the same character and memories being exhibited from a brain and/or body that is similar to the one we have at present, while being most definitely not identical to it, e.g. through the original surviving merely as a corpse. The way is then open towards overcoming the kind of problems raised by Rorty, as, for instance, a very different body producing too much adrenalin and so giving a hitherto unknown irascible hue to the memories.[35] For what this shows is not the necessity of bodily continuity nor even of the two bodies looking alike, but of them making possible the same type of effect on the person's character (which is, of course, what, pre-eminently, an exchange of brains would do.)

To such a rejection of the necessity of bodily continuity it is commonly objected that this would allow the logical possibility of one person being identical with two continuations of himself; yet, it is argued, it would be more natural to speak of these alleged continuations as replicas rather than as the same person. David Lewis is one philosopher who has directly challenged this assertion, and with his notion of tensed identity defended the propriety of saying that B and C are both the same person as A, the one person who existed before the fission, just as we talk of both the Woodstock Road and the Banbury Road as the same road as St. Giles, the one road which existed before it forked into two avenues. But I think our notion of identity is a more fluid one than this, and that our decision what to call the same person is determined by circumstances as we find them. So, for example, if my character and memories were xeroxed and transferred to another blank brain, and my own brain was left intact with my present character and memories, I think I would mind which of the two was executed. But what this shows is not that the brain necessarily

[34] Ibid., p. 93.
[35] A.O. Rorty (ed.), *The Identities of Persons* (University of California, Berkeley, 1976), p. 3.

has some role, but that the more features something has in common with my present state, the more I am prepared to identify with that as my continuing personality rather than any other possibility. The worry with reduplication is in fact not that I will have no interest in these identikits, but that my interest will be weakened because diffused over a number of different individuals. One life story that is uniquely me is no longer a possibility. But, were we to discover a world full of persons who, while having no bodily continuity with earthly beings, exhibited continuity of character and memories, each with just one former earthly being (the situation as described is rather what Heaven might be like), there would be no hesitation in saying that in such a situation it was survival of the same person, rather than merely replication.

However, it may be said that dispensing thus with bodily continuity is still a long way from defending the coherence of KM. Certainly there are further problems to be encountered, but they are not insurmountable. I have already noted that KM seems better off than reincarnation into non-human species because of the fact that God and man share their most significant features in common. This provides an answer to the objection that no clear sense attaches to what continues in this case. Thus, someone might argue that, if God is essentially omniscient and man essentially fallible, and these properties are lost, then the entities in question much also cease to be. The appropriate response is that the continuing entity is the same *person*, who can lose and gain the attributes in question. It is much harder to see what the continuing entity is in the case of man becoming one of the lower animals, and that is why KM is in a stronger position than such versions of reincarnation.

However, those like Lewis who emphasises the non-physical aspect of continuity do still insist that 'what matters in survival is mental continuity and connectness',[36] and this raises a problem for KM. For at the point of Jesus' birth there will have been a dramatic discontinuity in suppressed memories and a character as yet undisplayed. Were this situation to have been permanent, it has to be admitted that it would have called into question the legitimacy of speaking of the same entity being present over time. For nothing appears to continue that would make talk of 'the same thing' appropriate. But in fact continuity of character could eventually be shown in Jesus' earthly life, and after the Resurrection the God who became man would have memories both of his earthly life and of his former pre-Incarnational heavenly life. Thus, while at the point of birth one might with considerable justification have hesitated to speak of the same person being involved, retrospectively when the whole story is told there ceases to be reason for witholding assent. Nor is such retrospective 'plugging' unique to this case. A similar lack of mental connectness can occur with someone who suffers from

[36] D. Lewis, 'Survival and identity', in A.O. Rorty (ed.), op. cit., esp. p. 17 and pp. 24-9.

amnesia over an extended period but subsequently remembers both past stages of his life.

It will be useful to conclude by emphasising the extent to which the two criteria of continuity of character and memories are in fact fulfilled in this case. So far as the former is concerned, the possibilities are in fact much greater than in most cases of reincarnation. This is because the farther removed the animal is from man the less possibility is there for displaying identifiable human characteristics. It is thus, for instance, much more difficult to see how we would defend continuity of identity in the case of reincarnation into a frog than, say, into a dog, where we are at least sometimes prepared to use human predicates, e.g. grumpy, obedient. But, as already noted, the most significant predicates of God, i.e. those concerned with personhood are also possibilities in man. Moreover, not only, as we have seen, is the gap which occurs at the stage of foetus and early childhood capable of being plugged, but also it is not clear whether it is entirely appropriately so described as a gap. Certainly there is no public expression of character, but arguably it is only latent in much the same way as human character is unexpressed in the gap which is commonly presumed to occur between death and the appearance of resurrected bodies. Additional credence would be given to this claim that continuity of character is merely latent if sufficient emphasis were placed on its inherited aspect in the genetic make-up of the foetus, though obviously in this case the inheritance would come directly from the God he once was, and could not be greater than that in any other human being (otherwise his humanity would be in question). As for evidence of such continuity of character, this is not a particularly difficult matter for the Christian; for an interesting feature of all the models discussed in Chapter 5, including those adjudged non-incarnational, is that they all claim that Christ perfectly expressed the character of God.

As for the other criterion of continuity of memory, it would seem odd to speak of memories returning if they had actually been destroyed at the Incarnation. For then it would surely be more natural to speak merely of a belief that certain things had happened, just as there is a difference between someone suffering from amnesia whose memories return and someone who comes to a belief that certain things must have happened to him, though he has no recollection of them. That being so, it seems better to think of God the Son's memories in cold storage, as it were, rather than as actually destroyed. To talk thus of his memories having been put in some sort of storage bank pulls us back a little in the direction of TNC, but not to any significant degree. Certainly the two models do not merge, because on KM the memories remain totally unused throughout the Incarnation.

So far as the status of such memories is concerned, again KM fares better than reincarnational claims. For in the latter case neither we nor the individual concerned would be entitled to endorse the memories as

genuine memories until further evidence of continuity of character is forthcoming. This is because we know from experience that, no matter how firm human convictions may be, they are always corrigible. But such cannot be the case for someone who has returned to being what by definition involves omniscience, and, even if this were not so, there would still be the reassurance of two other omniscient persons to confirm and justify him in his belief. From our point of view, of course, we have no such reassurance, and that is why continuity of character continues to be important, combined with the belief that, when returned to his divinity, such memories would then arise both of his past human state and of his past divine state.

It may seem odd that no choice has been made between TNC and KM, but both models have on examination proved coherent and the historical evidence considered in Chapter 3 is compatible with either model. KM of course involves the more radical change in God and this may therefore be regarded as sufficient grounds against but, on the other hand, it would enable God to experience directly the human situation in a way that is impossible on TNC. The force of the arguments either way thus seem to me to be finely balanced, and a definitive choice impossible, though obviously to God the Son something swung the balance and he became incarnate in one way rather than the other.

The Coherence of the Trinity

My procedure in this chapter will be very similar to that employed in the previous one with respect to the doctrine of the Incarnation. Parallel consideration will be given to two models for the Trinity, what Chapter 5 labelled UM, the Unity Model, and PM, the Plurality Model, the categorisation being dependent upon which of the two demands of trinitarian orthodoxy greater emphasis is placed, the unity of the Godhead or the permanent distinction between its three constitutive elements. Again, as in the previous chapter, I shall examine how the two models fare in the light of certain standard objections that could be raised again them, these being the same as occurred with respect to the Incarnation apart from the obvious omission of the fallibility objection.

Analogy

Here the objection would be that no satisfactory analogy can be provided either for what is ultimately a unity being also fundamentally a plurality (UM) or for what is fundamentally a plurality being ultimately a unity (PM). Without such an analogy it is argued that we cannot even begin to grasp what might be meant by the claim.

 (a) UM. Augustine offers two analogies, which are to be found in consecutive books of his *De Trinitate*.[1] The former is: *mens, notitia, amor* (mind, knowledge and love) and the latter: *memoria, intelligentia, voluntas* (memory, understanding and will). Very roughly, the idea is that the mind or its latent knowledge of itself, the memory, through expressing itself gains self-knowledge and understanding and it does this because the will has self-love in desiring such knowledge. None of the imperfections in the analogy are, of course, meant to apply to God; the point rather is that, just as there are three faculties in man which are not ultimately totally separate entities, so there can be three 'persons' in one God, each of whom roughly corresponds to these three faculties.

The difficulty with Augustine's analogies, as we shall see, is not that they do not give sense to an ultimate unity but that they fail to ensure the other trinitarian demand, the permanence of the distinction between

[1] Books IX and X.

the three elements that are none the less in some sense ultimately one. Indeed, the inadequacy on this criterion of the earlier version, as expressed in Book 9, *mens, notitia* and *amor*, is so obvious that it is surprising that Augustine ever entertained it. For there is no clear sense in which mind, knowledge and love are or could be three fundamentally distinct entities; rather what we have is one entity, the mind, together with two of its states or activities. A possible explanation is that 'the ambiguity of the Latin contributes to this error',[2] with '*tria quaedam*' leading to a reification of the two states.

However that may be, the second analogy does seem more promising, since here we are offered what have traditionally been regarded as three distinct faculties. Shedd objects that 'it also fails in that these three are not all the modes of the mind. There are other faculties, e.g. the imagination'.[3] But this does not surely constitute a serious objection since one can conceive of a mind having only these three faculties. A much more serious, and to my mind, insuperable, difficulty is the fact that the whole tenor of modern philosophy, especially since Ryle's *Concept of Mind*,[4] has been clearly to move away from a faculty analysis of the human mind towards a dispositional one. If the arguments justifying that move are correct, as they largely seem to be, then all talk of faculties becomes essentially arbitrary; there are no entities corresponding to the so-called faculties; they are merely a convenient form of speech which might equally well be replaced by an alternative way of dividing up the mind. For example, one could divide up the work done by the three faculties in question between two new faculties, called perhaps the resource faculty and the acquisitive faculty, with the work formerly done by the faculty of understanding being distributed between the two, since its domain seems partly a matter of utilising what the mind already knows (like *memoria*), and partly a matter of gaining some new power (like *voluntas*) though admittedly with the difference that this power is not always practically oriented. If it is objected that this difference is sufficient to justify re-establishing the threefold distinction, it is hard to see why, since understanding and will alike contribute to an increased power to deal with one's environment, both theoretical and practical. Indeed, the boundary line between the two is a fuzzy one, with some aspects of knowledge highly practical and some aspects of the will, e.g. the will to believe, highly theoretical.

This being so, the natural conclusion to draw is, I think, that Augustine fails to provide us with a satisfactory analogy for UM.

[2] So Shedd in *The Nicene and Post-Nicene Fathers* (Eerdmans, Grand Rapids, Michigan, 1956), 1st series, vol. 3, p. 126, n.2.

[3] Ibid., p. 143, n. 1.

[4] G. Ryle, *The Concept of Mind* (Hutchinson, London, 1949; Penguin, Harmondsworth, 1963).

However, this may be thought unduly harsh, and an objector may point out that, although there are as a matter of fact no such fundamentally distinct faculties in the human mind of the kind envisaged by Augustine, we could conceive quite easily of the human mind taking this form and so in consequence preserve a handle for meaning when applied to the divine case. Indeed, it might be argued that, so easily is such a division conceived, that for centuries men believed without question in the existence of such distinct faculties. The difficulty, of course, is that we can have no more reason for thinking that the permanence of the distinction is preserved in the divine case than we have in the human case, when an analogy is being drawn with the human case. For what is there that is different about the divine person's possession of faculties that would prevent the reduction of the faculties that has been shown to be justified in the human case? Without an answer to that question, a defender of the coherence of the Augustinian analogy cannot get anywhere, and for my part I find it impossible to see how such an answer could be forthcoming.

However, in order to avoid possible confusion, it should be noted that the analogy is being rejected only as a coherent analogy for orthodox trinitarianism, where the three entities must be fundamentally and permanently distinct, not as an analogy for a trinity that is constituted by three reducible aspects, as in the heresy known as Sabellianism. For, on this latter view the idea of a single person with three aspects to his activity that indicate convenience of analysis rather than any fundamental distinction is exactly what is intended to be invoked, and so the Augustinian analogy, when used in this context, is entirely coherent (though this is, of course, not at all what Augustine intended). If the question be asked why we should not accept Sabellianism, the answer is that, while it undoubtedly defends monotheism, it is a defence which is bought at too high a price. Admittedly, the original grounds of objection[5] are not particularly impressive in the light of our knowledge today. Thus, the fact that it would make the Father suffer (patripassianism) cannot be held as a valid objection, since, as we have already seen, there is no particular problem in attributing suffering to the Son and, that being so, to extend the attribution to the Father will also create no special problems. In addition the original objection assumes the inferiority of the Son to the Father (the Father as supreme monarch must not suffer, even if the Son does), and I have already argued at the end of Chapter 3 for the equality of the persons. The other traditional objection was based on an appeal to Scripture, including the Old Testament, and Chapter 2 in particular has already argued the need for a much more sophisticated use of the Bible. However, despite these facts, Sabellianism must be

[5] Usefully summarised in J. Pelikan, *The Christian Tradition* (University of Chicago Press, 1971), vol. 1, pp. 179-81.

rejected, and the move made from economic trinitarianism to immanent trinitarianism: that is to say, from seeing the doctrine as merely making a claim about the Godhead's economy or management of the world to saying that the threefold aspect also says something about God as he is in himself. This further move is necessary because, as our historical and logical investigations have revealed, the kind of assertions to which one finds oneself committed must inevitably have immanent implications. Thus, in the case of the Son, with KM the need for permanent plurality in the Godhead would seem obvious, but even with TNC, while logically the model is compatible with no fundamental distinctions in the Godhead, on the historical evidence it is implausible simply because Jesus' recorded experience is not just of an internal divine power but of an external relation, i.e. to his Father. This cannot be explained satisfactorily in terms of the unity of his person, demanded by TNC, unless this external divine power is regarded as something over and above his own divine nature. Similarly, with the Holy Spirit it was argued in Chapter 4 that historically there are good grounds for supposing the distinction between Son and Holy Spirit to be permanent, while a logical analysis of certain types of religious experience, it was maintained, committed one to the immanent character of the distinction between Father and Holy Spirit.

None of this is to say that the only option is to understand 'person' in the sense offered by PM; it is only to demand an analogy from UM that, unlike Augustine's , will safeguard the permanence of the threefold distinction. However, if the analogy fails to show the coherence of acknowledging the fundamental plurality in the Godhead, there is no doubt that it does succeed in guaranteeing its ultimate unity, which is where the primary emphasis in UM lies in any case. Nor is UM shown to be incoherent in virtue of its failure to provide a satisfactory analogy. Rather, it is that without such an analogy doubts are bound to be increased. Such doubts would automatically be dispelled if some satisfactory alternative proposal to Augustine's was forthcoming. Consideration, for instance, might be given to Plato's tripartite division of the soul in the *Republic* or to Freud's analysis of the human psyche into *id, ego* and *superego*. But the trouble with all such analyses as analogies for a threefold essential distinction in the divine mind is that they are clearly no more than useful explanatory tools. They are not undergirded by any necessity that the human mind should be divided up in this way. Of course, as we have noted, all analogies break down at some point, but with UM the difficulty is that the analogies break down too soon. This is because their failure makes one doubt what it could mean to say that a mind might have internal divisions that are non-arbitrary. Do the failure of the analogies not perhaps suggest that it is of the essence of the mind to be one and really only one? A possible resolution of the difficulty would be to indicate three essential properties

that demand threefoldness, even if we are unable to provide any better analogy of how these three elements might cohere in the one mind than artificial divisions of the kind noted. Whether this can provide a satisfactory way-out will emerge in the next section, when consideration is given to Augustine's treatment of the three distinctive attributes that provide the justification for postulating the three elements.

But first we must examine what analogies are offered for PM.

(b) PM. Here the situation is quite different. For on this matter at least there is a degree of logical rigour in the discussions of the Cappadocian Fathers that is not to be found in St. Augustine. Logical terms are directly drawn upon in order to exhibit an appropriate sense in which what is fundamentally three might also be ultimately one, the appeal in this case being to the logical distinction between universal and particular, and it is against this background that St. Basil attempts to develop a suitable analogy.

He writes: 'The distinction between *ousia* (the one) and *hypostasis* (the three) is the same as that between the general and the particular; as, for instance, between the animal and the particular man. Wherefore, in the case of the Godhead, we confess one essence or substance so as not to give a variant definition of existence, but we confess a particular hypostasis, in order that our conception of Father, Son and Holy Spirit may be without confusion and clear. If we have no distinct perception of the separate characteristics, namely, fatherhood, sonship and sanctification, but form our conception of God from the general idea of existence, we cannot possibly give a sound account of our faith. We must therefore confess the faith by adding the particular to the common. The Godhead is common; the fatherhood particular. We must therefore combine the two and say, "I believe in God the Father".'[6] It is curious that Basil should choose to mention 'the animal' and 'the particular man' rather than 'man' and 'the particular man', but, whether one thinks of 'the particular man' as a member of the *species* 'man' or the *genus* 'animal', his basic point is surely clear, that the relation between the individual members of the Godhead and the Godhead is like that between any particular and its corresponding appropriate general or universal term.

The same point is made at greater length in Letter 38[7] by his younger and more philosophically astute brother, Gregory of Nyssa. The adage is given: 'Transfer to the divine dogmas the same standard of difference which you recognise in the case both of essence and hypostasis in human affairs, and you will not go wrong.'[8] Earlier in the letter, he had already explained the difference between general and particular as follows: 'Of

[6] Letter 236.6.

[7] This letter, which was formerly attributed to Basil, is now held to be by Gregory of Nyssa. So A. Grillmeier, *Christ in Christian Tradition*[2] (Mowbrays, London, 1975), p. 373.

[8] Letter 38.3.

all nouns the sense of some, which are predicated of subjects plural and numerically various, is more general; as for instance *Man*. When we so say, we employ the noun to indicate the common nature, and do not confine our meaning to any one man in particular who is known by that name. Peter, for instance, is no more *Man*, than Andrew, John or James. The predicate therefore being common, and extending to all the individuals ranked under the same name, requires some note of distinction whereby we may understand not man in general, but Peter or John in particular.'[9] The most natural way of interpreting this passage is, I suggest, to think of Gregory making a distinction between the sort of statements which we make about particular men, each with their own unique set of properties, and the statements that we sometimes make about man in general which sound as if we were referring primarily to a single super-entity (as with the term 'mankind'), and only secondarily to each individual man ('secondarily' in the sense that, though automatically true of each individual man, what interests us in making the statement is their universality). However, it must be admitted that later in the same letter there is a brief passage which suggests an alternative interpretation. He writes: 'It is customary in Scripture to make a distinction of this kind, as well in many other passages as in the History of Job. When purposing to narrate the events of his life, Job first mentions the common, and says "a man"; then he straightway particularises by adding "a certain".'[10] The reference is to the first verse of Job which begins, 'There was a man ...' but thereafter refers to 'that man', having identified him as being from the land of Uz and having the name Job. This suggests that what Gregory has in mind is the common essence or substratum that can be abstracted from each individual[11] rather than some overarching common term within which each individual is subsumed to make a common whole. Probably Gregory has simply failed to distinguish the two since they both arise naturally out of the distinction between particular and general terms, but the distinction is none the less an important one since they provide very different analogies for the Trinity. For, on the basis of the Job passage one might legitimately infer that one is entitled to speak of three gods but what legitimises talk of one would remain unclear, while at least on the interpretation I have suggested that much is clear: Gregory of Nyssa, like Basil, would be assuming a Platonic theory of universals,[12] according to

[9] Letter 38.2.

[10] Letter 38.3.

[11] This would be in line with the Aristotelian view of substratum (hulê) as genus and form as individuating within that genus.

[12] H.A. Wolfson in *The Philosophy of the Church Fathers*[3] (Harvard University Press, 1976), pp. 337ff. offers an exclusively Aristotelian interpretation. Treating the letter as one of Basil's, he offers additional support from a disputed letter of Basil's to Apollinaris (p. 343). But, while the terminology is sometimes Aristotelian, unless the basic assumption is Platonic, it is incomprehensible why Gregory should have thought that any strong claim to unity had been demonstrated.

which it is the universal that has primary reality and particulars exist in so far as they participate in that primary reality.

But, it may be suggested, even if the interpretation is right, the analogy is of little use since it succumbs to precisely the same kind of failure as we noted in the case of Augustine's suggestion for the UM, namely advances in philosophical understanding have shown the presuppositions on which it is based to be untenable. Thus, it may be said, just as attacks on a faculty analysis of the human mind have concomitantly undermined any plausibility Augustine's suggestion once had, so attacks on the realist Platonic theory of universals,[13] abandoned as it is by contemporary philosophers, have produced in effect the same devastating consequences for this analogy as well. However, this does not seem to me to be the case. Admittedly, Gregory's letter is not of much help. For, without the Platonist assumption, all that can be said is that the general/particular comparison shows that what is three can also be in a certain limited sense one, in that there may be one basic shared property or group of properties. It does not show that it might ever be right to regard this oneness as ultimate, as is demanded by the doctrine of the Trinity, that is to say, right to regard the three persons as essentially one thing.

However, in his short treatise *Ad Ablabium quod non sint tres dii*[14] Gregory does, I think, present the analogy in such a way that it can be successfully extricated from this objection. Paradoxically, he does this in a context in which the underlying Platonic assumptions of the analogy are made far more explicit than was the case in his other presentation. Thus the work begins by considering Ablabius' objection to the Cappadocian defence of the divine unity: 'The argument which you state is something like this: Peter, James and John, being in one human nature, are called three men; and there is no absurdity in describing those who are united in nature, if they are more than one, by the plural number of the name derived from their nature. If, then, in the above case, custom admits this ... how is it that in the case of our statements of the mysteries of the Faith ... (we) forbid men to say "There are three Gods"?' As a possible answer, Gregory first rejects the view that it is simply 'to avoid any resemblance to the polytheism of the heathen', but then accepts what seems at first sight an equally silly suggestion: 'We say, then, to begin with, that the practice of calling those who are not divided in nature by the very name of their common nature in the plural, and saying they are "many men", is a customary abuse of language, and that it would be much the same thing to say that there are "many human natures".' The only justification he offers at this stage is that: 'as we

[13] Beginning, of course, even as early as Plato (*Parmenides* 130-2) and Aristotle (*NE* 1.6).
[14] For the quotations which follow I have used H.A. Wilson's translation in *The Nicene and Post-Nicene Fathers*, 2nd series, vol 5, pp. 331-6.

speak of people, or a mob, or an army, or an assembly in the singular in every case, while each of these is conceived as being in plurality, so according to the more accurate expression, "man" would be said to be one, even though those who are exhibited to us in the same nature make up a plurality.' Here Gregory is at his most Platonic and most unhelpful, since clearly there is good reason why we speak of a mob, army or assembly in the singular and of men in the plural: the former, unlike the latter, exhibit a common identity and purpose. However, this fact does not escape Gregory's attention, and he therefore subsequently modifies his argument, the modification being such that it can be disentangled from its underlying Platonic assumptions. For, he goes on to suggest that God and man are not thus strictly parallel as universal terms, and that what justifies us in speaking of 'one God', when there is no corresponding justification for talking of 'one man', is the fact that an identity of operations is displayed in the case of the three divine persons that is not to be found in the human situation.[15] Thus, he writes: 'Perhaps one might reasonably allege as a cause why, in the case of men, those who share with one another in the same pursuits are enumerated and spoken of in the plural, while on the other hand the Deity is spoken of in the singular as one God and one Godhead, even though the three Persons are not separated from the significance expressed by the term "Godhead", – one might allege, I say, the fact that men, even if several are engaged in the same form of action, work separately each by himself at the task he has undertaken, having no participation in his individual action with others who are engaged in the same occupation.'

Here at last, it seems to me, we have the makings of a successful analogy for PM. The attempts, in the manner of the eclectic philosophy of his day, to use Aristotelian terminology to make an essentially Platonist analogy can be dispensed with. The important aspect to salvage from Cappadocian discussions of possible analogies is what we now have before us: the use of the singular is justified in virtue of the extent of the unity of activity displayed, just as the singular is justified in respect of men in so far as they show the same kind of unity, as in Gregory's instances of an army or assembly. Not that this ends all difficulties. Let me mention two. First, if in order to justify talk of a unity one minimises the differences between the three Persons by referring to an identity of operations, it then becomes puzzling how we can legitimise talk of 'three persons'; this is a question that I shall consider under the next general heading of 'attributes'. The problem is, of course, especially acute if identity of perceptual input and action output is, as seems intuitively plausible, a sufficient condition for identity of persons.

[15] H.A. Wolfson talks of 'the two solutions' (unity of genus and unity of rule), e.g. p. 332. But passages like this show that for the Cappadocians at least they are part of the same, single solution.

Secondly, there is the problem that the parallel instances I have quoted, i.e. army, assembly and so forth, may show rather more than the Cappadocians, and indeed traditional orthodoxy in general, would have liked. For the term 'man' is replaced by a new term in each situation in the human case at least, and this leads one to wonder whether the same ought not also to hold in the divine case as well, with, for instance, 'God' or 'Godhead' being exclusively reserved for talk of the three persons as a corporate entity; this is a matter to which I shall devote attention in the final section of the chapter which deals with the question of identity in general. But, for the moment it may at least with confidence be said that this final form of the Cappadocian analogy is not subject to the same sort of decisive objection we found to be present in the case of St. Augustine's proposal for UM. Unlike with divisions of the mind there is no difficulty in conceiving why we should speak of three persons as essentially and permanently distinct. Admittedly, it may turn out that the proposed analogies collapse at a later stage in explaining what makes the persons one, in not providing a strong enough sense of unity. But the worst hurdle has been overcome. For it is so much easier, once distinctions have been established, to argue for interrelations that justify talk of unity than it is to argue the other way round, from unity to non-arbitrary distinctions.

Attributes

Here the objection raised would be that there is no way of adequately describing the Godhead which allows distinctive attributes to each of the three persons that would permanently distinguish them, one from another. The easiest method of approach would presumably be to argue from economic Trinity to immanent Trinity, from the three persons' distinct activities in the world to permanent distinctions between them, but, as Maurice Wiles has argued, there are considerable difficulties in such an approach, since there is much overlap between the allegedly distinct spheres of activity that are sometimes postulated, as, for instance, creation, redemption, sanctification or creation, rational life and spiritual life.[16] Thus, to give but one illustration of the difficulties, and perhaps the most obvious, counter to the former division we have the fact that 'the New Testament most explicitly associates the second person of the Trinity with the work of creation, and this concept of the creative activity of the Logos is a dominant theme throughout the early patristic period'.[17] Has either model, then, a solution to these difficulties?

(a) UM. As is well known, Augustine in his concern for the divine

[16] Cf. M. Wiles, 'Some reflections on the origins of the doctrine of the Trinity', in *Working Papers in Doctrine* (S.C.M., London, 1976), pp. 1-17, esp. p. 3ff.

[17] Ibid., p. 4.

unity minimises the distinction between the external operations of the Persons, declaring, for example, at one point in *De Trinitate* that 'the Trinity works indivisibly',[18] something which he explains a couple of books later in terms of there being 'a single creative source with regard to the creature'.[19] The result is that the grounds of distinction have to be sought internally, and this is in fact what Augustine offers us in Book 5 in response to what he calls a *calidissimum machinamentum* ('most cunning device'), posed by the Arians, 'namely, that whatsoever is said or understood of God, is said not according to accident, but according to substance: and therefore, to be unbegotten belongs to the Father according to substance, and to be begotten belongs to the Son according to substance; but to be unbegotten and to be begotten are different; therefore the substance of the Father and that of the Son are different.'[20] The result of the argument would be, of course, the postulation of three independent substances, an option incompatible with orthodox Trinitarianism, but, equally, Augustine could not accept the other alternative mentioned, that these attributes be thought of as accidents, since on the traditional understanding of God he has by definition no accidents, no contingent or transient qualities. Augustine's solution is to suggest a third category from Aristotle's scheme of categories, that of relation.

Augustine is undoubtedly successful in drawing our attention to the fact that 'Father' and 'Son' are relational attributes; he also notes that the same is true of 'unbegotten' and 'begotten', though in the former case he has to deal with the fact that objectors 'do indeed say something that requires more careful discussion in respect of the term unbegotten, because neither is anyone therefore a father because unbegotten, nor therefore unbegotten because he is a father, and on that account he is supposed to be called unbegotten, not in relation to anything else, but in respect to himself'.[21] Augustine, however, successfully deals with the problem by pointing out that, though 'Father' and 'unbegotten' undoubtedly differ in meaning, the latter, like the former, is none the less a relational predicate, its meaning being constituted by a denial of a relation, that is to say, a denial that the Father's relational status is the same as that of the Son. The use of the term 'Holy Spirit' is discussed much more briefly.[22] Augustine notes that the term can be used indifferently of the Persons, 'but yet that Holy Spirit, who is not the Trinity, but is understood as in the Trinity, is spoken of in his proper name of the Holy Spirit relatively, since he is referred both to the Father

[18] *De Trinitate* 2.18.

[19] Ibid., 5.15. The Latin is 'unum principium' which Shedd (op. cit., p. 95, n. 6) translates as 'a single creative energy'.

[20] Ibid., 5.4ff.

[21] Ibid., 5.7.

[22] Ibid., 5.11-13.

and to the Son, because the Holy Spirit is the Spirit both of the Father and of the Son. But the relation is not itself apparent in the name, but it is apparent when he is called gift of God; for He is the gift of the Father and the Son, because "He proceeds from the Father", as the Lord says; and because that which the apostle says, "Now, if any man have not the Spirit of Christ, he is none of His", he says certainly of the Holy Spirit Himself.'[23]

Looked at purely formally, it has to be conceded that his proposed solution clearly evinces the brilliance of Augustine's intellect. For, it is undoubtedly true that on the basis of the relational predicates he mentions the three 'Persons' could be successfully distinguished. However, as soon as one looks at the content of the distinction, doubts immediately begin to arise. This is because it is hard to see how one can get beyond the purely formal distinction, and so claim that anything really significant is being pointed to, such that a permanent and fundamental distinction within the Godhead has been indicated. But, before decisive grounds for rejection are given, it will be appropriate to indicate why at the purely formal level Augustine's approach must be judged successful.

Instead of talking of the specific relational properties to which Augustine refers, let us put his solution in as general terms as possible, as this will indicate very clearly the measure of his success. In effect we have the claim that it is the Father who alone relates and is not related, the Son who both relates and is related and the Holy Spirit alone who is related but does not actively relate.[24] Logically, this saves the day, so far as a purely formal distinction is concerned, and one therefore suspects that this is what lies behind Augustine's proposals, in that thereby the uniqueness of each 'Person' is successfully delineated. At all events, one suspects that this is the real reason lying behind Augustine's enthusiastic endorsement of the so-called 'Filioque', the view that the Holy Spirit proceeds from the Father and the Son rather than just the Father. For, without it, the Son would formally be in exactly the same situation as the Holy Spirit, that is to say, related without actively relating. To be sure, Augustine nowhere acknowledges this to be the reason, but there can be little doubt, especially as he occasionally admits in passing his difficulty in finding an adequate basis for the distinction between Son and Holy Spirit, as, for instance, in the following passage: 'there is a further question also respecting the supreme Trinity itself ... which troubles men ... viz. why the Holy Spirit is not also to be either believed or understood

[23] Ibid., 5.11. The scriptural references are to John 15:26 and Romans 8:9.

[24] There is an interesting formal parallel in Aristotle's analysis of desire in *De Anima* 3.10 (433b15): 'That which is unmoved is the practical good, and that which produces movement and is moved is the faculty of desire ..., while that which is moved is the animal.'

to be begotten by God the Father, so that He may also be called a Son.'[25]

But, unfortunately, as soon as one presses beyond the purely formal level, overwhelming difficulties arise. This is because it is far from clear that any meaning can be attached to the three relations in question, fatherhood, sonship and procession or spiration. After all, their original context of meaning was just so different, the earthly Jesus' experience of Sonship vis-a-vis his heavenly Father and the early disciples' use of the symbolism of 'breath' to provide some account of their experience of an inflow of divine energy, which they regarded as coming from beyond themselves and therefore as proceeding from the Father, and possibly also the Son. This use of the terms is already highly metaphorical, and, that being so, it is unlikely that the terms can survive the strain of moving to an even more metaphorical context, especially in view of the fact that from the standpoint of doctrine, as I have already argued at the end of Chapter 3, one of the principal objectives in using the metaphors has to be abandoned, namely any suggestion of an inferior or dependent relationship. Of course, one could argue that the metaphors were intended to express intimacy and not inferiority, but there is no reason why the two alternatives should be thought of as exclusive. At all events, on any natural reading 'sonship' must surely suggest inferiority, since otherwise no explanation is provided as to why that term was chosen rather than another more clearly indicative of an equality in the relationship, such as 'friend'.

But, without inequality, it is hard to see how the relation can be the basis for making distinctions within the immanent Trinity. It might, for instance, be suggested that there is at least movement reflected in the terms, with the Father giving and the Son and Holy Spirit receiving. But, as soon as one reflects further on what might be implied by the notion of 'movement', one comes across insuperable difficulties. For movement is a temporal relation, and, on a traditional understanding of the concept of God, He is a timeless being. A timeless act of creation would not provide a useful parallel, since in that case there is movement only from our perspective (with the beginning of time), not God's. Nor would the problem be solved by making God a temporal being, since even then it will remain impossible to specify what is constituted by the relation, in particular what makes the movement one way. Thus, appeal to Augustine's psychological analogies will be of no help, since they seem to have inferiority built into them, in the former of the two with 'mind' being obviously of a very different status from 'knowledge' and 'love', though in the latter arguably it is the Son who is made superior by being identified with 'the understanding' over against 'memory' and 'will'.

One would have thought that in any case the difficulty of finding any parallel instances of two things distinguished only by a single relation

[25] *De Trinitate* 9.17.

would have given pause for thought. Normally there are numerous other means available of making the distinction. The only parallel which comes to mind, a repeating series of the same integer with the numbers distinguished only by the relative position that they hold in the series, suggests such a nominal distinction as to inspire little confidence.

(b) PM. It might be thought that the Cappadocians fare no better, since, like Augustine, they reject any distinction based on the economic Trinity. Thus, Basil, for example, in the context of a letter in which he is arguing for the divinity of the Holy Spirit on the basis that 'identity of operation in the case of Father and of Son and of Holy Ghost clearly proves invariability of nature', remarks: 'The Father, the Son and the Holy Ghost alike hallow, quicken, enlighten, and comfort. No one will attribute a special and peculiar operation of hallowing to the operation of the Spirit, after hearing the Saviour in the Gospel saying to the Father about his disciples, sanctify them in my name. In like manner all other operations are equally performed, in all who are worthy of them, by the Father and by the Son and by the Holy Ghost.'[26] In effect, their view does seem to be like Augustine's, that 'the peculiar property of each'[27] is a different relation, though they are more reluctant to use that terminology. Instead, they simply speak of paternity, sonship and sanctification or ingenerateness, generateness and procession, without underlining the fact that they are relational properties. (The former terminology comes from Basil, the latter from Gregory Nazianzen.)[28]

In fact, all that can reasonably be said on the matter is that there is perhaps a difference of degree in the extent to which the difference between the 'persons' is minimised, but certainly no difference in kind. Thus, it is Augustine who is less willing to speak separately of their distinct activities, and indeed provides us with a striking illustration to underline the point: 'I would boldly say that the Father, Son and Holy Spirit ... work indivisibly; but that this cannot be indivisibly manifested by the creature, which is far inferior, and least of all by the bodily creature: just as the Father Son and Holy Spirit cannot be named by our words, which certainly are bodily sounds, except in their own proper intervals of time, divided by a distinct separation, which intervals the proper syllables of each word occupy.'[29] This is developed a little later in the comment: 'So the Trinity together wrought both the voice of the Father, and the flesh of the Son and the dove of the Holy Spirit, while each of these things is referred severally to each person. And by this similitude it is in some degree discernible, that the Trinity, which is inseparable in itself, is manifested separably by the appearance of the visible creature.' What Augustine seems to want to say is that it is

[26] Letter 189.7.
[27] Letter 38.6.
[28] For Basil, cf. Letter 236.6; for Gregory Nazianzen, cf. *Orationes* 29.2.
[29] *De Trinitate* 4.30.

because of our frailty that sensible evidence is provided of the distinction, but that from God's point of view it is purely an internal distinction that does not affect his conduct in the world. At all events, it is particularly interesting to observe him remarking a few sections earlier in *De Trinitate*:[30] 'The Son is not properly said to have been sent in that He is begotten of the Father; but either in that the Word made flesh appeared to the world ... or in that from time to time He is perceived by the mind of each ... What then is born from eternal is eternal ... but what is sent from time to time is apprehended by each.' This suggests to me that it is only from our perspective that the persons seem to be operating separately, and, if that is the case, then obviously such appearances can be of no help in alleviating the problems we noted as arising when Augustine appeals to purely internal relations as the basis of the distinction.

The Cappadocians, however, exhibit more moderation, and so provide a way out of the dilemma. Gregory of Nyssa offers a dramatic image, but with rather different implications from Augustine. He compares the unity in difference to the colours of the rainbow: 'Now this brilliance is both continuous and divided. It is of many colours; it is of many forms; it is insensibly steeped in the variegated bright tints of its dye; imperceptibly abstracting from our vision the combination of many coloured things, with the result that no space, mixing or parting within itself the difference of colour, can be discerned either between blue and flame-coloured, or between flame-coloured and red, or between red and amber ... As then in the token we clearly distinguish the difference of the colours, and yet it is impossible for us to apprehend by our sense any interval between them; so in like manner conclude, I pray you, that you may reason concerning the divine dogmas; that the peculiar properties of the hypostases, like colours seen in the Iris, flash their brightness on each of the Persons ... but that of the proper nature no difference can be conceived of as existing between one and the other, the peculiar characteristics shining, in community of essence on each.' This image conjures up very different thoughts from those suggested by Augustine, particularly as in this case there is no comment on the inadequacy of human perceptions, so central to the notion of us having to enunciate words separately, rather than simultaneously. In fact, Gregory's image suggests that we take our perceptions, our perspective literally, but that when we notice overlap in operations we should remain unworried, since the same occurs with the colours of the rainbow without this implying that it is all the same colour. Equally, when we observe one person in operation, we should infer the cooperation of the other persons, just as we would infer the presence of the other colours of the rainbow, having once observed one of them suitably present. Indeed, he had earlier in the same

[30] Ibid., 4.28.

letter offered another image for just such an inference: 'And since the Spirit is Christ's and of God, as says Paul, then just as he who lays hold on one end of the chain pulls the other to him, so he who "draws the Spirit", as says the prophet, draws to him at the same time both the Son and the Father'.[31] Gregory has an additional motive for refusing to make the distinctions entirely internal in the manner of Augustine, namely his view that God in Himself is infinite and incomprehensible, since 'infinity is free from limitation altogether'.[32]

The difference of emphasis, then, amount to this: for Augustine the distinction between the persons is entirely a matter of internal relations, whereas for the Cappadocians it is a matter of what they are in virtue of having those relations, distinct persons. But, unfortunately, the latter's account is flawed, first because they omit the 'Filoque'[33] and so provide no clear account of the distinctions internally, and secondly because their emphasis on the persons operating externally as a unity leaves it unclear as to how distinct persons might ever be identified. This is to detect a difference of emphasis between Augustine and the Cappadocians which scholars such as Maurice Wiles reject,[34] but, whether correct or not, the important point logically is that such an account offers possibilities of development which will help solve the problem of finding an adequate basis for the distinction between the persons. This is because the Cappadocians seem to be employing a different notion of what makes for the unity of external operations. For Augustine it is the one individual God acting who provides impressions of distinct 'persons' acting so as to reveal his internal relations, whereas for the Cappadocians it is indeed these distinct persons acting, but always with the full cooperation of the other two persons, and always in such a way that no unique sphere of activity is claimed.

The grounds for hope are thus provided in the different concept of 'person' being employed. For it might be possible to extend the Cappadocian notion of the persons acting distinctly in the sense of separately (though in cooperation) to the idea of them acting distinctly in the sense of distinctively. This is an option that would not have been available to Augustine, because of his very different conception of what 'hypostasis' involved. Indeed, the dissatisfaction he expresses with the term 'person' could scarcely be more forceful: 'When the question is asked, "What three?" human language labours altogether under great poverty of speech. The answer, however, is given three "persons", not that it might be completely spoken, but that it might not be left wholly unspoken.'[35] But, fortunately, as their analogy of man as individual and

[31] Letter, 38.6.
[32] Letter, 48.4.
[33] Though it is sometimes detected in their writings, cf. e.g. alternative translations which have been offered for end of Book I of Gregory of Nyssa's *Adversus Eunomium*.
[34] Op. cit., pp. 11-14.
[35] *De Trinitate* 5.10.

man as genus makes clear, the Cappadocians are utilising something much nearer to the modern concept of person.

Of course, this by no means solves the problem, since we must still point to something that would justify us in distinguishing three consciousnesses, and thus three persons, a matter that seems not to have been discussed by the Cappadocians. But at least their talk of persons suggests a way forward in terms of distinguishing between the different content of their minds or their different mental histories, depending on whether we take them to be existing outside time or not. Admittedly, one could have three distinct human persons, indistinguishable in thought content, but this is because there are other ways of making the distinction not available in the divine case, as, for instance, spatial location. That being so, given the bankruptcy of any attempt to base the distinction on relations, it does look as though, in order to avoid identical thought content, we shall have to fall back on the economic Trinity.

The subsequent discussion now becomes heavily dependent on the arguments and conclusions of previous chapters. In Chapter 6 I defended the coherence of two christological models, TNC and KM. TNC by itself is capable of sustaining a unitary view of God (i.e. UM), which is not the case with KM since on that model the existence of at least one other person in the Trinity is required if the fundamental change which the model requires is to take place. But, if the arguments of Chapters 3 and 4 are correct, there are good historical grounds for distinguishing between the three persons, and so TNC must also be brought under PM. Of itself, such an appeal to human experience, as reflected in the historical origins of the Christian faith, would seem to me to be sufficient. This is because of the nature of the appeal being made, which in the process does rather more than establish merely economic trinitarianism. Thus, it was not simply successive phases or different aspects that were appealed to, as is the case in practically all accounts of the economy, in terms of which the absence of any ultimate distinction can then easily be postulated (the phases or aspects being seen as the work of a single mind, doing now one thing and now another). Such an option is excluded on my account because integral to the argument is the claim that the experience was not merely of God acting in a particular way, but of a Person acting who in the process is identified as being not another Person. That is to say, the experience of distinct Personhood antedates the realisation of a common identity. Evidentially, the distinction of the Persons is a more basic datum than their ultimate unity. This is one of the most important new perspectives that modern historical investigation of the New Testament has revealed, but so far it has been inadequately taken into account in discussions of the doctrine of the Trinity.

The objection of meaninglessness which we raised against Augustine's account of the internal relations would thus be avoided, and instead the distinction would be based on the persons' different external relations vis-à-vis the world, with each the subject of distinct human experiences

that have among their characteristics indicators of the fact that they are not experiences of certain other divine persons. However, at least two grounds of objection might be raised to the account I have so far given. The first would be to challenge the original interpretation of the experience as normative. After all, it may be said, an ultimate unity was subsequently postulated, and this may be thought sufficient to undermine the original interpretation of the experience. But, in reply it may be pointed out that the postulation of an ultimate unity depends on conceptual grounds which need not be seen as in any way undermining the data apparently given by those original experiences, namely a unity of common objectives displayed in the activity of the three persons. If the objector still persists in doubting in the light of this unity whether the individuals involved correctly interpreted their experience, all that can be said is that it is very hard to see why we should suppose them to have got it wrong, especially as the interpretative framework they implicitly committed themselves to was in violation of their natural cultural assumption of a strong emphasis on divine unity, a point made at greater length in Part II.

The other objection that springs to mind is that, though different thought content is indicated through the three persons being subjects of the different experiences to which they are related, dissatisfaction might still be expressed because the Persons are merely being differentiated indirectly through the agency of what other persons (human beings) experience, rather than directly in terms of their own personal thought content or history. Indeed, on this basis it may be said that we have not really got properly beyond an economic trinity to a truly immanent one. Fortunately, the difficulty is easily resolved. For not only, following the interventionist account I defended in Chapter 1, may we say that it is the three persons themselves who directly make such experience possible, but also that as a result of entering into these roles certain further differences in their thought content followed which are not themselves the subject of direct human experience. Thus, in the case of the Incarnation of the Second Person, whichever of the two models one takes, there are going to be certain events, particularly, of course, his earthly life, which are uniquely part of his 'history'. This will be true of TNC as well since, if we reject the unitary view, then it will be the Son alone who will allow the total interflow of experiences between the two natures that we saw was demanded, if the model was to be defended as coherent. As for the Holy Spirit, the same applies. For if my defence at the end of Chapter 4 of conceiving of Him always striving to become the subject of certain experiences is accepted, not only will there be a type of activity which uniquely distinguishes Him from the Father and Son through its special indwelling character, but also such striving will objectively occur whether or nor any particular human subject is directly aware of the fact. In other words, the Holy Spirit, like the Second Person of the Trinity, can

be described as having a unique 'personal history', the history of his attempts to become the subject of individual lives as they let themselves become the channels of his activity or, putting it in more explicitly theological terms, as they enable him to become 'the soul of the Church.'[36] But to such a means of differentiating the Persons it may be objected that it undermines the transcendence of God. For traditionally it is claimed that God is not dependent on his creation, and yet according to this account it appears as though it is only through that creation that God can be conscious of his trinitarian character. But this does not follow. At most what follows is that without such a pattern of activity the basis of the distinction would be inconceivable to us. No doubt other means unknown to us are available to the three Persons.

In short, then, my conclusion on the coherence of the attributes applied to the Persons of the Trinity is that sense can only be made of the distinction if one thinks of three distinct centres of consciousness, each with its own distinctive mental content. But the question now arises as to whether coherence has not perhaps been bought at too high a price, with the Trinity being split apart and it no longer being possible to speak of one God. This is the problem of identity, to which I now turn.

Identity

The question we must now deal with is the problem of whether there is adequate justification for speaking of *one* God, who is also in some fundamental sense three. Previous sections have already cast considerable doubt on the coherence of UM, but it remains worthwhile to look at its coherence in his respect as well, if only to ascertain the extent of its overall deficiency.

The question is particularly pertinent in the light of David Wiggins' recent book *Sameness and Substance*[37]. For he argues there against a relativity view of identity of the sort held by Geach in *Reference and Generality*,[38] according to which 'a particular *a* may coincide with some specified material particular *b* when individuated under some ... concepts and not coincide with *b*, but be distinct from it, when individuated under others'.[39] Instead, he adopts strict identity, holding that, if *a* is the same F as *b*, then *a* must also be the same G as *b*, and on this basis then rules out the Trinity as incoherent, since the Father is the same God as the Son but not the same person.[40]

[36] Cf. Leo XIII's *Divinum Illud* of 9 May 1897 and Pius XII's *Mystici Corporis* of 29 June 1943 (Denzinger-Schönmetzer, *Enchiridion Symbolorum*,[36] Herder, 1976, no. 3328 and 3807.

[37] D. Wiggins, *Sameness and Substance* (Blackwell, Oxford, 1980).

[38] P. Geach, *Reference and Generality* (Cornell University Press, Ithaca, 1962).

[39] Wiggins' account of the view in op. cit., p. 16.

[40] Ibid.; cf. pp. 37-42.

A large number of other alleged counter-examples to the thesis are examined, but he maintains that on reflexion none of them will be seen to involve a commitment to a relativity thesis but rather must be explained principally by either (1) ambiguity in time reference or (2) ambiguity in 'is' where the verb really means 'is constituted by' rather than 'is the same as' or (3) ambiguity in the intended reference of the subject. Examples of each, which he gives, are as follows: (1) 'John Doe, the boy whom they thought a dunce at school, is the same human being as Sir John Doe, the Lord Mayor of London, but not the same boy.'[41] 'Boy' is what Wiggins calls a 'phased sortal', that is to say, it is a count noun that only applies to part of an individual's existence, not the whole of it. ('Count nouns' are those which give us the ability to count, i.e. to answer the question 'How many?'. So, for instance, 'human being' is a count noun whereas 'water' is not.) (2) 'That heap of fragments there is the jug you saw last time you came to the house.'[42] It is the same collection of material bits, the 'is' of constitution, but not the same jug.(3) 'The present church is the same church as the old parish church, but not the same building.'[43] The ambiguity here is that 'church' is an expression which is sometimes used to refer to a building, and sometimes to a continuing congregation. Wiggins deals successfully with these and other alleged counter-examples to the thesis, and so the question inevitably arises whether either of the two models under discussion can save the doctrine from the incoherence he alleges.

(a) UM. Aquinas follows Augustine in adopting this model. Fortman describes his discussion as 'an exercise in verbal or conceptual gymnastics'.[44] This is certainly unfair. Aquinas shows much subtlety, and indeed he even refers to a passage of Aristotle's *Physics* which is also discussed by Wiggins, though not with reference to the Trinity.[45] But, that said, it cannot be claimed that he succeeds in providing a satisfactory answer to Wiggins. From his discussion it is clear that Wiggins would concede that the notion of a Trinity distinguished by its relations is *prima facie* coherent, but only provided no claim to numerical identity is made between each of the three persons and the Godhead: that is to say, provided that different entities or concepts are seen as being in play. But, if I read Aquinas aright, this is precisely what Aquinas would not have been willing to concede. Thus he writes: 'Granted both fathership and sonship are in reality the same thing as the divine nature, nevertheless their proper meanings imply in different respects.'[46] The first half of the sentence appears to imply that at most

[41] Ibid., p. 23.

[42] Ibid., p. 27.

[43] Ibid., p. 29.

[44] E.J. Fortman, *The Triune God* (Theological Resources, vol. 3, Westminster, Philadelphia, 1972), p. 208.

[45] Aristotle, *Physics,* 3.3.202b; D. Wiggins, op. cit., p. 41, n. 35.

[46] *Summa Theologiae* 1a.28.3.

Aquinas would have conceded the persons represent different aspects of the same thing, and that, so far would he be from admitting that the persons represent different entities or concepts from the Godhead that he would have endorsed a claim to numerical identity – 'are in reality the same thing as'. Certainly, the claim to numerical identity had been made not long before Aquinas' birth at the Fourth Lateran Council in A.D. 1215: 'We ... believe and confess ... that there is one supreme reality ... which is truly Father, Son and Holy Spirit, at once the three persons taken together and each of them singly.'[47] There is no doubt in my mind that this is the doctrine of the Trinity at its most incoherent. Theologically, one can of course understand the motivation behind it, the desire to preserve the claim that in any situation in which divinity is present the entire Godhead is present. But, logically, total nonsense is the result.

Fortunately, however, an alternative means of approach is available for UM, one that is in fact to be found in Augustine. For it is possible to argue that 'is' with reference to the godhead is an 'is' of constitution, rather than an 'is' of identity, and this is what Augustine suggests at one point in *De Trinitate*: 'We do not therefore use these terms according to genus or species, but as if according to a matter that is common and the same. Just as if three statues were made of the same gold, we should say three statues, one gold, yet should neither call the gold genus and the statues species; nor the gold species and the statues individuals.'[48] It is a solution that was to be rejected at the Lateran Council to which I have already referred, the reason being that it was taken to imply a belief in a fourth entity, and so the Council declared that 'in God, there is only a Trinity and not a quaternity, because each of the three persons is that reality, that is the divine substance.' It was, however, a possible implication of which Augustine himself was already fully aware, since he adds shortly after the passage already quoted that 'we do not say three persons out of the same essence, as though therein essence were one thing, and person another, as we can say three statues out of the one gold'. But it was a false worry in any case, since one can simply stipulate that all of godhead is to be found in the three persons without remainder, something of which Augustine again shows himself aware in the passage under discussion when he writes that 'there is nothing else of that essence besides the Trinity'.

Yet, for some reason doubts must have lingered in his mind. For he does not seem to have remained content with this constitutive analysis, entirely coherent though it is. At all events, elsewhere we find him using the incoherent language of numerical identity, as, for instance in a letter of A.D. 410: 'The Godhead is common to all (three persons) as the one of

[47] Denzinger, op. cit., no. 804.
[48] *De Trinitate* 7.11.

all and in all, and wholly in each one.'[49] Perhaps what troubled Augustine was the strangeness of treating godhood as a constitutive notion like gold. Certainly, it is very unlike the 'stuff' concepts which we would normally think of when the 'is' of constitution is mentioned. Presumably, what motivated Augustine to contemplate its appropriateness is his view of the Father communicating his essence to the other two persons, which is the basis for his view of the order pertaining in the relations that distinguish the persons. I have already argued that this order has no meaning outside its original context of the economic trinity, but in any case there is an additional reason for regarding the approach as unsatisfactory, namely its failure to take account of the meaning of 'god', which is not like non-count nouns such as 'gold', but a sortal concept meaning something like 'being worthy of worship'. Another possibility is the following: in the passage of *De Trinitate* already referred to he declares that 'the Father, the Son and the Holy Spirit together is not a greater essence than the Father alone or the Son alone'; this is true since three infinite beings still only equal infinity; but he may have been led on from this to infer illegitimately that since, apart from the one exception of KM, there is always identity of power between the Trinity and an individual Person there is also numerical identity of essence.

But, whatever the reason for Augustine's doubts about a constitutive analysis, it must be admitted that in principle at least the notion is a coherent one; the difficulty comes rather in finding an intelligible sense in which godhead might function like gold.

(b) PM. It is interesting to note the way in which the Cappadocians give the constitutive analysis short shrift. Thus Gregory of Nyssa towards the end of *Ad Ablabium quod non sint tres dii* does mention the relation between gold and individual coins, but, as the context makes clear, treats the relation as on a par with that between 'man' and individual men, while Basil in one of his letters[50] explicitly rejects the constitutive analysis for the same reasons later to be given by the Lateran Council, namely the implied recognition of a fourth entity: 'This explanation has some reason in the case of bronze and the coins made therefrom, but in the case of God the Father and God the Son there is no question of substance anterior or even underlying both.'

Instead, the Cappadocians adopt the notion of generic identity to which I have already referred earlier in the chapter. In Chapter 5 we noted how it is now generally agreed that Nicaea employed a generic notion of identity and not a numerical one, and indeed Stead argued that even in Athanasius, with whom the move towards numerical identity is commonly thought to originate,[51] 'we cannot claim that there is any

[49] Epistle 120.2.7.
[50] Letter 52.1.
[51] Cf. G.L. Prestige, *God in Patristic Thought*[2] (S.P.C.K., London, 1952), p. 213ff.

constant suggestion of numerical identity in the strict sense.'[52] That being so, it can scarcely be maintained that the Cappadocian position is disloyal to Christian tradition. Of course, in cases of conflict loyalty to the tradition must always give place to the truth, but in this particular instance it is arguable that the brush of logical incoherence with which the doctrine of the Trinity is so often tarred could have been avoided, had the suggestions of the Cappadocians been further pursued rather than those of Augustine.

At all events, Wiggins' objections can be avoided by their notion of generic identity, provided, that is, we indicate that God is not being understood as exactly the same concept or particular when an individual Person is under consideration, as when it is a matter of the whole Trinity. At this point some confusion may arise, and so it has to be emphasised that I am in no sense advocating a return to a relative view of identity. Rather, I am suggesting that two different, though related, notions be seen as being in play when we talk of the individual persons and the Trinity as a whole. 'God', as already noted, means something like 'a being worthy of worship', and there seems no reason why we should not think of there being in fact three such beings, about whom it is none the less appropriate to speak of one God or 'Godhead' (if a different term is preferred), because of the nature of the unity existing between them. The three Persons of the Trinity would then each correspond to what we traditionally understand by the meaning of the term, but 'Godhead' indicate the more complicated divine reality that in fact exists.

It is, of course, at this point that the spectre of tritheism will be raised. Indeed, the criticism is bound to be made particularly vehemently in my case, as the account I have just given clearly goes well beyond the Cappadocians in legitimising talk of 'three gods'. But the accusation is little more than a hollow war cry, which fails to take into account the considerable qualifications that are made in context, namely that they are so intimately related to one another that not only does it make sense to talk of a single reality, the Godhead, but also it is the ultimate reality, in that their unity is such that, though they have separate powers, to know the mind and will of one is to know that of all three. Indeed, because of this it would probably be less misleading to the ordinary layman to speak of 'three persons in one Godhead' with all reference to three gods omitted, though technically each does have all the attributes that would define him as a god.

However, that said, we must now examine the arguments that can be used to justify such talk of an ultimate unity. These may be conveniently divided into two kinds, those which appeal to a unity of external activity as the three Persons are seen from the standpoint of men, and those which appeal to a unity of internal activity, in terms of which it is the Persons themselves who are primarily conscious of themselves as one. Of

[52] C. Stead, *Divine Substance* (Oxford University Press, 1977), p. 266.

the two it is, of course, the latter which will be the more decisive since the former only establishes a unity of convenience from the point of view of our own classification of our experience, whereas the latter says something about the nature of things in themselves.

Wolfson draws a distinction between 'unity of rule' and 'unity of genus'[53] as a means of differentiating between the different types of arguments to be found among the Fathers, and it might be thought that this corresponds to the type of distinction just made. But this would be a mistake. It is, of course, true that the two types of appeal do not always appear explicitly together, but the passage I quoted from Gregory of Nyssa's *Ad Ablabium* in my discussion of the problem of analogy is, I think, indicative of the ultimate relation between them. For there Gregory appeals to unity of rule in order to substantiate his belief in a unity of genus, and this in fact would seem to be the point of appeals to unity of rule in general, that they are held to indicate an underlying unity of nature or genus, even if this is not always mentioned.[54] The result, partly of this relationship and partly because of the Cappadocians' insistence on the essential unknowability of God in Himself, is that, even when 'unity of genus' is under discussion, the matter is viewed very much externally, rather than in terms of how it might be seen from each Person's own perspective. It is this latter feature that I had primarily in mind, when noting a second kind of argument, an inference from God's internal life, as it were, rather than a consequence drawn from the unity of his activity in the world.

But, before I discuss that, something must be said about the argument from 'unity of rule'. So far as the historical evidence is concerned, it is beyond reasonable doubt that the claim is substantiated, and that, even if the three Persons do not always act together in every instance, they do always act with the same shared objectives in view. It is, after all, a conviction that was never challenged by the New Testament authors. At most, one can point to small inconsistencies such as, perhaps, the use of the term 'propitiation'[55]. Certainly, Marcion's attempt to drive a wedge between the God of the Old Testament and the New has only to be read (in reconstructions of his argument)[56] to reveal its immediate implausibility. Aristotle closes his theological discussion in Book Lambda of the *Metaphysics* by quoting Odysseus' words to the Achaean troops fleeing in disarray to their ships: 'A multitude of masters is no good thing; let there be one master, one king.'[57] Following such

[53] Op. cit., p. 312 ff.

[54] Apollinarius seems to identify the two in a letter to Basil, quoted in G.L. Prestige, *St. Basil the Great and Apollinaris of Laodicea* (S.P.C.K., London, 1956), p. 53.

[55] Romans 3:25, I John 2:2. Another example is possibly Mark 15:34.

[56] Cf. e.g. E.C. Blackman, *Marcion and his Influence* (S.P.C.K., London, 1948), esp. ch. 4 & 7.

[57] *Iliad* 2.204 (quoted from the Lang, Leaf & Myers translation).

sentiments, doubts may remain and it be thought that, unless there is in fact 'one master, one king', there is just not enough to justify us in speaking of one God or Godhead. But, the interesting thing about the quotation from Aristotle is that it is immediately preceded by a complaint against the absence of any principle of unity in a particular plurality, not by a complaint against plurality as such: 'Those who put mathematical number first and make a series of kinds of substance, each kind with different principles, make the universe itself a mere succession of unconnected items, with many governing principles.'[58] One might also note the way in which Stead tries to correct Merlan's emphasis on a unitary view of God in Aristotle by drawing our attention to the other divine unmoved movers (who move the planets, as distinct from the universe as a whole) mentioned in Chapter 8 of the same book, and in that connexion, he remarks: 'When he pictures divinity in these terms, Aristotle seems to have formed a clear impression of the quality of divine life, but not to have finally determined whether that life is concentrated in a single centre or distributed in a society. A divine society could in some sense accommodate the claim that "God is one". It would be a unique reality. It would no doubt be harmonious, and thus could avoid the Homeric objection to polytheism, which is based on the possibility of conflict. Again if it forms a hierarchy as Aristotle once suggests, it must include members which though subordinate are not defective ... And so far as he conceives of divinity in this way, there is an easy transition to the Christian doctrine in at least one of it main historic forms, as a Trinity of persons identical in nature though differing in rank, yet each perfect and coeternal.'[59] But it is doubtful whether Aristotle's commitment to a divine unity in plurality can be put as strongly as this. For, although he does at one point speak of the unmoved movers as jointly *to theion* (the divine), more normally he speaks of them separately as *theoi* (gods).[60]

However that may be, it can at least be claimed, especially given his remarks immediately preceding the Homeric quotation, that he would have been prepared to entertain the notion, which is more than can be said for most philosophers. This is because the absence of any real possibility of conflict is not regarded as enough. The stakes are set higher at the absence of even the logical possibility of conflict. But the demand is misconceived. First, it should be observed that the power of the infinite cannot but be circumscribed by the infinite and so two infinite beings in conflict with one another would at most produce a stalemate (i.e. with the power of one cancelling out the power of the other so that nothing happens either way at all). Secondly, because the factors that lead

[58] *Metaphysics* 1075b 37-1076a3.
[59] C. Stead, op. cit., pp. 90-1.
[60] For the former, cf. 1074b3; for the latter, 1074b2, 9.

human beings to change their mind, particularly lack of knowledge of the future and any automatic power to affect it, do not apply to the divine, constancy is commonly thought to be a basic divine attribute. But, if that is so, the possibility of conflict will be ruled out, as soon as it is established on the basis of the historical evidence that all three persons exhibit constancy in the same direction. Presumably, part at least of the motive behind the desire to exclude the logical possibility of such conflict, no matter how unlikely, is the wish to avoid attributing contingent, accidental predicates to the Godhead. But to postulate any doctrine of the Trinity whatsoever is already to go beyond attributes that can reasonably be claimed to be inherent in the meaning of the term 'God'.

But to this it may be objected that without some kind of necessary connection between the common intentions, there will be no way of distinguishing the situation from, say, Aristotle's close friends who have 'one soul',[61] thought two bodies. Will not the fact that the three Persons always agree and cooperate in what they do argue only for a shared enterprise rather than a common identity in one substance? One reason for resisting a move towards ruling out the logical possibility of conflict is that it would then be impossible to attach any ethical significance to divine harmony. But, more important, it is hard to see why such a move is necessary. For not only do the factors mentioned in the previous paragraph make the situation very different from the inherent likelihood of conflict between even the closest of human friends, but also even within a single person there is no logical guarantee of the avoidance of internal conflict. So schizophrenia is always a possibility and it depends on the actual degree of integration in the person, not on *a priori* logical considerations, whether or not we are prepared to speak of a single human personality. This suggests that the appropriateness of the language of unity is a matter of degree, but in the divine case unity of purpose is not in doubt. However, suppose the essentialist demand correct and it necessary to indicate some aspect that necessarily makes the three Persons have the same purposes. This could still be provided. For we might argue from the necessary goodness of God to the necessity of the three Persons having the same purposes. Alternatively, it could plausibly be contended that the point of the term 'god' is to indicate the necessity of separate worship; but, if this is so, necessarily the use of the plural 'gods' is excluded by an economy of divine action in the world which never reveals conflicting purposes between the three Persons.

What then the first type of argument incontestably establishes is that from the point of view of human classification it makes sense to speak of 'one Godhead' since the worshipper is thus directed to the fact that the three 'beings worthy of worship' have the same intentions and purposes

[61] Cf. *NE* 1168b7 and 1166a31.

vis-à-vis the world and thus vis-à-vis him as a worshipper. It is reasonable to infer that such a 'unity of rule' reflects something about the nature of the Godhead in himself, since otherwise it is hard to see why an alternative regime should not exist, such as respective spheres of influence. That being so, what the second type of argument does is provide a rationale for the three persons acting as a unity in terms of their internal divine life.

Probably the best known attempt to argue thus in English is to be found in Leonard Hodgson's *The Doctrine of the Trinity*. Hodgson contrasts 'mathematical unity' with 'organic unity': 'Approximation to the ideal of mathematical unity is measured by a scale of degrees of absence of multiplicity; but approximation to the ideal of organic unity is measured by a scale of intensity of unifying power.'[62] The Trinity, he suggests, falls under the latter category, as indeed does man himself, with whom he contrasts the mathematical simplicity of the unicellular amoeba, especially as 'on the usually accepted scale of values, the higher we go in the world of living creatures, the more complex does the organisation become'.[63] His conclusion, therefore, is that 'when we have learned to measure by a scale of intensity of unifying power we no longer think that, because the elements in the Godhead are not sub-personal activities but complete persons, the degree of unity must be less than in the human self and that consequently the doctrine is tritheistic'.[64] All this is very encouraging, but, unfortunately, he takes us no further. Indeed, there is an obvious objection to his account as it stands. For he fails to explain why God, instead of being thought of as a more complex organisation than man with resultant greater scale of intensity of unifying power, should not instead be compared to ordinary civil society, a more complex organisation also, but one which tips over into disintegration of any strong notion of unity. The result is that the conclusions he draws from the doctrine about the proper nature of society are left entirely unfounded. He suggests that acceptance of diversity is a necessary conclusion,[65] but it is hard to see why, unless one is given a strong basis for unity first, which can then withstand the proposed diversity, and that is precisely what he fails to provide in both cases.

A more satisfying approach is to be found in Betrand de Margerie's *La Trinité Chrétienne*. In a chapter entitled 'Famille, Eglise, Ame Humaine' he examines in detail these three analogies for the Trinity, of which only the last is commonly considered, but which he finds the least adequate of them all. He acknowledges that Augustine had good reason to adopt that particular model, given the circumstances of his time when

[62] L. Hodgson, *The Doctrine of the Trinity* (James Nisbet, 1943) Lecture IV, pp. 89-96, esp. p. 94.
[63] Ibid., p. 91.
[64] Ibid., p. 96.
[65] Ibid.; cf. pp. 186-7.

any suggestion of polytheism had to be avoided, but adds that "son rejet de toute image familiale est un anachronisme que nous n'avons pas de raison de retenir aujourd'hui',[66] the main reason given being his conviction that the other two are more Biblical: 'Le Nouveau Testament situe la Révélation trinitaire dans le cadre de l'expérience familiale (relations père-fils), de l'expèrience du langage ecclèsial (relations maître-disciple, parole donnée et acceptée) et du mystère même de l'Eglise (relation époux-épouse, symbolique de la relation Christ-Eglise elle-même symbolique de la relation Père-Fils).'[67] Whether he is right or not in this matter, we need not consider here. It is his development of the other two images which is important.

With the family model, rather than pursuing its Biblical form, he notes a reference in Gregory Nazianzen, who argues that something may be of the same species but not generated by quoting the case of Eve who was of the same species as Adam and Seth, yet, unlike Seth, not generated.[68] Margerie thinks that a detailed analogy must be intended, with Adam as Father, Eve as Son and Seth as Holy Spirit,[69] but it seems to me more probable that all Gregory wanted to establish was the possibility of identity of substance without generation, as in the case of the traditional story of Eve's creation which could then be applied to the case of the Holy Spirit. However that may be, he does develop his proposed interpretation in a very dramatic way in that, following Mühlen, he suggests we think of the Trinity in terms of a married couple with child, a 'Je-Tu-Nous' analogy.: 'En disant "Tu," une personne n'est pas encore entrée en relation réciproque avec une autre, aussi longtemps que cette autre ne la traite pas réciproquement de "Tu". Et même quand deux personnes se traitent reciproquement de "Tu", elles n'ont pas encore adopté une attitude commune devant une troisième, ce qui advient dans le "Nous" ... L'alliance est l'expression ou le signe d'un "Nous" intime. Ainsi, le "Nous" conjugal est présupposé a l'acte commune aux deux époux, l'acte de la génération, par lequel leurs deux personnes s'orientent dans la direction d'une troisième, l'enfant.'[70] One could, of course, complain about aspects of the analogy, such as the fact that the generation of the Son seems to be ignored, but I have already suggested that there are no good grounds for applying this notion to the immanent Trinity. Yet, on the other hand, the double procession of the Holy Spirit is clearly implied within it, which I would reject for the same reason. Its advantage lies in the fact that here at last we have an explicit suggestion of a unity in the Godhead that is based on the perceptions of the Persons

[66] B. de Margerie, *La Trinité Chrétienne dans L'Histoire* (Théologie Historique 31, Editions Beauchesne, Paris, 1975), p. 4-6.
[67] Ibid., p. 418.
[68] *Oration* 31 (Theol. V), 11.
[69] Op. cit., pp. 368-9.
[70] Ibid., p. 376.

themselves. Admittedly, Margerie does not follow this up to the degree that one might have hoped, but this much is surely clear, that marriage is the sort of situation in which individual personalities can be transcended into a higher unity, through mutual love and understanding eventually producing a common conception of themselves and the experiences that befall them.

Much the same can be said for Margerie's other analogy. He declares that of the three 'c'est l'analogie ecclesiale qui est la plus explicitement contenue dans la Révélation'[71] and refers us to the great Johannine prayer for unity[72]. He also makes the following highly pertinent remark: 'Le Nouveau Testament nous montre non seulement le "cor unum" des chrêtiens, mais encore une "circuminsession des coeurs" mutuellement présents les uns aux autres au sein de l'Eglise',[73] and then refers us to a couple of Pauline passages, including II Corinthians 7: 2-3, which he accurately translates as: 'Faites-nous place dans vos coeurs ... Vous êtes dans nos coeurs à la vie et à la mort.' What is interesting about these passages is again the internal perspective to unity which they provide. For what is supposed to provide the church with its unity is not just unity of practice, still less the unity of a united perspective to those outside its fold, but rather a unity that comes through 'circuminsession des coeurs' – in theological terms, the indwelling presence of the Holy Spirit that makes the Church the Bride of Christ; in secular terms, a shared vision that leads the individual to subordinate his identity in the larger whole.

Both analogies thus have their use in drawing our attention to some of the ways in which individual personality can be transcended. But there seems no reason why we should limit ourselves to these analogies. For, when the sociology of knowledge has been used so often to undermine the plausibility of incarnational and trinitarian doctrines,[74] it is surprising that it has not been noticed that it can equally well be used to bolster such doctrines in this context. This is because, particularly since Durkheim's *Primitive Classification*[75], we have become acutely aware of how far the way we view and understand ourselves and our relation to the world is a function of our society as a whole and not just of us as individuals. We think through our society and in the limiting case are simply identical with its consciousness. This is what Durkheim called 'mechanical solidarity', as distinct from what he regarded as a more developed 'organic solidarity'.[76]

It is surely unnecessary to pursue the matter in detail here, given the

[71] Ibid., p. 397.

[72] John 17:21-2; discussed on pp. 390-1.

[73] Ibid., p. 395.

[74] E.g. in D. Nineham, *The Use and Abuse of the Bible* (S.P.C.K. edition, 1978).

[75] E. Durkheim, *Primitive Classification* (ed. R. Needham, Cohen & West, London, 1963).

[76] Discussed in S. Lukes, *Emile Durkheim* (Allen Lane, London, 1973), p. 147ff.

vast amount of evidence that exists from sociology and anthropology, which clearly indicates that consciousness is not something absolute. Indeed, it seems beyond reasonable doubt that it is coherent to suppose that consciousness can be transcended into a group identity which is regarded as primary; there is just so much empirical confirmation to hand. None the less, two objections, which could be raised to suggest that it might not be an adequate basis to account for divine unity, had better be dealt with here.

The first concerns the fact that the strongest evidence for such consciousness comes from the most primitive societies, and so it might be argued that it can only come about through the suppression of aspects of the personality, a suppression that modern liberal societies have overcome and which it would in consequence be inappropriate to apply to the Godhead, especially as we normally think of only logical and moral constraints applying in this case. Certainly, if we thought of the model necessarily operating as in the primitive way we find, for example in the Old Testament story of Achan (whose whole family is punished, despite the fact that he alone is guilty of the offence in question)[77], we would be reluctant to apply the notion to the Godhead. But the Bible also has St. Paul's treatment of the Church as the Body of Christ to which I have already referred, and one can also quote modern secular examples of such a consciousness as, perhaps, for instance, Maoist China. The truth would seem to be that there are different ways of producing such consciousness, some of which involve the suppression of aspects of the individual's consciousness, and some of which do not. The latter case is well exemplified by a successful marriage, where it is not a case of endless compromise with each taking their turn at suppressing their real wishes, but the gradual move from being able in love to see issues through the other's eyes to a point where each sees, as it were, through a common prism.

The other objection questions whether the extent to which this prism operates is enough to justify talk of a divine unity. After all, it may be said, there are certain problems that are unique to the divine case; in particular, there is the fact that the attributes that are unique to divinity are distributed among three persons rather than one. However, we have already noticed that each Person's omnipotence will be frustrated, unless he enters into cooperation with the other two Persons. That being so, it does look as though this particular attribute is most appropriately applied to the Godhead as a whole since, without such cooperation, the individual Persons would in practice have at most the power to frustrate each other's designs, 'omninolence', as it were. Again, with omniscience it would seem most apposite to refer this also to the Godhead as a whole inasmuch as, though each would be omniscient to the maximum extent

[77] Joshua 7:10-26.

that was logically possible for them, their combined knowledge would be greater in that certain experiential knowledge would be uniquely applicable to one or other of them as, for instance, the Son's direct knowledge of suffering. Finally, while each is perfectly good, it is arguable that the individual moral attributes are most appropriately applied to the Godhead as a whole in that predicates such as all-loving, compassionate, just, etc. can only be explicated in their full richness of meaning if they are considered with respect to the Godhead as a whole with the distinctive aspects of the activity of the three Persons fully taken into account.

In brief then, my conclusion is that UM bristles with difficulties, some of which are more intractable than others, and that, therefore, both negatively through this failure of UM and positively on account of the, I hope, proven coherence of PM, we have every reason to adopt PM, in the sense given, as our model for the Trinity.[78]

[78] Unfortunately, R.W. Jenson's *The Triune Identity* (Fortress Press, Philadelphia, 1982) reached my attention too late to refer to it in any detail. While adopting a more narrowly focused and rather different approach from my own, it represents an encouraging sign of renewed interest in the relevance of philosophical issues. I think he underestimates the historical difficulties (cf. e.g. pp. 12 and 22), which are in any case briefly treated, but his longest chapter, 'The One and The Three', is clearly relevant to this chapter and valuable, especially for his attack on internal relations as the basis of distinction in the Godhead (cf. esp. pp. 116-26).

Conclusion and Prelude

The Divine Trinity

The conclusion of my argument then is clear. It is that not only can the doctrine of the Trinity be defended as logically coherent (Part III), but also there are sufficient grounds for believing it to be true (Part II), provided it is set in the wider framework of a justified belief in an interventionist God who engages in a particular form of revelatory dialogue with man (Part I). However, despite the detail and complexity of argument that has proved necessary to reach this conclusion, I am aware that much still requires to be done. It is for this reason that I have entitled these concluding remarks 'Conclusion and Prelude'. An explanation of why this is so can best be afforded by taking as illustrations the two most influential recent books on the doctrine of the Trinity, Moltmann's *The Trinity and the Kingdom of God* and Mackey's *The Christian Experience of God as Trinity*.[1] I want to distinguish two senses in which this work should be seen as a 'prelude'. The first concerns issues which have already been discussed in previous chapters, while the second raises as important topic to which only passing allusion has been made.

(i) The first concerns the plea I made in the Introduction for the founding of a new discipline of philosophical theology, or at any rate the widening of the horizons of the philosophy of religion to a point where the extensive number of philosophical issues raised by both biblical and doctrinal theology is fully acknowledged. Examples in the preceding chapters have been taken mostly from the writings of Biblical scholars. But systematic theologians like Moltmann and Mackey can equally be used as illustrations.

The very title of Mackey's book is strange. For, despite the reference in the title to experience, nowhere is any attempt made to analyse the nature of religious experience, and indeed at one point he disclaims any need to do so.[2] But, if the argument of Part I is correct, such an analysis is indispensable to any adequate defence of belief in God, even if one rejects the doctrine of the Trinity as Mackey does. Again, his treatment of the

[1] J. Moltmann, *The Trinity and the Kingdom of God* (S.C.M., London, 1981); J.P. Mackey, *The Christian Experience of God as Trinity* (S.C.M., London, 1983).

[2] Op. cit., p. 254.

Biblical material exhibits the same kind of conceptual mistakes as those to which I drew attention in Part II. So, for example, it is hard not to convict him of the false equation between historical original and theological truth. He rightly informs us of the pluriform character of the scriptural witness to Jesus. But he then goes on to infer from this that 'it represents a specific infidelity to the professed allegiance to the supremacy of Scripture to try to constrain that rich diversity within the confines of any systematic doctrine of the Trinity'.[3] Likewise he writes as though it automatically counts against the orthodox view that 'the "substance" language which after Nicaea they came increasingly to champion simply could not claim anything approaching the same scriptural support as the language used by the Arians'.[4] But, as I observed when discussing Dunn, neither scriptural diversity nor scriptural language should be our final court of appeal. For, given the nature of the revelatory dialogue, in which God always respects human freedom, we are lead to expect a degree of conceptual confusion that will require independent assessment and ordering. Not only that. Such investigations may reveal ontological implications of which the original authors were unaware. That is why all Mackey's attempts[5] to establish the exclusively functional character of New Testament christology are beside the point. As I argued in Chapter 3, even if this was entirely conceded, the incarnationalist has still not lost the argument. Likewise, his remarks that much of the language about the Spirit in the New Testament 'may have to be read as christology strictly speaking'[6] and that in Paul there is 'a virtual identity of spirit and lord in his theology'[7] fail to hit their target. For, as Chapter 4 argued, that can be conceded to be largely true and yet the separate personhood of the Holy Spirit still be defended. Indeed, the argument is not at an end even if there should be no evidence forthcoming from the New Testament. For that still leaves the whole range of mystical experience to be explored. Finally, equally in respect of the argument of Part III one finds Mackey wanting. He talks about the 'lameness'[8] of Gregory of Nyssa's attempts to differentiate between the Persons of the Trinity, and describes Augustine's discussion as 'an example at once of theological ingenuity and of the dead and rigid abstraction to which the theological development had descended under the weight of its own logic'.[9] But it is significant that he does not give either the Cappadocians or Augustine the benefit of the doubt. Only their most formal distinctions in terms of relations is discussed, and not those

[3] Ibid., p. 49.
[4] Ibid., p. 165.
[5] Ibid., pp. 51-65.
[6] Ibid., p. 74.
[7] Ibid., p. 76.
[8] Ibid., p. 145.
[9] Ibid., p. 156.

aspects highlighted in my own examination of the coherence of the doctrine. He also exhibits a strange indifference to logical terminology, as, for instance, when he says of Augustine's psychological analogy that 'there is an obvious enough sense in which these three, though distinct, have an identical content or substance'.[10] Substance language is 'container' language (i.e. 'thing' language), not 'containing' language (i.e. 'content' language).

Moltmann's conclusions are very different from those of Mackey. He enthusiastically endorses a Plurality model for the Godhead. Given the argument of Chapter 7 this is obviously a position with which I sympathise. Unfortunately, it is hard not to endorse Mackey's criticism[11] that Moltmann fails to take sufficient trouble to demonstrate that his position is scripturally based. In addition, and of more relevance to present concerns, like Mackey he is a systematic theologian who proceeds without any great awareness of the impossibility of extricating the issues from philosophical considerations. So, despite adopting the plurality model, he offers no extended discussion of what might justify talk of one God, and indeed two possible justifications are mentioned only in passing, that 'it lies in their fellowship'[12] and that 'without the social relation there can be no personality'.[13] But, in respect of the former, not only does he not tell us how this might differ from close friendship in this life, he even goes on to suggest without further conceptual explanation that 'the union of the divine Trinity is open for the uniting of the whole creation with itself and in itself'.[14] Again with the latter he fails to take account of the possibility that the reason for personality being a social relation in respect of human beings may not apply to God. For surely it is due to the fact that in our case personality is something which has to develop, and can only do so under the guiding hand of parents and teachers. This failure to take on board philosophical considerations is in fact symptomatic of his whole approach. Note, for instance, the following two sentences which are typical of the comments he makes: (1) 'A God who cannot suffer cannot love either; a God who cannot love is a dead God.'[15] (2) If God is love, then he does not merely emanate, flow out of himself; he also expects and needs love.'[16] Given the importance of such remarks to his view, one might have thought that an extended analysis of the concept of love would have been offered but it is nowhere to be found. Yet clearly 'suffering' must mean something very different in the case of God, if he knows how events will turn out, and, even if he does not, there

[10] Ibid., p. 159.
[11] Ibid., p. 205.
[12] Op. cit., p. 95.
[13] Ibid., p. 145.
[14] Ibid., p. 96.
[15] Ibid., p. 38.
[16] Ibid., p. 99.

would still be the reassurance that comes from knowing that one is in ultimate control. Again, it is far from clear to me that the ability to love implies any need for that love to be reciprocated, as (2) implies. Conceptual analyses of the kind offered in Part II are thus indispensable, if his position is to be maintained. Indeed, as it is he lapses into total incoherence in his desire to say God needs the world because there is only properly love 'where there is pure neediness in the receiver'.[17] For even in the human case one of the greatest joys in friendship is sharing things which do not need to be shared, e.g. a walk in the country or a meal.

The first sense in which this book is a prelude, then, is in indicating the necessity for the complete permeation of theology by philosophy. In saying this I should not, of course, he be taken as implying that there are no outstanding problems in my own discussion. Far from it. In fact, consideration of many of the questions examined in this book is still in its infancy. This is certainly true of the analysis of religious experience, upon which much of the argument hangs. But it is equally true, for example, of the questions of logical coherence discussed in Part III, or the criteria for the objectivity of an event discussed in Part II, or the tests for veridical revelation examined in Part I. It is precisely because so much remains to be done that I have argued for the necessity of a discipline of philosophical theology.

(ii) I suspect that theologians reading this work will be more surprised by the absence of one particular feature than they will be by the presence of the various innovating features that undoubtedly exist in my discussion. This is because so much of modern theology is obsessed by a desire for immediate relevance. The missing feature is the absence of any discussion of why the Incarnation happened or why the Holy Spirit chooses to relate to man in the way Chapter 4 suggested. It is not that I think such questions unimportant. But it does seem to me that, unless one asks what happened before the question why it happened, one will inevitably be putting the cart before the horse, with all the conceptual chaos that implies.

Mackey, and to a lesser degree Moltmann, illustrate this fault. Moltmann has an extraordinary chapter[18] in which he argues that the Unity Model has reinforced patriarchy and dominance within society rather than encouraged mutual cooperation and respect.[19] Whether this is true historically is questionable, but, even if true, the Plurality Model would not necessarily lead to the latter objectives. After all, three-man juntas are almost as common in the modern world as one-man dictatorships. One hopes that such thoughts played no significant part in leading Moltmann to advocate the latter model. Unfortunately, in the

[17] Ibid., p. 58.
[18] Ibid., Ch. 6, pp. 191ff.
[19] Ibid.; cf. esp. pp. 194 and 216.

case of Mackey it is clear that his desire for relevance has got the better of him. Thus he unhesitatingly avers the priority of orthopraxis over orthodoxy,[20] and, that being so, one cannot help wondering whether his desire for reconciliation with Jews and Muslims[21] has not triumphed to the resultant detriment of a proper analysis of the New Testament evidence. Yet he only offers us a very vague characterisation of the shared ideal.[22]

But God is not to be so easily moulded to human aspirations or preconceptions. That is why it is essential to discover first the truth of what happened before we go on to ask why it happened. It is certainly an astonishing truth that God should be so interested in a being of such vastly inferior powers as man. The difference is so great that it is rather like a man showing profound interest in the fortunes of a frog.[23] But that clearly must be the implication of the doctrine of the Trinity, particularly the Incarnation. Moreover, if the argument of Chapter 1 was correct, it is an inference that may legitimately be drawn only from such a doctrine. Otherwise the strength of the claim is inevitably weakened. That is why concern for the truth of the doctrine must precede any analysis of its implications.

At this late stage in my discussion this is obviously not the place to say what these implications are, save to make one comment. I suspect that any investigation of them will once again raise profound philosophical issues. To mention but one, there is the question of the nature of Christ's presence in the Eucharist, and whether this can be satisfactorily distinguished from the work of the Spirit. To mention a much larger issue, there is the whole question of whether a satisfactory philosophical defence can be given of the traditional claim that individual salvation depends on a present divine activity that is inextricably linked with the events discussed in Part II. But all that must await another day.

[20] Op. cit., p. 222.
[21] Ibid. pp. 248 and 30-5.
[22] Ibid.; cf. p. 241.
[23] cf. Isaiah 40:22.

Index

38,145

DEMCO